The Arts in Health Care

The Arts in Health Care

A Palette of Possibilities

Edited by Charles Kaye and Tony Blee

Jessica Kingsley Publishers
London and Philadelphia

of related interest

Music Therapy in Health and Education
Edited by Margaret Heal and Tony Wigram
ISBN 978 1 85302 175 6

Storymaking in Education and Therapy
Alida Gersie and Nancy King
ISBN 978 1 85302 520 4

Communication Skills in Practice
A Practical Guide for Health Professionals
Diana Williams
ISBN 978 1 85302 232 6

Art Therapy in Practice
Edited by Marian Liebmann
ISBN 978 1 85302 058 2

Published with the support of the King's Fund

First published in 1997
by Jessica Kingsley Publishers
116 Pentonville Road
London N1 9JB, UK
and
400 Market Street, Suite 400
Philadelphia, PA 19106, USA

www.jkp.com

Library of Congress Cataloging in Publication Data
A CIP catalog record for this book is available from the Library of Congress

British Library Cataloguing in Publication Data
the arts in health care : a palette of possibilities
1. Arts Therapeutic use 2. Art therapy
I. Kaye, Charles II. Blee, Tony
615.8'5156

ISBN 978 1 85302 360 6

Contents

Colour Illustrations

List of Figures

To Heather and Edwina
With love and admiration

Introduction

Tony Blee

A Practical Book

This is intended to be a practical book. When we first thought about producing it, the main thing that we wanted to do was to make the reader, after reading about what other people had done, say, 'Why don't we do that?' So it is not a philosophical book, although inevitably it includes the contributors' thoughts and perceptions about their work. Nor is it a book about Art Therapy, which is already well covered elsewhere, although throughout it is concerned with the therapeutic effects of the arts. Especially we wanted to look forward. We did not want to produce simply a record of what has been done, but to show what could be done and to open up possibilities in the reader's mind.

The Audience

We also wanted to reach the widest possible audience. We wanted to produce something that would interest all those who work in the NHS: managers at all levels, nurses and medical staff, professional and technical staff and all the many categories of support staff. We also wanted to gain the attention of Chairmen and Non-Executive members of Authorities and Trusts.

However, it is not just for those who work in the NHS. We hope that it will be of interest and help to other artists and architects, to the many voluntary organisations and to those who make grants to, and sponsor, art initiatives in the NHS.

As a glance at the contents pages will show, the subjects covered demonstrate the very wide range of the arts in health: from painting to writing and from buildings to music and to food. It is important to remember that the arts are international and the book includes some interesting examples of what is happening in the United States of America.

The Contributors

People have been unbelievably helpful to us in producing this book. All the authors have made their contributions free of charge and we are most grateful to them. They were either people we knew already or people with whom we were put in touch. There is a very efficient network in the arts world and all the time people were saying to us, 'Have you tried so and so?'

We have ended up with a good representation of all those who work in the arts in the NHS but inevitably there are many people and many splendid initiatives that we have left out; they will have to await another volume.

We have allowed the contributors to say what they want, how they want. One thing that we have learned is that there are no right or wrong answers. It is what appeals to the individual that is important. Our thanks are due to all the contributors and to those who helped us in our work.

In particular we would like to thank our publisher for her continuing support, Rachel Plato – and Tracy Taylor her successor – for their unfailing secretarial skills and hard work and Julie Elwick and Hilary Bean for their help and suggestions. We had valuable advice from Peter Senior and Malcolm Miles. Our librarians were patient and resourceful: we thank Alison Farrar and Judy Phillips at Broadmoor Hospital and Brenda Goddard then at North Hampshire Hospital.

Richard Burton, in his contribution, used the phrase 'a palette of possibilities'. This seemed a perfect subtitle for this book and we are most grateful to him for that.

We thank too Sobell Publications for their permission to quote from Lynne Alexander's 'Throwaway Lines', the North Carolina Medical Journal for permission to reprint 'Taking Shape: Environmental Arts in Health Care' (NC Med J 1993; 54:101–4) by Janice Palmer and Florence Nash and Dinah Livinstone of Katabasis for permission to use part of a poem by Cicely Herbert. We also thank Charlotte Mayer for her permission to use a picture of her sculpture 'Tree of Life'.

Any book about art really needs to be illustrated in colour. This is very expensive to do and so we are most grateful to the King's Fund, not only for its general encouragement, but also for its substantial contribution to this cost which has made such a difference to the impact of the messages in the book.

Art in the NHS

Fuelled by such brilliant initiatives as the Attenborough Report, by organisations such as Arts for Health and by the enthusiasm of individuals – many of whom appear in this book – a tremendous amount has been achieved in developing the arts in health care in the last ten years or so. New buildings are built with at least the importance of the environment in mind and old buildings are imaginatively refurbished. There has been a major move from just 'bright-

ening the place up' towards realising what the arts can do to produce real patient-centred care.

But the more progress we make, the more we can see how far there is to go. There are still many places where senior managers and Boards do not realise what could be done or who do not see the importance of it. Many old buildings still look dreadful and many new ones could look better. Patients are still left lying in bed with nothing to look at but a blank wall.

Funding

One of the basic essentials is getting funds to pay for what you want to do. The NHS is still far too sensitive to be able to spend exchequer money on the arts; managers have to spend a lot of their time demonstrating that the money they do spend could not be made available for more nurses or doctors or bits of expensive medical kit. Nigel Weaver's contribution on 'Purchasing and Commissioning' (Chapter 6) gives some good practical advice and more help can be found from some of the books mentioned in the bibliography. Sponsorship is one method that can be particularly successful and there are examples in the book of where this has been used to great effect. Hospitals are places visited by thousands of people every day and the private sector will often pay for this opportunity of wide exposure by sponsoring works of art.

Our hope is that eventually the position will change and that it will come to be realised that it is perfectly legitimate, indeed essential, to spend exchequer money on the arts because of the benefits that can be demonstrated. In Holland a specific allocation is made for artworks when budgets for new government buildings are prepared.

Administrator

The key to making any progress is to find a good administrator, co-ordinator or director. The Isle of Wight's successful programme is, in a very large part, due to the fact that it has an extremely effective director in Guy Eades and he is full-time. Several places have successful people working on a part-time basis – and that is certainly better than nothing – but real progress will be made only when full-time directors are appointed. It is not an easy job. Mary Hooper demonstrates this in Chapter 3 describing her work at Hastings but, as she also points out, it is exciting.

Renovating Old Buildings

Most people have to start with doing something to improve old buildings and there are three contributions giving examples of how this can be done. Peter Salmon (Chapter 7) describes the approach in the psychiatric environment where there are special requirements to be met and Gail Bolland (Chapter 8)

describes what has been possible to achieve at Leeds. The Bolingbroke Hospital was at one time a rather depressing geriatric hospital and Peter Millard (Chapter 22) describes its conversion into a place where the quality of people's lives is the prime consideration.

New Buildings

If you are fortunate to have a clean slate in the shape of a brand new building, there are many ways in which the arts can be brought into play. St Mary's Hospital on the Isle of Wight has attracted a lot of publicity both during and after its completion. Richard Burton, whose imagination, creativity and, above all, perseverance led to what many regard as the best designed hospital in the country, describes his approach to it in Chapter 10. Stephen Nichol was part of the team for St Mary's and, in Chapter 9, he shows how carefully the interior design was planned.

Working with Patients

Art in health care is more than just providing attractive environments. Those who use the arts in working with patients are able to develop people in unexpected ways and to draw out from them the most surprising creative responses. There are several excellent examples in this book.

Fiona Sampson (Chapter 18) and Lynne Alexander (Chapter 20) describe, with some impressive examples, the work of the writer and poet. Chris Barrett (Chapter 19) and Brian Chapman (Chapter 23) work as painters-in-residence, Bernie Arigho demonstrates the value of reminiscence therapy in Chapter 21 and Sylvia Lindsay and Raphael Eban show, in Chapters 4 and 5, what organisations outside the NHS can do with music and paintings. In Chapter 23, Ruth Preece describes work at Ashworth Hospital and the contributions from the United States – by Devra Breslow, John Graham-Pole, Sidney Holman and Mary Rockwood Lane and by Janice Palmer and Florence Nash in Chapters 15, 16 and 17 – demonstrate how it can all come together. The work of 'START', an arts centre in an inner city district of Manchester, has already received considerable publicity and Langley Brown, its founder Director, tells us more about it in Chapter 24.

Working with the Community

Soon after the significant development in hospital art, people remembered that the arts are for everyone and that the whole community needs to be involved. There are three particular examples in this book.

Guy Eades, writing about arts for the Hospital and the Community in Chapter 12, describes how art for the hospital became art for the community

and Meryel Boyd (Chapter 13) describes how that process can be taken up and extended by a completely separate organisation working with volunteers.

The work undertaken by Celebratory Arts, who are based in Lancaster, is some of the most exciting: it shows how whole communities can be motivated to develop themselves as communities and also how messages about health can be woven into this work and made part of everyday life. This is described in Chapter 14.

The External Environment

A building that is beautiful inside merits beautiful surroundings and gardens. Well-designed landscapes can bring peace and tranquillity when we need it. John Lynch's contribution in Chapter 11, with its detailed and beautiful drawings, describes in detail the approach that is required. Richard Burton, in designing the new St Mary's on the Isle of Wight, paid great attention to the external environment and describes his approach in Chapter 10.

The Future

A theme that runs throughout this book is the development of the involvement of the people for whom the NHS is caring – a move away from the paternalistic, we-know-what's-best-for-you approach towards one that engages the individual's mind and body. This is made particularly clear in Malcolm Miles' chapters (26 and 29) and Ruth Cusson's description of the Poole approach to Planetree in Chapter 28 shows how apparently simple changes in the environment can start to demonstrate the change in attitude. Dr Robin Philipp of the Department of Social Medicine at the University of Bristol builds on the work of Celebratory Arts and, in Chapter 27, demonstrates the need for more research in the Primary Care field.

If it is possible to predict future developments in the arts in health care, it is along these lines that the leaders in the field will take us.

Hospital Food

It may surprise you to see that hospital food is included in a book about the arts but, as John Rice makes clear in Chapter 25, it can certainly be an art form and, done well, it makes a tremendous difference to the lives of patients.

Persuading People To Do It

All the contributions to this book should, of themselves, persuade you to try to do more – but you are probably already converted. There remains the problem that others may not be converted and there is, unfortunately, still the question of how you get round the problem of the uninterested manager or chairman

who thinks it is all a waste of time. In such cases it is a question of 'softly, softly', of gradually gathering support and stimulating interest amongst those who can be more readily convinced.

Some organisations have found that exhibitions help to start things moving. These can be of artworks by local artists or – and this can be very rewarding – by the staff themselves; it is often surprising how much hidden talent there is. Chelsea and Westminster have reserved a space in which anyone can display their work for a specified period. This approach can also be linked to a competition.

The important thing is to make a start.

State of the Art
An Overview

Charles Kaye

The Aesthetic

We can see it in the cave paintings: experience is being recorded in a form that adds to the environment. The striking drawings on the walls capture, display and enhance. It would seem to be almost an inevitable outcome of observing. But in our more compartmented contemporary existence we have had to struggle to find ways of returning to the impressionistic freshness of expression that we see in those drawings. Perhaps we have become more used to separating the strands of life as living becomes more and more complex; the task of integration, or re-integration, is difficult to achieve. Nowhere can this be more relevant than in our experience of illness and treatment and in our approach to the outcomes of care, recovery or death. We have increasingly isolated these parts of our lives; agreed that they should be conducted in different environments; and made a pact with the carers. That pact says that professionals may have control of us, so that they can treat and care, at which time we patients may be returned again to the status of individuals. In this process aesthetics are seen to have little or no value. Care equates with control and surrender and the disease (or even the natural function, childbirth) blots out the person, her or his tastes and reactions. As Goffman (1968) observed in his classic study on institutions:

> The obligation of the staff to maintain certain humane standards of treatment for inmates presents problems in itself, but a further set of characteristic problems is found in the constant conflict between humane standards on one hand and institutional efficiency on the other. I will cite only one example. The personal possessions of an individual are an important part of the materials out of which he builds a self, but as an inmate the ease with which he can be managed by staff is likely to increase with the degree to which he is dispossessed. (p.76)

Or, as the playwright Thomas Southerne puts it:

> And when we're worn
> Hack'd hewn with constant service, thrown aside
> to rust in peace, or rot in hospitals.
>
> (Loyal Brother, Act 1)

The Past

Historically, as institutions for health care have been developed, their aesthetic dimension has been very varied. Many of the European medieval foundations (which were not fully hospitals in our modern sense, e.g. institutions for foundlings) had considerable artistic embellishment. Sometimes this reflected the religious nature of the foundation and offered pictorial images which set illness clearly in a context of belief, for example Rogier van der Weyden's altarpiece at Isenhiem. Sometimes the embellishment reflected the wealth and status of the patron and founder. At a later date it could be the result of an artist's desire to enlarge his reputation by associating himself with such a project – as did Hogarth when he painted the great staircase at St Bartholomew's for no fee. It was also recognised that an impressive building could help attract funds to assist with its purpose – as with the eighteenth-century Foundling Hospital of Thomas Coram in London.

Two consistent themes emerge from these early hospitals and the artworks that they contained: they were seen to enhance the standing of the institution and they were designed, in different ways, to encourage the residents to improve, whether in health or behaviour. The motives may have mixed but there is a consistent pattern of using art as an intensifier of purpose. Like the drawings on the cave wall, it seemed a natural thing to do.

With the proliferation of Victorian public welfare (and in its health inheritor, the National Health Service) that link, those forms of expression, had largely disappeared. Although there are of course exceptions, the great bulk of buildings which comprised the NHS in its early years paid little regard within their walls to the aesthetic dimensions of existence. They were very much settings for the treatment of disease. Perhaps the sheer volume of buildings influenced this. There are interesting exceptions: for example the asylums, built out of town – often in delightful rural settings – with the central administrative building of a high standard of finish which was not reflected in the wards behind and the TB sanatoria deliberately placed in attractive surroundings which offered fresh air and congenial surroundings as an aid to recovery.

Certainly the new hospitals that the NHS was planning and building in the 1960s and 1970s eschewed any connections with their early predecessors' concern with appearance and experience. Stark settings for care became the standard, accompanied, perhaps, by an unwritten but nevertheless strong

assumption that decoration was frivolously self-indulgent and, in any case, leached away funds needed for the 'real' purpose.

The Change

The landmark of change in this area was the Report on Arts and the Disabled which focused attention in an authorative and considered manner on the value of the arts in the healing process. Though its principal focus was on the arts and disability, it made clear statements about health care:

> The provision made for the arts in the social services of local authorities and in the National Health Service is uneven. The arts are frequently seen as an optional extra – in the social services as something to be added when resources allow, and in hospitals as a 'comfort' rather than as an integral part of the healing and caring process. Arrangements which are far more comprehensive and systematic are needed. (Attenborough 1985, p.64)

By its emphasis it made the subject respectable within the NHS although, of course, it could only point a direction. Pioneering work by Peter Senior based in Manchester and through his Arts for Health organisation founded in 1988, began to create changes in buildings and attitudes. Others were also concerned and work like that of Dr Hugh Barron at St Charles Hospital in London, where he initiated a determined programme introducing artworks throughout the hospital, was – and is – extremely effective. Nigel Weaver in Chapter 6 contributes valuable practical advice on how to achieve this. The organisation, Paintings in Hospitals, described in Chapter 5, was another early recognition of the need to make available, at a modest cost, original paintings in hospital settings. This movement is now well established and a number of the chapters in this book illustrate how it has developed both in the United Kingdom and in North America.[1] However, it should be noted that it's certainly not universally accepted. One Health Authority recently sold paintings bought for display in its hospitals. Its spokesman was quoted as saying:

> We had the paintings valued and it was clear we would not recover the amount spent – whether that was because the market had fallen or because they weren't good purchases in the first place is a moot point. I wouldn't have given house room to most of them. (Health Service Journal, 27 April 1995, p.8)

1 By no means limited to those countries: for a very interesting account of work in Australia with young patients, see 'Art Infection: Youth Arts in Hospitals' published in 1994, Department of Adolescent Medical Unit, Sydney University.

The Foundation

Even within this development, however, there are clear phases which illustrate an interesting progress. Initially there's a strongly felt view from health professionals that patients deserve better surroundings, more stimuli and more 'beauty' to look at (and respond to). Thus is initiated decoration of bare surfaces and the offering (almost in a parental fashion) of chosen images to brighten up an otherwise dull, or even hostile, environment. This step of softening bleak environments was important in recognising a lack and trying to supply it. It has provided much in many uncongenial settings where funds and scope are limited. It remained, from a patient's point of view, a passive state; the patient was on the receiving end. He (or she) was shown images and might, hopefully, respond. A good beginning and useful ingredient, although limited in scope and application, but an excellent footing for further development.

The Development

Gradually the movement expanded in parallel directions. These were characterised by their multi-dimensional nature, not restricted to one group or one activity. We could conveniently call them the integration of design and the involvement of the patient.

In the area of design, recognition followed decoration. If art additions to an existing building could make it better, why not plan such features from the start? So new schemes incorporated artworks at a very early stage with Architects and Artists working alongside each other to produce the best effects. Particularly noteworthy is the proliferation of art forms: tapestries, stained glass, sculpture, mobiles, needlework. Both Richard Burton, architect, and Stephen Nicoll, interior designer, describe this process with regard to St Mary's Hospital in the Isle of Wight. Other examples of this approach can be seen in the Conquest Hospital in Hastings, Sussex and at the Homerton Hospital in London.

The opportunities these partnerships can create are intoxicating. The value and essential nature of this are now formally recognised by the Department of Health in their Health Building Note I (1988):

Quality of Design

2.19 A proper level of professional and technical competence is assumed on the part of all building professionals, whether in private practice or employed by the NHS. Because the technical complexities of hospitals absorb so much of the energy of the designer, there is often a risk of inadequate attention being paid to aesthetic aspects. Health buildings should be attractive visually, both internally and externally and in all aspects of design – colour schemes, finishes, furniture, fabrics, lighting, signs and artwork. The architectural attribute often referred to as

'delight' or 'grace' cannot be added as a cosmetic afterthought; it results from the creativeness of the designer. It is thus of great importance that, when choosing the architect (and where applicable, landscape architect or interior designer) that a firm (or within a large firm, or a Region's design office, an individual) is selected with the skill to produce a building which is beautiful as well as functional, soundly constructed, and economical both in capital and maintenance costs. These selection criteria should also lead to a design which, by choice of materials and shape of building, is sympathetic with and complementary to its landscape and to neighbouring buildings.

2.20 A good looking building accompanied by pleasant landscaping improves morale of staff and patients and can be just as economical as an unattractive one. It is to be hoped that the 'Poor Law' mentality which assumes that a barren dreariness befits an NHS building, and that an agreeable environment denotes extravagance, is a thing of the past. Works of art enhance the interiors of health buildings; their provision should be incorporated into the architect's brief and the scheme budget. The employment of artists in various media has not only furthered this objective, but has successfully involved patients, staff and volunteers in environmental improvements (re 'Arts in the NHS', DHSS 1983; also 'The Arts and a DHA; proposals based on a case study', DHSS 1985.)'[2]

This Departmental enthusiasm and support has not yet reached the level of commitment which would set a fixed investment of a proportion of a scheme's costs to be spent on artwork. In Holland such a scheme exists, set at one and a half per cent of basic costs of federal buildings. It provides practical support for praiseworthy ideals. We should perhaps be striving to establish a similar minimum here to ensure that the inevitable last-minute trimming of the budget does not eliminate, or postpone, the provision of important elements of an integrated design. Furthermore, a stated national policy on the 'arts investment' in capital schemes would render otiose the damaging conflict between 'money for the arts' and 'money for health care'. The formal recognition of the proper interrelationship of the two is overdue. At the same time, we should recognise that the zenith of the new large hospital has probably passed. Tomorrow's buildings are likely to be fewer and more modest.

The Patient
The parallel movement draws patients into the experience. It takes the human being as the essential measure, rather than the specialty, department or 'floor'.

2 This message has been further emphasised by the recent publication 'Better by Design', HMSO 1994.

Thus increasingly they are seen not simply as the beneficiaries of carers' or administrators' 'good taste' but as sharers in the experience. It recognises the significance of the individual and what he or she is undergoing on a personal basis:

> Illness is an experience that takes us out of ordinary life and into a transition period for body and soul. Illness can be a liminal experience, a descent into neglected psychological and spiritual realms, a potential turning point for the soul, and an opportunity to tap into sources of healing. For this to be so, as patients seek medical help, they also find themselves on an inner pilgrimage or on a quest for the mysterious healing Grail. Beds in hospitals are thus filled with patients – who also may be pilgrims. (Bolen 1994)

More use of the performing arts, such as the well established 'Music in Hospitals', particularly increases patient involvement. The move from audience to participator is easily made and can, and does, unlock a whole depth of reaction and identification. The work of the Royal Shakespeare and the Royal National Theatre Companies in the high security setting of Broadmoor Hospital exemplifies this. Both companies have given performances of classic dramas to mixed audiences of patients and staff which have been followed by workshops where patients, under clinical leadership, examine their own reactions to the drama they have just seen. This has been well described in the book *Shakespeare Comes to Broadmoor* (Cox 1994).

Similarly, the work of writers and artists-in-residence has moved from viewing to creativity, drawing out from patients reactions to their illness and their condition that often have no other easily available outlet. Three such artists describe their work in this book and one of the products is illustrated on p.?? (an Isle of Wight poster poem). This unlocking is a key step in the recognition of the patient as an individual undergoing what is usually a major and disturbing experience. The encouragement to discover and share self, as part of the process of care, moves the patient from spectator to participant, from a visitor to the art gallery to the participant in a workshop. The patient becomes the subject rather than the object. This is nicely described by Bernie Arigho in Chapter 21 on reminiscence work with the elderly, which can be interestingly paralleled with design work at Graylingwell Hospital by Peter Salmon and associates where elderly-care wards included a period shop which incorporated artefacts and articles drawn from the time of those patients' youth.

It should be stressed that none of this work supercedes the process of care and treatment. It represents the use of artistic expression to encourage patients to reflect on themselves in treatment as individuals. It is also paralleled in some work done in the United States:

> One day, at a nursing home in Connecticut, elderly residents were each given a choice of houseplants to care for and were asked to make a

number of small decisions about their daily routines. A year and a half later, not only were these people more cheerful, active, and alert than a similar group in the same institution who were not given these choices and responsibilities, but many more of them were still alive. In fact, less than half as many of the decision-making, plant-minding residents had died as had those in the other group. This experiment, with its startling results, began over ten years of research into the powerful effects of what my colleagues and I came to call *mindfulness*, and of its counterpart, the equally powerful but destructive state of *mindlessness*. (Langer 1989, p. 1)

The Community

Simultaneously much of this work in design and participation has had the admirable effect of reducing the isolation of those ill-in-care from the rest of the community. The contract for recovery that was earlier described creates a class apart of those who are receiving treatment. Separate buildings, separate regimes, restricted access and different conventions mean that the patient is set apart in many dimensions from his or her family and other ties. Out of respect for authority, faith in medicine and fear of illness, we all conspire in this segregation: perhaps we have even embraced it as a way of avoiding difficult questions about disease and death. The thought that the community, and not just the health professionals, should own the sick is now much more acceptable, even if difficult to realise in practice.

There is a central and continuous role for the local community in contributing to the health care setting and expressing themselves through and in it. Chapters here describe this process variously pursued in the Isle of Wight and in the North-West. They signal a continuing and expanding interplay between the healthy and the ill which seeks to remove the barriers of 'inside' and 'outside'. The sharing of experience and the joint mobilisation of resources are central themes. This is not the hospital within its community but the community within its hospital. This does not just concern hospitals; any health centre, surgery or community-base can develop the same inward-looking isolation. The arts form a vital link in this transformation. As Marina Vaizey, the novelist, describes it in her commentary on *A Picture of Health* (an exhibition of pictures about breast cancer):

> Modern medicine is in many respects, both to its professionals and its 'clients', a ritualistic activity, still cloaked in part in mystery. And art too is a mysterious process elucidating a mystery, helping to find a pattern in chaos, or at least to act as witness to the connection between outward event and inward reaction. (Vaizey 1995, p.28)

The Culture

The reciprocal of this ownership by the community is the change in culture within health care. If health care is to be part of the community, then the former must reflect the latter's values. If the individual is to predominate, the 'machines' for caring, from large hospitals to doctors' surgeries, must reflect that fact. Attitudes and levels are changing and art and design play key roles in this process.

Leave behind the notion of the most efficient disease factory and introduce the use of art to bridge between individuals in different states and you have changed the conventions of behaviour. Malcolm Miles tells an interesting story of redesigning a hospital's out-patient reception area. Through the process of consultation with the staff about what was required and through the exercise of viewing things through the patients' eyes, change was achieved. A glass screen, sliding panel segregation and humiliation was abandoned in favour of an open counter at a lower level inviting rather than categorising. That represents a change in culture; a different way of working based on a different awareness; to be of assistance to, rather than to have power over; to help others rather than to direct them. This current is discernible in society at large, indeed is codified nationally in the Citizens' Charter initiative, but its practical realisation in health care is particularly welcome.

The Benefits

Many health workers feel uncomfortable about accepting health care as a business or in using commercial terminology to describe and assess their work. Yet even the sceptics have absorbed, perhaps reluctantly, the tenets of investments and returns and the relationship between the two. In this, of course, the health service is no more than mirroring the experience of public service as a whole. We now accept, even if by *force majeure*, the need to analyse rather than assume and to justify rather than assert.

Yet that proper discipline does not reduce everything to measurables: fortunately humans still have right *and* left brain activity. The intuitive and instinctive cohabit with the rational. They inform each other rather than deny their complementary strengths.

Thus, in reviewing what might be crudely called 'the payback', we can and should use the quantifiable (objective) and the perceived (subjective). On that basis one could construct a hierarchy of benefits which could be categorised in the following way:

- Morale: an improved environment (achieved through the employment of the arts and artists) benefits staff and patients by demonstrating concern and expressing civilised standards which relate the setting to the individual. Studies in industry (Roethlisberger and Dixon 1939)

and in health (Revans 1962) show improved morale can be related to greater efficiency.

- Appearance: a well maintained environment focused on the individual is less likely to be vandalised or be neglected.

- Improvement in Health: given stimulus, in terms of more direct attention via the arts and/or a more congenial environment or outlook, patients' health can benefit directly. As evidence of this, we can quote the studies of Ulrich in Intensive Care Units (1984), of Revans (1962) on the effect of 'happy' hospitals and of Langer (1989) in her work with the elderly. These more formal studies could be supplemented by a host of anecdotal observations about the effect of the use of the arts on individual patients, as the quotations from the Ashworth Hospital articles in this book demonstrate.

- Business: higher morale of staff and consistently better appearance will add to the attractiveness of a health facility inspiring confidence in patients and pride from staff. Factors likely to contribute to better 'business' are very relevant to the health service Trusts and their development.

- Quality Standards: using the arts to recognise and encourage the individual as the central feature of health care involves a reappraisal of values. The re-calibration of the relationship between patient, staff and environment will mean setting new standards for behaviour and treatment. The acknowledged and nurtured partnership will suggest new forms of monitoring. A more rigorous examination and audit of care and its context will result.

This listing is tentative and calls for more structured research into direct links between the arts activities we've described and the health and behaviour of staff and patients. Even so, the justification for the investment stands buttressed by both the scientific and the humane, equally valid.

The Future

If one follows these strands carefully, the progression indicates some pathways in the future. The patient is no longer merely the spectator (although she does admire her surroundings); the patient participates and shares, remains a member of the same community that both provides and receives health care. But most importantly, the individual patient begins to exercise choice. Previously there was only one choice an individual made and that was to become a patient. Thereafter choices were made by the professionals and acquiescence was the payment for early release from health care and the return to normality. Now we can help each individual to negotiate and choose from a range of ways tailored to the individual. Furthermore, it is recognised that each patient has a right to

personal space and possessions; he or she is not an alien to be stripped down for treatment. Professor Millard (in Chapter 22) describes the process of 'personalisation' in his pioneering work at Bolingbroke Hospital, involving a great capacity for taking care as well as caring. Health care need not be uniform in its application and is certainly not absolute in its wisdom. The movement that started by putting pictures on blank walls is now designing environments to enhance control by patients rather than control of them.

This is best exemplified in Chapter 29 by Malcolm Miles on the 'Planetree' philosophy where the very design and the essential organisation of the setting are to do with giving patients choice. A choice over their environment, their degree of personal privacy, over what and how they eat and over their treatment. It incorporates a commitment to helping patients learn and understand. Help is available by the provision of an environment that in scale and arrangement is closer to the everyday, that doesn't abandon warmth on the pretext of clinical absolutes. The very design of medical and technical equipment can be significant in this respect; the aesthetic, the familiar is not incompatible with the clinical. More thought and design originality will be required to produce an acceptable blend. The preparation, presentation and sharing of information becomes an appropriate precursor to the making of decisions. This work is accepted as part of the responsibility for providing sensitive health care. In this philosophy the library at the patients' disposal would be chosen to make available knowledge, not just through books but also using information technology; interactive videos[3] and virtual reality techniques offer enormous possibilities. The patient becomes a partner in care; that partnership will vary with individuals and the rhythms will differ but the philosophy remains consistent. Some of this has, of course, already been seen in the hospice movement which seeks, paradoxically, to give the patient more control in his last weeks and months. This wider approach, which should influence all aspects of care, is to be tested in this country in several general hospital settings – in Poole, South Tees and the Isle of Wight.

The 'Planetree' looks to bring together design, environment and philosophy to provide a setting for sharing care, life and choice. As such it builds on, and depends on, the work we describe in this book; it assumes all those values and carries the philosophy about individuals one step further by making informed choice central to treatment and care.

3 An 'Interactive Entertainment Network' is now being developed for pubs! 'Interactive media are now integral to our marketing plans', said Patrick Burton, the media manager for the Allied Domecq Group. 'The system is due to be piloted in 10 of Allied's 2,000 pubs in late summer.': *The Independent on Sunday*, 16 April 1995.

References

Bolen, J.S. (1994) 'Illness as a Grail Quest and Pilgrimage.' Address to the 1994 Society for the Arts in Healthcare (USA).

Carnegie Trust (1985) *Arts and Disabled Report, Report of Committee of Inquiry Under the Chairmanship of Richard Attenborough.* London: Bedford Square Press.

Cox, M. (1994) *Shakespeare Comes to Broadmoor.* London: Jessica Kingsley Publishers.

Goffman, E. (1968) *Asylums.* London: Pelican Books.

Langer, E.J. (1989) *Mindfulness.* Reading, MA: Addison-Wesley.

Revans, Professor R.W. (1962) 'The hospital as a human system.' *Physics in Medicine and Biology, October 1962, reprinted Behavioral Science, Volume 35, 1990.*

Roethlisberger, F.J. and Dixon, W.J. (1939) *Management and the Worker.* Cambridge, MA: Harvard University Press.

Ulrich, R.S. (1984) 'View through a window may influence recovery from surgery.' *Science,* 420–421.

Vaizey, M. (1995) 'A picture of health.' In *Why Art? Paintings and Drawings of Breast Cancer Care.* London: Sheeran Lock Fine Art Consultants.

Part I

Background and Context

To wake the soul by tender strokes of art,
To raise the genius, and to mend the heart;

Pope: Prologue to Addison's Cato

The Arts in Health Movement

Peter Senior

The 'Arts in Health Care' movement in this country can be said to have started in 1973 when I was given permission to become artist-in-residence at St Mary's Hospital, Manchester. This led to the establishment of 'Hospital Arts', Britain's longest serving team of artists in health care, and from this beginning many other developments subsequently took place.

Helping to Heal – The Arts in Health Care (Croall and Senior 1993) attempts to summarise the state of the arts in health care as it stood in 1992:

> The vision, skills and dedication of many individuals has helped to establish a legitimate and valued role for the arts in a variety of health care institutions. The hope now is that what is still only available to a minority of patients in certain areas will, before the end of the millennium, become a basic provision in health care throughout the country. (p.7)

The last chapter of the book concludes with a 'manifesto for action' which consists of twelve recommendations and we state that, if these recommendations were implemented, the social, spiritual and medical benefits to patients and health care staff would be considerable and unmistakable.

Nearly three years later, the question 'so what has changed?' can be asked. The climate for health care in the National Health Service has changed with the establishment of Health Trusts as has the division of roles of responsibility and authority into 'purchaser' and 'provider' authorities. This changing climate of the health care service has, in many areas, increased interest amongst health managers in the benefits and services which can be provided through the arts in health programmes.

In the drive to make hospitals more attractive and more competitive, the search is on to find new ways of creating a pleasant, welcoming environment. Once again the realisation has dawned that people should not be treated in austere, clinical, uncomfortable and unfriendly environments. The name 'hos-

pital' derives from the latin word 'hospitalis' – a house for the reception and entertainment of pilgrims, travellers, or strangers. This sounds more like a hotel!

Everyone understands that hotels should be welcoming, comfortable and friendly and contain interesting and decorative features such as fountains, chandeliers, art, craft and decoration of all kinds. They are also very aware of the usefulness of, and make use of, music and live entertainment for the well-being of their guests.

These days many more hospitals now boast of arts and craft and have decorative features. Similarly, dance, music, theatre, creative writing, poetry and other art forms now complement the healing environment. There is now a greater awareness that the arts draw welcome publicity to health venues and bring enjoyment, community participation and financial support. Far-sighted health managers now appreciate such benefits, in a health service where the current watchword is 'quality care'.

What is so fascinating about this art movement are the different approaches which have evolved in different places. In terms of which arts, crafts and cultural activities are most needed for a particular hospital, hospice or health centre, it is crucial to match the skills and qualities of the artists.

Often it is the qualities which the artists can bring to a particular hospital, hospice or health centre and what, in terms of arts, crafts and cultural activities are most appropriate. The arts evoke response from the senses and should appeal to the heart and, however much is written or spoken about them, there is no substitute for seeing and experiencing the arts in action and noting the effects first-hand.

There is now a great deal of arts activity taking place within all aspects of health care. Some are on an occasional basis but increasingly many full-time arts programmes are being developed. Successful projects require considerable dedication by a number of individuals with a sincere belief in the value of the arts for health care. A co-ordinator leading such a development needs a clear understanding that the arts should serve the whole health care community. That person needs to be sympathetic and skilful to gain interest and support from as many people as possible.

What has been recognised and reported in so many cases is that for the small amount of money required to 'pump-prime' an arts programme, the results and benefits are out of all proportion to this modest initial investment. Mainstream funding is now being found in many cases where projects have proved their worth after two or three years. This provides examples for everyone both in this country and abroad to study and evaluate.

Amongst the activities of Arts for Health as a national centre is the provision of information in response to enquiries about the world-wide network of the arts in health care projects, also to encourage and establish new developments, organise seminars, training days and conferences. Arts for Health aims to continue studies and research to support the belief that the arts can assist health

care. It is important to determine the effects and values found in all areas of this work. Our research programme is not only concerned with evaluating what is necessary for a high quality health care environment but also to determine the most appropriate art, craft and design for health buildings.

It is hoped that the exhibition 'Helping to Heal', commissioned by Arts for Health and currently touring the UK and countries abroad under the auspices of the British Council, will help to demonstrate the profoundly useful and enjoyable nature of this work and encourage further interest, developments and good practice.

The Arts Co-ordinator's Job

Mary Hooper

The Arts Project for the Hastings and Rother NHS Trust was established in 1988. Its purpose was to develop and implement a programme of visual and performing arts within the health care services in the district, focusing on the Conquest Hospital which was, at the time, still in the construction stage. The architects of the hospital, Powell Moya Partnership, provided the initiative for an arts strategy which was commissioned from Lesley Greene (formerly Director of the Public Arts Development Trust). The strategy set out options and recommendations for commissioning and purchasing artworks. This included:

- identifying opportunities for art within the hospital layout
- assessing priorities and methods of achieving these
- giving guidelines for an arts committee, the administration of an arts programme and curatorial responsibilities.
- an itinerary and estimate of costs and an appendix with supporting information

The result of this was the appointment of a committee and a curator and the establishment of an Arts Trust with charitable status. Initial funding was provided by South-East Arts and the former Hastings Health Authority. There now exists an arts team who raise funds and manage a comprehensive programme for the arts in all the hospitals and clinics in this area. This covers a wide spectrum of activities involving artists, writers, musicians and performers in:

- Commissioned artworks for specific sites.
- Workshops and artist-in-residence schemes for patients with special needs.
- Musical and other performance events for patients in long-term care.

- Projects involving schools and other local groups and organisations. These help to create stronger links between the community and the health service producing artwork designed for specific sites within the local hospitals and clinics.

- Exhibition areas for work by school children, students, local amateur art and craft groups and travelling exhibitions. There are galleries for painting, sculpture, crafts groups and photographic work on loan from professional artists. The Arts Team also organise the selection and purchase of pictures for out-patient departments, wards and clinics.

The Arts Project now plays an important part in the perceived experience of the hospitals in the Hastings and Rother NHS Trust and is used to assist both staff and patients alike in providing a caring and positive environment.

Over the past year, with the support of sponsors, Leagues of Friends and charitable donations, we have been able to develop all the activities of the Arts Project: commissioning of site-specific work, staging of concerts, the active participation of patients and staff in artists-in-residence schemes, the development of the exhibition areas and gallery spaces and the general selection and purchase of pictures for different units. We have undertaken several large projects on behalf of the Trust – including the commissioning of a series of murals, a water feature, the design and landscaping of a special courtyard for the elderly and the enhancement of waiting and treatment areas. There are many more individual schemes and full details of these are available on request.

One of the priorities in the latter half of 1994 has been to develop an arts strategy for Phase Two of the Conquest Hospital (due for completion in March 1997). The Hastings and Rother NHS Trust appointed the artist Sue Ridge to work in collaboration with the design team and myself to identify specific aspects of the project design that are to be considered, to assist in the development of proposals and to help provide briefs which would subsequently be used for commissioning artworks. A detailed report has now been produced together with a fully illustrated brochure.

Phase Two has given us the opportunity to revisit the first phase of the Conquest Hospital and the strategy includes the opportunities for integrating art into the environment that were missed or that have been created due to the re-configuration of the whole hospital. It also benefits from the experience of patients and the staff who have occupied the hospital since it was first operational in 1992. This has enabled us to identify specific needs of the environment and think carefully about the type of artwork that will enhance the building and contribute to the recovery from illness. Examples of this are, works to facilitate route-finding; identification of different medical centres; alleviation of high levels of stress in areas such as Intensive Therapy Unit, Coronary Care Unit, counselling rooms, radiology treatment areas and Accident and Emergency.

The achievements of the Arts Project in Phase One, in terms of actual commissioned works, are modest due to the difficulties in obtaining necessary funding, but we have been very successful in creating an arts culture where one did not previously exist so that proposals for Phase Two should receive much greater support and greatly enhance the possibilities of obtaining grants and sponsorship.

The integration of the arts into health care is now firmly established as part of the policy for health services in this district. Its success owes much to the medical and non-medical staff of the Hastings and Rother NHS Trust who have given it their full support. The Arts Project is a registered charity and has received assistance from South-East Arts, East Sussex County Council, Powell Moya Partnership, the Hastings and Rother District Councils and contributions from many sponsors locally and nationally. The task of seeking funds for future projects is a continuous one and none of the work is carried out at the expense of medical care. The development of the arts for this district is now well established and has real and exciting potential, especially in view of the construction of the second phase of the District General Hospital, which will provide many new opportunities to demonstrate the value of a percent for art in architecture.

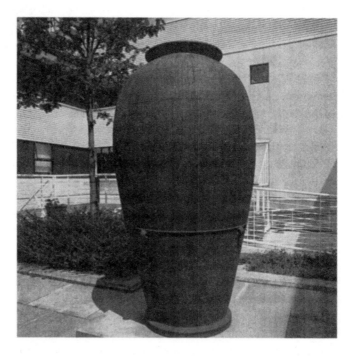

Figure 3.1. Conquest hospital, ceramic jar by Jennifer Jones (sponsored by Powell Moya Partnership, architects to the hospital)

This commitment by the Trust to the Arts Project, not only in principle but also financially, is a key factor in its success. The Trust will also actively encourage partnership-funding from contractors and suppliers to ensure the success of the Arts Programme – and by comparison with other services, a relatively modest investment in financial terms is needed.

Those who, understandably in a climate of constant financial restraint, oppose such an initiative need only be directed to the overwhelming amount of documentation supported by both medical and government sources that endorses the development of the arts in health care as both a quality issue and as an aid to recovery, bringing access and enjoyment of the arts to a broad section of the community.

To summarise my personal experience of working within this area of the arts, I feel that my most valuable contribution is as a catalyst, facilitator and mediator between all the parties involved – the artist, the sponsors, the people who have access to the commissioned artworks or those who are involved in participating in performances or workshops.

One of the most vital stages to get absolutely right is the initial liaison and development of a brief before a commission is awarded or artists engaged to carry out workshops or performances. We are frequently being asked to contribute solutions and ideas in different situations and these all have very specific criteria to consider. To be able to give a proper response it is necessary to research artists and different art forms constantly. Because of the very unique environment within health care, I think that many 'relatively new' art forms using film, sound and light are appropriate where more traditional artworks will not affect the environment in the same way. This is not to say that these do not have an essential part to play in an overall scheme. There are also many occasions where compromise is very important to include donated works and create a place for amateur groups within the local community to display their work or make a contribution to the commissioned work.

It is necessary to develop an intuitive feel for works that will actually complement the style of architecture within which they are placed, to understand the specific use of those buildings and the people who use them. However, these factors should not mean that a banal solution is the outcome.

It is also important to remember that on many occasions the artists get a raw deal and, at the end of the day, the success of the project is due to their work, and part of my role is to protect their interests – not least to see that they are paid properly and on time, and that their professional skills are rewarded and recognised.

It is a very exciting environment within which to work, to develop ideas and promote the arts, and particularly rewarding because it gives access, participation and enjoyment to a complete cross-section of the community.

Music in Hospitals
The Best Medicine in the World

Sylvia Lindsay

The Development of Music in Hospitals

Many years have elapsed since the days when the 'lunatic asylum band' provided concerts in psychiatric hospitals for the benefit, we are told, of the local gentry and the patients, or since people were marched into a vast hall under the watchful eye of the Medical Superintendent, men on one side, women on the other, to listen to a formal recital given by artists who were remote from their audience on a high stage.

Happily, things are very different now. Music is for sharing and there is far greater accessibility than ever before to concerts where the informal and friendly presentation and opportunity for everyone to participate are allied to a high professional standard of musicianship. Such are the concerts given by the Council for Music in Hospitals.

For these artists, their 'concert hall' may be the space between one bed and the next or their 'stage' a cramped corner in a smoke-filled drop-in centre. Our musicians could be performing sitting cross-legged on the floor among a group of children with multiple handicaps who are propped up or lying on special cushions. Equally, kneeling by a wheelchair and holding a frail hand they may sing a special request, such as *I Love You Because*, or play gently by a hospice bed for a comatose patient and their relatives.

From the Isle of Barra to Belfast, from Inverness to the Channel Islands, patients and residents in hospitals, homes, hospices, day centres, rehabilitation centres and countless other venues, are benefitting from the concerts arranged for them by the Council for Music in Hospitals. Each year the Council provides more than 3500 special performances and the work is now familiar in over 1000 different locations throughout the United Kingdom.

Ideally, everyone should have the chance to share and to participate in these programmes, but even in the 1990s not everybody is aware that live music is

readily available or, indeed, how much a concert presented by artists who totally understand the needs of the clients can promote well-being, help to relieve suffering and facilitate recovery. One patient told us 'as they were singing, pure joy welled up in me'.

The Council for Music in Hospitals was founded nearly fifty years ago and during that time we have learned a great deal about the important ingredients of a successful hospital concert, and have been able to assess many of the benefits which live music can bring to the patients and residents. Experience has shown that the live presentation can be infinitely more valuable than the finest recording or tape. It enables the patients to cross the line between just hearing something (the background music which goes in one ear and out the other), and the infinitely more active pursuit of *listening* to and taking part in a performance which is carefully linked to individual needs and preferences. The live concert provides the focal point for holding the attention of an audience, which is so helpful, for example, for those who find concentration difficult. People are able to see the music being produced, can feel and even try the instruments, and the visual aspect is further enhanced by our musicians dressing up for every occasion, some making as many as five or six costume changes during one hour of music: 'The soprano's beautiful voice and lovely blue sequined dress did more for our residents than any box of pills!' (Rokefields Nursing Home, Dorking).

The Musician and the Patient

Above all else, artists must be able to relate to the patients while creating the happy, informal environment in which their audience can enjoy a professional performance. For this reason, and in order to ensure that we are using skilled and adaptable musicians, our artists are auditioned and chosen with the greatest care. As well as having a warm, friendly outgoing personality, they must be able to use all the additional communication skills of touch, eye contact and voice, as well as having the sensitivity to know when close contact is welcome and when it is not appropriate. Talking about music by painting a word-picture, or relating a personal anecdote, play an important part in creating a shared experience in which everyone feels involved. Working without the music (the printed page is a real barrier to communication), the artists can move round among their audience, holding a hand, kneeling by a chair or sitting by a bed, thus making real contact with individual patients: 'It was a delight to see the way the patients responded to the individual attention given by the singers and how even the most retiring were drawn into the sing-alongs' (K. Taylor, Divisional General Manager South, the Fosse Health Trust).

In addition, the artists need to have an extensive repertoire which will enable them to provide as many as possible of the patients' own requests. This is quite demanding and our experienced artists will frequently 'play it by ear' as regards

the content, varying the programme as the concert proceeds, responding to the needs of their audience so that everyone can have the chance to hear the music of their choice. This wide repertoire could cover anything from classical to old tyme, and from songs from the shows to more modern tunes. One artist returning from a hospital concert told me that he had been asked to play the Moonlight Sonata, followed by a request for 'Daisy, Daisy'! – not at all an unusual combination in a hospital setting!

Variety, Adaptability and Co-Operation

With several hundred artists on our books, the music we can provide ranges from programmes using early medieval instruments, psalteries, sackbutts and serpents, to jazz groups and flamenco dancers. Singers and singing groups are very popular, as are the instrumental/vocal trios and quartets, and there are many special programmes for the children: 'The Tuba was so gently and expertly played that I realised the therapeutic effect of the vibrations of the notes. One lady was delighted to play the marimba, a reserved man joined in with the hosepipe and funnel, and the Chaplain asked to play the didgeridoo.' (Report from St Helena Hospice, Colchester.)

We hear from the hospitals that they appreciate our understanding of their needs. Artists must be imperturbable and able to cope with the countless happenings and interruptions which may take place in the busy hospital setting. We know there must be drug rounds, firebell practice, that budgies may escape, the piano could be a third down, and perhaps is home to a family of mice! On a more serious level, we are used to playing, if requested to do so, for a dying patient.

The artists themselves value this area of their professional life very highly. One well-known pianist who has worked for the Council for Music for a number of years wrote: 'If for one moment our music has helped to allay the fears and pain of just one patient, we, the musicians, are extremely privileged to be a small part of the healing process.' (Daphne Ibbott, Pianist).

It is our policy to liaise as closely as possible with our contacts in each venue, and we do appreciate the co-operation of the people in charge at all times as this helps us to provide the music which will contribute to the welfare of and bring the greatest pleasure to, everyone concerned. We receive reports from the doctors and staff and from the artists after each concert. These enable us to evaluate some, at any rate, of the benefits which live music can bring to the patients and residents of every age.

Children

This is a part of our work which is rapidly expanding, with children as young as a few months old participating in some of the sessions. One example of this is the regular concerts which we provide at Southampton University Hospital,

funded by Children in Need. Here two of our artists, a singer/guitarist and a harpist, have alternated in giving the sessions, visiting four different wards on each occasion. This regular contact has enabled the musicians to build up a relationship with the children who may be ill or have broken bones, have severe learning difficulties or communication or emotional problems. One of the artists wrote: 'There were about three children who were recovering from brain surgery. I took the harp right next to them and the nurses were really pleased with their response to the music.'

The frequent (three or four times a week) concerts we give at Orchard Hill (part of Queen Mary's Hospital for Sick Children at Carshalton) are another example of our work with young people. Here the members of the audience are suffering from very profound physical and mental handicaps and we are working with a small group who are able to see, to feel and to try the instruments on a one-to-one basis. An artist wrote about his visit to this hospital: 'It's wonderful how music can reach all these young people. Patsy held my hand throughout one concert. I was told she was deaf and blind and the only way she could hear was by vibration, but to see her smile was wonderful.'

Learning Disabilities

For people with learning disabilities the concerts provide an opportunity to enjoy a concert which is adapted to their special needs and the fullest participation is encouraged with plenty of scope for everyone to join in singing and dancing. This nearly always results in many offers to 'take the stage'. Sometimes, in addition to the regular concerts, we provide a 'Travelling Road Show' in which the artists go round from one ward or villa to another, spending perhaps 30 or 40 minutes on each. This means that people who are unable, because of their disabilities, to attend an event in the hall or social centre, can still enjoy their own personalised concert. The music, as well as being an entertainment, can open up new avenues of awareness in which residents have the chance to experience many different instruments and styles of music. The sessions provide the relaxed environment in which there is ample opportunity to interact as a group and to practise social skills: 'Thank you for giving our residents the opportunity to experience "real live music". They were enthralled.' (Report from the Elms, Bristol).

Mental Illness

A great many of our concerts are given for people suffering from a mental illness and these may vary from short-stay patients to the older residents, some of whom will have become institutionalised over the years. An example of the latter was the special event we were asked to arrange to celebrate the wedding anniversary of two patients who, between them, had been in the same hospital for a total of 99 years! These concerts may take place on a ward, in a social

centre or a tea bar, or even the chapel, and the widest possible range of music must be available. One of our artists, having been asked beforehand by the man in charge for a light programme, was able to respond immediately to an unexpected request from a patient for some Vivaldi. The staff who were present expressed their amazement as they had not previously realised that there were music lovers in the group. This does highlight the need for us all to be aware of the very varied tastes of a hospital audience and how vital it is to focus on the needs of the individual.

For mentally ill patients, music does indeed 'soothe the savage breast' but also it can be a motivating force for those who are depressed, withdrawn or lacking in volition. A concert will sometimes provide the catharsis which, through laughter and through tears, may bring a long-awaited emotional release. Our experience has shown that music can form a bridge between a real and an unreal world and patients who are confused are frequently able to relate to music when words have lost their meaning. For many, attending these concerts can be a useful part of their rehabilitation programme and a preparation for going out into the world and learning to form relationships with those around them: 'The artists were very professional in their presentation of a broad repertoire suitable for our group. The audience were uplifted by the artists, who created an air of normality and helped to feed and stimulate the social and psychological needs of our clients.' (From Lodge Moor Hospital, Sheffield.)

It sometimes happens with deeply depressed people, and also for those with a wide range of other disabilities, that they may manage to speak for the first time for weeks, or even months, during or after a concert: 'One lady opened up and responded after forty years of silence.' (From Gartnavel Royal Hospital, Glasgow.)

We always like to make time for a cup of tea with our audience after a concert as this is a valuable interlude when, in a relaxed environment, the music having woven its magic spell, the patients may be prepared to talk to the staff and to the artists about their difficulties and their fears: 'The concert stimulated conversation between patients and staff and brought back some lovely memories; feelings of joy, sorrow and happiness evolved.' (From a Nursing Home.)

The Elderly

Our elderly audiences can vary from the sprightly nonagenarian or centenarian (we recently played for the oldest inhabitant in Scotland, aged 111 years) to those suffering from advanced dementia: 'When you think of sitting day in, day out in the same corner of a hospital ward, then the value of these concerts is immeasurable.' (St Clements, Bow.)

For all these people, music brought to their lounge ward or day-room can be more than just a welcome break in day-to-day routine. The concerts help to combat the sense of isolation felt by so many who are in long-term care. The

fact that lovely musicians come in from the outside world, take the trouble to change into marvelous dresses and to find out just what music will be most meaningful, all helps to reinforce people's sense of identity. It makes them feel the world still cares and that people love them.

Figure 4.1. 'Creating a happy environment' Kay Carmen with a resident of Knowle Park Cranleigh

'I wish you could have seen the smiling faces – and the tears in the eyes of some – when "their" song was played.' (Nether Edge, Sheffield.)

Of course, many of the elderly residents like the well-loved classics remembered from their younger days and ballads and old tyme music, all of which serve as valuable aids to reminiscence. For these people, and for many who have suffered strokes and whom we may encounter in the hospitals, homes and stroke clubs,

the physical effects of the music are sometimes remarkable. We see backs become straighter, eyes shine more brightly and disused limbs will mark time to the music. One stroke club organiser wrote: 'Feedback from the members has shown me what a magical moment it was for them, and for me, to see those with a paralysed arm clapping in time and those unable to speak actually singing. This is something I will treasure.' (Deal Stroke Club.)

Music in Hospices

With the growth in the hospice movement, the demand for music in this area is increasing rapidly. These are very special venues for our artists, requiring the greatest sensitivity of approach and the presentation of suitable music. The concerts not only give the patients a chance to listen to a programme of their choice, but also, because music can break down emotional barriers, may be a starting point through which people can come to terms with their illness and learn to talk about and share their problems: 'A patient who never smiles and doesn't speak very much to anyone sang and asked for a request. After the concert she called me over to chat, told me all about her life, past and present and that she writes poetry.' (From an artist.)

In most of these venues we provide a concert of perhaps 30 to 45 minutes duration followed by much time spent responding to calls for visits to individual bedsides. This is becoming a regular part of our hospice programmes as the staff build up their confidence in the experience and sensitivity of our artists, which enables them to respond appropriately to every situation. Families and friends also benefit from the music, which provides a fresh topic of conversation and is something special which they can share with their loved ones: 'There is untold value in these concerts – they give the patients the opportunity to look forward to something different, to think about a choice from the programme, and enjoy the content and sharing with their friends and relatives afterwards.' (Copper Cliff Hospice, Brighton.)

It may also be of interest to record that we have made a number of visits to the Intensive Care Unit at Guy's Hospital. After one of these sessions Dr Bihari, the Director of Intensive Care Services, wrote: 'In the Intensive Care Unit we so often forget the soul of the patient. Music helps us to speak to that inner being and to bring some extra comfort.'

The Power of Music

We are frequently told that our music has lifted the mood and cheered the spirits of the staff, as well as of the patients. We are very aware of the pressures on the carers and hope that we are able to contribute also to their happiness and well-being. In every venue their enthusiastic support of these concert is of inestimable value both in encouraging the patients, in setting the scene and, wherever possible, by attending the events and reporting back to us very fully

afterwards. Despite our considerable experience in concert-giving,[1] I am nevertheless keenly aware that there is always a great deal more for us to learn. I am convinced that for many people who are locked in a cage of pain or loneliness of fear, music can be the key which will unlock the door and let in the light of the sun, but this key has many facets and the more we understand them the better we can use music's healing power which, as one patient told us after a concert, 'was better than diamorphine any day'!

The Council for Music in Hospitals[2] is a registered charity. The venues pay about half of the actual cost of putting on a concert – if they can. Many are given free of charge if there is money available, or through sponsorships. We also depend on grant-making trusts, firms and private benefactors to help us to 'bridge the gap' between what the hospital can afford and our realistic costs. Looking ahead, our aim is to reach ever further afield so that all those who, because of their age or their disability, are unable to attend a concert in a public place can yet enjoy hearing live music which is brought to their own centre, ward, lounge or bedside by skilled and caring musicians. Because we feel that live music offers something unique towards the care and treatment of patients and residents, and that it is 'the best medicine in the world', we will go anywhere, however small or remote, if we can help to bring the joy of music to even one person. The Sue Ryder Home, near Peterborough wrote: 'We laughed, we cried, we clapped the beautiful dresses, our very ill patients forgot their pain for a while – totally involved with the songs sung by caring singers, in fact *the best medicine in the world*.'

Perhaps the last word should come from the Churchill Hospital in Oxford who wrote after a concert: '*Music really is the food of love*.'

1 My book *A Songbird for the Heart*, published by The Pentland Press, tells the history of the CMH with a more in-depth look at our work.

2 Council for Music in Hospitals, 74 Queens Road, Hersham, Surrey KT12 5LW.

Paintings in Hospitals

Raphael Eban

'What a good idea!' you might say. 'Enough of empty brown walls and large featureless stairwells and corridors. Even patients might like to have something to look at while waiting to see the doctor, to have an X-ray or to have blood taken. But what sort of pictures, how to find them, choose them, pay for them, mount them, take responsibility for them?'

We at Paintings in Hospitals have the answers. For thirty-five years PiH has been buying original paintings by (mainly young) British artists and has rented them out at a nominal fee to hospitals for display in their public places and waiting areas. From a small beginning at the National Hospital, Queen Square in 1960, it has grown to a collection of 1400 paintings to be found in over 80 hospitals in England. It was originally started up under the wing of the Nuffield Foundation and funded by them for the first fifteen years. Its primary function is to bring good contemporary paintings into the hospitals which use our services, and so improve the general quality of their environment and provide a focus of interest for patients and staff alike. It helps to act as a source of patronage for the young painters whose paintings it buys – either from galleries or directly from the artists.

We try and buy paintings of high quality which are suitable and which will stand up to scrutiny over time. We look for those which have painterly, rather than merely illustrative or decorative, qualities. Over the years many works have been bought from artists who had, or have since acquired, a distinguished reputation. Such names include Gillian Ayres, Elizabeth Blackadder, Sandra Blow, Prunella Clough, Mary Fedden, through the alphabet to Ann Redpath, Julian Trevelyan, Keith Vaughan, Kyffin Williams and Alexander Zwarenstein. There are now over 850 names in the catalogue. We are always alert to find new and unknown young artists of promise.

The type of work bought varies. It is obvious that not all paintings which might be considered 'works of art' are suitable for display in hospitals. The policy is not to consider works which are gloomy or disturbing in content or

excessively sombre in colour. When 'context' is not in question – as in abstract or non-figurative works – care is taken to exclude those which might be considered to have a disturbing interpretation. The general tone of the collection is therefore positive and bright, with many flower paintings, still lifes and landscapes. There are oil paintings, watercolours, drawings and some prints and collages. There are some abstract paintings, mainly highly decorative, which go splendidly in stairwells or long corridors.

We rent paintings to a hospital on a contractual two-year basis at a rate of £15 per painting per year. This can be renewed for up to a further four years if wanted. We then like to recall them for redistribution and offer a new selection in their place since it is too easy for paintings in the same place for a long time to become background 'wallpaper' for the staff. We normally hold an exhibition once a year to show the new works acquired during the year and also a proportion of pictures already rented out which have been recalled for redistribution to other or newly joined hospitals.

We employ a part-time director and a part-time curator since there are considerable administrative complexities in controlling such a collection. Apart from routine office administration, invoicing and collecting fees, there are specific curatorial activities which include recalling, cleaning and re-framing pictures, and monitoring their continuing safety and integrity on hospital walls. On the hospital's part, there needs to be a responsible person to take charge of the paintings, arrange secure mounting and display on walls and sign the agreement with us on behalf of the hospital.

Since 1989 we have embarked on a policy of expansion. With our help, a sister body was set up in Edinburgh in 1993 and PiH (Scotland) is now an independent and thriving organisation. We held an exhibition in Exeter in 1994 (in place of our annual London exhibition) and recruited several West Country hospitals as a result. We have just started a similar scheme in Ireland with the help of funding from the Gulbenkian Foundation (funds are to be applied equally in both Northern Ireland and the Republic) and have already formed a committee in Wales. We are full of ideas and hopes for further expansion but are limited in this, not so much by lack of funds as by the need to find committed and enthusiastic people in their own localities who are fired by our concept and wish to push it forward in their own hospitals. We wish to start and encourage locally-based schemes that raise their own funds and purchase suitable works by local artists.

In summary, we offer a service that provides the opportunity to display good quality works of art in hospitals without any need for capital expenditure. Our address is c/o the Samaritan Hospital, Marylebone Road, London NW1 5YE (0171 723 7422).

Part II

Working with Existing Buildings

And not by Eastern windows only,
When daylight comes, comes in the light,
In front the sun climbs slowly, how slowly
But Westward, look, the land is bright.

Arthur Hugh Clough

Purchasing and Commissioning Visual Art in Hospitals

Nigel Weaver

This chapter is written for those hospitals where there is a desire to beautify, or cheer the place up, and a degree of uncertainty about where and how to start. It draws upon my experiences as a chief officer in two districts between 1974 and 1993 where I was able to achieve a good deal at very little expense. Initially, twenty years ago, there was comparatively little appreciation of the contribution of art in hospitals and so my efforts were largely self-directed. Nowadays there are a number of organisations that will help with advice or designing a comprehensive approach, and their contribution is addressed in more detail elsewhere. Twenty years ago cash was still limited and it is perhaps worth dealing at this early stage with the question of financing art projects.

Finance

For most people, art projects are going to have to be financed from non-official sources. The most accessible to all hospitals are the 'endowment' or 'amenity' or 'free monies' that are available to each. Teaching hospitals were allowed to keep their endowment funds when the NHS began in 1948 and some, like St Thomas' and Guys, are substantial fund-holders in this way, and use the income from their endowments largely to finance improved amenities, medical research or staff developments. Many are generous contributors to the arts cause. Pre-eminent are St Thomas' Hospital in London and Aberdeen Royal Infirmary, where for some years substantial sums have been committed for the purchase of works of art, and very impressive collections are on display in both.

For the majority of hospitals that are not teaching hospitals with separately maintained endowment funds there is an allocation made each year by the Department of Health from the central pool created in 1948 by the amalgamation of all the funds then taken over by the Government. This is apportioned

to all hospitals on the basis of so much per bed. This income is intended to be used for 'extras' that the Exchequer would not normally see as part of routine health service expenditure and art must, therefore, compete with other demands, and for a severely constrained sum. However, with 'patient amenities' now being more substantially covered these days, and with the cost of upgrading buildings or putting in additional toilet accommodation, etc., being so expensive, it is unlikely that this money will be used in this respect; and, in any event, improvement to the fabric is now accepted as part of normal Trust activity. It is, therefore, worth enquiring in each locality what sums are available from this central allocation and to what use it is put. In addition, and since 1948, sums of money left specifically to a hospital have, quite properly, been allowed to remain with that hospital and often comparatively large sums of money are kept in the Finance Director's ledgers and, perhaps, under-used. This is because sometimes the sums are earmarked for some specific use or ward or department; or that they do not add up to anything significant in the eyes of the Finance Department. But, to the arts enthusiast, sums of anything over £500 are important. Enquire about this aspect. In one district I was concerned with, a quarterly print-out of such sums often revealed money that Sisters or Department Managers were unaware about and that could be brought into play if they were looking for money to finance some imaginative project.

And look too for the defunct fund – which will still be in the ledger because perhaps nobody has yet realised that the 'XYZ Fund' of 1952 never reached its target or that the need has now passed and the money sits unused. In the present day climate of change there are often sources of money originally allocated to hospitals that have since closed. With the consent of the Charity Commission, these can be transferred to other hospitals or use – provided that the beneficial intent of the donors is continued. One strong claim is if the work of a hospital that has been closed has been transferred to another and this continuity can be demonstrated. In this way the former 'cottage hospital' endowments can be utilised by other, less well endowed, hospitals. Pre-1948 'voluntary' hospitals (i.e. those not funded and run by the local authorities at the same time) were often generously supported in their locality and now, with the passage of time, it is often these smaller hospitals, in small towns or villages, that are made redundant and whose work, latterly often care of the elderly, is transferred to another site. Endowment funds may be left to lie in limbo for want of resolution about what to do with them.

The final, local, call for funds is the League of Friends. Leagues of Friends are, by definition, concerned with enhancing the quality of patients' lives while in hospital and usually feel that their efforts are not to provide essentials more properly the responsibility of the Government. For many years they saw a role in providing television sets (particularly during the time that the Government regarded them as inessential) or hair dryers for ladies wards. Christmas gifts were another. Here again time has wrought changes. Televisions are now

provided with the furniture; and state benefits for the long-stay patients now almost render superfluous the need for the Leagues to distribute boxes of toiletries at Christmas (except insofar as the act of giving extends a welcome hand of friendship). Leagues of Friends usually find fund-raising large sums of money very difficult and so their regular income (and benevolence) is accordingly limited, but they are still worth approaching for modest support for artistic ventures in patient areas. For example the payment of the £15 a year hire charge for an original painting from Paintings in Hospitals multiplied by, say, five pictures on a ward is a modest grant, but with very tangible benefits.

Having looked at the in-house sources of funding, one moves to external sources. At the local level there are the familiar sources – Round Table, Lions, WRVS and any local charitable trusts that may be appropriate. Specific appeals for major commissioned work has its place and may be used. Some, like the Healing Arts: Isle of Wight appeal used the catalyst of the newly constructed district general hospital to launch an appeal, which was successful and now embraces commissioned works of art in the building as well as an active arts programme in the visual arts, music, theatre, dance and creative writing. Such a wide-ranging programme is beyond my experience and so this chapter will concentrate, for the most part, on the purchasing and commissioning of the visual arts only.

For the sake of completeness in this section, one must move to national funding options. Hard work will be called for, plus perseverance, and the motto 'Where there's a will there's a way!' will need to be adopted by the enthusiast(s). There are funding bodies, and there are charities in this field, but all are under-funded and over-subscribed, hence the need for tenacity and evidence of a well thought out plan. Funding may be available from:

- Regional Arts Boards
- Local authority funds – either for the arts and recreation budget, or via government grants like Urban Aid
- Business sponsorship – consult The Association for Business Sponsorship of the Arts, Nutmeg House, 60 Gainsford Street, London SE1 2NY (0171-378 8143)
- Local or national charitable trusts – consult *The Arts Funding Guide* from The Directory of Social Change, Back Lane, London NW3 1HC (0171-284 4364) and other of their publications
- King Edward's Hospital Fund for London (if within Greater London) 11 Cavendish Square, London W1 (0171-307 2400)
- The Heritage Lottery Fund (National Heritage Memorial Fund, 10 St James Street, London SW1P 1EF (0171-747 2030) or the Arts Council Lottery Department, 14 Great Peter Street, London SE1P 3NQ (0171-747 2030) – they are both concerned, at the time of their

inception in-1995, with grant-giving for capital projects costing over
£10,000, although 'capital' for this purpose can include commissioned
works of art. Raising substantial sums of money via these bodies is
probably best pursued in conjunction with some organisation expert in
the field.

Purchasing

Having considered some of the financing options, we will turn to the subject
of visual art in hospitals – original watercolours, oils or prints and sculpture.

I am firmly of the view that there is still plenty of scope for the committed
individual (or individuals) who want to beautify their hospital environment.
Hopefully this will be a precursor to other, more ambitious, and well thought
out plans. It may not be open to everybody to clear away the junk and
extraneous matter that litters our hospitals (and which, for some reason, does
not appear to afflict private hospitals), or to rationalise the signposting, or cheer
the bare miles of walls. What can be achieved is some worthwhile improvement
to areas within a hospital by selective purchasing or commissioning, and
ultimately, where a hospital-wide Arts Committee can broaden it, over a wider
front.

Without advocating centralism for its own sake, I have to say that to achieve
improvements in the varied environments found within a hospital today it is
desirable to commit this work to the vision of one person or a small committee.
Some hospitals will have a natural leader in this sphere and status is less relevant
than having the expertise and the vision, and the confidence of management
to let them achieve. Currently multi-disciplinary working is in vogue but in the
past visionaries, more often than not on the medical staff, played a very
significant role in improving the quality of the environment by introducing
works of art in a controlled manner. The work of Dr Hugh Baron, a consultant
physician at St Charles Hospital, London, in transforming that Victorian
institution is an outstanding example; and in the mid-1970s the successful work
done by Peter Senior, as an artist coming into the teaching hospitals in
Manchester, was to lead to the ultimate creation of the nation-wide organisation
Arts for Health working with health bodies in implementing arts projects.
Pre-dating both was Sheridan Russell, a medical social worker at the National
Hospital for Nervous Diseases, London, who showed loaned pictures in the
waiting areas and wards with noticeable and beneficial effect and went on to
found Paintings in Hospitals. My own experience, at Charing Cross Hospital,
London, and in hospitals in Barnet, north London, was perhaps made easier
initially by also being the Chief Executive, but the ultimate compliment was to
have department heads coming to ask for works that could enhance their
departments.

In short, an individual needs to be identified (or indicate their availability) who has the requisite knowledge and who can give the initial lead and enthusiasm. That individual may need to be guided by some person who has experience in hanging pictures, for there is more to this than simply banging in a nail! Harmonious groupings, being 'on the line', and matching pictures to places requires some skill or feeling at the least and local advice from an art school, gallery or practising artist, is desirable. Grouping works sympathetically, often by the same artist is desirable. This has been done to great effect in the Chelsea and Westminster Hospital.

The individual then needs to be trusted and given his or her head to a large extent. Choosing pictures by popular vote is not always feasible, although when it is possible to stage an exhibition and ascertain the most popular choices it is helpful. What must be maintained is an unabashed emphasis on quality, originality and suitability and this is best left to one pair of eyes, even if not every purchase meets with universal approach, but that is life. In an effort to beautify a hospital, care should be taken to purchase original works (and break away from the popular Constable and Renoir reproductions we have seen so often before) and of a professional standard so that hospitals do not become the repository of 'Sunday painters', however well intentioned. Pictures executed in memory of a patient fall into this category, and making the arts co-ordinator or committee responsible for approving these donations may save you from displaying an obviously inferior work because there was no way you could personally find to decline it. There may be plenty that needs to be done but high standards should be set, and met all the time, even if it means slower progress. Neither should we subject patients to shoddy work: we should aim to enhance in some way all those who come into contact with it by demonstrating the best of contemporary art.

Purchasing can start with a grant of as little as £500 or £1000 grant. This can go further if works are bought from auction rooms rather than always from established galleries, and if limited edition prints are purchased. The latter will carry a number at the foot of the image, the first, over a horizontal line, its own sequential number under which will be the ultimate number of the edition, after which no more copies will be produced. Techniques vary, ranging from cutting on lino or wood, engraving on copper or silk screen printing, and many famous artists also produce work in these media. The number helps to distinguish the work from reproductions – run off in their thousands and without bringing the skill of the artist to bear (who will supervise and sign all truly limited editions).

Auctions houses are to be found all over the country. In London the four major companies – Sothebys, Christies, Bonhams and Phillips – all have premises out of the centre where they regularly auction less expensive works than they do in the West End. Phillips also have a network of provincial rooms at places like Bath, Chester, Edinburgh and Leeds. Catalogues are available and bids can left with the auctioneer after viewing, (which he will use on your behalf

in capping any bid from the floor until either your bid is successful or overtaken). In the former case, the purchase is made, if appropriate, at less than the ceiling you set. Buying this way is straightforward and often buys works one-third to one-half of the price in a gallery. The catalogue will give a guide price of what the auctioneer expects to sell the work for, but this is not to stop you putting in a bid for a lower figure if you cannot afford more, and succeeding. For example, in late 1994 Christie's in South Kensington had for auction as one lot two oils on canvas by a reputable artist who died in 1988, each measuring 3'x 2', with a lot guide price of £200 – £400. The same artists had just featured in a West End gallery where similar work was selling for £500 each. A commission bid for £310 was left and the two oils ultimately purchased for £300 – a saving on gallery prices of £700. In the 1970s, by purchasing for hospital display in this way, a range of works, often by quite famous names in the art world, were obtained for an average cost of £25. By the early 1990s this average figure had moved to £45, but still gives an indication of what can be achieved if you go and search. Unframed work can be purchased but you need a reliable framer who will enhance the work by mounts and a sympathetic frame. Even the most insignificant work can be made to look important – and vice versa – so choose a framer with care.

In starting out it is worth concentrating resources in one area so that the results can been seen and the works have a chance to impact. Two medium sized paintings hung in a large traditional out-patient waiting area will hardly be noticed; hang 6, 12 or 20 and they will be noticed! Do not space works many feet apart in long corridors; let them 'breath' a foot or two apart by all means, but start at one end and work on steadily. Do one department thoroughly, positioning works where patients can see them, and not just staff. (Remind yourself how boring it is when you are inclined in the dentist's chair and he has the benefit of an eye-catching picture that you glimpsed as you walked in).

Having accomplished the purchasing and hanging, a word about what follows. Experience is that, unless some steps are taken to avoid it, the normal movement of staff means that those who were initially committed and instrumental in getting works of art up will not always be in post and their successors will, in all innocence, fail to maintain the scheme. Perhaps the greatest danger is when alterations take place, or the area is decorated, and items are removed. Unless particular care has been taken to record the positions the task of re-hanging may never take place. Goods stored in a safe place get forgotten. Changes of personnel may mean that the taste of the previous occupants is distinctly unappreciated by their successors. Damage may occur; even theft. For the latter there are a number of anti-theft hanging devices. Overall the maintenance of an artistic legacy is best done by a committee or group who are informed, active, vigilant and will see to the continuity of works in their original or new positions. This means record-keeping and a self-perpetuating committee that takes on new members as others leave it.

Commissioning

This chapter has pre-supposed that you are not involved in one of the 300 arts projects that were identified in 1992. Certainly since the 1970s, the realisation that the visual arts have a significant place in hospitals has gathered pace although there is still a noticeable tendency only to associate comprehensive planning and artistic developments with the commissioning of new buildings. It is not essential to await this still too rare event, although when it is done well, as in the Chelsea and Westminster Hospital (1993), the overall result can be exhilarating.

To gather new ideas, and to be excited by other hospitals still achieving good care amid outmoded buildings, I would refer you to *Helping to Heal: The Arts in Health Care* by Peter Senior and Jonathan Croall (published by the Calouste Gulbenkian Fund in 1993 at £8.95). This charts the growth of 'arts for health' over the last twenty years and highlights what had been done and looks at the many organisational, social, financial and artistic problems that can arise. Peter Senior is also Director of the organisation Arts for Health established in 1988 to inform, advise and offer a consultancy service for arts projects and events.!1•

For those who wish to go one more immediate and still inexpensive step, there is the use of colleges or departments of art in collaborative settings. Barnet Health Authority, between 1984 and 1994, entered into an agreement with the Department of Art at the Roehampton Institute, London, assisted by a grant from the Chase Charity, that enabled students in the final year of their combined honours degree course to design works of art within the extensive facilities of the health authority (which at that time directly managed ten hospitals and a number of community health facilities prior to the separation of the authority into two NHS Trusts in 1992). Under this, in return for a modest contribution towards the cost of material used, students on the course had to obtain approval for their project from the appropriate hospital staff about designs and schemes they would propose for particular areas of the hospitals or clinics designated for the project. The student first had to take the brief and advice of the department staff involved and then submit finished scale designs and costings before getting approval and proceeding to execution as part of their degree. The standard of work carried out in the various media of glass, mosaic, ceramics, vitreous enamel, print-making or painting was universally high, and this has also been the judgement of the external assessors to the degree course. The number of students now wishing to take Art in a Community Context course has grown to such an extent since 1992 that the commission sites have gone

1 As a facilitator and guide to more ambitious plans, contact with Arts for Health is advised. Their address is: The Manchester Metropolitan University, All Saints, Oxford Road, Manchester M15 6BY (0161-236 8916).

beyond the former health authority and in 1995 were in 120 hospitals, schools, universities, churches and public libraries. This unique venture was developed by Keith Grant from experience gained at Charing Cross Hospital in 1980. Grant is a successful practising artist who, for a time, combined this career with being Head of Art at the Institute. Joining this scheme can be recommended to any facility within travelling distance of Roehampton.[2] Alternatively, approach your local college and see what prospects there are for similar local collaboration.

Conclusion

This chapter started with one man or one woman with a vision, but also urged the need for a wider representative committee. Nobody in the NHS will need any advice on how to form a committee! As they do their work, experiencing – as many others before them – scepticism turning to enthusiasm and delight, they will do well to bear in mind the view of one outside the health service, the art critic and writer Richard Cork:

> Art is able to provide solace, exhilaration and satisfaction in a huge variety of different forms. Above all it is able to humanise a building, infusing an often soulless and impersonal environment with affirmation…many critical moments in our lives occur there – from birth through to death – and they ought to take place in surroundings which honour their true significance. (Baron and Greeve 1984)

Reference

Baron, J.H. and Greeve, L. (1984) 'Art in hospitals.' *British Medical Journal 289,* 1731–1737.

2 Contact should be made with the Head of the Department of Art, Roehampton Institute, Froebel College, Roehampton Lane, London SW15.

Recipe for Conversion
Working in the Psychiatric Environment

Peter J Salmon and Graham A Moore

Introduction

Take an existing building of anything from 30 to 150 years of age and which has possibly received a minimum of maintenance. Add two principal groups of people each with special and inter-related needs (the cared for and the carers). Mix carefully, add the Project Sponsor's financial constraints and the final result of this amalgam should be a refurbishment which is fit for its purpose whilst, and most importantly, it contributes to patient recovery in an environment which gives the closest possible parallel to the type of accommodation which we in the 'normal' world call home.

In order to achieve a successful conversion it will be necessary to evaluate the client and user-group needs and expectations – which undoubtedly will have to be finally agreed as a compromise between expectations, essential requirements and budget. Given an open cheque book, quality is easily achievable. Inevitably what has to be achieved is 'quality with economy'. A much more demanding target.

Of all the ingredients, the most difficult to ascertain is patient need. The patient has little or no input except that which may be voiced through the caring staff and, although many patients may be hospitalised for a considerable time, the likelihood of individual patients, or, indeed, the entire patient group, changing wards cannot be ignored. The environment provided must therefore allow, within reason, for the minimum of disturbance to the fabric or finishes if this should happen. The over-personalisation of patients' individual rooms should be restrained as re-location of that patient to another room or ward may cause additional stress due to the change in environment and familiar surroundings, which could hinder recovery.

Much can be learnt from consultation with staff, who are best placed to identify areas of special need, however small, which may have been encountered

in the past, and to relay to the design team the patients' wishes and expectations. It should be one of the designers' tasks to 'design out' problem areas. It is unlikely in this demanding environment that all problems can be eliminated as with every solution comes a variation on the original problem.

The design team need to provide a building which serves the needs and requirements of the many disciplines, departments and personnel that need to work within it and use or maintain its facilities. At design stage, it is essential that all parties are able to provide a schedule of their requirements. This requirement brief needs to be co-ordinated and all requirements brought together centrally and cross-related where possible.

So where does one start when faced with this recipe?

Assessing the Building

The condition of the basic fabric of the building needs to be taken into account and main structural components such as roof, walls and windows assessed for condition and repair need which must be linked to the intended life span of the area in question. In many cases areas may be stated as requiring a relatively short life span of, say, 5 to 15 years and local repairs may suffice, providing that the client is appraised of the risk element and the possibility of future expenditure on repairs in order to maintain the building in a weathertight condition. Regrettably, on many refurbishment projects the basic requirements of the fabric of the building take second place to the internal environment. Repairs to roofs, walls, windows, etc. are not seen or appreciated in the final project. Only when a problem does arise are they considered. Unfortunately, in some cases this may be too late as internal damage will already have occurred.

The survey of the building should be as detailed as possible. This may have to be undertaken within an occupied ward which precludes any form of 'opening up', investigative process or extensive measuring. Photographs are therefore invaluable, but it must always be remembered that any photographs must not include patients – for obvious reasons.

Assessing the Needs

Having gained some knowledge of the building, the next essential ingredient is establishing exactly what the client requires of the completed project. In some cases the brief can be indeterminate and may amount initially to little more than a one line statement that the refurbished area is to provide accommodation for a particular number of patients. The rest of the brief will be developed around the patient numbers and needs – which will determine the level of kitchen facilities, day area and recreation space, toilets, laundry, storage, etc. Of all the requirements, the one which tends to be overlooked the most is the need for storage which, even when acknowledged, often has to be set aside in favour of other demands.

It is sometimes difficult to be positive at the onset as the potentially interesting parts of the building (which may be developed) are sometimes drowned by the first impressions of drab and uninspired interiors within an equally unattractive structure. However, therein lies the challenge.

Having completed a general arrangement or layout, the new pattern and the links between areas can be considered, as can patient and staff movement. The degree of observation can be assessed and maximisation of available space achieved.

The final arrangement should be conducive to providing a sense of community and family for the patient, and an environment for staff which allows the development of a caring ambience.

Sleeping

Patients' sleeping arrangements may either be in large dormitory type rooms or they may have the advantage of individual and relatively private bedroom areas. There are positive and negative sides to both arrangements. The individual patient bedroom allows a higher level of privacy in what is currently referred to as a person's own space. However, this level of privacy also adds to problems of safety, security, level of nurse observation and potential response time in the event of an incident. Equally, if the incident occurs within a patient's individual room, it may have the benefit of being more easily contained and preventing a disturbance by other patients. The ability to identify and isolate such a problem is of paramount importance to the nursing staff.

Having provided a patient with a personal bedroom, toilet facilities may need to be added which may be provided either by combining existing rooms or perhaps by an extension of the existing building. In all cases the observation levels from the viewing panel provided in every patient door must be considered and every possible effort be made to eliminate 'blindspots' within the room. This is rarely totally achievable as, having provided the basic homely requirement such as wardrobes, there is immediately the possibility of concealment behind a partly open wardrobe door or perhaps within the wardrobe itself. Many of the more serious blind spots within an area can be determined by plotting sightlines on a drawing in both the horizontal and vertical planes. Such details are of considerable benefit to safety and security when considering proposals.

Should patients be accommodated within a larger dormitory type accommodation, then this should be divided with partitioning to give a level of privacy which does not detract from the benefits of the easy observation available in such an arrangement. The partitions can be provided to give each patient an individual area or a group of two to four patients a 'shared area'.

Although dormitory accommodation is currently least favoured, it can provide a much higher level of observation at all times – particularly at night

– and more so if a nursing station is provided within the dormitory area. Whereas patients with private bedrooms are, as far as possible, provided with toilet and washing facilities in their own room, patients in a dormitory must have a night toilet facility attached to the dormitory to eliminate the need for staff attending a patient in this situation leaving the area.

Safety

The possibility of obtaining or manufacturing weapons from furniture and fittings must be taken seriously. Many of the manufacturers specialising in furniture for hospitals have some knowledge of the problems to be overcome but obtaining samples for destruction testing is recommended. The result may be quite surprising and the nature and scope of harmful objects which can be obtained, astounding. Items that in a normal situation are considered quite innocuous – such as staples or a loose woodscrew – can, in a different situation, be converted into a lethal weapon, either for self-injury or injury to others. As far as possible, items should either be as indestructible as possible or, if damaged, should not provide obvious weaponry.

It is easy to forget that patients have all the time in the world to consider such matters, even the edge of laminate-finished surfaces can be released over a period of time and eventually broken off to provide a razor sharp edge. The list of potential weapons is inexhaustible and in many cases beyond the comprehension of people not accustomed to the environment. The reason for the refurbishment should be to provide a more stimulating situation for the patient, which hopefully will reduce or minimise the tendency and time available for such considerations.

Living Space

The needs of the patients extend far beyond the sleeping arrangements into day and recreational areas where they will spend most of their waking hours if they are not allowed to leave the ward to participate in various forms of occupational therapy.

The living space usually includes the dining, sitting, television, activity and learning/quiet rooms. Although large rooms are desirable for maximising circulation space and patient observation, they should be carefully divided or broken into smaller areas in such a way that observation is not impaired. All too often it is assumed that a patient group, or indeed any large number of people, are best accommodated in seating which is arranged geometrically around the outer perimeter of the room with all chairs facing inwards. This is not the case and patients require, at various times, either complete isolation to be alone with their thoughts or to sit with a smaller group, perhaps watching TV, listening to the radio, playing table games, whatever. The use of visual relief assists in this breaking down of a large number of people into smaller units.

The needs of visitors should not be forgotten and provision should be made for quiet rooms where patients can talk to their families or medical staff. Such areas should be as remote from the general areas of the ward as practicable in order to maintain the quiet and relaxing ambience required of such a facility.

Staff also usually find this breakdown of space beneficial as it provides the facility to sit quietly with a patient discussing problems or concerns and gives the effect of privacy but maintains the observation levels and the facility for quick response in the event of problems.

Corridors

Patients will inevitably spend some time 'walking around' and the corridor areas can be an effective means of giving personal isolation from other patients or staff when necessary. Wherever possible the corridors should be made to feel as light and spacious as possible with visual relief on walls in the form of paintings, murals, etc. The sometimes claustrophobic effect of numerous doors can be lessened by the careful use of colours and other features which take the eye away from a concentration of uninteresting physical features.

Corridors are also usually the first impression that visitors get of the ward and should, therefore, be welcoming. The range of visitors to be considered includes patients' families, medical practitioners, lawyers and visiting staff.

Interior Design

The common thread running through any such refurbishment should be sympathy with the patients and de-institutionalisation whilst maintaining nursing needs and other mundane, but nevertheless fundamental, requirements of such an area.

The range and nature of finishes available to the interior designer have increased considerably of recent years and whereas not so many years ago hard floorcoverings and emulsion painted brick walls were the norm, there is now an extensive range of specialist carpets and wallcoverings available. The colours and designs available in linoleum also make this an acceptable material. Companies can now offer a computerised pattern-cutting service in linoleum and other hard floor coverings which provide a considerable visual relief into otherwise large bland and uninteresting areas.

Services

Often neglected until the last moment is the renewal and concealment of services to comply with current requirements. Many older buildings do not have the facility to readily accept a new installation concealed within the fabric of the building and renewal can lead to high levels of surface installations,

which for practical and aesthetic reasons will need to be concealed and yet reasonably accessible for maintenance purposes.

At ceiling level, services may have to be concealed by a false ceiling. The void thus created can provide a useable space in which to distribute most services. Visually this is preferable to a large number of ductings or boxings along ceilings and walls.

There will inevitably be a need for some boxings to cover vertical pipe drops and the position and overall size of such boxings will need to be considered with the services consultant. They can either be made into a deliberate feature or, more likely, just be as unobtrusive as possible.

Areas can be dramatically changed by the considered use of lighting, although the areas to be lit often require the use of large numbers of lights which, if accessible, for safety reasons should be flush with, or recessed into, the ceiling. These can, nevertheless, be tastefully arranged and relief can be given in the form of downlighters providing a wash of light onto walls or particular features. Such wall-washing light systems can also be used to provide subdued lighting in day or corridor areas for use during the hours of darkness. Lighting can make the most ordinary of rooms look interesting. Inappropriate lighting can lessen the benefits of a refurbishment, cause eye strain, lead to accidents and make the environment very depressing. Aesthetically, lots of lights in different places generally provides the best effect.

Disabled

The additional needs of wheelchair-bound/disabled patients must also be taken into account unless there is a specific instruction that such patients will not be residing in any particular ward. Such considerations include basic means of access into and around the ward, width of doors, increased area of sleeping facilities and, of course, special toilet and bathing facilities.

In most cases the provision of disabled facilities has to be on a general basis as the range of disabilities catered for cannot be predetermined. However, modern equipment does provide the flexibility to cope with a maximum number of disabilities with any single piece equipment or aid.

Recreation

Patients' recreation and rest time is inevitably spent within the confines of a secure area, which may either be within the ward or a garden area. Security should be as discreet as possible. Planting needs to take into account the safety considerations and omit berries on plants, thorns and trees with low-level branches which may be used to breach the safe area. Water features, garden seating and barbecues within a garden area are useful for relaxation and pleasure and can often be used to diffuse an otherwise tense situation. The garden need not be a high cost item. An adequate relaxation area can be created at reasonable

price and will not detract from the simple enjoyment of being outside of the confines of the ward.

In some cases patients may be able to play an active role in the upkeep of the garden and a less formal garden may be tolerant of patient involvement. Patients may well be allowed into the garden alone. However they must not be afforded the facility of closing doors into the garden area thereby isolating themselves from staff.

Art

Art should not be considered solely as the application of pictures. Art encompasses the design, the material finish and the fixtures and fittings. All of these directly contribute to the visual appearance, but are rarely considered separately. The overall effect is the final product, upon which a general judgement is made.

Health care buildings present a number of problems: they are heavily occupied, often abused and subject to a level of use which dictates that the finishes and the materials for construction need to be of suitable quality. The buildings are generally occupied 24 hours a day by staff, patients and visitors, and the need to provide an efficient and pleasant place of work for the staff is as important as providing a safe and pleasant environment for the patient and visitor.

The design team have the option of imaginative use of colour to create an appropriate atmosphere for different areas. They must be aware that colour can be used to great advantage, particularly in refurbishment schemes. Rooms may be shortened, heightened or lengthened by the careful use of contrasting colour. The designer must also be aware that the colours chosen need to satisfy a great number of people who use the building for different purposes. It would be impossible to please all parties with every colour scheme, but a variety of schemes should provide something for each user.

Colour may be chosen by the user but this may not be advisable – with the exception of some special care facilities and some long-term patient facilities where colour choices can be offered. Colour should be appropriate to, and relate to, the area in which it is being used. It is advisable to avoid trends and bold patterns which lose appeal after a short period of time and are not necessarily conducive to a relaxed atmosphere.

Conclusion

Having painted an apparently rather bleak picture on restrictions, they are not insurmountable and, with care and imagination, the result achieved can be a credit to all concerned. But most important of all, it should provide a much improved environment for patients and staff which is conducive to a lessening of behavioural problems and easier nursing. A good environment forms a vital

component in the route to the overall healing process, which, unlike a broken limb, is not fully understood.

By creating an environment that is not depressing to live or work in and colour schemes that can be enjoyed, we are contributing towards a better environment for recuperation and improved staff efficiency and also promoting greater care from all users, thus lessening damage and maintenance costs. Incorrect choice of colours, materials and finishes can clearly be a disaster.

A very basic starting point of such a project should be reduced, in simple terms, to a personal level in that if you were unfortunate enough to find a member of your own family in such an environment, what would you expect that environment to provide?

Modern materials and finishes are manufactured to ever increasing standards and quality need not suffer as a result of trying to de-institutionalise.

Maintenance of finishes should never be overlooked. Unfortunately this is all too frequently forgotten. There is little point in applying a non-maintainable finish or material in a high risk area where, in the event of damage occurring, normal procedure would be repaint the area in a plain 'British Standard' colour – thus leading to early visual deterioration and disappointed patients and staff. This, in turn, negates the original intention of developing a sense of care and consideration for their surroundings. In many cases patients will develop a heightened sense of responsibility and control or limit damage by a fellow patient either by direct discouragement or by seeking the assistance of staff.

Although the fabric of the building and the interiors are of material things, they sometimes provide a safe haven for a number of years. They should therefore, wherever possible, be designed to relieve the stress and personal conflicts which could otherwise be aggravated.

Post-occupancy evaluation consists of an assessment completed after the upgrade has been completed and occupied for period of time. This is to evaluate how it functions in relation to design objectives with the prospect of gaining knowledge for future designs and upgrades. A most invaluable source of learning.

Most of the above is directly applicable to new construction and to schemes of refurbishment. It is probably true to say that the demands on the design team are less onerous for new construction than for refurbishment schemes where the building exists and, very often, the user-group's ideals make the design jigsaw a little more difficult. It is also true, however, that refurbishment with careful consideration can offer some splendid transformations and a measure of the success can be taken for future record.

The consideration throughout must therefore be for *design that cares.*

CHAPTER 8

Projects for Specific Needs

Gail Bolland

Hospital environments generally require that arts projects be well designed if they are to sustain a meaningful presence. The need for good design extends to consideration of the people using these environments and their formal and informal interaction with a space as much as to the space itself.

The following outlines three projects from the United Leeds Teaching Hospitals NHS Trust (ULTH) Arts Programme. Two are designed for specific areas to support medical care or operational services. The last, which is actually two similar projects under one heading, is designed to embody a corporate identity through its sense of history.

Cardiology Intensive Care

Research shows the deleterious effects of sensory deprivation on post-operative patients in intensive care: post-operative delirium, in which patients experience nightmarish interpretations of their environment is common; a stressful and potentially life-threatening condition for people already in a very vulnerable state (Wilson 1972). Rogers S. Ulrich (1991) has also pointed to the 'views' of the world which offer most comfort and reassurance to people experiencing illness in hospital.

The ideal response to the findings of this research would be to place all intensive care units in buildings where generous windows reveal views of natural beauty. In reality, most intensive care units are in cities and many have restricted or no window view available to the patient in bed. Add the often repeated suggestion that 'something should be put on the ceiling' for patients who are confined to bed and you have the reasons for setting up the Intensive Care project.

Take Heart, a forward looking Leeds based charity, which was established by former patients to provide enhanced support for cardiac patients being treated within ULTH, agreed to fund a pilot project which proposed to test-run

an arts in intensive care installation intended as a standard provision for intensive care, treatment, and acute ward areas. If successful, the project will then extend to all of the above areas in a large new £80m wing of the Leeds General Infirmary (Phase 1) due for completion in December 1996.

Intensive care areas are busy high tech environments with little surface area not already in use. They are also necessarily sterile environments, in terms of finishes, and offer little scope for interior enhancement to soften the ambience.

Simon Catchpole, interior designer for Llewelyn Davies, architects for Phase 1, considered the standard suspended ceiling as a framework for installing artwork into the intensive care environment. Knowing that Leeds General Infirmary has considerable purchasing power in terms of the size of its Phase 1 redevelopment, lighting manufacturers were approached to design and produce a lightbox fitting which would sit flush in the standard suspended ceiling, replacing the usual 600x600mm ceiling tile. The box would need to have a diffuser panel, be easily maintained, allow for artwork in the form of photographic transparency (later also to include stained and painted glass) to be changed, be powered from the normal services and have a separate wall switch to give patients and staff the choice of whether the box would or would not be illuminated independently of other light fittings. Moorlite produced a prototype to this specification.

Having solved the technical difficulties within the interior design brief, the next stage in this project was to bring in an artist. In other projects the artist has shared the resolving of technical problems from the beginning, but here the skills of an interior designer, with experience in designing for hospitals and large commercial buildings, provided the important technical and commercial knowledge which has allowed the potential for ceiling-mounted artwork to be integrated into the building design.

Two artists were approached, one a photographer and one a stained and painted glass artist. The second, Sasha Ward, was chosen to produce work for paediatric areas. The first, Kate Mellor, whose work we will examine here, was asked to produce work for adults in intensive care and treatment areas. Kate Mellor won the 1993 Yorkshire and Humberside Photographer of the Year award. She has a special interest in the natural environment, environmental issues, and the conservation of wilderness.

Mellor was given all research material pertaining to environments in health care, and intensive care in particular. She visited intensive care areas and met staff, and through Take Heart, ex-patients. She was asked to produce twenty images which could work singly, or in a configuration of up to five units, based on the research and meetings. It is proposed that these images be permutated, under the direction of the artist, to create a 'unique' installation for each Intensive Treatment Unit (ITU), treatment room or ward. A flexible design, in terms of configuration of images, was necessary from the artist as decisions on whether Phase 1 ITU areas would use 'beam' or 'pendant' systems for moni-

toring and life support equipment had not been decided, and it was clear that layout for beds and equipment might vary from area to area.

Mellor decided that landscape which included vegetation and/or water would provide the main content of her work with emphasis on composition which offered an unambiguous, positive and interesting sense of place and sensation to the viewer. To be avoided were images which might give a sense of claustrophobia or agoraphobia; jaggedness or confusion of texture and image; rock, tree, or water formations into which figures or gestures or objects might be read; images which are culturally symbolic of ill luck, death or the afterlife. It was felt that the Spring and Summer seasons provide the most reassuring images of the natural world. As these seasons are unpredictable, and relatively short in Britain, Mellor used a visit to Tasmania to work on the project.

With some months yet to complete the photography, the artist has already submitted a body of work for consideration. Take Heart are deeply impressed with the quality of the work, as are staff for areas for which the project is proposed.

The pilot project is set to run from September 1995 to September 1996. It has been warmly welcomed in principle as an enhancement to treatment and acute ward areas, where it is thought that patients and staff will respond positively to the beauty of the images. Where the project needs to be tested and evaluated most is in the ITU environment to demonstrate whether the project does have a measurably positive or negative outcome for patients, or staff. Less crucial, although still important, is the technical performance, and the issues regarding maintenance costs. Nottingham University's Centre for Organisational Health Development, under the leadership of Phil Leather, the Centre's Assistant Director, is looking at ways to evaluate the project. The Centre has already completed a comparative study of health care environments at the Gloucester Royal NHS Trust (Leather and Watts 1993).

This project, like the following, is integrated into the function and fabric of its environment. The artist brings to this situation an element which transcends the painstaking design which underpins and supports the work. As Ralph Snyderman (1991) has said:

> The arts give expression to that aspect of human health not readily accessible or quantifiable. They reinforce and encourage the presence, in a health care setting, of communication, courage, hope, understanding, compassion, humour, acceptance, and peace. Without these, all the magnificent assembled resources of a great medical centre have, ultimately, no real objective... We are not a collection of technologies in pursuit of a collection of problems. We are people seeking to comfort, heal, and protect other people. (Foreword)

External Works

As stated in describing the previous project, the Phase 1 Redevelopment of Leeds General Infirmary is an £80m new wing to the hospital which is located in the centre of Leeds.

The LGI site is an historic one: the original Infirmary buildings were designed by Sir Gilbert Scott RA, architect of St Pancras Station and the Albert Memorial. The building is now Grade 1 listed; the only NHS building to be listed at this level. Around the LGI are a number of buildings of historic and civic importance; Leeds Civic Hall, the Old Medical School, and the Leeds University Campus.

This part of Leeds is an area of great architectural interest and any development such as Phase 1 must recognise this in the way it relates to individual buildings and also the overall urban setting. It must likewise give consideration to people's use of the area: an important pedestrian route, travelled daily by many city workers, University students and staff, as well as staff, out-patients and visitors to the Infirmary runs through the site. The Trust has a strong commitment to promoting the concept and use of innovative interior design and integrated artwork into its health care environments. The Trust saw the challenge of the external works and landscaping around the new building as an opportunity to extend this ethos into the urban setting by appointing an artist to work with the design team in developing proposals for external works which would have a strong design purpose whilst ensuring that important operational functions could be carried out.

After a brief selection process, Tess Jaray was appointed as landscape artist. Jaray trained in fine art and has been for many years a prominent painter and teacher. However, in recent years she has broadened her scope of work. Her experience of urban design was an important factor in her appointment, based upon her proven achievements in her internationally acclaimed work in Centenary Square, Birmingham, and the Cathedral Precinct in Wakefield. A grant from the Henry Moore Sculpture Trust provided the fee for the exploratory consultation.

The main area of attention for Jaray's commission was the 'main entrance square' to the new wing through which a sizeable proportion of the LGI's visitors and staff will eventually pass. The square will also act as a drop-off and pick-up point for ambulances and taxis. On top of this, a new Accident and Emergency department will be served by the square. In Jaray's words, the area will be virtually a 'bus station' in operational terms and the danger would be that the necessary functionality of the space would overwhelm attempts to design for personal human scale. The challenge for Jaray was:

- to develop a design, within the allocated budget, which supported the hospital's day to day operation

- to design a welcoming environment which would contrast with the usual stark approach to a hospital
- to design paving, lighting, and planting proposals which would meet the stringent requirements of Leeds City Council and English Heritage whilst enhancing pedestrian navigability of the area.

It was not easy for an artist to take up membership of the design team. There are huge cultural differences in the training, use of language and ideas between the arts and the various disciplines in the building and building design industry: the stereotypical clichés of wasteful, scatty, 'primadonnerish' artists and philistine, bullying, cynical builders/planners may always hover in the air before trust and a working relationship is built.

Jaray and her work were soon respected. The scheme has been very much a combined effort of skills and expertise from all members of the design team with Jaray providing a cohesive and characterful identity to the external approach to the hospital which responds aesthetically to the diverse architectural setting.

Tess Jaray wanted to provide the person coming to the hospital with a 'moment of serenity' which would be created through the play of muted colour, shape and pattern. The broad shapes of blue-grey, buff, and rose-terracotta bricks and pavers, with the evergreen planting, serve to simplify and clearly define the use of space.

By making the space clearly readable, anxiety about ' where do I go?' will be reduced and the sense of the United Leeds Teaching Hospitals NHS Trust's care as an organisation for patients, staff, and visitors will be conveyed. The use of pattern and detail lighten and give rhythm and interest. Jaray described her design for the lighting as an 'arabesque' of lights. The whole is welcoming, elegant and functional. It will also work from the inside out, providing pleasing views for patients inside the building.

The end product will be unique. The Phase 1 building and its approach will have a special identity for the people of Leeds and Yorkshire, enhancing the City of Leeds for future generations in the same way that the Gilbert Scott building, commissioned by the General Infirmary over a century ago, still does today.

Archive History Projects, Leeds General Infirmary and Chapel Allerton Hospital

In November 1993 Leeds General Infirmary celebrated its 125th Anniversary on its present site: in 1994 Chapel Allerton Hospital, which had existed on a split site, opened a new wing, which extends its newer building, and vacated its original site. It was felt by staff in each hospital that these occasions required some visible commemoration.

The Infirmary looked towards the arts to find an appropriate means of expressing the history of their prestigious teaching hospital and its arts co-ordinator was asked to make some proposals.

The Infirmary, like many hospitals, is rich in archive material, as well as having a 'living history' of anecdotes. Being a complex organisation it also has more than one history: the history of nursing, of surgery, of medicine, of the architecture, and the social history of the people employed there – all of these are discreet strands which weave together to make the whole.

A working party was set up, drawing representatives from across the Trust whose responsibility was to research the history and the archives for their particular area. The first task was to establish which histories of the LGI were desired to be told for the anniversary, and who would be the audience. The second task was to look at what sources of material were available to illustrate these. In fact the nature of the treasures unearthed, many sent in from the public and retired staff in response to a press appeal, influenced the 'shape' of the histories which emerged.

It was proposed that a computer-generated 'photo-montage' would be the best way to stylistically homogenize the extremely diverse 'archive' which was daily growing, some of which was very valuable, some fragile and tattered, and some of which was three-dimensional (nursing medals and trophies, etc). After a brief selection process, Woodgate Graphic Design Studios were appointed to design six 8'x 6' panels which would be displayed along the Chapel corridor as a permanent exhibition.

Woodgates, a studio of graphic artists trained at Leeds Metropolitan University, not only understood the brief very well but were excellent communicators and organisers. They gave structure to the archive search and cataloguing process, provided enormous creative input into ensuring that the histories were clearly and attractively depicted and were sensitive to personal and departmental ownership of the project.

The first five panels depict: The History of The Buildings; Surgery; Nursing; Social Life; Technology. The final panel looks to 'The Future'. The panels are linked stylistically by a background and border motif taken from the tiled floor of the original Gilbert Scott entrance.

Postcards and an illustrated history brochure were also produced from the artwork. The project was funded by the Special Trustees.

The success of the Infirmary's project inspired Chapel Allerton to undertake a similar venture. I quote a report by Rachel Wheeler, then Commissioning Officer for the new wing:

> The closure of any hospital is an emotive issue. The prospect of the closure in April 1994 of the original Chapel Allerton Hospital (part of the United Leeds Teaching Hospitals NHS Trust) brought a considerable sense of loss and sadness amongst staff, patients, carers and the local community. Even though all the services were transferring to a brand

new hospital and the old buildings were in a poor state of repair and not suitable to deliver modern health care, there was still great affection for the old hospital. Indeed, it had a glowing reputation for its high standards of care, and the friendliness and dedication of its staff.

In early 1994, during the commissioning of the new hospital, it was decided to preserve the memories and have a permanent physical reminder of the old times in the form of an exhibition. Why?

- To help ease the transition process from the old to the new
- To show off a proud history and to highlight the achievements of a much-loved hospital
- To create a link with the past which would be enjoyed for many years to come
- To exploit the potential of the old photographs and artifacts etc. which were coming to light as staff sorted out their departments in preparation for moving
- To be a significant addition to the collection of artworks in the new building; these had been commissioned as part of the United Leeds Teaching Hospitals NHS Trust's arts programme, which is based on research which shows that patients recover more quickly in pleasant and stimulating environments

A group was established by staff from Capital Solutions (a division of the Trust, which had been responsible for commissioning the new hospital and co-ordinating the provision of artwork in it) to gather and select material for the exhibition; the group also included staff with knowledge of the history of the old hospital, the Trust's Public Relations Officer, and representatives of two of the hospital's voluntary organisations. The involvement of the volunteers served to strengthen links with the voluntary services and was a way of paying tribute to their services over the years. Contributions of exhibition material came from many staff and an appeal in the local media generated a good response from the public.

The graphic design company, who had produced a similar exhibition to mark the 125th anniversary of Leeds General Infirmary, were brought in at an early stage to contribute their ideas to the process of exhibition production. The staff from this company showed enormous patience and made great efforts to understand the history of the hospital for themselves. Theirs was not only a creative input, but an intelligent appreciation of history and sensitive and inspired use of material. Also, they contributed much to the sense of fun and team spirit in putting together the exhibition.

However, the project was not without its problems. Identifying funding was the most serious of these, and at one point threatened the whole venture. However, the Trust's Facilities Directorate pump-primed the project and contributions were received from a number of sources; these included the Chapel Allerton Hospital League of Friends, the Wounded Warriors' Welfare Committee, the Forces Help Society and Lord Roberts Workshops, and VB Johnson and Partners (Quantity Surveyors for the new hospital building). The overall investment was deemed to be worthwhile, especially considering that the exhibition would last at least the lifetime of the new building.

After months of gathering and selecting visual material, an accompanying text was produced. The process was extremely time-consuming, and unfortunately coincided with a time of intense commissioning activity at the new hospital (which incidentally took over the Chapel Allerton name). However, the group had set itself a deadline of producing the exhibition in time to celebrate the official opening of the new hospital by The Duchess of Kent in July 1994, and was determined to achieve this for maximum effect.

The exhibition, illustrating the history of the hospital from the opening of the original building in 1927, delighted people from the moment it was put up. Three themes are highlighted: treatment and care, social history and the role of voluntary organisations, and the development of the hospital estate. Of particular interest is the use of fascinating photographs depicting the hospital's special role in treating war pensioners and its development of artificial limb technology. The exhibition also conveys the hospital's lively social life, from the Wounded Warriors' coach trips to the cinema shows, radio broadcasts and concerts on the recreation hall stage.

The exhibition is a work of art in its own right and has an accessible visual appeal. Spanning 25 feet, the use of colour and shape is vibrant and striking. However, the benefits of the display go beyond the visual; the images portrayed are very positive; looking at the happy faces of patients and staff on the photographs brings a smile to all observers. For the hospital's elderly patients, looking at the display arouses interest and stimulates memory, and for all patients and visitors, the exhibition offers a talking point. On a practical level, it provides an orientation feature, helping people find their way to and from the main entrance.

From the staff's point of view, the exhibition helps to foster a sense of identity and belonging. It is something which they have helped to create and have ownership of and pride in. There is so much to look at within the display that they return to it again and again; it promotes the importance of their work and is a morale-booster on a day-to-day basis.

Undertaking the exhibition project was not easy, requiring a considerable investment of funds, time, enthusiasm and interest. However, the end result more than justifies the effort and demonstrates just how successful the use of arts in a health care setting can be.

All of the above schemes were designed and co-ordinated by Health care Arts in consultation with United Leeds Teaching Hospitals NHS Trust.

References

Leather, P. and Watts, J. (1993) *Comparative Evaluation of Two Neurology Clinic Waiting Areas: Interim Summary of Results.* Centre for Organisational Health and Development, Department of Psychology, University of Nottingham.

Palmer, J. and Nash, F. (1991) *The Hospital Arts Handbook.* Durham, NC: Duke University Medical Center.

Ulrich, R.S. (1991) 'Effects of interior design on wellness: Theory and recent scientific research.' *Journal of Health Care Interior Design 3*, 97–109.

Wilson, L.M. (1972) 'Intensive care delirium.' *Arch Intern Med 130.*

Part III

New Buildings

...it lies
Deep-meadow'd, happy, fair with orchard lawns
And bowery hollows crown'd with summer sea
Where I will heal me of my grievious wound.

Tennyson *The Idylls of the King*

St Mary's Hospital
An Alliance of Arts and Interior Design

Stephen Nicoll

Background

It is tempting, in a discussion of hospital art and design to make sweeping or broad-brushed statements. Generalisations can be misleading; policies described might actually have been made 'on the hoof' and hindsight can be clearer than forward vision. But I would like to think that this description is a fairly accurate summary of such an alliance between art and design.

Good fortune allowed that my involvement with St Mary's spanned the entire building design and construction period 1982–1990. It was, admittedly, a somewhat protracted project but what was unusual was that a designer was allowed personal involvement in the arts. I became one of the commissioned artists; people have asked me 'how?', but there's no mystery. Having studied at Art College, I believe in the value of 'hospital arts'. Some ideas submitted by me were liked and sponsorship became available. This chapter describes some connections between building design and those artwork commissions with which I was involved.

From the point at which the architects Ahrends Burton & Koralek were encouraged by the Department of Health at Euston Tower to introduce Peter Senior (then of Hospital Arts, Manchester) to the project, it was decided to see if an arts project 'theme' might be allied to the interior design specification and selection process. Few teams have, to date, completed a total, cohesive, thoroughly-worked-out thematic arts installation, but there was, at that time, a 'model' collection in St Thomas's, Lambeth – a product, so I understood, of the visionary spirit of Eugene Rosenburg, and perhaps others. Its theme, deriving from eclecticism, could be termed 'Modern'.

Themes

Using Peter's direct experience in the medical world, and by investigating the suitability to the Isle of Wight of a unifying subject, we agreed on 'Water'. In the previous year I had visited the Alhambra at Granada and was aware of the therapeutic value of gently running water: its presence and audibility. That idea appeals, but I know of no hospitals which have openly flowing streams in their foyers and corridors (though there may exist the odd fountain) – a threat of Legionnaires disease being amongst the impediments. Substitutes for real water thus become a metaphor and much art consists of symbols for ideas and concepts, whether figurative or abstract.

In the intervening years plenty of water has flowed under other Health Service bridges. Since we began the St Mary's project similar schemes have sprung up and flourished in most regions. Ideas are pooled and shared or plagiarised and cannibalised. This is progress. But there may be in fact only a limited arts repertory, and certainly no unlimited funds. To take the example of Elderly wards: in 1974 the idea of 'Reminiscence' as an arts theme would have been radical; in 1984 it was still fresh; but in 1994 it seemed obvious and almost clichéd.

To summarise many long debates: we settled on 'Sea Water' for the ground floor, 'Fresh Water' for the first, and the 'Flow of Memory' at the top level. Accordingly, the colour scheme was to be based on palettes beginning with floor-level colours of blue, green and pink, respectively.

Materials

With reference to materials, this is a low energy Hospital and all components were evaluated from the point of view of heat loss or retention. Floors, if generally laid with eight millimetre thick carpet, might be expected to retain perhaps two per cent more heat in the building than other materials under review – including five millimetre thick studded rubber which would give longer-term durability. In the event, cost restrictions led to the extensive use of two and a half millimetre linoleum. One major visual advantage was that small artistic details could be inlaid and welded. Thus, into the ground floor's blue lino were woven curves of blue and green at key points, simulating 'waves'. For side waiting bays the change was to oatmeal and the allusion was to 'sandy beaches'. On levels one and two we occasionally intercut the green or pink lino with grey stripes and termed them 'footpaths'.

Co-ordinated seating in these areas used blue and green 'wild heather' pvc upholstery and white frames. Department entrance doors were (respectively) tints of the principal level-identity colour ranging in hue (for instance) from a dark green through mid-green to an amazing lime or jonquil. Duct doors and WC back panels throughout the building were similarly integrated (blue, yellow, green and peach). Rooms followed the principle that a 'public use' door

was coloured in a tint (e.g. blue WC doors) while 'staff only' doors were always white or grey. Walls were white (00E55), cream (10B31), blue-grey (18C31) or pink if fairfaced block, and so on through soft furnishings, hardwood joinery, metal-framed furniture, handrails and ceramic tiling. Solar blinds replaced curtains; lighting was low-energy. In essence, with such a policy in force, most items needing a colour or material selection fitted neatly into the scheme.

Artwork

Artwork commissions for the ground floor included the community tapestry designed by Candace Bahouth on local 'aquatic' themes, and divisible into one hundred and forty-four 12" woollen squares, each made by a local guild. Its predominant colours were blue and red. Cubicle curtains by Sian Tucker on themes of flags and sails were printed by Skopos Fabrics in three colourways: blue/yellow (ground floor), green/yellow (first) and peach/green (second). Following Sian's selection by an arts sub-committee from a shortlist of Southern Arts Association approved crafts people, I provided her with a brief, itemising the building's existing firm colour choices and the desired themes for motifs.

Also planned were works using ceramic, pebbles, rope, canvas, sails, flotsam and jetsam and photographs. I was invited to make a submission for the out-patient's waiting areas and proposed an amalgamation of some of these. The idea was for seven large-scale 'holiday postcards' entailing a measure of workshop-manufactured, studio-painted artwork and the addition of 'found' objects. The Isle of Wight County Press – latterday descendants of George Brannon's original scenic-view etching company – commissioned the series. All of them made reference to the County Press as printers and sponsors and summarised the attributes of selected places on the island.

Made in medium density fibreboard (MDF), each was routed out with a 'postage stamp' motif and had cut-outs for the addition of wood-block place names. Principal designs included Cowes, for which a typical 1930s view was painted – the Schneider trophy winner; the Admirals Cup winner; the Liner 'Aquitania' – together with original postcards and memorabilia bought in antique shops (see colour plates). For Ryde the subject was 'means of arrival at, and travel on the island' – a paddle steamer; the hovercraft; a steam train; and an applied strip of pitch pine to suggest the famous pier. Its telegram is suitably bland, ironically typical of the non-urgency of most postcard messages; 'arrived safely; crossing uneventful; hotel comfortable'. Other 'cards' incorporated driftwood; pebbles and sand from Alum Bay; pressed orchids and butterflies; Keats, Auden, Lewis Carrol and Tennyson poems lovingly inscribed in Italic, Typewriter or Bocklin typefaces.

One other consistent feature in the Out-patients Department was Anne Heckle's calligraphic illustrations of Island poems which were mounted and framed in a blue-grey that matched the walls.

A long-held idea originating from the Southern Arts Association was to provide a point-of-sale for locally produced crafts. As part of my experimental work in components and finishes, I produced a 'knock-down' showcase consisting of silver-hammer paint-sprayed MDF with perspex cylinder displays. It looks, on a plan view, rather like a telephone. It is a prototype which would be cost effective in manufacturing runs of about six.

Design Co-Ordination

We produced many 'artist impressions' of how the building might look with speculative commissions. The sketches themselves could be framed! For Level one we drew cross-sections of the length of the corridors and illustrated them with pictures of fields, large-scale foliage and flowers, waterfalls and streams. For Level two we envisaged montages of old black and white photographs of shipwrecks or street and farm scenes. There could have been the wholesale removal and installation of an old sweet shop at Brading; the elderly lady owner thought the idea wonderful!

Externally, Richard Burton, together with James Hope, envisaged a court-yard landscaping scheme incorporating dry riverbeds, boulders, yellow flowers, seats and sculpture. Visiting the Stoke Garden Festival in 1986, I was struck by the similarity in character between much of its sculpted landscape and foliage, and Ahrends Burton and Koralek's own vision of an organic hospital environment. Indeed, Richard Burton was subsequently involved with architecture and design at the Liverpool Garden Festival.

There were few areas which did not receive consideration. Peter Senior produced endless sketches of entrance doorways and 'mobiles' or ceiling patterns suitable expressly for the post-operative recovery room or a children's ward. Ceiling tile paintings were commissioned from Anne Toms for the brain scanner room – where, of course, they do exactly what is intended – to reduce patient anxiety and make scanning easier.

In several subsequent projects we have incorporated signposting into our work. We are gaining experience in the provision of symbols and pictograms as a substitute for, or an appendage to, words. One over-riding aim is to eliminate banks of signs and arrows by the rationalisation of names and directions. A term originating from America is 'wayfinding': it is wide-ranging and all-embracing and is, to some extent, a description of solutions to the orientation problems raised by complex and ill-planned buildings. A well-designed piece of architecture relies less on signs and direction-pointers than key landmarks.

The Arts for Health consultancy for which I work believes that an arts project needs cohesion and continuity. There is no obligation to liberalise or evangelise art, and there is a sense in which fewer artists make for greater effectiveness. An analogy would be to have several different architects or designers on a project – a disparity of styles would follow. We would like to see a 'model'

project in which a small arts team would provide all the commissioned works of art in a new hospital building. Brought in at the right time, fully aware of the design aims and principles and properly funded, the result could be a definitive and inspired arts project – a true Alliance of Art and Design.

St Mary's Hospital, Isle of Wight
Arts Project

Richard Burton

The low-energy Hospital at Newport is exemplary in a number of ways, not least for the abundance of artworks and art events in the 'pathfinder' building. The objective of this chapter is to encapsulate some of the history of the project so that the people involved and the methods used can be properly recognised, but also I wish to point-up some of the benefits which have accrued and speculate on the future.

I must admit to pleasant surprise that my direct clients, the District, now the St Mary's Hospital NHS Trust, have been able to achieve so much so successfully without in any way using 'kitsch' or 'chintz and china'. In part, I put this down to the effect of a decent modern piece of architecture in which both the above aspects would be out of place, and the other part I put down to a rather extraordinary group of people who have been involved, many of them from our original design sessions. In a small way, history was created on the Isle of Wight in the 1980s, and it was to affect the ethos of design attitudes to modern hospitals in the 1990s and gave the Isle of Wight an alternative focus since the building is seldom out of the news (BBC2 1990, *Sunday Times* 1989, 1990, *Times* 1990, *Architect's Journal* 1986, 1988, 1989, *Architectural Review* 1991, *British Medical Journal* 1984, 1987, *Design* 1992). It can be said with some confidence that up to the time St Mary's appeared, the number of well designed modern NHS hospitals could be counted on one, maybe two, hands; and none had an integrated arts programme instituted during the design process. Since then things have changed for the better – particularly because some science is being used to examine the beneficial effect of the environment on patients – and this has underpinned the welcome change in design aspirations.

Background

We – Ahrends Burton and Koralek – were commissioned as architects to design St Mary's Special Development Project for the DHSS in late 1981. It was to be based on the findings in a report to the Department on energy reduction, of which we were part-authors. It postulated that a 50 per cent reduction in energy was possible in nucleus hospitals and outlined the means.

We already had the foundations of St Mary's started in 1982 when Howard Goodman, the then chief architect of the Development Directorate and an inspiring chief architect, gave a talk at the Institute of Contemporary Art entitled 'Art in Hospitals'. He had been invited by another important player, Sandy Nairne, to give this lecture and I was the only architect in the audience. There was enough to inspire a survey by Peter Coles in 1983 and an important conference at the King's Fund entitled 'Art in Hospitals'. One of the speakers was an artist, Peter Senior, and again I was listening and, simultaneously, Howard Goodman asked me to introduce an arts project of a broad nature into the St Mary's project. For me, as painter/architect and someone whose roots were in the art world, this was a great opportunity and I asked that Peter Senior should be my consultant. Peter was virtually the only person in the UK who had hands-on experience of a living hospital arts project. He was, for me, the ideal person and became a key player. He has gone on to direct 'Arts for Health' – the premier advisory body on the subject in the UK.

We worked to a small group chaired by Geoff Mayers, supervising architect at the DHSS, but the work was led by me and I had, as well as Peter, Stephen Nicoll as my collaborator interior designer and James Hope as our inspiring landscape designer.

We decided to examine the possibilities for art in the hospital, not limiting ourselves to static art. We decided on a palette of possibilities including a hospital collection which could rotate to suit people's tastes, exhibitions of local and other works in waiting spaces so that these spaces changed, mobiles, landscape, space for drama and live music, craft work such as curtains and hangings and sculpture inside and out. We then developed a method of illustrating these on plans – much as one would any other discipline. At this stage it is important to understand that we planned the works to be completed over time with a minimum first stage.

Making it Happen

We chose a theme, 'the healing effect of water', which was underpinned by James Hope's Monet lake (onto which most wards could look) and his interpretations of water in the courtyards – such as the 'dry river bed court'. We also planned extensive fountains in the courts but these were later omitted because of Legionella outbreaks elsewhere, which made their inclusion risky and expensive. Stephen Nicoll co-ordinated the colours of the hospital to

harmonise with the concept and help location. Thus the ground floor (entrance level) has a blue theme and the lino floor is treated as a canvas for the artist to weld in different colours and shapes to support the concept of 'the healing effect of water'. Stephen is also a painter and many of these ideas he has personally brought to reality, including the floors and many of the excellent signs which relate to local themes.

Nothing can be done without support and finance. When we started, the common assertion was that money for arts reduced that for medicine; we argued successfully that arts money comes from other funds which never would be used for medical purposes. So it was that the Gulbenkian Foundation funded the initial three years with help from Southern Arts, The Trust Fund and others, including ourselves. During this period the focus moved to the Island and a steering group under the chairmanship of David Wastall, district administrator, was formed. It was during the initial period that the local administration was worked out and an arts co-ordinator, Michael Dames, employed. His year in office was enormously stimulating and the foundations were laid, but the essential ingredient of the arts co-ordinator being a member of staff was not achieved. However, when Guy Eades was appointed the following year, the whole system of local administration was instigated with an overall committee chaired by the Chairman of the District Health Authority, Brian Livesey, and the steering group was given responsibility for up to £10,000 expenditure. Guy became a member of staff and continues in his post today. I suggested a powerful group of patrons should be formed, and this was done.

Using our overall plan, Peter and Guy instituted the key pieces in phase one: a community tapestry by Candace Bahouth; a competition for the wave wall won by Brian Chapman; a commission for the chapel, supported by Southern Arts, by Ray Smith, of tiles to be made in Portugal. We didn't achieve success on this, but, instead, he has made a stunning tiled wall in one of the stairs. Special curtains were commissioned from Sian Tucker, furniture for the chapel from Rod Wales, and local embroiderers began to make some quite outstanding three-dimensional representations of Newport. The collection was added to, and tried out, in the existing buildings.

During any building programme there seem to be frustrating delays for those on the outside. In St Mary's case, regional indecision regarding costs and delays, in part due to the cladding and in part due to the services, made the hospital take nine and a half years from the time of our commission until it was occupied in April 1991. During the latter part of this time the arts project kept the scheme alive in people's minds, especially as things such as murals and children's play areas were being done in the existing buildings and, of course, for the new building, the community tapestry with its 144 squares was being made all over the Island and put together in situ. This period was also good for getting sponsors. Major sponsorship for the lake was achieved and for the wave wall and the large-scale postcards in the out-patients department.

For my part, I saw a change in cultural understanding and I saw how much support we got from the administrators – Tony Blee, then district general manager, Mike Powell, now chief executive of the Trust, and John Bird – who were enthusiastic because they understood before many that an efficient, reassuring hospital environment sends the message to the patient that 'here is a competent, caring medical establishment'. This was confirmed by the King's Fund in their report following an audit when they said: 'The innovatory main hospital building is a great asset to the Trust and is a facility of which the people of the Isle of Wight can be proud'.

But details matter; for instance a key finding in hospitals is that if a wall has a work of art on it, it isn't vandalised. Thus the arts project involved my full architectural team so that walls didn't become unusable and covered with switches and thermostats, the Fire Officer was happy with the flame-proofing of the works of art, the planning of the dining space was such that it could be used for music and drama, the security of the works was assured by the method of fixing and that was compatible with the type of walling and so on. It was a complex process which needed extra fees to be paid because there really was a lot to do. The idea that these things somehow will happen and are part of the architect's normal work is naïve.

The Complete Hospital

By the time the hospital opened to the public in 1991 some of the main pieces were in place and 26,000 people, one-fifth of the Island's population, came on the open days. Many saw the result of their own work hanging on the walls; it helped to hand over this building, the largest single building contract on the Island, to the community. Since then they have taken it to their hearts and minds, and I am of the opinion that the arts project was a major bridge.

Since that time the hospital has revealed its fundamental nature, that of a daylight hospital – arising out of the concern for energy conservation. The spin-off is that the works of art look good and it seems to benefit both patients and staff. Initial reports certainly confirmed that, on moving in, patients from other hospitals on the Island felt more aware and even more mobile. There is no doubt that the morale of staff is enormously high, which affects the patients directly – this concept was introduced by us and it is gratifying to note that it is now generally accepted in the NHS. So the arts project is in part for the staff and their well-being. It is also for the visitors and day-patients, again to reassure them, to locate them, to divert them. Finally it is for the patients.

Common experience and many consultants tell us that patients benefit from having a good, well designed environment rather than a depressing one; that good natural light, natural ventilation, plants and landscape and a good outlook onto views all conspire to help our feeling of well-being and healing. The questions have to be asked: how, and how much, and when?

Although Ulrich (1984) has done some fundamental research which lights the way, there is a great deal to do to disentangle what the actual aspects are that affect us and in what measure. I see this as the necessary future research to underpin our common experience. We don't want to overlay our hospitals and places of healing with unnecessarily complex interiors trying to ape 'home', nor do we want to reduce the interiors to such an extent that they provoke sensory deprivation. We have to find the balance and only when we have some more knowledge, through the application of science allied to the architect's and artist's minds, will this occur.

St Mary's, meanwhile, stands as a very significant pointer to how, in the 1990s, modern architecture can integrate modern design and works of art for the benefit of the community.

References

Architect's Journal (1986) 'Astragal.' *Architect's Journal,* 2nd May, *183.*

Architect's Journal (1988) 'News.' *Architect's Journal,* 3rd August, *187.*

Architect's Journal (1989) 'Hot beds.' *Architect's Journal,* 22nd November, *190.*

Architect's Journal (1991) 'Hospitality.' *Architect's Journal,* 3rd July, *194.*

Architectural Review (1991) 'St Mary's' *Architectural Review,* February, *1128.*

Art in Hospitals (1983) November.

Arts in a Health District (1985) January.

BBC2 (1990) *Building Sights.*

Better by Design (1994) London: HMSO.

British Medical Journal (1984) 'Hospital building in the NHS.' *British Medical Journal,* 1st December, *289.*

British Medical Journal (1987) 'Medical news.' *British Medical Journal,* 7th November, *295.*

British Medical Journal (1990) 'Salvaging the environment.' *British Medical Journal,* 14th July, *301.*

Design (1992) 'Dear Virginia.' *Design,* June.

King's Fund (1994) King's Fund Audit at St Mary's, June 1994.

Scher, P. (1996) *Patient-Focused Architecture for Health Care.* Manchester: Arts for Health Care.

Sunday Times (1989) 'The "green" hospital that could save a fortune.' *Sunday Times,* 15th October.

Sunday Times (1990) 'Art transplant in a "green" hospital.' *Sunday Times,* 5th August.

Times (1990) 'Focus.' *Times,* 3rd August.

Ulrich R.S. (1984) *Science 224,* 420–421.

Spaces Between Buildings in the Health Care Estate

John Lynch

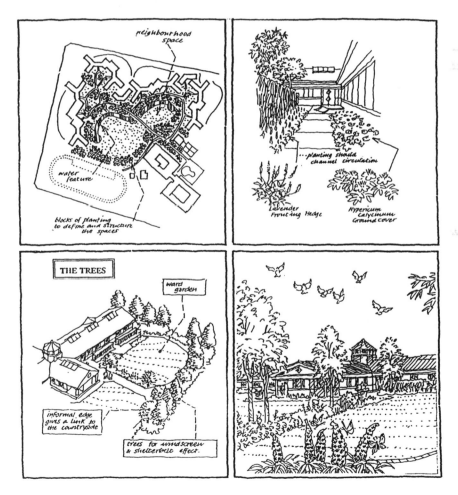

A point of view

Introduction

It is now recognised that we all respond to the environment in which we live and work and this can be of even greater concern to people when they are anxious, vulnerable or ill such as – patients within a hospital.

Research has shown that the process of healing can be helped when patients feel relaxed and at ease; and in environments that are non-stressful, supportive and easy to comprehend, these features are of even greater importance when patients are long-stay and, perhaps, mentally ill.

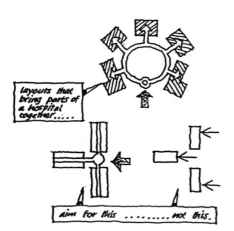

In addition, successful treatment can often be aided or even rely on, the development of trusting relations between the patient and the clinical team.

Therefore, layout solutions should be planned so that they physically bring people or parts of a hospital together, and so that they project an openness and clarity about the organisation which the individual patient can understand and relate to.

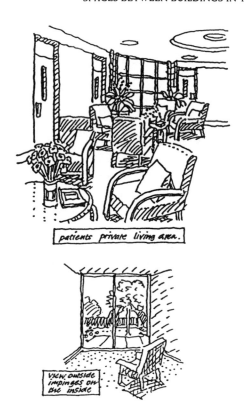

patients private living area.

view outside impinges on the inside

Evidence before the Special Hospitals Service Authority (SHSA) even suggests that disturbed behaviour can be triggered as a result of shortfalls in the immediate physical environment. Some examples of this are: high levels of noise, a lack of personal or quiet space, austere decor and surroundings, poor standards of housekeeping and maintenance and inadequate facilities to store personal possessions, together with overcrowding and inadequate sanitary facilities.

The SHSA has, therefore, defined the environmental standards needed for secure wards[1] with the aim of making wards smaller and more domestic in scale, and planned for family-size groupings of the patients with facilities on the ward to extend the range and choice of living. Other aims are to avoid long corridors and to provide a homely looking interior setting with internal spaces that are more light, open and airy.

The SHSA has started on a capital works programme to implement many of these measures and improve the physical and environmental standards for the patients within the three special hospitals at Broadmoor, Rampton and Ashworth.

But, that said, the work to improve the interior environment of buildings cannot be fully realised without consideration being given to the quality of the outside spaces, such as the gardens, courtyards and terraces around the wards; and to the larger spaces and grounds that form the setting and backcloth for life in a hospital.

This chapter, therefore, looks at work which is being undertaken, or is under consideration, for the spaces-between-buildings at Ashworth Special Hospital.[2] Some of the principles that underpin the design approach there may be of interest to others who are either directly or indirectly concerned with the health

1 SHSA Secure Ward Design Guide: published 1992.
2 Ashworth Hospital, Parkbourn, Maghull, Liverpool, L31 1HW..

care estate. But, bear in mind that the types of patient and the physical nature of different sites and buildings – and whether these are in urban surroundings or semi-urban, or semi-rural (as at Ashworth) – will all demand specific solutions that are related to local factors, conditions and needs.

Relationship with Surrounding Spaces

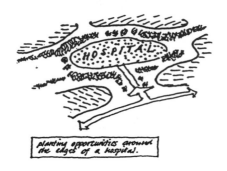

planting opportunities around the edges of a hospital.

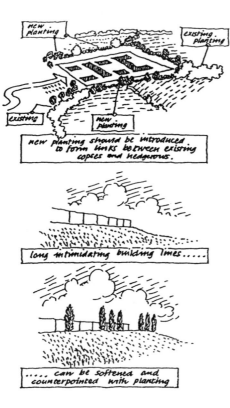

new planting should be introduced to form links between existing copses and hedgerows.

long intimidating building lines.....

..... can be softened and counterpointed with planting

Because of the general bulk, large scale and spread of a hospital complex, the physical impact that it has on the local environment is of vital importance. It can appear as an intrusive or even alien neighbour. Planting opportunities should be looked for that will soften its impact and make the development look more at ease with the surroundings, help to integrate it with the site and give it a sense of maturity and belonging and give it a more interesting and attractive imagery, both from the inside and from the outside.

Planting opportunities that will help to extend a sense of greenery around the edges and articulate the spaces around the perimeter of the site should also be sought. This can be by introducing new planting to form links between existing plant groups, infilling or reinforcing thinly planted areas to form positive hedgerows, copses or screening belts or by using plants to counter point any hard, long and perhaps monotonous lines of buildings, and especially boundary fencing or walls. Planting can also be used to form an effective but natural looking barrier around the perimeter of a hospital.

Concept Strategy Plan

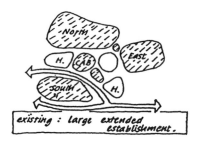

existing : large extended establishment.

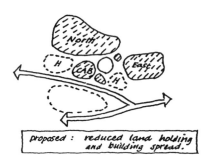

proposed : reduced land holding and building spread.

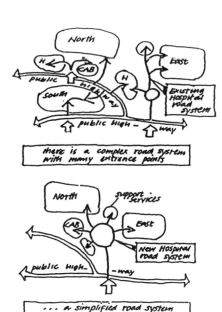

there is a complex road system with many entrance points

... a simplified road system

Hospitals often appear as over-large, rambling and unfriendly looking establishments. They can be confusing to be in or to understand, or to see how they are organised and work. This can heighten feelings of anxiety and give an impression of a lack of order and make them appear to function as a series of unrelated and disparate parts.

The planning aim for Ashworth Hospital is to rationalise the estate by making better use of existing building assets and reduce the land holding and building spread of the hospital. This will bring revenue savings and reduce the problem of extended movements for patients and staff. It will also help to bring about a clearer perception of how the hospital works and the location of the main hospital parts, and how these relate to each other.

Currently, the various elements of the hospital are accessed by different sections of road. These are difficult to follow and have awkward bends, junctions and sightlines. Some roads are shared with other users and it is difficult for a visitor to find out where to go. Also, there are too many road entrance points and the hospital fails to register any effective presence to the public highway. The aim, therefore, is to rationalise and simplify the road system and to introduce a clear, easy-to-follow road pattern which has a direct planning ge-

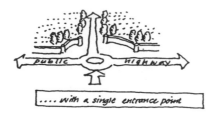

.... with a single entrance point

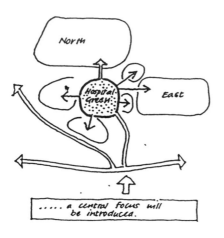

..... a central focus will
be introduced.

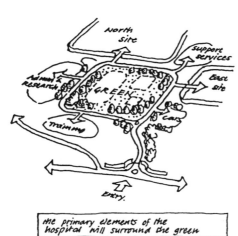

the primary elements of the
hospital will surround the green

ometry that will logically lead to each of the main elements of the hospital. The number of road entry points will be reduced to a single, specific entrance point leading from the public highway. This entrance will be designed to have visual impact onto the public highway and register a positive sense of direction as it leads into the hospital.

In addition, and so as to promote a better impression of 'whole hospital' with a clearer sense of location and orientation, and to strengthen the feelings of corporate identity between the different hospital functions – a central focus will be introduced. This will be planned as a hospital green surrounded by the primary elements of the hospital. Each will have an entrance from the green and each will have a presence on the green.

This arrangement should produce a stronger sense of community and 'togetherness' – an important feature for a hospital and one that is currently missing at Ashworth. The re-planned hospital road system will be simply re-configured around the green. This should make it easier to locate within the hospital complex and the new green, if sensitively planted and ground-shaped, could produce a pleasant, campus, parkland-like setting for the hospital and open up potential for the introduction of other features of landscape and visual interest that would help to soften the impact of buildings, walls and fence lines, and produce a more friendly, attractive and caring imagery for the hospital.

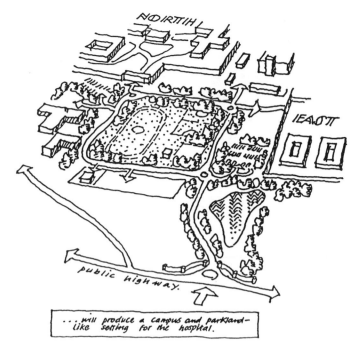

. . . will produce a campus and parkland–like setting for the hospital.

Primary Spaces

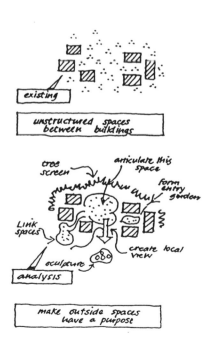

existing

unstructured spaces between buildings

analysis

make outside spaces have a purpose

One of the key steps within the design process to establish a concept strategy or development control plan for a hospital is the task of analysing the existing outside spaces that lie between buildings; to identify how these physically work, how they function and how they register as spaces.

A planning aim set for Ashworth Hospital is that none of the outside spaces between buildings should appear as unplanned or 'left-over space'. The intention is to make the outside spaces appear to have a purpose, look interesting and seem cared for.

Within the main business core of the hospital – Ashworth North – there is generally little sense of

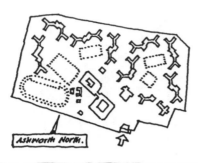

Ashworth North.

existing: unrelated elements within a
large continuum of space

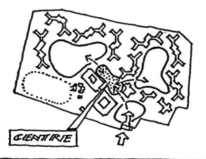

CENTRE

proposed: form a series of articulated
and contained outdoor spaces.

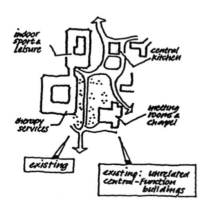

indoor
sport &
leisure

central
kitchen

meeting
rooms &
chapel

therapy
services

existing

existing: unrelated
central-function
buildings

structure to the spaces that lie between the buildings. Landscaping and planting has taken place but this has been introduced in an ornamental way to decorate and add interest rather than to structure and spatially plan the outside spaces. The various buildings and wards are generally single storey and appear as unrelated elements within a large continuum of space.

The planning aim, therefore, is to introduce landscaping as a space-forming and structural element and to inter-relate this with the buildings to form a series of articulated and contained spaces within the hospital.

In addition, there is no impression of a centre. It is possible to walk through this key part of the hospital without having any sense of having reached, or passed by, it's centre, or of having any positive feeling of 'arrival'. To improve these short-comings a number of planning measures are proposed.

First, a civic space is to be introduced. This will be created by developing a planning relationship between the central-function buildings and achieved by paving the space lying between them (as sketched).

This simple planning device should serve to tie these buildings together and make them appear as a related building group around a contained space – which should then have a different character and quality to the other, mainly

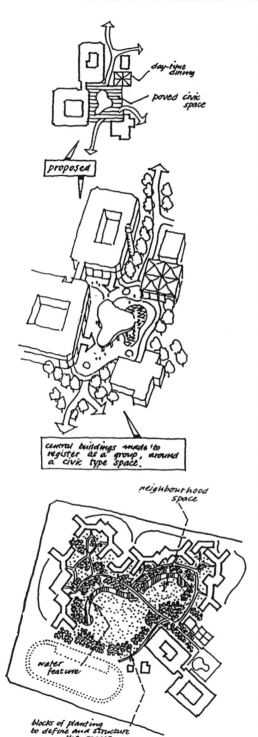

day-time
dining

paved civic
space

proposed

central buildings made to
register as a group, around
a civic type space.

neighbourhood
space

water
feature

blocks of planting
to define and structure
the spaces

grassed, spaces within the hospital. It should, also, then register as a central focus and a number of opportunities can, over time, be introduced.

The buildings flanking the civic area can be shop-fronted: a number of these are therapy buildings with activities that are colourful and exciting. These can be extended into the square – which can then be used as a setting for exhibitions and display of artwork, sculpture, music, outside theatre and drama. Seating, lighting, water features, patterned paving, ornamental and formal planting, outside canopies and covered areas can be introduced.

Indoor sports, leisure, meeting and religious activity rooms, shops, dining and snack facilities adjoin, or are planned to front, this civic space which, by their nature and concentration, should make it function and become a positive and lively patients' centre; in townscape terms, make it appear as a natural civic focus for the hospital.

A second strategic aim for the outdoor spaces is to introduce blocks of planting that will help to subdivide the site into a series of specific spaces and give the impression of the wards being sub-grouped around their own neighbourhood area.

This should make them appear more sheltered and protected. Their scale will be smaller and they should look more characterful and individual, with dif-

ferent views and a greater sense of interest.

These planting blocks, or copses, should also help to soften hard building lines and produce a greener and more parkland-like setting, and give an impression of buildings placed between trees, rather than, as now, of trees placed between buildings.

Within this context, the aim will also be to introduce water, as its enlivening yet calming effect in the landscape cannot be overstated. In addition, at Ashworth Hospital, there is a ground-water and land drainage problem which could be eased by introducing a water feature.

Rather than introducing a large expanse of water, which could be difficult to manage, it might be that water is introduced in the form of a linear, winding, canal-like shape, which could then be related to, and used to define, each of the neighbourhood spaces.

This water feature could be attractive to walk along, or sit beside, and provide opportunities for the pathway system to bridge-across – all

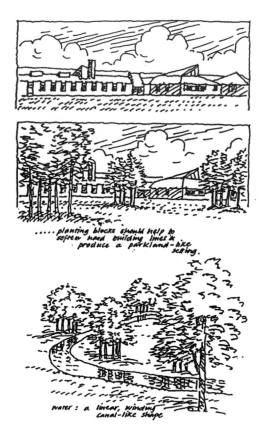

planting blocks should help to soften hard building lines & produce a parkland-like setting.

water : a linear, winding canal-like shape

.... pathway system to bridge across.

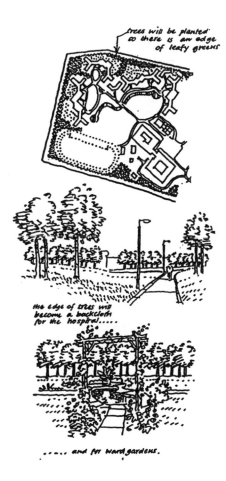

trees will be planted so there is an edge of leafy greens

the edge of trees will become a backcloth for the hospital.....

..... and for ward gardens.

adding further interest and change for the patients within the hospital scene.

There are no pleasant views of the surrounding countryside from the Ashworth North site – as can be the case in many hospitals where the immediate outside environs offer little in the way of prospect or visual interest. Therefore, a third strategic aim for Ashworth is to plan to focus inwards and create internal views from features of interest, and from the planting scheme.

To meet this aim, trees, in the form of a screen, will be planted around the perimeter so that there is a pleasant edge of leafy-greens around the development. This will also give an illusion of spaces continuing beyond the trees.

This edging of trees will become a pleasant outdoor backcloth for the hospital and for ward gardens, provide leafy views of foliage from windows and create a more calming and verdant setting for the patients.

A fourth strategic aim is for the roads and pathways. Many of these run between fairly bland and unexciting buildings. The aim is to plant alongside them to

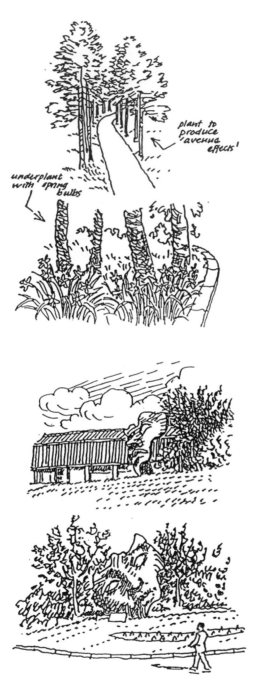

produce 'avenue effects'. Build-
ings are then glimpsed be-
tween foliage and trees and do
not dominate the hospital set-
ting.

In this way, the pathways
will become more interesting
and enjoyable to walk along
and this effect will be accentu-
ated if the avenue trees are va-
rieties selected for their
seasonal effects and, in addi-
tion, are under-planted with
spring- and winter-flowering
bulbs.

Within that context, a fifth
strategic aim will be to create
natural focal points, new vistas
and features of interest at node
points or direction changes in
the pathway system, enliven or
characterise certain areas and
other key points.

Sculptures could have a key
role in achieving this as sculp-
ture is already being success-
fully used at Ashworth
Hospital to create focal points,
vista stops and to add interest.
This feature is described in
Chapter 23 by Ruth Preece.

Sculpture can be used to
give a distinct character to a
particular space and can be in-
troduced where maximum im-
pact, and perhaps drama or a
message or a surprise, is
needed. This may be at a pri-
mary entrance point into a hos-
pital or in some other particular
feature space. The eye-catching
piece in the sketch was placed

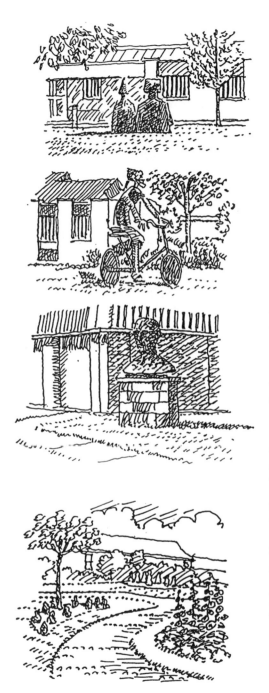

in the internal entrance space to Ashworth North.

Sculpture can be used to bring out, or to add to, the atmosphere of a particular place, and to accentuate the ethos of that space, as, for example in the sketch where the tranquility and repose of a little green square is heightened by the two figures.

Or it can be used in an enlivening way by bringing a comic quality and sense of fun to a lacklustre area alongside a pathway or by giving a sense of place and direction at a rather bland and characterless building corner.

Bringing notes of interest and variety to the outdoor spaces can, of course, be made by the nature and variety of the planting schemes using the colour, flowers, foliage, bark and fragrant effects of selected trees, shrubs and herbaceous plants either in individual, large or small groupings, or in island or ornamental bed arrangements such as conifer, heathers, annuals or rockeries.

Rocks can be placed to enhance their ruggedness and their natural sculptural and tex-

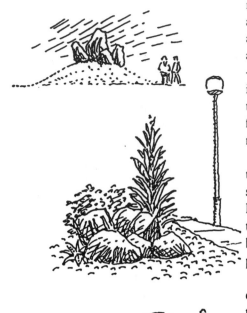

tural qualities. In the same way, the architectural quality of many plants can be used to achieve a sculptural effect. In all cases these affects can be accentuated by night lighting – which is especially important if the views can be seen from the patients' room windows or from other evening-used rooms.

As well as contributing to the environmental setting, sculpture, as an art, can stimulate and interest people, and in this way help to aid recovery by having a positive effect on a patient's well-being.

A sixth strategic aim is that consideration should be given to the quality and character of all outdoor artifacts and a standard vocabulary of parts should be established for items such as: signing, roads, pathways, car-parking, lighting, seating and fencing, as well as for the character and nature of the hard landscaping: surface materials for roads, pathways, pavings, kerbs, edgings, channel blocks, gulley points and housings for services so that there is an order and grammar about these, and an empathy between them, and so that they fit the scale and quality of the outdoor environment that is being sought for the patients.

seating

lighting

bollards

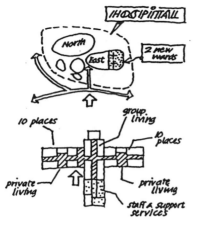

Garden Spaces

The next part of this chapter examines the spaces that are immediately adjacent to a ward and which should, ideally, be treated as areas dedicated to the ward. In this case, the approach taken for two mental illness wards, at Ashworth East, is drawn on as the reference.

The building geometry and corridor planning for these two new wards was largely determined by the constraints of system building. There was a need for a speedy delivery. The time for construction was five months. There was also, a need for a cash-led approach with a building rate of £640 per square metre, which includes the enabling work, professional fees and poor ground conditions.

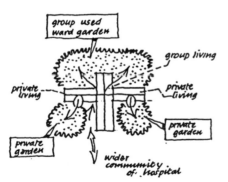

The site is exposed, flat, bleak and fairly featureless. Within these constraints the design aims that have been set for the garden areas are to plan them so that they function as continuums of the indoor spaces and to extend the indoor design concept for the ward – private living and group living – into the outdoor areas so that there will be a perception of private gardens on the one side and a larger ward garden for group use on the other, giving the patients the choice of quiet, private, more intimate spaces on one side or a larger-scale, more active garden on the other side, but taking care to plan both of these as protective outdoor rooms – so as to foster a feeling of privacy and ownership – and to take account of the exposed nature of the site.

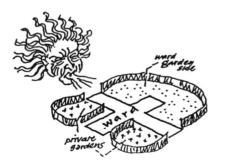

The therapeutic importance of a pleasant view of nature is widely accepted. A further design aim is to ensure that each patient's room has a view, either into a private garden on one side or into the ward garden on the other.

There are long views to the flat surrounding countryside. These are not particularly attractive but are, nevertheless, of some interest.

The aim with the edge planting is to attempt to take account of this by only allowing glimpses through to the surrounding countryside and framing the views with branches and foliage. This should help to heighten the value of the views and make them appear as a series of differing views located around the garden.

A key feature in the approach to the design of the gardens is the introduction of hedging – arranged so that they establish a definite relationship with the buildings and appear as extensions that then help to define and articulate the outdoor spaces. As well as acting as screens, they will also help to soften the long brick walls of the buildings. A variety of hedges with different characteristics are needed and these will be specified as:

- informal or semi-wild hedging
- formal hedging
- privacy hedging
- ornamental or fronting hedging

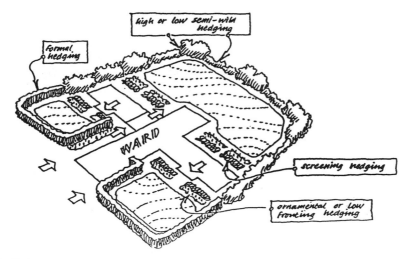

Hedging

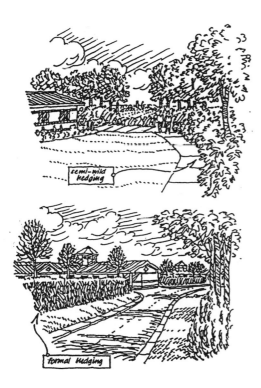

The *semi-wild hedging* will be used as underplanting to the tree groups and the aim is that it should function as a hedgerow in the countryside, which can act as a good habitat for insects, birds and even wildlife. In this instance it will form an appropriate transition between the hospital development and the surrounding countryside and farmland.

The *formal hedging* will appear much as front garden hedging does in older, suburban housing areas producing a leafy screen between the road system and the gardens, reducing the impact of the buildings and bringing a pleasant sense of greenery to the outdoor spaces.

The *privacy hedging* will be planted to obtain physical separation between the gardens and the windows to the patients' rooms and to channel

patients or visitors from walking up to
room windows. These hedges will con-
sist of double rows of a single flowering
shrub species such as hypericum hid-
cote, potentilla, hydrangea, senecio or
other similar plant material.

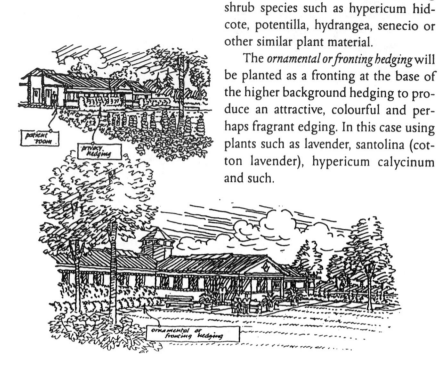

The *ornamental or fronting hedging* will
be planted as a fronting at the base of
the higher background hedging to pro-
duce an attractive, colourful and per-
haps fragrant edging. In this case using
plants such as lavender, santolina (cot-
ton lavender), hypericum calycinum
and such.

The Trees

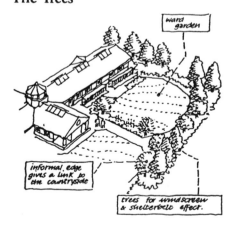

Trees will be used to wind-
screen and act as shelterbelt
planting around the gardens.
These will mainly be: horn-
beam as the dominant tree,
swedish whitebeam as the sec-
ondary and rowan used as a
smaller, daintier counterpoint
tree.

hornbeam whitebeam rowan
(pyramidalis)

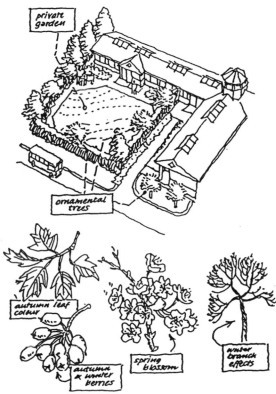

Ornamental trees will also be used but these will mainly be planted on the private, wind-protected garden side. These smaller trees should have a more appropriate scale that will suit the private garden areas. They should also appear more interesting and provide spring blossom, autumn leaf colour, scarlet berries and interesting twig effects in winter, and canopies of green or purple in summer. Ornamental hawthorn and varieties of flowering crab-apple and prunus are the types of tree that will be used.

There will also be space left for specimen and accent trees but these will be planted later and selected in conjunction with the patients, staff and visitors.

The Gardens

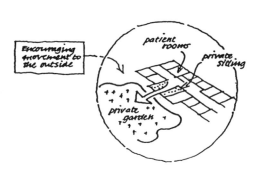

A key aim for the private gardens is that these will be planned as spatial extensions to the patients' sitting areas and arranged as quiet, private outdoor spaces that appear to belong to each patient group.

They will contain seating and paved areas for relaxing, looking, reading or strolling and, within the framework provided, the patients will be able to develop a range of more personal gardening and planting themes.

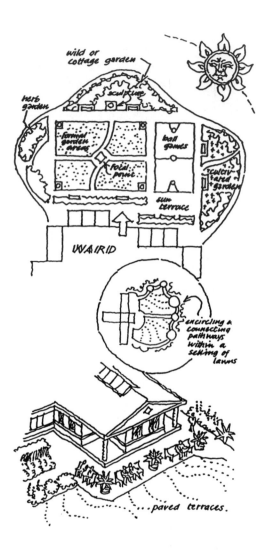

The main ward garden will need to meet a varied range of needs and be larger in scale than the private gardens. It will still be used as a place to sit, sun-bathe, relax and allow the patients to feel close to nature but it should also allow the patient to socialise, take exercise, participate in games and other more lively activities.

Sunny terraces, protected outside sitting areas, a pleasant space for the garden, interesting views, paved pathways and space for ball-games are some of the many features that can be considered but which will largely depend upon the therapeutic and care needs of the patients.

For the Ashworth East wards, where the patients are long-stay, the intention is to provide a framework with some key features within which, and over time, various themes can be introduced.

The initial provision will comprise: paved terraces with a number of different sitting areas and a series of encircling and connecting pathways placed within a setting of lawns, hedges, trees and ornamental plants – leaving scope for a selection of specimen trees and shrubs, developing beds of

... *variety of sitting areas*

herbaceous annuals and perennials and planting areas of spring bulbs, or for cultivating herbs and vegetables to suit the garden aspirations of the patients.

Pleasant sitting areas are a key feature of a communal garden and a range of these will be planned: some close to the ward group living areas and others within different locations of the garden. These will be designed to have an individual quality and character.

Key Outdoor Spaces

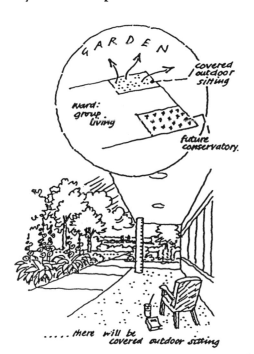

...... *there will be covered outdoor sitting*

As well as outdoor sitting areas there will be covered outdoor sitting areas that will extend from the group living spaces. In poor weather the patients will still have the facility of being able to be close to the garden and enjoy the freshness of nature and feelings of the outside.

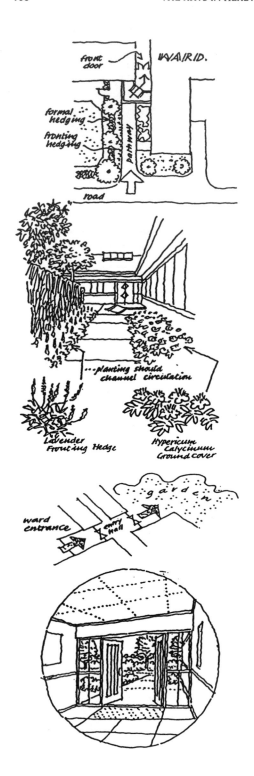

Another key outdoor space is the immediate approach to a ward. Here planting should be made a main feature and should be designed to make the approach to a ward attractive and pleasant.

The planting should also help to channel the circulation in the direction of the entrance or front door, without there being any sense of uncertainty or loss of direction.

First impressions, which are important, are often signalled by the appearance of the entrance area to a building. In this respect, sensitive planting and screening should give a positive focus and project a sense of clarity and purposefulness about the building, and about the organisation who are responsible for running it.

It was also considered important that there should be an awareness and appreciation of the pleasant garden lying outside and that this should register immediately on stepping into the entrance area of the ward.

The entrance hall has been planned so that it appears to continue through the building and into the garden beyond.

Included within the planting strategy are plants that will attract and support

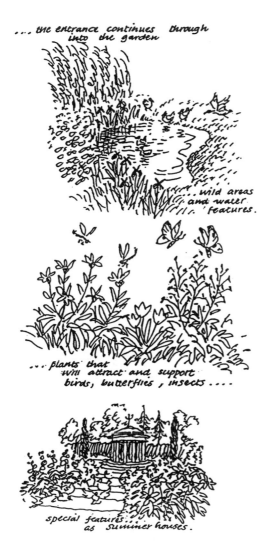

... the entrance continues through into the garden

.... wild areas and water features.

... plants that will attract and support birds, butterflies, insects

special features... as summer houses.

birds, butterflies, insects and also, perhaps, wildlife. Space has been included to allow this important theme to be extended, in a participatory way, by the patients, staff and visitors. Plants such as buddleias and sedums can be introduced as well as developing spaces for wild areas, water areas and outdoor arrangements for pets (pet therapy).

In the same way, colour and scent (aroma therapy) and touch have been addressed within the planting framework using lavender, rugosa roses and santolina, but again leaving scope for these themes to be built on. There is space available for the introduction of specimen trees and shrubs or feature planting such as knot gardens, rock gardens, pergolas, trellis work and summer houses.

Conclusion

The aim of this chapter has been to attempt to create a greater awareness, and to stress the importance, of the outside spaces between buildings and their role in helping to create a sustaining and comforting environment for the patients. And of emphasising the need to make all the outside spaces within a hospital work in some positive and purposeful way, as well as looking cared-for and pleasant. And of the importance of using landscaping as a planning tool to make the buildings and outside spaces relate and work together as a positive continuum of inside and outside space.

To end on a more practical note, health care buildings should, perhaps, be designed and constructed more as simple, homely and direct forms. A greater proportion of the capital funds allocated to them should be channelled into the design and planting of the outdoor spaces. Instead of just designing and concentrating on a building, the aim should be to create a place.

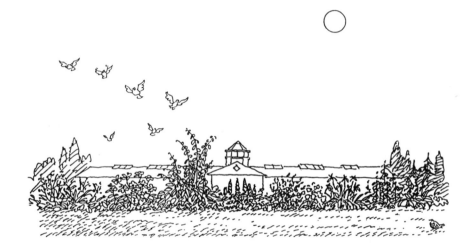

Part IV

The Community

In the tendrils of their care
I leaf and learn again.

Cicely Herbert, *Nurses*

Healing Arts
Isle of Wight – Arts for the Hospital and the Community

Guy Eades

Origins and Organisation

'Healing Arts: Isle of Wight' was established in 1985 by the Isle of Wight Health Authority, as part of its Charitable Trust, to develop a programme for the full range of National Health Services on the Island.

An important policy decision was taken from the outset in that both the 'acute' services and the 'community' health services should form the basis for the development work of Healing Arts. Consequently, Healing Arts now provides one of the most comprehensive arts in health care programmes of any district in the United Kingdom. That policy decision was made in the light of the knowledge that 'acute' services receive the higher public profile, and this would be dramatically further emphasised with the commissioning of the new St Mary's Hospital at Newport, whilst the 'community' services, which attract far less public attention, are continuously in just as much need and, through the specialist attention of the arts, can respond to individuals' health needs equally, if not more effectively.

The project remains part of the Charitable Trust but has moved from the purchaser to the provider sector and is contracted to provide its arts services in equal measure to 'St Mary's NHS Trust' and the 'Isle of Wight Community Health care NHS Trust'. Healing Arts, for purposes of day to day administration and management, is integrated into the Directorate of Estate and Property Services at St Mary's NHS Trust with full office and secretarial support. Accounts and payments are serviced by the St Mary's Finance Department and Healing Arts takes full advantage of the Trust's corporate services.

The Healing Arts project, however, continues to be managed by a committee whose membership is comprised of representatives of all interested parties at a

senior management level. The two NHS Trusts are each represented by their
Chief Executives and a Non-Executive Director; the Health Commission by
their Chair and a Non-Executive Director. Additional members are drawn from
the Charitable Trust, NHS Trade Unions, Community Health Council, Southern
Arts Board and Isle of Wight arts representatives. This broad-based management
structure at senior level ensures that Healing Arts is properly integrated into the
management structure of the NHS on the Isle of Wight, has well established
lines of communication with all parties for whom it is providing services and
that the Island's community has the opportunity to shape and direct its
programme.

An Integrated Approach

The commissioning of the arts at St Mary's Hospital is now well documented,
not least in Chapters 9 and 10 by Stephen Nicoll and Richard Burton. There
are two essential points to bear in mind:

First, the commissioning programme was conceived from the outset of the
designing of the hospital – thus ensuring that the arts are now part of everyday
health care at St Mary's. This planned provision at the design stage ensures that
the building has an integrated interior design scheme of floor patterns, curtain
design, decorative paintwork finishes and views from windows to gardens and
landscapes. It also ensures that the spaces for commissioning artworks (whether
in specific wards or departments or the public spaces of entrance foyers, waiting
rooms and restaurant) have been conceived from the outset as visually important
parts of the building design. They are free from all the other necessary building
features (e.g. fire alarms, light switches, radiators, etc.). This is important because
no project is ever going to be sufficiently well resourced to be able to deliver
its full commissioning programme at the opening of a building. Realistically,
this can only be achieved over years so these spaces need to be identified at the
outset – especially as subsequent alterations to services and fixtures add so much
more to the commissioning costs. Artworks on loan can be temporarily
displayed in some of these sites until the purpose-designed artwork can be
afforded and commissioned.

Second, Healing Arts has never tried to turn the hospital into an art gallery.
The purpose has been to contribute to the healing, cure and care of its patients
and clients. It believes the arts have a contribution to make in this process, which
many people find special, and are able to produce results which are not
achievable through other means. This is a perception shared by many artists –
both professional and amateur – and Healing Arts seeks to make these
connections between artists, health care professionals and the community, of
which the NHS is both composed and serves.

The consequence of this approach is that Healing Arts always seeks to
provide the artist – professional or from the local community – who is most

qualified to run a project to the highest levels of quality and appropriateness. The project must be available and accessible to any member of the community who wishes to participate. This means involving and addressing the needs and interests of persons for whom the arts are not necessarily a regular activity.

Examples

I wish to mention two projects which we currently support. The first is a continuing programme of working with the many persons in the Island's community who have an interest in embroidery and making textile works for public display. The second is the programme run since 1988 of a Writer-in-Residency working with those receiving long-term care in the community.

The embroidery projects have as their aim a work for public display appropriate to a particular space in a department. Usually the project is structured with two essential conditions. First, the project is led by an experienced professional textile artist or textile group and second, that the making of the work should involve a broad cross-section of people who may have special health care needs. The first condition ensures that someone with both the organisational experience and artistic and creative skills is leading the work. Any artwork, or arts activity, which is commissioned for public display should demonstrate a sense of good design, craft and creativity. It must be able to engage the viewer constructively. The viewer may not personally express a liking for the work but should appreciate its appropriateness for its setting. The second condition, of involving members of the community in the process of making the work, is to meet the essential premise that the arts in the NHS are actively part of the healing process and to give members of the community the opportunity to participate, shape and belong to the creative event. The results are of value to the individual, the department to whom the work belongs and the long-term relationship between the health care organisation and the community who form its 'customers'. We have tried to ensure that each of these embroidery projects are accessible to a wide range of abilities and persons who have special needs.

As a result, a work is designed in such a way that persons with physical disabilities resulting from a stroke, persons with learning difficulties or persons in long-term elderly care, together with sixth form high school students and members of the Women's Institute and Embroiderers Guild can all work together on a project. The sense of achievement and pride in the completed work is very substantial. Visitors to the Isle of Wight can see examples of projects of this nature at both St Mary's and the Frank James Hospitals, East Cowes.

The second example of the 'community' arts in health care project – our Writer-in-Residence programme – is structured differently and has a different intention. The emphasis is directed towards the individual to encourage their

own personal creativity and identity during the period when they are receiving health care and to enable them to use this experience as a valuable skill in their future working career or personal context. The creative writing programme is designed to create better understanding between health professional and client and develop new lines of communication and understanding. The programme has been designed for mental health, learning difficulties programmes and the elderly. This programme is described in depth in Chapter 18 by the writer and poet Fiona Sampson.

Conclusion

This informal, yet professional, approach is at the heart of the value of the arts and creativity in health care. Its approach is to the individual in the context of his or her relationship with the wider community. The programme celebrates the unique and the difficult and allows the opportunity for the voicing of the several points of view which the situation creates. The arts respond to the challenges that arise out of illness, ill health and disability. They are not a panacea but their use in health care is an indication of the ability of our communities to respond with vigour and understanding of the challenges of ill health.

In conclusion then, the arts can be directed towards building relationships between communities and the hospitals which serve them. At their best they shape the structure of our hospitals as social buildings and establish patterns of communication between patients, staff, managers and public which contribute substantially to the creation of a humane and considerate public service. Equally, the arts working in the community, that is outside hospital buildings, enable individuals receiving health care to express and develop methods of communication which are of immense personal value and creativeness but also at times ask the health delivery organisation to be self-critical.

Arts in health care is developing a role for the arts in a social context. There are many common features that link this to arts in education, arts in the probation service and arts in prisons. The health care perspective which has developed in the United Kingdom over the last twenty years has significantly extended the range of interaction between the arts and the general public, mostly for the better. However, the arts are not just in health care to soften the challenges but also to create new responses and understanding about some of the most difficult issues and events people face in their lives. As science and technology develop more complex systems and treatments for our benefit, and organisations re-structure to respond, the responsibility falls to the arts to express the responses of the individual to these new circumstances.

The arts working in partnership with the community of individuals are increasingly understood not just to be a patrician, intelligent, wise and civilising initiative in health care. They are proving to be one of the most effective means

whereby the community enters in, and actively contributes to, the shape and social challenges of new health care services, buildings and health care organisations. The Department of Health needs to consider new methods of achieving its targets set out in its document *Health of the Nation 1994*. Targets to reduce heart disease, improve nutrition, reduce suicide and limit use of drugs and cigarettes are not being achieved by the conventional means. The arts have an excellent record of addressing issues of compassion, poverty and world charity. The Department of Health should consider greater partnership with Regional Arts Boards, Public Health Departments, and arts organisations in the community as to how some of these issues may satisfactorily be addressed, for the arts in the age of NHS Trust and 'Care in the Community' are only now being properly understood as effective partners.

Independent Arts

Meryel Boyd

Background

Gloomy, dispirited, face to the wall, feelings of worthlessness and what's life for? Sheer boredom, lack of achievement, atrophy of mind and spirit, the little square screen?

All these feelings, and more, maybe unspoken and unrecognised, can be the lot of those residing in institutions and residential homes; prison as much as actual prisons for those incapacitated by disablement or the infirmities of old age. It is recognised that those who have suffered disabling cerebral incidents, such as strokes or accidental brain damage, can be helped to rehabilitate themselves – not only through conventional physiotherapy but also through the application of the arts, music, painting and drama.

On the Isle of Wight a few years ago, the need for such services was identified and an organisation was started to take the arts into residential homes, day hospitals and even into the three Island prisons. These needs were met by the provision of sessions of therapeutic arts: music, art, reminiscence therapy, creative movement and drama. Thus Independent Arts was born. It is an Isle of Wight registered charity whose work is solely Island based. At first, activities were on a purely voluntary basis organised from the home of the Project Director. As people became aware of the services being provided, with early recognition from the Health Authority, Independent Arts expanded into a disused ward of a local hospital. The lease for this expired in January 1992 and a year of great change commenced with temporary accommodation being followed by a move to our new resource centre, the Studio. This is a renovated Portacabin, with a special custom-built ramp leading to the Art studio and administrative offices. The former is used for art sessions for different groups and individuals, some of whom arrive in their wheelchairs carried in specially adapted buses. The more mobile may be brought in by volunteers from the local Rotary Clubs.

Finance and Administration

Funding was desperately needed and, after much struggling, grants were obtained from the Isle of Wight County Council and the Consortium on Opportunities for Volunteers which, together, helped fund full-time direction for three years and art, music and reminiscence managers were appointed. It was found that the therapeutic sessions could not be efficiently provided totally free and clients were asked to pay part of the costs. Apart from salaries for the permanent members of staff, volunteers required assistance with travelling expenses, art materials had to be paid for and musical instruments obtained. Reminiscence therapy was enhanced with slide shows, taped music and even videos. Drama required some stage properties and costumes, although improvisation is part of the scene!

As the organisation, registered as a charity in 1987, expanded the scope of its activities, finances had to be organised on a businesslike basis. The major source of present income, now 60 per cent of turnover, is from fees charged to clients. The true cost of the provision of such services would be beyond the resources of the clients. In particular, the residential homes for the elderly have had to face a cut in their funding from the social services. The shortfall of required income has been met by grants from local authorities, health authority funding jointly with the social services department, and the Rural Development Council. These have been granted on a three-year basis hitherto, but none is permanent and all have to be applied for and renegotiated at regular intervals.

Independent Arts has also been fortunate in receiving grants from national grant-making bodies for specific projects, amongst which were the provision of the new Studio, from the Rural Development Council, Platinum Trust and Health Authority. Charity Projects gave a grant over three years to provide necessary equipment for the Studio and funds for marketing and organisation of our services.

To meet the needs of these disparate clients, who have a sense of helplessness, disorientation, and isolation as common factors, Independent Arts provides a range of services, usually under the direction of an artist with expertise in the field required. A music session might consist of a keyboard player accompanying a singer who moves amongst the audience encouraging each one to join in a form of 'sing-along'. Other musicians – a guitarist, a one-man-band – will perform to an audience who clap in time or join in with simple timpani. This kind of participation is geared to the age and ability of the clients. Older people will enjoy singing songs of their youth and will quite often remember whole verses or sing aided with songsheets. Those with learning disabilities prefer to join in with rhythm and noise and learn simple refrains.

Activities with a participatory element are of the greatest benefit to clients. We hope to encourage latent or obsolescent abilities and give the client the feeling that he or she can, after all, still do things and has his or her own personality – which is so often submerged in communal living.

The two administrators operate day-to-day running of the charity on a part-time basis, complementing each other's sphere of operation. One manages the programming of involved schedules of artistic sessions, engagement of artistes, contracts and financial planning; the second spends more time fund-raising and organising fund-raising volunteers, grant applications, and overseeing the press and public relations field. The work areas of both these administrators overlap considerably and they can assume each other's role where necessary.

Helping these two administrators are a variety of volunteers and assistants (including a part-time paid bookkeeper who has another role as a volunteer singer and art assistant). Different volunteers and trainees tend to come and go on the administrative side as new government work/training programmes are set up and discontinued. Volunteers are of fundamental importance to the work of Independent Arts and, in return, Independent Arts can provide an excellent opportunity for volunteering, both for those in the community who want to do something to help others and for those who want to gain experience and move on into paid employment. Their work is subject to overall control by the Council of Management (the Trustees) – a group of six individuals recruited both from the retired and those who are still active in business or the professions.

Equal Opportunities

Independent Arts was set up to benefit the disabled and older people. It attaches great importance to implementing an Equal Opportunities Policy to obviate the danger that it could appear, to some degree, patronising – which it most definitely is not. A third of the Council of management are of retirement age and half of the Fund-raising Committee are over fifty years of age. One of the volunteers, an excellent keyboard player, was, until recently, at a school for people with learning difficulties.

Clients

The last two years have not only seen a change of location and viability but also an explosive expansion of our services – leaping from approximately 70 sessions per month to 150. This may in part be accounted for by expansion of the number of residential homes, but certain requirements of the social services have also played a part.

By far the largest group of clients are the occupants of residential homes for the elderly, both those run by the social services and those in the private sector. With 26 per cent of the Island's population over retirement age, the proportion of people requiring residential care seems ever expanding. Frequently a move from home into a residential dwelling with several or many occupants, all strangers, disorients and depresses an older person. They are left feeling

redundant and 'on the scrap heap', with nothing to do and, perhaps, without the health or strength to initiate anything themselves.

Independent Arts also provides services to the Trusts through Healing Arts – whose work is described elsewhere in this book. Arts sessions are held in the local rehabilitation unit for those who have suffered from strokes, musical sessions are held at a day centre for those with learning difficulties and so forth.

Activities

Another area of interest is in the three prisons on the Island, which range from very high security down to a rehabilitation type of unit with farm and outside prisoner activities on the programme. The prison education services have co-operated with Independent Arts over the years, with one or two spectacular examples such as the Parkhurst Mural which local schoolchildren painted together with prisoners under the direction of Independent Arts art director, Adrian de la Roche. In 1990 there was a prison poetry competition, judged by Ted Hughes the Poet Laureate, which was promulgated in conjunction with the Island-wide Tennyson Festival. Although not all initiatives prove to be viable, there are regular meetings between the three prisons, Independent Arts and the local Quay Arts Centre in which arts ideas for the prisons are explored.

Creative movement follows on from this, with its use of music used to promote physical activity for those with little mobility. This is specifically geared to the abilities of each individual group and is not just a keep fit class. A group of younger people come from the local Cheshire Home to our Studio for this. For them it is not just the exercise which is beneficial, the outing in itself is stimulating and interesting. The drive in their specially adapted minibus is about seven miles and can take them either over the high downland or through a town with lots to look at.

Art helps develop co-ordination of eye, hand and brain and is of great benefit to those who have suffered strokes, have cerebral palsy or who have partial paralysis and spasticity; it brings out latent talent amongst older people. Not everyone can be a Michael Angelo or a Van Gogh, but some of our best results have been achieved by a deaf and dumb 40-year-old man who had suffered meningitis at the age of two, a man who has suffered a stroke – initially coming to our art sessions in a wheel chair and now, thankfully, walking and by old ladies and gentlemen who have never before painted and now produce 'winning' paintings in our art competitions.

Reminiscence therapy has proved extremely popular in the residential homes for the elderly. It is designed to stimulate the memory by showing pictures, slides and artifacts of days gone by, or by playing music of the period of the clients' youth. One of our projects co-ordinated groups of schoolchildren with residents of their local homes. The children asked questions about the second World War and recorded and re-enacted the anecdotes heard. This not only

delighted the elderly people but was counted as a project for examination purposes for the schoolchildren. One of Independent Arts' aims is to encourage participation between groups of different ages and abilities in the community.

Drama has been the subject of workshops integrating groups from local High Schools and a school for those with learning difficulties. Recently the schools have taken over the organisation of such sessions for themselves. For two summers Independent Arts produced historical playlets for the British Trust for Conservation Volunteers during their environmental weeks. These were directed by Independent Arts and written and acted by volunteers. Local school groups attending the occasion were involved in the crowd scenes. Recent drama proposals include groups of older people setting up their own activities in their village centres. Here Independent Arts hopes to act as a catalyst rather than total organiser.

Fund-Raising

Some volunteers form the Fund-raising Committee, whose chairman is on the Council of Management. Their function is to top up the annual income of approximately £52,000, aiming to contribute four to five thousand pounds per annum. This is achieved through the customary activities such as gala concerts, curry lunches and charity balls, which are all great social occasions. In addition, a charity shop is held twice a year selling second-hand goods. Volunteers attend craft fairs and bazaars selling items made from our clients' art work. The art clients regularly enter our competitions for such subjects as christmas cards, Island views, still lifes, etc. The winning entries are printed as greetings cards and sold to make a profit for Independent Arts. Mounted prints of many of our paintings and drawings are also sold at such events.

Sales of art products do not raise large sums of money but add to a wide-ranging PR scheme. The volunteers selling goods always talk about the way in which the products came into being, by whom and so forth. Some volunteers have come forward as a result of the beneficial effect our services had on themselves or their spouses. One of our clients, once in a wheelchair, is now not only a successful artist but also a willing volunteer. He is happy to assist at the charity shop or man our annual art exhibition.

'Community Road Show', our annual art exhibition, tours to four or five centres on the Isle of Wight giving the less mobile population on the Island more chance of seeing their own or others' work. In 1994 we were fortunate to receive sponsorship for this from Readers' Digest. Although some of the paintings are for sale, plus the usual greetings cards and prints, the main purpose of this exhibition is twofold: to encourage our clients and raise their self-esteem, and to promulgate the activities of Independent Arts and gain publicity in the local media.

Since our fund-raising is dependent on sponsorship of different kinds – from the Rural Development Council and national companies such as Readers' Digest down to very small local businesses such as Brighstone Landscape Design – we seize every opportunity of making the news and gaining deserved publicity for our sponsors. Generally we try to raise our public profile through news items and editorials.

An additional aspect of PR is giving talks about our work to groups such as the WI, Townswomen's Guilds and Rotary Clubs. No charge is made for these talks but there is often considerable subsequent support given to us. This ranges from practical help such as Rotary members driving our disabled clients to classes through to outright donations, either from individuals or from groups making Independent Arts their 'Charity of the Year'.

These unsolicited gifts from different groups in the community encourage Independent Arts not only to carry on with existing work but to strive to improve it and extend it to other less advantaged people. There is a wide body of less well off older people and disabled in local villages who cannot reach centres, through lack of mobility and suitable transport or finance. To remedy this and improve their quality of life we have commenced a pilot project in local village centres this year. This is supported by an anonymous donor Trust and the County Council. These subsidised art classes for the elderly and disabled started in one village reading room, followed by two more village halls. Subsequently, two local day centres, and one Lions' Club approached us to start similar arrangements on their premises. It is hoped to follow on with other types of activities and, if possible, to enrol volunteers as assistants, if not organisers.

Looking Forward

We already have several new projects in the pipeline: one a giant collage involving schoolchildren and older people in the same localities; another a sculpture project with workshops in the prisons and local art centres in conjunction with our Community Road Show. To assist with this project we are seeking the involvement of a team of international volunteers recruited through Quaker International Social Projects.

Ideas and opportunities are endless. Our work has been recognised as socially beneficial by the making of grants from all sorts of local organisations, councils and individuals. As long as this kind of support and encouragement continues, and the need for such life-enhancing artistic activities is recognised and demanded, then organisations such as Independent Arts will be part of a healthy community life.

Celebratory Arts
The Arts in Primary Health Care

Tony Blee

Celebratory Arts for Primary Health Care is an enterprise run by Alison Jones and John Angus from a base in Lancaster. John originally designed and printed posters for theatre companies and Alison was a stage designer for theatres and had worked with the physically and mentally handicapped in long-stay hospitals in Devon.

They describe Celebratory Arts as follows:

> An association of artists who work in alliance with health practitioners, schools and members of the community to promote positive health.

> We produce artworks and work with communities to organise participatory events about good health. Projects are designed for particular places but the work produced has a wider potential. Our posters and cards are in demand nation-wide.

> Projects start small, but once a relationship is established, it is maintained and develops in a number of different ways over time.

> A finished piece of work is only one part of a complex shared process aimed at making people and communities aware of health as an integral part of their personal lives and that of the community.

> It is this process that forms the essence of our approach. Describing ourselves as artists can be misleading. We use creative arts as an aid to understanding and a means of communication.

> Our use of the arts comes from direct personal experience – the need in our lives to mark moments, express feelings and celebrate. It is this we bring to our work. The key is the quality of communication – the warmth, the humour, the understanding and, perhaps most importantly, the recognition of chatting and informal conversation in an

unthreatening environment as a primary means of raising awareness on health issues.

The fact that artworks are produced that are seen in public places nation-wide further enhances the process by generating a sense of ownership and pride in the product and its message.

They called it 'Celebratory Arts' because Alison soon found that the most rewarding part of her work as a visual artist involved creating relevant community celebrations with local people. Following her own experience after the birth of her first child, she realised that 'the Health Centre should be a centre of caring in the community where an individual's or family's needs can be attended to with dignity and respect'. It could not just be left to Health Centre staff – everyone must be encouraged to participate in it.

The best way to describe their work is to describe some of their main projects.

Brierley Hill

In 1987 Alison met a doctor in Brierley Hill, Malcolm Rigler, who was looking for an artist to help him look at ways of sharing responsibility for health and health promotion. The project involved a short residency, setting up a craft-based workshop and looking at future possibilities for the surgery and its locality. Activities included making cards to celebrate the births of new babies. (This is still continuing.) The products look really good and were essentially simple to make; decorating the surgery with bunting for celebrations and marking moments, for example weddings and christenings. These are the big things in people's lives and it is easy to let them go by. Celebrating them expresses feelings and helps the development of mental health in individuals and the community; and establishing a story-telling evening and using this to develop health promotion.

The project demonstrated that using the arts in this way could improve the quality of the environment and provide an innovative approach to health promotion and teaching aids.

Handsworth

A year later they started another project in a Health Centre at Handsworth, Birmingham, with Dr Laurie Pike. They took the very typically institutional waiting room, with its staff sheltered from the public behind screens, and opened it out. They changed the seating arrangements and covered the notice boards in coloured fabric. The staff were drawn into the project and, with one member of staff helping to paint a decorative lampshade with the word 'welcome' on it, got people talking to each other about their different cultures.

A Breath of Fresh Air

This previous work led to a bigger, longer-term project connecting Withymoor Surgery, Brierley Hill Health Centre, a secondary school and professional artists and musicians.

They talked to the Locality Manager at the health centre who suggested taking the subject of cancer prevention and smoking to the school where the children had 'done' smoking and were not interested. They were, however, interested in the environment and in clean air. They decided to set up a project on the lungs. For a whole term the school worked on its own. One of the products was a very powerful relief sculpture by fourteen-year-olds of what they thought health was about – a scene of doctors cutting up a body with blood everywhere! Then the artists went in and started their own work. One exercise was to look for objects equivalent to lungs that could be used in the artwork. Some were incorporated in a design for a mobile. Sponges, trees and kippers were examples.

They spent five days in the health centre. They installed the mobile in the waiting room and put up an exhibition of children's work from the secondary school.

Simple things like a sign saying 'look' resulted in people getting up from their seats and looking at the artworks. They produced a box with the slogan 'What's in a chest?' on the front of it. When you opened the box, you saw images of clean, healthy lungs and of lungs clogged up and polluted as if through smoking.

Finally, they organised the lantern procession to bring the community together and celebrate its health. The candle-lit lanterns have proved extremely popular everywhere and are easily made by covering a willow framework with tissue paper.

Diabetes

Another project was with a diabetes specialist nurse. They produced three boxes in cubes, seven inches square, showing the process and stress of coming to terms with diabetes.

Warrington

Another project was carried out in Warrington with the local Health Promotion Unit and Arts Development Officer. This involved working in a school to produce a leaflet about the heart. The children produced images and words by working with a writer and a visual artist. At the end of the week there was a big celebration and display of their work. One of the things produced was a heart-shaped display of fruit which could then be eaten. Some of the children hadn't tasted cherries before.

Open Your Heart

Mike White, the Arts Officer for Gateshead since 1989, inspired the next project which started in 1991. The King's Fund had made a grant for a project working with older people to improve their quality of life. The Family Health Services Authority was keen to do something on coronary heart disease.

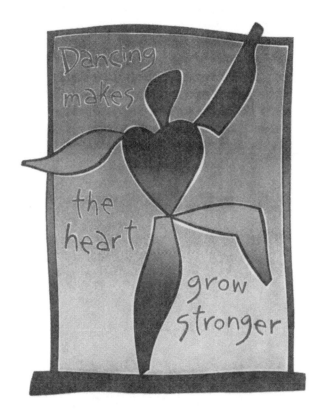

Figure 14.1. Dancing makes the heart grow stronger

A training day was set up with a workshop for about twenty people including doctors, nurses, nurse managers, teachers and representatives of old people's organisations. They made a sculpture of a heart out of fresh fruit which became the centrepiece of a display – and was reproduced on a postcard (see colour illustration).

They took older people into the school to work with the children. One of the men involved was a retired carpenter. He was inspired to produce a box in the shape of a row of terrace houses ('Home is where the Heart is') with heart-shaped openings displaying a healthy side containing attractive objects

together with fruit and bread and an unhealthy side containing unpleasant and broken objects.

The project was another success, with the whole community becoming involved. They celebrated with another lantern procession and children and parents made bread in a temporary kiln that a local baker set up for them.

The children produced images, heart boxes/houses, poem machines and a multiple-author poem in an Elizabethan form which echoed the beating of the four chambers of the heart. All the works created were exhibited in the local Health Centre, some remaining there permanently.

The work continued in 1994 with a project called 'Cold Hands, Warm Hearts', which again culminated in a lantern procession and firework display. This project took place in a particularly deprived area where Celebratory Arts were working with the Health Promotion Unit and achieved results not previously thought possible. Many agencies have been brought together including schools, the police and the library as well as the local authority and the health authority.

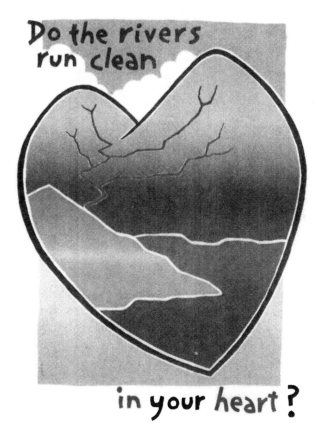

Figure 14.2. Do the rivers run clean in your heart?

Celebratory Arts is of major and unique importance for two reasons:

- it shows how art can motivate and interest in health (not just curing sickness but positive health)
- it concerns itself with the whole community and starts to answer the question 'What is a healthy community?'

> The creative arts should move to centre stage in all our health promotion initiatives, and the common sense of the people should count for just as much as the expertise of the experts. Teachers, artists and others in the community must get involved in the process if we are to have a healthier society. (Malcolm Rigler, General Practitioner, Brierley Hill)

(Posters and cards are for sale. Further details from: Celebratory Arts for Primary Health Care, 32/34 Main Street, High Bentham, Lancaster LA2 7HN. Tel: 015242 62672.)

Part V

Experience from Abroad

God and the doctor we alike adore
But only when in danger, not before;
The danger o'er, both are alike requited,
God is forgotten and the Doctor slighted.

John Owen, *Epigrams*

Creative Arts Opportunities for Hospitals
The UCLA Experiment

Devra M Breslow

Art That Heals (ATH) developed five programmes at the University of California at Los Angeles Medical Centre/Cancer Centre which used arts interventions to reduce stress and facilitate coping with hospitalisation. These experiences were very well received by patients and nursing staff especially. Educational modules were developed so that others may learn from these programme models.

Background

Art That Heals, a programme within the non-profit UCLA Jonsson Comprehensive Cancer Centre, evolved from a fourteen-month demonstration project into a multifaceted programme serving nearly all patients in the UCLA Medical Centre. Art That Heals evolved by testing one concept after another, evaluating patient and staff response, searching for essential funds and institutionalising the concept where possible. In one sense, Art That Heals challenged the traditional academic medical centre managers to humanise the environment, to capitalise on patients' sensitivities and to do so at minimal cost.

The five programmes aimed at uplifting the emotional states of hospitalised and ambulatory patients at the Jonsson Cancer Centre and UCLA Medical Centre, major teaching and research institutions. These programmes were: Art-as-Therapy, Strolling Musicians, The UCLA Art Cart, Changing Exhibitions by Artists with Cancer and Confronting Cancer Through Art 1987 (the first national exhibition by artists with cancer). The setting for this activity was the UCLA Medical Centre, which then operated over 600 acute care beds, and the Jonsson Cancer Centre, which operated two out-patient clinics.

Serendipity was the mother of Art That Heals. In the fall of 1981, a group from UCLA Extension was introduced by the author, a long-time JCCC administrator, to two Cancer Centre clinical units. When a request for proposal was issued by the mental health-focused Robert Ellis Simon Foundation (Beverly Hills, CA), the group coalesced and submitted a proposal to examine the impact of visual art therapy on UCLA cancer patients. A successful $50,000 grant to explore Creative Approaches to Coping with Cancer launched Art that Heals.

During the demonstration project, ATH's director discovered several other American hospital arts programmes. She also conducted a thorough literature search for models: evaluated arts inventions in acute care hospital settings and clinical trials using one or more arts interventions. This search produced no models of either type.

The conceptual principles which legitimised Art That Heals programmes were: to restore a sense of *self control* by the patient/participant, to *reduce stress*, to facilitate coping, and to tap into *life-affirming* inner sensitivities.

The institutional rationales for these programmes were: to bring spiritually uplifting activity from outside into the highly technological hospital setting and to reinforce the humanistic qualities of the institution. ATH programmes involved both health professionals (art therapists, their clinical supervisors and an arts/health administrator) and trained volunteers (as musicians, art cart workers, artists with cancer).

While there are a growing number of hospital-based arts programmes, chiefly in American and British teaching hospitals, *few concentrate on dynamic, one-on-one interventions.* Art That Heals, from the beginning, developed dynamic interventions in which the patient controls the experience, its duration and content, as a genuine form of empowerment. Skills acquired through these interventions serve patients well in other contexts both in and outside of the hospital. Most American hospital arts programmes focus on group experiences: changing exhibitions, performances for ambulatory patients or building an institutional art collection, all of which enhance an institution's physical environment and reputation in an increasingly competitive climate.

Budget

ATH functioned as a non-profit endeavour staffed by a part-paid administrator, part-time art therapists and a host of volunteers. Core support of about $25,000 a year came from the Jonsson Cancer Centre where the programme director was based. The Simon grant and recurrent philanthropy supported Art-as-Therapy. Without essential funding from the UCLA Medical Centre, whose patients and staff were the primary beneficiaries of ATH's programmes, the potential was never fully realised. Patients were never charged for any ATH service.

Art-as-Therapy

Aided by the $50,000 grant from the Robert Ellis Simon Foundation (Los Angeles), a fourteen-month project demonstrated that traditional art therapy was useful with hospitalised cancer patients. The principal findings were that:

- Art therapists must be given an intensive mini-course in cancer, both its manifestations and psychosocial implications, prior to working with patients. (This was satisfied subsequently by a course offered by the Cancer Control Division at JCCC/UCLA).

- Art therapists must participate in regular psychosocial rounds on the unit where each functions.

- Simple, non-threatening materials should be used, taking little time to set up and remove.

- Group debriefing of the therapists by a skilled psychologically-based professional (psychiatrist, psychologist) is essential to deal with problem issues raised by patients and therapists' own reaction to the patient encounters.

- Periodic evaluation is desirable. It will enhance programme acceptance and integration into routine oncology care.

- Art therapy among a group of waiting out-patients has a totally different context and produces less intense results than work with in-patients.

- Oncologists who include meditation and individual and group support in their treatments will welcome art therapy. Therapeutic encounters are also helpful to family and friend care-givers. Therapists should devise ways to help them.

In 1983, the successor concept Art-as-Therapy was launched. Masters level art therapists, grounded in mental health principles and intervention techniques, were recruited and exposed to a 64 hour course in the psychosocial aspects of Cancer. Each then selected an oncology setting to work in: the bone marrow transplant unit, medical-surgical oncology unit, leukaemia-lymphoma unit or gynaecologic oncology service. In a typical working day each therapist would engage from four to seven patients in a one-on-one experience. For five years, funds from The Roth Family Foundation and donations managed by Mr Norman Cousins enabled the therapists to work at UCLA one day a week. From 1983–88, over 2500 individual patient encounters were held, with progress noted on an Art Therapy Notes record.

The therapists were able to articulate goals which remained consistent through the programme life. Art therapy, whether art production, 'talk' only or blend, was used to facilitate and maintain positive self-esteem, and to reinforce the search for productive, personally satisfying coping styles. The ultimate goal

was to regain a sense of control – to normalise what was a host of aberrant experiences. The process was supportive therapy, lending emotional and practical support while the patient juggled both personal and medical needs. The end product was often one or more artworks, tangible affirmation that the maker is alive and capable of coping with the fact of his disease and his confinement. The experience evoked insights and energy, restoring a sense of wholeness to the person. The patient learned to trust the art therapist, whether this was a single encounter (common on the medical-surgical service) or repeated encounters (common on the bone marrow and leukaemia units).

Figure 15.1. Cancer dialogue (illustration by Ann Perkins)

The therapists quickly learned that simple art materials were the most effective and least intimidating. Soluble coloured pens and pencils which turned to paint with water on a pen, swab or finger were as popular as collage, for which therapists carried small boxes of words and images cut from magazines. Among the final products were: graffiti walls, joint drawings, collages for themebooks, journals and very simple, often powerful, pictures which patients asked to be hung where they could see them. The themebooks became a significant non-verbal medium which the therapist circulated from patient to patient. They were especially useful in engaging a patient who was timid about producing art. The books had a thoughtful, powerful, sharing sense: *You are not alone with your cancer.* One could make a collage or picture for a book called 'What's it Like', 'Hanging in There', 'Reflections' or 'Great Escapes'.

As the work was intense, more so than in traditional mental health settings, clinical supervision and support were essential. In the ninety-minute mid-day break between two patient-work sessions, the Rap Session, the therapists met with a sympathetic clinical psychologist or psychiatrist to discuss issues of transference, to learn about medical treatments and side effects and the impact of medications, and to guide the therapists with their own sense of trauma and loss. Transference and counter-transference were regularly aired, for the patients perceived the therapists as nurturing confidants. Therapists also participated in psychosocial rounds on their service. In individual patient sessions, if a person presented unresolved medical or psychological issues, therapists would report them, in confidence, to the appropriate staff.

The SOAP assessment form was used for each patient encounter. A health services evaluation, a year into Art-as-Therapy, lauded the programme for its process and outcomes but recommended strengthening 'structure', integrating the programme into routine hospital care. We then invited nurses, social workers and physicians to participate in Rap Sessions. The therapists became respected members of the oncology team; nurses especially depended on their regular visits. Therapists made presentations within and outside of UCLA; in fact, they still do.

During the five years of Art-as-Therapy about 2500 individual patient encounters occurred. One exhibition of this work helped inform the institution about its merits. Several other hospitals in America now support individual art therapists with cancer patients. Not surprisingly, art therapy has won acceptability with thousands of AIDS patients. We believe the concept is highly viable for hospitalised cancer patients and can be readily adapted to other chronic illnesses such as renal disease. Therapists must have a knowledge-base about the disease and its psychosocial dimensions and they need clinical supervision to perform at their best and feel supported within the institution.

Strolling Musicians

Music is known as a powerful mood agent. Whilst some patients bring their own compact 'Walkman' devices to hospital, live music is very rare. Strolling Musicians (SM) evolved as an intimate experience between a musician and one or two patients (most UCLA rooms were twin bedded). We selected volunteer musicians who were mature, had previous community or volunteer experience and played a highly portable, soothing instrument. In the auditions we excluded a musical saw and harmonica but welcomed a dozen musicians who chiefly played the guitar. A young concert violinist did a successful pilot experience, in which we answered 20 questions about the logistics and types of music people wanted to hear and whether SM would work for infants and older adults. One of our most popular Strollers was the first-chair cellist of the Los Angeles Chamber Orchestra, who stood 6ft 8inches, but could fold himself around his

instrument in a cramped dialysis room, an intensive care unit or conventional hospital room. The guitarists could play country, folk music, classical, 'oldies and goodies', show tunes and familiar music which most patients would ask for by name or by humming. Some Strollers sang softly.

We learned rapidly that infants and young children were immediately responsive to live music. You could see instantly how their mood changed from pain and fear to a calmer state. People seemed to be either relaxed or energised by the experience. Adult patients found the music loosened their tongues. Or helped them tap rhythm under the covers. Or break into healthy tears. Patients confided very intimate information about their illnesses and their apprehensions, their feelings of being undefended. The musicians had been given extensive on-site sensitivity training which stressed letting the patient guide the experience – how much music, which music, how much to divulge – with the assurance that the guest, the musician, would not repeat any confidences. Greeting a patient by his full name, a simple gesture, was the standard. Only a patient could invite a musician into his private space. We soon realised that many of our African-American patients were used to playing instruments and singing in church choirs. Often a patient asked to borrow the guitar, to play it himself.

As the musicians came at different times throughout the week, they rarely met each other in the hospital. Twice a year we held jam and discussion sessions in a private home so the musicians could trade experiences and insights. Some became very attached to individual patients and would follow them by telephone after the patients left the hospital. Strolling Musicians was an immediate success – especially as the floor nurses could see how it transformed difficult, dependent patients. Before seeing any patient on a given service, the musician stopped at the nursing station to inquire which patients nurses thought would benefit and who should not be disturbed. In time, most musicians also spent ten minutes or more in their stroll of two to four hours playing for the nursing staff. This bonded nurses and musicians. We considered formal evaluation several times but were advised to accept observations and positive feedback as validity. This concept can be adapted to any setting. The impact is totally different from canned, piped-in music or group concerts. Strolling Musicians is intimate, life-affirmation.

The UCLA Art Cart

We adapted the concept developed 25 years ago by Dr Lynn Thompson of the The New York Hospital into The UCLA Art Cart. While this, too, is a one-on-one experience, it lacks the intimacy or depth of the programmes above. Similar to a book or gift cart, and more recently a 'laugh' cart – all pretty standard in American hospitals – an art cart carries mounted or framed images which are offered to patients at the bedside. Hooks are already affixed to the

wall at a predetermined height (not to interfere with any legitimate hospital function). The volunteer who brings the cart (heavy carts demand two staffers) displays the images and lets the patient select one. When we began this activity in 1982, the average length of stay was at least four to five days. A decade later, it is much shorter. At peak operation, the Art Cart, in one week, reached about 400 adult patients (excluding those in paediatrics or intensive care units). In the coronary care unit, staff made the selections and reported positive interest in the changing scenery.

Some hospitals have only framed reproductions or appropriate photographs from nature. We used mounted fine arts posters donated by over 200 galleries, dealers and museums world-wide. Within a year you could tell something quite specific about the taste of UCLA hospitalised adults. They preferred images of beauty, landscape, recognisable persons and animals and, especially, the work of the Impressionists. They shunned images of inanimate sculpture, pop art, op art or hard edge. An art cart is a very inexpensive operation to establish and sustain. The key to success is sustaining a cadre of enthusiastic volunteers. About 50 American hospitals and many nursing homes operate art cart programmes.

Changing Exhibits by Artists with Cancer

The concept, which began innocently, became that which gave Art That Heals its most visible reputation on campus, in the Los Angeles arts community and, ultimately, to an international audience through the 1987 national exhibition.

In 1982, the author was approached by the head of the UCLA Cancer Pain Clinic: Could I create an art exhibit in the new oncology clinic by a professional photographer, a patient with very few months to live? Exploring permissions, logistics and locating a vendor to donate plexiglass box frames took time. The artist, a 52-year-old woman dying of breast cancer (which had killed her mother only a few years earlier), selected which luminous colour photographs to display. The exhibition opened three days after the artist's death. Her family and friends gathered, after clinic hours, for a celebration-of-life reception that would become a hallmark of the 'Changing Exhibition' concept.

Initially, we drew only on artists who were UCLA patients. The turning point was showing the work of such a patient, who, at 41, had achieved professional success but was dying of a bizarre tumour. His one-person show demonstrated more sophisticated work, with publicity. The first 'holiday-staff' show revealed how talented our own staff and their children were. Conversations between patients and staff took on a new dimension.

Once we stopped limiting ourselves to UCLA patients, the art became much finer and more diverse in content, style and media. We did not accept an artist simply because he or she had cancer. The art could be very professional, as it continued to become, or be by Sunday painters, but it had to be tasteful and not crude. The Clinic Administrator was the advocate for the patients, screening

out any works which were offensive or could literally make sick people sicker. (We avoided images that were black or excessively red, for example). The ATH Director was the advocate for the artists. With a simple notice in the Los Angeles Times we could examine the work of six to ten artists, set a schedule and make the venue professional. With only 55 linear feet and fixed fluorescent lighting, each show was a challenge. While there were no facilities for three dimensional work, we did show work by a superb tapestry artist. The ATH Director came to know the artists when selecting their work, often at their homes or studios, and planning the simple reception for which the artist provided a guest list. Many clinic and hospital staff and medical school faculty interested in the arts/health connection regularly attended these receptions. These small events in the campus life were large events to the artists. For an artist still undergoing horrendous treatment, possibly restricted to a wheelchair and wearing a turban or a wig, this was a time of pride and hope.

We began selling a few images at each show – initially to clinic staff, who became quite possessive about the concept. By 1985, artists who had experienced cancer were calling us. Three artists from northern and central California paid to have their exhibits shipped to us. Not only was the quality of the art improving but there was efficiency and public awareness. We held eight to ten one-person shows a year. For the artist, having a show at the UCLA Bowyer Clinic was a tremendous thrill. But this was not a venue for an artist who was denying his cancer.

For me, personally, getting to know the artists – their battles with cancer or Kaposi's Sarcoma (a form of cancer associated with AIDS) – was the most significant aspect of the work. Perhaps 25 per cent of the 50 artists honoured with one-person shows died soon after, or even before, their exhibitions. The idea of rewarding their cancer status, a tribute to creative energy, took on substance and urgency. We held several posthumous exhibitions when the artist died just before his scheduled showing. We were asked to exhibit the work and memorabilia of the British born actress Joan Hackett, which brought the clinic gallery to a broad community.

In March 1985 the notice placed in the Los Angeles Times attracted 25 calls in 48 hours. Clearly the Bowyer Clinic Gallery venue was viable for the designated population: artists with cancer. It became the seed of the next concept: the 1987 national exhibition. Between February 1982 and February 1989 fifty artists were given one-person exhibitions. There were also five 'staff holiday' shows and five other group exhibits. Regarded as 'more bang for the bucks', this concept is very inexpensive to replicate.

Confronting Cancer Through Art 1987

In March 1985 we reviewed the work and designated exhibition dates for the 25 artists. When the campus gallery declined to stage a regional or national

exhibition by artists with cancer we visited several major community galleries. The idea was welcomed by the Brand Library Art Galleries in Glendale, a magnificent space (over 300 linear feet of properly lit wall space) which also accommodated three-dimensional work. A date was secured: May to June 1987.

A panel of jurors was assembled in the summer of 1986. The jury decided to make the show national, even though we had only eight months lead time. The UCLA Public Information Office provided publicity assistance and the executors of Corita Kent's estate gave permission to use a particular passage and image on the catalogue cover and poster. Elements of the catalogue fell into place: an essay by Norman Cousins and essays and poetry by persons who have faced cancer.

The national competition produced 67 entrants who submitted slides of 315 artworks. The jury – professional curators and gallery directors in Los Angeles – narrowed the juried field to 76 works by 36 artists. The quality was remarkably high. In advance of the judging we approached 15 artists with cancer, or their heirs, to be invited, non-juried artists. Six nationally-recognised invited artists accepted: Robert Arneson, Martha Alf, Laura Andreson, Ruth Weisburg, the late Frederick Wight and the late Corita Kent. We agreed to install the works of the invited artists together. As the show was installed the blend of juried and invited artwork was seamless, for many of those juried were art educators who were well known in their regions.

There were poignant moments around the exhibition. Three days before the opening (but 10 days before the formal opening reception), our youngest artist, a very gifted 20-year-old named Megan Jones, died of her cancer. There was time to insert a page in the catalogue dedicating the exhibition to Megan's memory. Thirty-six of the 42 displayed artists were living (only three of them failed to attend the opening reception), coming to Los Angeles from throughout California, Canada and six distant states at their own expense. The next day, 12 of the artists were interviewed by National Public Radio. We estimate that 3500 people viewed the exhibition during its four week run. Over 8000 catalogues have been sold since that time and a like number given to cancer support and professional groups.

Many of the artists attribute their survival, and ability to continue working, to the support of family, colleagues and support groups. But they consistently cite the ability to make art as the pre-eminent force – a creative outlet for their complex emotions. The CCTA artists asked to sustain a network. A newsletter is issued several times a year, full of *their* news and exhibition notices. In the nine years since the exhibition, we know of only five artists who have died.

Replications

Soon after the 1987 national exhibition an ambitious proposal was submitted to the National Endowment for the Art (NEA) to create a travelling 'Confronting Cancer' exhibition at six to twelve enthusiastic museum sites in two years. Each exhibit would be unique, combining a core portion of the 1987 show with that of regional artists with cancer. While this was not funded, the national publicity about the 1987 exhibition sparked inquiries about how to stage such exhibits. Two groups have replicated the Confronting Cancer exhibition: an all-volunteer organisation in Albuquerque, NM, conducts annual exhibitions drawing on the art of indigenous Native Americans, oncology professionals as well as established local artists, and a cancer hospital network in Wisconsin has twice conducted state-wide exhibitions. There may be others about which we have no knowledge.

The educational kits were compiled and publicised in 1988–89. More than 170 requests have been filled. We have had feedback that at least 35 health institutions have adopted one or more of these concepts. Strolling Musicians was transported to the Mary Hitchcock Medical Centre in Hanover, New Hampshire, by one of our original Strollers who launched the programme while at graduate school.

Programme Demise

Art That Heals was never financially supported by the UCLA Medical Centre, despite annual requests. The 1987 exhibition failed to secure a major corporate donor before, or in the year after, the exhibition, thus creating a printer's bill deficit. The logical end was to release the Director, creating JCCC salary savings to pay the printer. She closed out each ATH component. While this imaginative and psychologically-grounded programme was immensely popular with patients, hospital staff and those involved, without a consistent material commitment by the UCLA Medical Centre, it was in peril. The ATH Director subsidised the programme for several years. She has given slide-talks throughout the United States, Canada, Europe, China and Australia, which has inspired many institutions to create their own hospital arts programmes. Her presentation in Gainesville, Florida, in Spring 1990 led to the remarkable programme at Shands Hospital (see Chapter 16 by Professor John Graham-Pole, Sidney Homan and Mary Lockwood-Lane).

Perhaps the most important lesson from the UCLA Experiment is how political hospital arts programming can be. If Art That Heals had been created by a UCLA Medical Centre administrator or major medical figure (as at Shands), it would have survived – at least to 1992, when the occupancy rate plummeted and local competition became razor-sharp.

Conclusion

Arts programming in health care settings has validity. It attempts to demystify hospitals and to counter real or imagined indifference by staff to patients. When the idea is advanced and supported by enlightened hospital administrators, hospital arts programmes thrive and expand. Increasingly, American hospitals, especially costly academic medical centres, use market strategies to keep the community 'coming in', so involving both artists and patrons from the community and hospital personnel is a partnership with great potential. Start with a pilot project in which you pose questions and seek answers. *Above all, take risks.*

Resources

These educational kits are available at no charge. Request them from: Art That Heals, UCLA, 1100 Glendon Avenue, Suite 711, Los Angeles, CA 90024.

Changing Exhibit Concept for Outpatient Hospital Settings

Guide to Strolling Musicians

The UCLA Art Cart

How to Stage a Regional (or National) Art Exhibition by a Special Constituency

Dillom, D, Gross J, and Lewi-Rucker M, 'The role of art therapy with hospitalised cancer patients' (unpublished manuscript).

Individual copies of the 64-page (32 in colour) exhibition book, *Confronting Cancer Through Art 1987 National Exhibition*, are available. Send your cheque for $11 made out to the Regents-UC to the address above. The commemorative poster is available for $22. Both prices include tax and postage.

The Hospital Arts Handbook is available for $25 from Cultural Services, Duke University Medical Centre, Box 3017, Durham, NC 27710. It describes the history and rationale, and arts programmes of over 30 US hospitals. Postage is included.

This chapter is based on a slide-talk presentation at the 14th World Conference on Health Education, Helsinki, Finland, June 19, 1991. It is dedicated to the memory of Strolling Musician Nils Oliver, Art Cart volunteer Fred Dehgani, and Confronting Cancer artists Robert Arneson and Megan Jones.

Building Arts in Medicine

John Graham-Pole, Sidney Homan and Mary T Rockwood Lane

Principles of Arts in Medicine

In 1991 when health care givers and artists met to establish the Arts in Medicine (AIM) programme at Shands Hospital and the Health Science Centre of the University of Florida, there already existed an extensive literature to support the claim that the creative arts can play a vital role in health services; from Lazarus's empirical studies in *The Practice of Multimodal Theory*, showing the value of systematic creative writing and journal-keeping in mental-health clinics, to the account of the therapeutic use of drawings with children in Glaister's and McGuiness's *Helping Chronic Trauma*. Indeed, several of AIM's founders led double lives as health care givers and artists or had personal experience with the relationship among the body, mind, imagination and health. What would happen, they speculated, if we thought of the artist as a health care giver, and, conversely, the health care giver as an artist?

The Programme at Present

The central focus of AIM is the Artist-in-Residence programme, which brings professional artists in direct contact with patients, families, students and the hospital staff. At present AIM's various activities range from placing art carts in the lobby of the Children's Cancer Clinic, to ease the long, anxious waiting hours for children and their parents, to acting and mural-painting sessions for emotionally disturbed diabetic teenagers who, separated from dysfunctional families, live full-time in the hospital's Diabetes Project Unit. There are ongoing programmes on twelve units. Various artists – painters, dancers, actors, musicians – interact with patients, families and staff. Sometimes that interaction takes the form of a performance in which patients and staff participate; at other times, the artist will assist the patients in more direct expression of their own feelings about illness and hospitalisation. 'Writing toward Healing', a monthly workshop at which patients and staff learn together to face their illness by

writing about it, or 'Charley's Corner', where part of the therapy consists of artists and staff getting patients out of bed to attend weekly performances in the visitors' lounge by story-tellers, musicians, painters and actors, are typical of activities that supplement the Artist-in-Residence Programme.

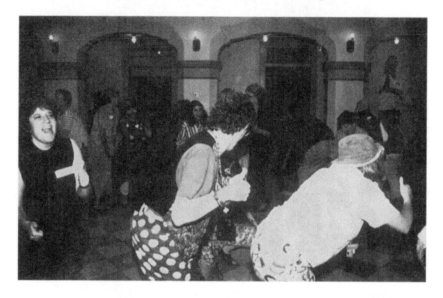

Figure 16.1. A 'laughter and playshop' for hospital staff and artists: a regular AIM activity

A Sample Programme in the Bone Marrow Transplant Unit

Given the patients' long stays and the severity of their illnesses, the Bone Marrow Transplant Unit (BMTU) has offered artists an unusual chance to work in an intensive care setting. AIM's initial programme stressed the visual arts, with materials selected for their simplicity and comfort.

Artists identified patients and family members to work with. Each was given an acid-free paper, an 8-by-10-inch journal, and an art bin stocked with drawing pens, coloured pencils, coloured markers, Fimo clay, glue, scissors and other supplies. These materials were chosen to foster exploration with mixed media and encourage each patient to develop a process that was challenging; the art journal would provide an opportunity to create a personal story blending past and present. Working directly with nurses, physicians and other care-givers, the artists were asked to commit two to three months, spending six to eight hours each week on the project. Since she herself had discovered in her painting a way out of depression, the nurse-artist who headed the programme proved a role model to patients no less than fellow artists. Her knowledge of their profession also accounted for the ease with which nurses on the unit became liaisons between artists and patients. Within a few months, the staff themselves

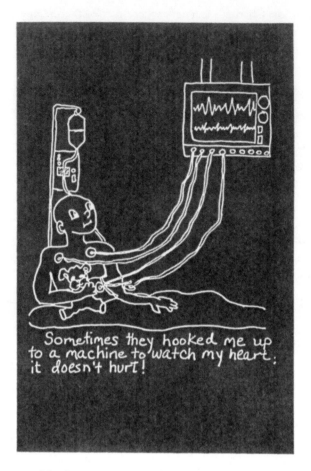

Figure 16.2. One of the illustrations composed by a patient–artist for an educational colouring book on bone marrow transplantation

were making specific requests for artists and media. Now doctors even write prescriptions!

Each artist conducted several workshops for families and staff, the goal being to kindle an interest, through this personal experience, in a process nourishing the patient's spontaneity, self-expression and creativity. Each workshop was attended by about a dozen people, including families, nurses, physicians and their assistants, occupational and physical therapists, child-life workers, chaplains and clerical staff. One multimedia artist worked with Fimo clay because it is easily manipulated into three-dimensional objects such as sculpture, jewelery and holiday ornaments. A fabric artist conducted several hands-on sessions involving painting hats and tee-shirts. This same artist designed a fabric art-box that has an easily accessible paint selection and a stretched tee-shirt to enable the patient to paint in bed. Afterwards, the tee-shirt

can be slipped under the bed to dry. This she was able to market successfully for use at other hospitals, an opportunity that exists for all artists working with their own designs or production.

A Workshop for Patients

With older patients, one theatrical work that has proved effective is Samuel Beckett's two-page play *Come and Go*, where three elderly women, sitting on a park bench, recall the happy days of their youth when they sat on a log at kindergarten 'holding hands and dreaming of love'. When one exits, the remaining women gossip about something horrible that has happened to their partner, something about which they hope she is ignorant. Beckett never specifies just what the calamity is and so audience members are left to supply, each in his or her own way, the missing line. Each woman plays all three roles: the person who exits; the one who, upon that exit, tells the secret to her partner; and the partner receiving the whispered secret. At the end all three sit once more on the bench. Two questions asked by one of the characters are met by ominous silence: 'Shall we not speak of the old days?' 'Of what came after?' Then she asks the third question: 'Shall we hold hands in the old ways?' That is, instead of trying to make sense of why life has turned so tragic, should they now duplicate the hand-holding bonding them in kindergarten? The three then join hands in a daisy-chain pattern as the character Flo delivers the final line: 'I can feel the rings.'

Elderly patients are usually asked to volunteer. Sitting before the group, on chairs arranged to resemble the park bench, they first read Beckett's enigmatic text. Then they rehearse the play, with the director adding all of Beckett's stage directions as well as asking the audience to participate by imagining costumes and lighting effects. Finally, the volunteers give a formal performance. After that the audience discusses what the play signifies to them: what is actually whispered about the woman who has exited? What does Flo mean by 'the rings'? Typical of Beckett's works, *Come and Go*, like his *Waiting for Godot*, forces the audience to fill in what is absent or ambiguous. In effect, they become fellow actors, seated in the house. Invariably the audience read themselves into the play. Variously identified as wedding bands, bonds among the women or the signs on a tree showing its age, Flo's 'rings' was called, by one astute man with terminal cancer, 'the connection' between audience and performer. 'We weren't there at their kindergarten or when something bad happened to them. That's just talk – their memory. But the past isn't entirely dead, or irrelevant, because right before us they do something: make a ring with their hands just the way they used to sixty years ago.' Then he added, 'I haven't got long, I know, so what I'm trying to do is the same thing – make sense of the past by bringing it into the present.'

Community Outreach

AIM also conducts programmes outside the confines of the hospital. In the past
year members of the Artist-in-Residence staff have visited clients in the Home
Care Programme and recently a conference on healing was held at the Cultural
and Nature Centre in downtown Gainesville specifically because that location
would attract citizens who might normally not come to Shands Hospital. A
'Laughter and Play Workshop', to cite another example, has been given at
various community hospitals, social and service organisations and at conven-
tions both in Florida and about the United States. In June 1995 AIM sponsored
a major symposium titled 'Re-Storying Lives, Restoring Selves: Art and Healing'
which combined nationally-known speakers, numerous hands-on workshops,
therapeutic dancing and a specially commissioned play called *Oh, Doctor! Oh,
Nurse!* both celebrating and parodying the medical profession, as well as a
pre-conference day-long session on 'The Art of Designing Spaces to Facilitate
Healing'.

Research and Education

Along with its various activities, AIM has initiated educational and research
components. Soon to be re-established as the university's Centre for Art and
Health, AIM will give university-wide courses team-taught by health care givers
and artists, both at the undergraduate and graduate level, with participating
faculty released part-time from their regular department responsibilities. Al-
ready planned, for example, are courses on 'The Physical and Psychological
Dimensions of Play for Ill Children' taught by a paediatrician and psychologist,
'Art, Society and Perceptions of Cancer' taught by a historian and an oncologist
and 'Comedy: Aesthetic and Therapeutics' taught by a literary critic/director
and a physician who is also a professional clown. Not solely theoretical, these
courses will involve the students' fieldwork in related AIM programmes. For
example, students on the course on 'Dimensions of Play' would help in the Tile
Project at the Children's Cancer Unit where AIM artists have assisted patients
and their families in creating hundreds of ceramic tiles which, when assembled,
will be exhibited as collages or 'walls' in the hospital's main entrance.

The Centre will also bring together faculty interested in doing research in
the general subject of art as therapy or in the related topic of the link among
the mind, body and the creative imagination. AIM will seek funds for such joint
research, provide a forum for the exchange of views and assist faculty with
publication.

Workshops for Physicians and Medical Students

Some of AIM's programmes offer a more graphic educational illustration of the
artist's role in the hospital and in medical training. This is especially true of

acting workshops attended by physicians and medical students. The purpose here is to offer a theatrical perspective on typical activities in the hospital, especially interactions with patients. Without diminishing the naturalness or the human element of such interactions, developing an actor's awareness allows one to achieve the effect of watching oneself on video-tape, but rehearsing the situation beforehand rather than viewing it after the fact. For example, in one exercise a professional actor plays a patient waiting in a room to hear from the physician of any change in his diagnosis – indeed, assuming the physician has good news. A real-life physician plays the physician in the exercise. The activities involve going to the door, opening it, greeting the patient, walking across the room, asking him to sit down and then announcing bad news. The AIM director and physician-actor then try out various options. Just how do you open the door? Boldly? Confidently? Quietly? Tentatively, so as to give the patient some visual clue of your news? Casually, so as not to alarm him? And how do you walk across the room to greet him? What signals, if any, do you want to send before your announcement? How do you sit down with the patient? Do you ask him to sit first? How do you 'stage' your announcement? How close do you sit to the patient? When precisely do you sit? How do you phrase the bad news? What happens if you get right to the point? Or do you approach the topic gradually? What context, if any, do you provide for your remarks? As the patient recoils from the unexpected news, how do you treat him? Do you touch him? How much longer do you sit with him? Do you exit to the door with the same movement as you entered the scene?

Perhaps physicians with a good 'bedside manner' need no such rehearsals, or, in their own way, acting as their own director, do such rehearsing naturally without labelling it as such. The acting exercise, however, holds what Hamlet would call a 'mirror' up to the action, allowing participants to be at once engaged and disengaged. As one physician commented: 'Thinking of the situation as a play makes the patient and me fellow actors, or each of us an actor eager to play well to the audience of the other'.

Components for Maintaining Such a Programme

Leaders

While avoiding a hierarchical structure is important, you must have leadership. We have found this is best achieved by forming an alliance between two or three of those most committed, with representation from both health care workers and artists. Currently we have an executive committee of three people: a doctor, a nurse and a professional artist. We have confidential weekly meetings to deal with problems, priorities and administration as well as to support each other and keep focused on AIM's larger objectives. We plan shortly, because of the rapid growth of our activities, to expand this executive committee to an eight-person group that will meet less frequently.

Artists

You cannot create such a programme without artists. They may come from the community, from the campus or from among your own staff – hopefully all three. One usually also begins to identify artists from among patients, though these will tend to come and go. The artists will have many different reasons for getting involved and it is a matter of trial and error to find those artists who will work best in your particular setting. And remember that most will be unfamiliar with, or even alienated by, the health care environment.

Health Care Allies

Equally self-evident is the fact that you need committed allies and advocates from among care providers, and the more diverse the better. Given the nature of current leadership in health care, it is good to have a senior physician involved from the start. Still, nurses are the primary caretakers – at least in the hospital setting. No programme will thrive without their help; a strong, visible alliance between doctors and nurses is ideal. If you are more interested in a community-based programme, you will get great support from practitioners of 'alternative' (or complementary) health care.

Co-Ordinators

At first we were long on ideas and short on organisation. We encouraged the situation and didn't worry about it. Lots of brainstorming and letting imaginations run wild is just fine. But there came a point when we cried 'We don't need any more ideas! Where do we start? We have to prioritise!' This was the time to look around for the person who had been there from the start, quietly taking things in, maybe making notes, not saying all that much, keeping his or her feet firmly planted. If you have such a treasure, cultivate that person because he or she will be the one who can create structure out of your creative chaos.

Volunteers

While we don't think anyone should give of his or her energy, time and talent for nothing, the reality is that everyone does a lot of volunteering, particularly at first. And indeed volunteers will remain the key to your success. Even when we got funding – and although it was restricted so that we couldn't pay all these people, even as all around us the hospital administration was laying off workers – we knew that monetary rewards couldn't be our primary goal. Beware of those for whom it seems to be. Cultivate your existing volunteer organisations, yet always remember that volunteers don't *have* to do anything.

Art Supplies

We found we needed unlimited amounts of these. Our artists told us what they wanted and led us to the best places for discounts. Once you have a budget, establish, through your co-ordinator, a set amount for each artist to work with. Once you see this plan is working you will then get a better idea about priorities. At all times you'll need to be on the look-out for donations. Supplies are easier to come by than money.

Money

Now to the thorny subject of money. You don't need much to get started; don't think you have to have a government grant up front. What you have working in your favour is the natural alliance between health and the arts, an alliance that appeals to everybody. So, we were bold in asking for financial help. After we had some early publicity for the programme, we made a packet of materials for potential donors. We also suggested ways they themselves might get involved in the programme.

Publicity

We decided to go public early with what we were doing. Once we had made the first tentative offerings – a children's art exhibition, a staff talent show, a talk or two, a meeting with interested people – then we got the programme out to the media. We are surely all aware of the daily deluge of materials on our desks and in our mailboxes, most of it deadly. What we were doing made great copy. Nor did we neglect our local television and radio stations. We moved from an events mailing list to a one-page newsletter to a brochure to a handbook to a one-page calendar to prominently placed exhibits and bulletin boards with notices of our activities to a quarterly eight-page newsletter – all in the course of two years. As your programme evolves, you'll want to find a group of experienced, well-connected people to handle your publicity. Along with fund-raising, publicity is an area that many groups neglect – out of inexperience or from discounting it as unexciting or secondary.

Meetings

As we gathered this diverse and independent group together we found it hard to keep track of everything that was going on. Therefore, meetings were essential. We ended up having several each week; no one person could attend them all. Still, it's a good idea if one of the leaders is there. At present we have five meetings a week: business (two), artists and staff (a support group), networking for newcomers and a 'happy hour' with community musicians. We

also have day-long retreats several times a year – to refresh ourselves and to see where we are.

Fun

'If it ain't fun don't do it. But if you gotta do it, make it fun' (Peter Russell). We hope we never lose sight of the link between this wonderfully creative programme and having fun. Whenever we feel things are getting away from us, when tensions are high or a programme bombs, when we suffer through administrative hassles, we need to remember just why we became involved with this arts in medicine programme. We wanted to humanise things. We wanted to break down barriers of isolation and competitiveness and fear. We wanted to show how useful, how vital the artists can be in health care. We wanted to remind ourselves, as well as others, that good health is a concern for all of us. 'The function of medicine is to have people die young as late as possible' (Ernst Lynder).

Evaluation: Successes and Challenges

Preliminary quantitative measures suggest that the programme on the Bone Marrow Transplant Unit has improved patient morale and lessened feelings of distress, loneliness and anxiety. AIM is also studying reports, journals and other written observations by both participants and staff. The artists' feedback has been especially illuminating. One commented: 'This is an opportunity to share my art in more meaningful ways, reaching out to patients and their families...[and allowing] an individual to express and confront self and to let go of despair'. One artist described herself as 'a new person concerned with them as people, not patients'. A nurse observed that 'It means a lot to families and patients to have a friend from outside, since many of our patients are far away from home'. One mother noted that her journal helped 'keep [her] focused on being as supportive as [she could] to [her] daughter'.

The amount of time artists could spend on the BMTU was limited and it became clear that they needed prolonged residencies for their role to develop into an effective intervention. The original concept of volunteerism itself was unrealistic and unfair and AIM realised it would have to secure funds to pay artists a modest honorarium. Older patients at first resisted the notion that they too could be an artist or tap a sense of creativity still active within them. This lack of confidence was less of a problem with children under ten. It also became apparent, as artists discussed form, colour, shape, art materials and process, that the staff and patients found the language unfamiliar; it has taken some time to establish a common 'language'. In fact, a request was made for an introductory art programme grounded in a nursing practice framework.

The initial monthly workshops proved too many; both artists and staff needed more time to develop a collaborative relationship with patients and their

families. There were also the time restraints of the staff's responsibility to patient care. AIM now plans to offer 'Continuing Education Credits' for each workshop to encourage staff attendance. An occasional problem was inappropriate dress and behaviour on the part of some of the artists; the hospital environment places high values on professionalism and formalised role behavior, issues about which the artist needs to be sensitive. Finally, only two of the artists had specific training in either medical or emotional care of seriously ill people.

AIM is a cost-effective programme. On average, AIM volunteers spend 831 hours per month on the various units at Shands – for a yearly total of approximately 9972 hours. A monthly breakdown of volunteer time shows 6769 hours with patients and family and 2256 with staff and physicians – for a total of 108,312 patient-contact hours each year. Given AIM's $50,000 yearly budget for the Artist-in-Residence Programme, the total cost for each patient intervention is just 45 cents.

Using a standard rating scale, we recently evaluated the responses of nearly 1000 samplings of patients, families and staff. The average rating (out of a possible 10) was 9.5 for 'enjoyment', 9.1 for 'mental/physical benefits' and 8.3 for 'involvement'.

Still, hospitals can be conservative places and the AIM programme has been viewed suspiciously by some of the staff, dismissed as little more than a 'feel-good' exercise (perhaps a somewhat curious complaint given the general mission of a hospital) or an intrusion on staff time and resources (increasingly the hospital's donation is being supplemented by funds from outside sources). Nor will every health care giver want to give equal importance to the mind – let alone the imagination – when it comes to treating physical, or even emotional, illnesses. AIM wants to fit in with the hospital, while at the same time recognising that the programme itself, even if its goal be the modest one of complementing conventional medicine, challenges the present system.

Much of the early discussions about research, for example, revolved around AIM's desire to gain credibility with health centre researchers, to *flatter* them, in effect, by adopting their own quantitative methods: members thought they had to 'prove' that there is a link between physical health and art. Only recently have artists felt confident enough to admit that such quantitative research is not what they do best, nor even the appropriate method for a subject that may be more amenable to the qualitative method. In point of fact, the so-called 'proof' that art is vital to well-being, that it is useful in making a person whole, is at least as old and well-established as the principle enumerated in the Hippocratic oath. This said, it must still be admitted that AIM needs to 'sell' itself to the establishment.

This selling has not been as difficult as it may have seemed at first. Increasingly, hospital staff are requesting Artists-in-Residence; in this regard, the nursing staff has become AIM's best advocate. The most consistent and conspicuous presence in the various units, nurses are the witnesses to the effects

that artists can have. There is a rich history of artists who were physicians, or physicians who were artists, and, as the programme has become better known, various members of the hospital staff have revealed their creative side. For instance, the Associate Chair of the College of Medicine is a concert pianist and composer, and, accordingly, has performed at numerous AIM functions.

AIM itself was the victim of its own good intentions: there were ideas and volunteers before an administrative superstructure could be put in place. Much of our energy, and almost all of our interests, go into the daily interactions between artists and staff; grant-writing, even publicity, sometimes take a back-seat. Only four years old and already boasting a national reputation, in some ways AIM has grown too quickly so that its members sometimes wonder if the trinity of programmes, courses and research – the basis of the planned Centre for Art and Health – will prove overwhelming.

This said, what AIM learned in the BMTU served as a model, with adjustments, for the Artist-in-Residence Programme as it spread to nine other units.

A Final Thought

Along with its historical connection to the arts, the medical profession, in its own terms, has signalled – literally – its kinship with the arts. One speaks of *performing* medicine and of the physician's *art*. Perhaps a third term is even more revealing: the room in which, as part of their education, medical students watch senior physicians perform surgery is called *the theatre*. Arts in Medicine antici-pates the day when the artist will be as natural and as official a presence in the hospital as the physician or nurse. That day is not now, perhaps not even in the near future. Nevertheless, we think it will come.

Some of the Programmes AIM has Created

The Artist-in-Residence Programme. Painters, musicians, writers and other artists spend 12–15 hours a week on several different units of our hospital, presenting interactive workshops for staff and families and working one-to-one with patients. These activities encompass everything from movement, music and painting to sculpting, drama and poetry.

The Performing Arts Series. Monthly performances by performance artists are staged in the Health Centre atrium, emphasising participation by patients with physical and emotional illness together with families and health care givers.

Writing for Healing. This monthly workshop led by two creative writing teachers explores the well-documented use of writing as a tool for healing.

Movement and Dance Workshops. This bi-monthly workshop is for all of us interested in exploring how dance and movement can help us express ourselves and support each other.

Laughter and Play Shops. We perform these playshops throughout our Health Centre and increasingly at other places in the community. They are designed to remind adults of things children already know – that laughter is good for you!

The International Artists Series. Through collaboration with our Performing Arts Centre internationally recognised artists are commissioned to conduct workshops and presentations.

Art-Cart. A mobile art cart equipped with art supplies is available for non-ambulant patients.

Touring Art. this is a touring gallery of art created by children living with cancer and other life-challenging illnesses.

Cancer Centre Performances. Artists from community and campus, sponsored by · our community's Junior League, perform interactive theatre, dance, music and story-telling to an audience of young and old out-patients, families and health care givers.

North Central Florida Hospice. This programme is exploring, through art, how health care givers can express and deal with the losses occasioned by their work.

Long-Term Care Project. This programme is being developed to bring art in all its forms to extended care facilities in and around Gainesville. We are currently developing an outreach to individual homes through our hospital's Home Care Team.

Information is available from the author c/o: University of Florida, Pediatric Hematology/Oncology, PO Box 100296, Gainesville, FL 32610–0296. Tel: (352) 395–0114; FAX: (352) 338–9808

CHAPTER 17

Taking Shape
Environmental Art in Health Care

Janice B Palmer and Florence Nash

The effect in sickness of beautiful objects, of variety of objects and especially of brilliancy of colour is hardly at all appreciated. I have seen in fevers (and felt, when I was a fever patient myself) the most acute suffering produced from the patient not being able to see out of window and the knots in the wood being the only view. I shall never forget the rapture of fever patients over a bunch of bright coloured flowers.

People say the effect is only on the mind. It is no such thing. The effect is on the body, too. Little as we know about the way in which we are affected by form; by colour and light, we do know this, they have an actual physical effect. Variety of form and brilliancy of colour in the objects presented to patients are actual means of recovery.

(Florence Nightingale 1888)[1]

Picture this: two post-surgical convalescent wings in a hospital in suburban Pennsylvania. Through the windows of one, the gaze stops short against a blank, shadowed brick wall. From the other, the view is of the green contoured landscape outside, dotted with trees and generous with sky. A few years ago, patients recovering from gallbladder surgery in these two units were the subjects of a study that gathered some interesting data. Patients with the nature-view window had shorter post-operative hospital stays (averaging 7.96 days versus 8.7 days), had far fewer negative comments ('patient is upset,' 'needs much

1 *Notes on Nursing: What it is and What it is Not* recently excerpted in a newsletter published by Healing Through Arts, Inc., Gina Halpern, executive director, Box 411, Wayland, MA 01778.

This chapter first appeared in the *North Carolina Medical Journal* (NC Med J 1993; 54: 101–4). Reprinted with permission.

encouragement') recorded in nurses' evaluations and tended to have lower scores for minor post-surgical complications such as persistent headache or nausea. On the other hand, the wall-view patients needed more doses of potent narcotics (an average of 2.48 doses versus 0.96 doses). The nature-view patients could more often be managed with weak analgesics such as acetaminophen. (Ulrich 1991)

This study is significant because it is one of the few that offers concrete, bottom-line support to a matter so grounded in common sense and instinct that it would seem to need no explanation. Anyone who has ever fled the city for a weekend in the country, taken a vacation at the beach or opened curtains to flood a room with sunlight is responding to the essential interplay between environment and well-being.

The notion that physical surroundings can have a significant effect on health is hardly a new one. Since Hippocrates, physicians have recognised the importance of spiritual refreshment in physical healing. Galen set his patients' litters outside in the agora on nice days so that they might experience the restorative power of the familiar sights and sounds of a busy market square.

Hospitals have come a long way since Galen – for better and for worse. As the science and technology revolution accelerates, the expectations of both providers and health care consumers race to keep up; we now routinely receive a staggeringly expensive level of institutional and technical response to medical problems. Health care facilities are under pressure to provide medical care at the volume and speed necessary to pay for these modern miracles. The pressure mounts, the pace quickens, and the hospital environment becomes increasingly unresponsive to the human aspects of those most fundamental experiences – birth, death, fear, isolation – that lie at the core of its operations. Nearly drowned out by the Machine, the spiritual element of healing is the casualty of progress.

Happily, there is a counter-trend afoot: a partnership between medicine and the arts being forged in hospitals across the United States and abroad. Increased recognition of the power of the arts to shape the emotional as well as the physical environment lends strength to a growing movement to incorporate the arts into health care facilities. This new partnership seeks to 're-humanise' the health care environment with the tools of aesthetic experience and expression.

Whereas arts medicine and traditional art therapy focus specifically on the diagnosis and treatment of illness and injury, the health care arts movement assumes the broader goal of integrating the arts into the lives of hospitals, hospices and rehabilitation centres, targeting not just patients and their families but the whole community of medical and support staff. Access to the arts is key. Budding health care arts programmes work in their facilities much as arts councils work in the larger community: they explore and promote the spectrum of arts – dance, drama, literature, visual and plastic arts, whatever is available – tools to aerate and cultivate the life of the institution. They operate wherever a benefit can be envisioned and an opportunity can be found (or made).

The Cultural Services Programme at Duke University Medical Centre

Some of the ground-breakers in this new field have formed a support, educational and advocacy organisation: the Society of Health Care Arts Administrators (Palmer and Nash 1991). The Cultural Services Programme (CSP) at Duke University Medical Centre in Durham is one of the oldest and most vigorous of these pioneer programmes, offering services in visual, performing and literary arts, computer graphics and video and arts medicine. It was established by a physician, Dr James H Semans, who felt that there should be practical ways to make the restorative and reassuring powers of art available to hospital patients, visitors, and staff. 'My own experience of the uplift that often came with cultural enrichment indicated that if the patient was able to experience [this] while in the hospital…some part of the hospital's mission in the area of the healing arts would be accomplished.' (Semans 1991, p.1)

In 1978, with funding from the Mary Duke Biddle Foundation and the National Endowment for the Arts, Cultural Services began as a collaboration with the Durham Arts Council to explore the potentially powerful role of the arts and humanities in the health care arena. From modest beginnings it has grown to include such projects as a closed-circuit patient television channel, a poet-in-residence who reads and writes with patients and leads an informal weekly brown-bag discussion of poetry or short stories for students and staff (see Daniels 1992), an American Dance Festival class performance in the hospital courtyard, 'Room Service', a programme of strolling musicians on patient units, a collection of traditional North Carolina quilts hanging in every obstetrics and gynaecology patient room, a developing archive of North Carolina writers reading their works as part of the hospital's books-on-tape lending library, and a touchable art gallery in the Eye Centre for visually impaired patients and visitors.

CSP's involvement in environmental design came about by way of our art collection. By our third year we had acquired more than 1000 paintings and prints by North Carolina artists, primarily to hang in patient rooms and waiting areas. When the hospital administration decided to remove the information desk from an entry foyer and was interested in using sculpture to make the resulting space more welcoming, CSP was asked to oversee the selection and installation of a piece that would be a significant art acquisition and would also improve the atmosphere of the entry. Although we were delighted with the opportunity, it became apparent that it was essential to consider how the space was used and that 'retrofitting' a piece of art would not solve basic traffic-flow problems or meet any aesthetic objective.

We began to take a closer look at the idea of using art to redefine the environment and were confronted with the more fundamental issue of how the environment itself defines the processes it contains. It was then only a short step for CSP to connect with the public art movement, an emerging forum for

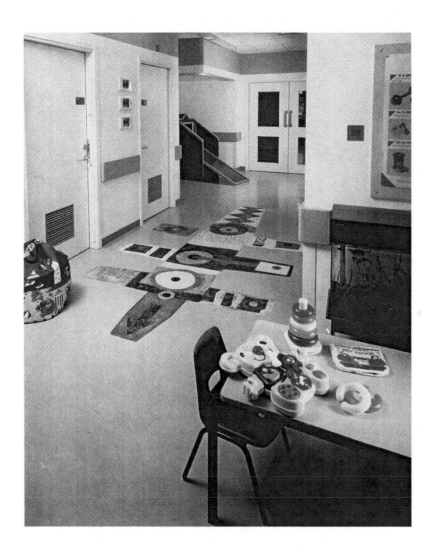

Crocodile flooring by Hilary Prosser: An abstract and imaginative design enlivens the children's out-patient area in the Conquest District General Hospital in Hastings

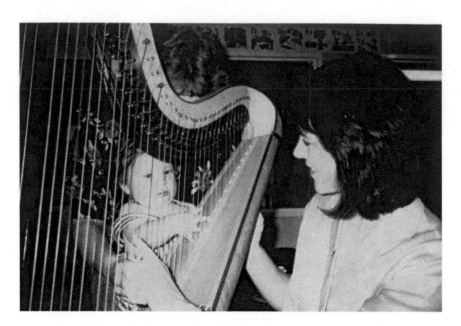

Margaret Knight with a young patient at the East Surrey Hospital, Redhill

Exterior, St Mary's Hospital, Isle of Wight

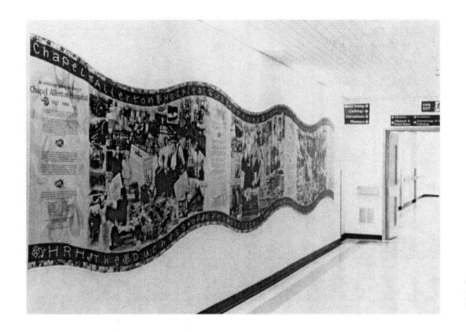

Chapel Allerton History Project

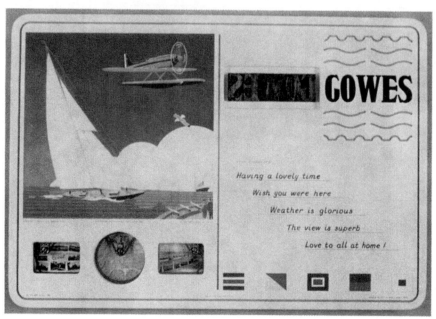

(© Stephen Nicoll)

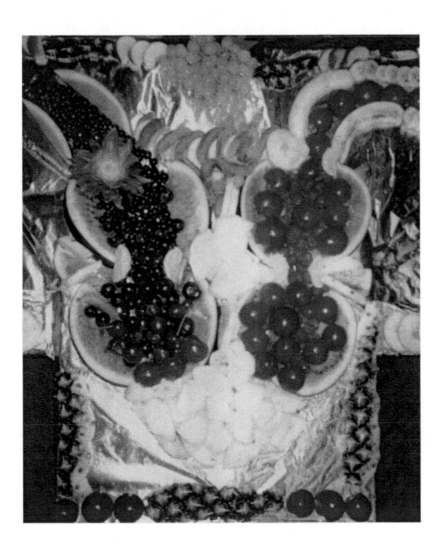

Fresh fruit heart display

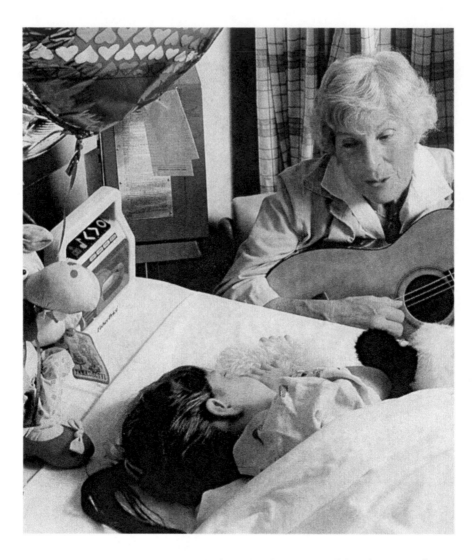

Guitarist Bernice Van Steenburgen and cellist Nils Oliver are two of the volunteer Strolling Musicians who entertain patients throughout UCLA Medical Center.

Furness General Hospital Glass Screen (Photograph by Christopher Barrett)

Dining Room: A Mediterranean vista adds space and light to the room together with co-ordinated furniture and decor resulting from enthusiastic teamwork.

artists who take a particular 'interest in the shape or character of (an) environment and the nature of...experience in a public place' (McLaughlin 1991, p.1). Art and artists are invited to actively join the process of altering environments and directly affecting the way people experience them, but they do so by recognising and 'marking the uniqueness of (a) particular place or community' (McLaughlin 1991, p.1)

Likewise, the basic purpose of the health care arts movement has been to make an alien environment more responsive to the emotional needs of those within it. So the CSP has enthusiastically embraced the tenets of public (or environmental) art, a comprehensive concept that includes the kinds of activities promoted by CSP since its inception. Roger Ulrich (1991), a behavioural scientist and associate dean of the Texas A and M School of Architecture, gives three criteria for 'supportive design' in health care facilities. These articulate the goals of environmental art at Duke Medical Centre:

- a sense of control with respect to physical and social surroundings

- access to social support

- access to positive distractions in physical surroundings.

In addition to activities that bring a variety of 'positive distractions' into the hospital, we seek out projects – and in some cases projects seek us out – to change the physical facility itself. At present we have ten environmental arts projects in different stages of development, most of them still on paper.

Our first major target was an outdoor courtyard that was an uninterrupted plain of concrete badly in need of visual relief and practical use. With grant support from the North Carolina Arts Council, we contracted with artists Jim Hirschfield and Sonya Ishii to create a temporary installation in the space. Their design included custom-built benches, large planter pots containing small shrubs and newspaper vending machines containing newspaper-sized cards commissioned from an artist. Ishii and Hirschfield explained that the vending machines expanded the installation's participatory function to 'visiting relatives [who] could purchase one or more drawings as a kind of "get well" artwork.' The proceeds went to support the paediatrics child life programme.

Viewed laterally from ground-level windows in the lobby, the courtyard design appears random but to patients in the bed towers above, the design reveals two giant opposing spirals, like colourful whirligigs. Without altering this underlying pattern, we recently added to the installation an exhibition of 'critters' created by Bynum artist Clyde Jones. His capricious constructions of reindeer, hippopotamuses, horses, pigs and birds cut from logs with a chainsaw weave in and out of the benches and planters. The artist recently gave a demonstration of his singular woodworking technique as hundreds of people – patients, visitors and staff – watched from the courtyard and the windows above.

Another major project designed by Hirschfield and Ishii, a roof garden on the hospital's fifth floor, has undergone shifting fortunes. Their original proposal, for which we received a grant from the National Endowment for the Arts, was for a space designed to address the needs of two patients populations: paediatrics and obstetrics/gynaecology. Administrative staff from these two units met with the artists to describe their particular concerns, such as the need to provide flexible play space for the children while at the same time keeping them away from patient room windows. The project eventually reached an impasse because the conflicting needs of the two groups could not be resolved within the structural constraints of the site. This process exemplified the difficulties of retrofitting. The impasse was resolved when the director for child life pointed out that, because a new elevator was being built, the play yard could be relocated outside and still be accessible.

The artists then went back to their drawing board to create a new design to serve the obstetrics and gynaecology patients and their new scheme was well received. Its prospects looked bright until a major problem emerged: new regulations concerning load-bearing capacity for the space have gone into effect and people will no longer be allowed on the rooftop. A third design is now required to create an installation that will provide patients in the surrounding rooms with only a visual experience.

Another garden is being designed for the enjoyment of Eye Centre patients and visitors. It will feature plants that provide aroma all year round. A grant from the North Carolina Arts Council supports the design of the project by a ceramic artist and a metal sculptor, who will collaborate with the medical centre's horticulturalist to create seating, plant-holders and paving patterns. This fragrance garden will be developed in conjunction with other plans for landscaping the surrounding area – which extends between two large buildings and will eventually connect with the new paediatrics play yard.

Another Eye Centre project will provide a landmark sculpture to give greater visual definition to the building's driveway entry. We requested slide submissions from members of the Tri-State Sculptors Guild (North Carolina, South Carolina and Virginia). From these we selected seven sculptors who submitted additional slides. We will begin the final selection process in the Spring. The chosen artist will be commissioned to prepare a formal project proposal which we will use to solicit funding for fabrication and installation of the sculpture.

Incorporating Art Early and Facility Planning

All these projects address Ulrich's criteria. Each is being designed to give the patient maximum experience of control while at the same time keeping uppermost the need for refreshment and relief. In the planning process we address the many ways in which our experiences are shaped, both directly and obliquely, by the physical structures that contain us. Think about your own

experience in hospitals and clinics and consider the messages conveyed to people entering a facility: what kind of mind-set is established just in getting from the parking lot to one's destination? Is it difficult to find your way? What, if anything, is conveyed about the mission of the institution? Is the facility patient-centred? Does anything indicate that anyone cares that the patient is there? Does the environment project familiarity or alienation, comfort or fear?

Before the patient even reaches the doctor's office there are environmental factors that affect his or her psychological and emotional responses to the upcoming clinical encounter; the outcome is already engaged. Malcolm Miles, Director of the British Health Care Arts Centre, states:

> The interface of doctor and patient occupies a small part of the time during which a person is hospitalised; yet the patient is interpreting the data of her or his senses all the time. This affords endless opportunities to create a sense of recovery and well-being through environmental factors in which the arts, including architecture, design, and landscaping, have a major role to play. This argues for the practicality (and economy) of incorporating the arts into the medical environment right from the initial facilities design meeting. Such seemingly simple elements as signage, lighting, wall covering, and paving, for example, may have as much aesthetic impact as sculpture or a fountain. Including an artist's insights in the design and planning of these elements can be much less expensive than retrofitting, and the effect on the overall atmosphere of the facility can be profound. (Miles 1992, p.27)

The CSP looks forward to a new level of engagement in environmental design. Duke University is embarking on extensive renovation and additions to the medical centre and we have been asked to participate in the facilities planning process. We will now be able to spot, and take advantage of, early opportunities for artistic involvement in defining the impact of the space on its inhabitants. The areas for which we will have input include entries, lobbies, waiting areas, patient lounges and passageways. We will be involved in design that facilitates traffic-flow, including getting visitors easily across the considerable distance from the parking deck into the building. We will participate in designing the lobbies in such a way that they can be converted into performance areas. We have begun discussions with the administration about a patient library and a medical history museum.

One project already under way is a collaboration with the North Carolina Museum of Life and Science to develop an educational, interactive installation in the Eye Centre paediatric clinic. In this pilot project we will work out the 'bugs' and define the process by which we can best involve medical centre personnel. The success of projects such as this relies on the informed co-operation of everyone: receptionists (who spend all day in a single environment), engineering and operations staff (who can tell us what's behind the walls) and

physicians and professional staff (who have an interest in the educational content of the display). This promises to be a highly attractive collaboration as far as funding is concerned. If the pilot phase is successful we will propose a similar and more extensive collaboration for the waiting area in the new children's hospital now being planned.

This kind of project is truly an exciting example of the real 'cultural services' that are realised when all elements of the medical centre come together. Our hope is that every element in future health care facilities will be chosen consciously to contribute, in even the most modest ways, to the spiritual and emotional well-being that must underlie physical healing.

References

Daniels, K. (1992) 'They wrote us a poem.' *North Carolina Medical Journal 53*, 645–8.

McLaughlin, J. (1988) 'Preface.' In P. Fuller *New Works: A Public Art Project Planning Guide*. Durham, NC: Durham Arts Council.

Miles, M. (1992) 'Asclepius and the muses: arts in the hospital environment.' *International Journal of Arts Medicine 1*, 2, 26–29.

Palmer, J. and Nash, F. (1991) 'The hospital arts movement.' *International Journal of Arts Medicine 1*, 1, 34–38.

Semans, J. (1991) 'Preface.' In J. Palmer and F. Nash *The Hospital Arts Handbook*. Durham, NC: Duke University Medical Centre.

Ulrich, R.S. (1991) 'Effects of interior design on wellness: theory and recent scientific research.' *Journal of Health Care Interior Design 3*, 97–109.

Part VI

Artists in Residence

Of their mattress-life oblivious
All the patients, brisk and cheerful,
Are encouraging the dancer,
And applauding the musician.

W.E. Henley, *Interlude*

Some Questions of Identity
What is Writing in Health Care?

Fiona Sampson

> You ask me why.
> I always question.
> Poetry is expression
> Feelings moulded in words
> Shaped into sentences.
>
> A transient feeling
> Encapsulated into words.
> Set free from the mind
> That today feels
> Anger, hatred, sadness, joy.
>
> Set down on paper
> Written by hand
> Typed by fingers.
> I write poetry to tell you
> How I feel – but do you listen!

<div align="right">

(Jenny, The Cedars Mental Health Day Hospital,
Isle of Wight Community Services Trust)

</div>

'What is writing in health care?' It's my experience that health care managers, occupational therapists, community writers, even hospital arts project adminis-trators, are equally likely to start a discussion with this fundamental question. Though they may mean different things by it, broadly speaking they are referring to a set of questions along the lines of 'Who does what to whom, and why – and who pays?' For my colleagues these questions represent a starting point, but they are also integral to the development of the practice of writing in health care. I've been addressing them since 1988, in practical, historical and theoretical terms. Coherent practice arises from a specific history and is based

on specific aims and ideas and I've found that the most useful answers address all three areas. In this chapter I intend to map them briefly.

My first post working with writing in health care, as writer-in-residence for the Isle of Wight District Health Authority, was also the first to explore systematically the possibilities of provision throughout the range of areas of NHS health care. We quickly found out that this comprehensiveness was significant. This was partly because of the opportunities its status lent the work but also because we were developing a practice by the scientific method – by empirically testing a hunch that some kinds of provision might be useful in principle – and we needed to find out as much as we could about where and how writing works in health care, and to what end. As this suggests, looking at the way in which that initial residency was organised should allow us to situate writing in health care in at least some of its practical and intellectual contexts.

Another equally important way to examine the identity of a writing project is to look at its content – what activities go on, what writing is produced and what clients and staff feel about their involvement. I'd like to spend part of this chapter looking at four different kinds of writing project activity. I will finish with a brief discussion of the skills involved in such projects and of the administrative and funding structures they imply.

The context for writing in health care is not and has not been primarily literary. Nor have its approaches developed by analogy to art therapies, music therapy or even the valorisation of story in psychotherapy. Instead, the practice is to be found at the junction of changes in thought about the ways in which health care is delivered and the national movement for the provision of arts in health care – historically a movement to humanise the health care setting through the visual arts (see Senior and Croall 1993).

Since my first residency on the Isle of Wight, I've worked on a wide range of short- and long-term projects in health care settings, from maternity hospital to psychiatric prison unit. I've been funded, variously, through an NHS Occupational Therapy budget, by Health Authority Trust Funds channelled through hospital arts projects, by my Regional Arts Board and other arts organisations and by community funding organisations such as the Rural Development Commission and the Wiltshire Community Foundation. Initiatives generally involve joint funding: one of the effects of this may be to give equal weight to the health care and the art, or community, identities of the project. My first residency for the Isle of Wight District Health Authority, for example, was initiated by the Health Authority's own arts project and jointly funded through District Health Authority Trust funds and Southern Arts. The District Health Authority was committed to the quality of its health care provision and Southern Arts to widening the role for the arts in its region. The contract established the proximity and tension between these aims: my brief was to 'develop uses for writing and literature in health care'. As a result, that

first residency was equally committed to the production of good writing and to sharing the aims of the health care units in which I worked.

What this meant in practice was that we did not regard facilitating access by health care clients to undiscriminated writing or other verbal activities, such as quizzes or assertiveness training, as satisfying my brief with sufficient rigour. We based the residency's work on the belief that certain kinds of writing – whether produced by or used in other ways, for example in discussion, by clients – offer something extra by virtue of their literary type. What that 'extra' might be is admittedly a bone of contention in contemporary cultural and literary studies, but the residency worked to find what 'extra' ingredients might be required of a writing practice by the health care criteria of units in which it was situated.

Not all of these can be reduced to the criterion of whether a practice could be said to 'heal'. For example, they include respect for client confidentiality and the consequent notion of the client's 'ownership' of his or her history and account of that history. In other words, respect for the individual's account forms part of the new client-centred approach to health care. In long-term rehabilitative and mental health care the individual literary account creates those imaginative margins of individuality and activity which help the client to assume an active role. Community care posits a role for client responsibility which at its best can be seen as empowering the object of expert clinical attention to achieve full subjectivity. The acquisition of skills of real quality, rather than provision which patronisingly assumes that any 'community' or 'disadvantaged' group must be capable of only limited achievements, allows integration of clients into the mainstream of expert activity which is going on in their health care units and addresses the balance between the roles of client and health carer. Finally, the arts activities have a history of association with the idea of healing. They may be said to offer, for example, catharsis, escape, or the scope for contemplation and reconciliation (see Downie 1994).

As the residency for the Isle of Wight District Health Authority developed, guided by the context in which it was initiated, it established that links could be made between writing as an arts activity and health care aims. It also instigated a range of activities – from exhibitions in local libraries to workshops incorporated into a weekly programme of group psychotherapy to special programmes for hospital radio – and a repertoire of exercises. However, it had not yet established what – apart from the accessibility of an artform made through the medium of something as immediate and everyday as language – might be peculiarly useful about *writing* as an arts activity in health care.

Areas of Activity

Subsequently, I have not only returned to work for the Community Services Trust of the Isle of Wight DHA, but have carried out a wide range of writing

projects in health care, from in-service training days for charities to work in, for example, a psychiatric prison unit, a hospice, a maternity hospital, with head-injured patients in rehabilitation and in long-term geriatric and psycho-geriatric care. This 'division of labour' has clearly delineated for me four main areas of activity which writing in health care affords. At the same time, I've begun to explore ways in which theory – of language or of personal identity, for example – might formulate the potential achievements of writing in health care. The result is, I hope, a clearer 'map' of the principle identities of writing in health care:

1. In work with people with learning difficulties, skill-bearing exercises – such as description, which develops the habits of more prolonged and exact thought, and narrative, which requires the continual exercise of judgement about characteristic or desirable development and also allows the writer to examine character – must be introduced in enjoyable and unmystifying ways. This may well mean, for example, sidestepping difficulties with literacy by using dictation. (For the sake of clarifying their status I will also call the authors of these written texts 'writers'). It should also mean valuing the written product of sessions sufficiently highly to edit and display it – in exhibition, publication or performance – so that clients gain access to the sense of writing as an activity in which they can participate fully and successfully, even to the point of acquiring an audience. For example, this poem by members of the writing group at a Day Centre was one of a set published as professionally-designed posters (see Figure 18.1).

Contemporary care practice for people with learning difficulties aims to facilitate their access to all those elements which carers identify as essential to a dignified and fulfilled life. Care plans take note of where the individual client needs extra help to achieve ordinary ends such as privacy (careful toiletting procedures) or community (group homes). The chance for the individual with learning difficulties to develop in the role of an intellectually independent human subject may have to be positively facilitated too. Institutionalisation and the lack of confidence that can come with difficulties in the acquisition of skills are themselves 'difficulties'. Philosophers from Plato (see Lee 1955, pp.383–6) to Wittgenstein (see Blackwell 1969, p.5) have claimed that the individual makes his way through the world in language. Insofar as his ability to symbolise his experience to himself is limited, for example by his vocabulary, so is his ability to observe and manipulate his experience through judgement and imagination.

THE FOG

The fog's a lady.
She's mysterious, keeping secrets.
I've got a secret box of chocolates,
I've got secret thoughts,
I've got secrets sometimes
– maybe they're flowers
given by girlfriends and boyfriends

The fog covers things up
Fog is blue, white,
grey on the back of wind.

The fog is good
because she comes out at night
like a girlfriend.

The moon comes out at night too,
like the Mona Lisa.

Figure 18.1. St Cross House Isle of Wight Community Services Trust Day Centre Writing Group. Designed by Andrew Mead: Healing Arts: Isle of Wight 1993: No 3.

2. It is here, rather than in the context of specific exercises, that the
 practice of using writing and literature with people with learning
 difficulties overlaps with work with people with mental health
 problems. What both kinds of writing groups develop as their
 members become confident with at least some writing techniques is
 not discursive *authenticity*. To what further phenomenon after all
 would an individual's account, whether fiction or not, be 'authentic'?
 Rather, the writers in both kinds of group develop narrative *authority*.

The writing practice in a mental health care unit may or may not be carried out
in a trust group co-led by trained therapists; and it may or may not operate as
a closed group which allows participants to develop a full sense of a writing
peer group. But each of these different formats allow clients, who may for a
number of reasons – from terrorisation by psychosis to a history of poor care
management – lack confidence in their version of their own experience, to
present and to explore that version. It provides an opportunity to take up the
role of narrator, perhaps hitherto assumed in group members' lives by care staff
or by other members of the community. This opportunity is afforded both by
skill-bearing exercises such as the production of technically sophisticated
poetry of a calibre not hitherto associated with the writers involved and by
thematic sessions which use reading and writing literature to explore the world
of the writers' experiences. This active repositioning, in which the client takes
narrative control of his experience, can also be useful in work with clients who
are experiencing the objectifying drama of acute health care, for example in
surgical units or with women in ante-natal wards.

3. Work with writing in mental health care settings can allow clients to
 assume the authoritative position of the narrator and explore what
 they can formulate in language (symbol) and how. The effect of such
 work can be to rectify the subjectivity of the individual client
 involved. He is taking up an active position and eschewing rival
 versions of his own experience. Practice in long-stay and/or
 rehabilitation units also works to reify the individual client's sense of
 his subjectivity, and indeed its general profile. The recipient of
 long-term health care, who has occupied few, if any, alternative roles
 over a period of weeks, months or even years, may lose the sense of
 his own subjectivity and the experience of his own agency. The
 process of encouraging individuals in this position to write may
 involve imaginative and skill-bearing exercises, for reasons we have
 looked at above. However, where older people or the dying, for
 example in hospices, are involved, the acquisition of new skills may

be less important than the collection, appreciation and rendered permanence of clients' own stories of their experiences.

The perceived need to take stock, or to complete some of the work of understanding which goes on in every human life, are patterns these clients encounter in the expectations of their families and often of their carers too. That does not mean, however, that these expectations are false or that such needs are always met. Where there is a writing project, a unit is likely to find out more about its clients and see them take a greater role in discussions. The result offers, I would suggest, a demanding, but rich, model of a 'choral' health care communication community, in which clients are also discursive participants.

4. 'Uses for writing and literature in health care' need not be exclusively concerned with the health care clients as writers. Other forms of provision can supplement workshops or can access health care units, such as Accident and Emergency, where acute care demands or lack of staff support preclude workshopping. In America, 'bibliotherapy' allows texts to be read and studied as the stage for explorations of moral dilemmas or cathartic examinations of emotions (see Jones 1990, pp.11–24). We have already touched on this in stage 2 above. We have also touched (under 1 above) on the importance of valuing the writing produced by a project to the extent of exhibiting and/or publishing it. Experience leads me to prefer display in prestigious venues such as arts centres in order to reach a wide audience with work which is being designated as an achieved *product* as well as *process*.

Writing in health care can bring literature into the health care environment in other ways too, for example by commissioning poems for display in the unit, or through hospital radio. Theatre companies can be brought into day rooms to perform: many specialise in working with community audiences and facilities. In each case the idea that language limits its content is as pertinent as it is in, for example, devising skill-bearing exercises for clients. The work of poets and theatre companies of the highest calibre – whether contemporary or not – will have the most to say to clients of health care.

One of the points that has arisen repeatedly in this chapter is this insistence that the work done in certain types of writing activities which we designate as 'literary' has significantly more in common with the aims of health care than that achieved by others. In other words, a health care writing project requires a team member with significant literary skills in order to work in useful ways. This is a strong argument for bringing in a professional writer to run a project. A second argument values the idea of an animator who encourages clients into

the centre-stage of writing and in doing so steps out of the conventional hierarchical model of relations between clinical health carer and client. A writer is no clinician; but neither can she – and by extension the activities she initiates – be dismissed from clinical convention that marks out the writer's work as a special event in a health care unit and makes the content of writing activities more accessible to clients.

This is not to recommend that health carers be excluded from a potentially exciting project. A new, visiting, and perhaps temporary, member can be refreshing for a team. Conversely, it's important to give someone new to health care the appropriate induction and supervision to enable them to work effectively in a unit. A writer might only visit each team with which she is working once a week. It's important that clients and staff are encouraged to support these visits. A 'host' staff member can make this easier: where there is no arts administrator or STAR (Social Therapeutic and Recreational) nurse for a unit, it is a good idea to designate some kind of informal line-management arrangement. Such an arrangement can also provide a framework for recording or evaluating a writing project: work which may be done in several ways, from a questionnaire to attendance statistics to a critical literary evaluation of the work produced.

Finally, and despite the complexities this chapter has touched on, it's important to add that writing projects in health care are easy to run. They require no special facilities, expensive or messy equipment and, above all, no history of the display of special abilities in participants. Writing in health care aims to include and celebrate the verbal skill of the individual who finds himself in receipt of health care. These skills fundamentally shape his experience: their significance, in the contexts of recent changes towards client-centred health care, are an arts provision which must earn its position in society by a rigorous outreach policy, and the universal need for human dignity must not be ignored.

Happiness/Unhappiness

Happiness is the feeling of finally completing
the jigsaw, filled with memories.

Unhappiness is where the pieces of jigsaw
are missing and cannot be replaced.

(Andrew, Church View Social Services Day Centre, Isle of Wight)

References

Downie, R.S. (ed) (1994) *The Healing Arts.* Oxford: Oxford University Press.

Jones, A.H. (1990) 'Literature and medicine: traditions and innovations.' In Clarke and Aycock (eds) *The Body and the Text.* Texas: Texas Tech University Press.

Senior, P. and Croall, J. (1993) *Helping to Heal: The Role of the Arts in Health Care.* London: Calouste Gulbenkian Foundation.

A Painter's Perspective

Chris Barrett

Introduction

One way of implementing an arts policy within a hospital is to employ an artist-in-residence. When Furness General Hospital, Barrow-in-Furness, Cumbria, decided to take this course, it was felt that a visual artist on site for a twelve-month period could make a notable impact. With a broadly-based brief, it was hoped the artist would be able 'to bring their expertise to bear upon the problem of blandness in the built environment' and 'to introduce the visual arts to hospital staff, patients and community as a valuable resource in health care'. What follows is an account, from an artist's point of view, of some aspects of that residency and a discussion of some of the broader issues raised.

The Local Scene

These objectives were in response to a report commissioned by South Cumbria Health Authority from British Health Care Arts (now Health Care Arts). In this report, Malcolm Miles set out three areas of concern: the need for an arts policy integrated into other aspects of planning in the unit, the identification of specific sites and opportunities for the arts and the importance of developing local community links. The Hospitals Arts Group was then formed. It consisted of a number of key managers, staff and a patient representative, who set about formulating an arts policy. Priority areas were identified and the decision made to appoint a full-time visual artist-in-residence. As a result of working closely with the local County Arts Development Officer and Northern Arts, a third of the necessary funding was found from these sources; the remainder was drawn from Hospital trust funds. I was among the two hundred or so artists who responded to the advertisement placed in the Artists' Newsletter magazine. A shortage of well-qualified and capable artists is not going to be one of the problems for anyone setting up a hospital residency. Artists' attitudes to public art have changed more than is generally realised. Few artists now concentrate

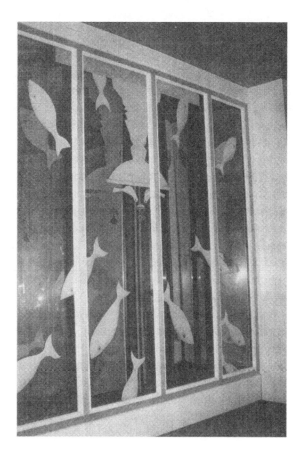

Figure 19.1. Furness General Hospital glass screen (illustration by Christopher Barrett)

their work exclusively on personal concerns or questions of artistic form, or have complete confidence in pursuing totally gallery-based careers. Almost all dynamic contemporary art is concerned with questions of interaction. Modern art is likely to be about the way individuals relate to society and the created environment or how men and women interact or how humans relate to nature. Academic courses for artists wanting to work in public contexts are increasing in number all the time, which suggests the change of emphasis is already well established. No doubt, like many other artists who saw the advertisement, I was attracted by the chance to focus my activities by being able to respond to a particular and challenging environment. After completing some paintings for an exhibition at the Museum of Modern Art, Oxford, I began the residency on April Fool's Day 1992. The original twelve-month contract was extended until the money ran out in August 1993.

Use of Colour

It was obvious that one of the causes of the perceived 'blandness' of the hospital environment was the colour, or rather the lack of it. This was most obvious, not in the two Victorian hospitals for which I also had responsibility (the 117-bed geriatric and psycho-geriatric hospital at Roose and the 76-bed geriatric and out-patients' hospital at Ulverston), where a great deal had been done to create a homely atmosphere through the use of colour and furnishing, but in the modern 404-bed Furness General opened in 1984. Indeed, it was the latest extension to this new building (1989) which was felt to be the worst. On the day of opening there had been complaints about the oppressive effects of the grey paint. There were jokes about leftover paint from the battleships which were once built in the town. After a few years, decisive action was taken and the walls were repainted in a lighter shade of grey. Architects will often specify grey, which, according to Dr Max Lüscher (1970, p.52), represents an unoccupied territory, a 'no-man's land…a region of separation', despite studies which suggest that only violet, in an architectural context, will provoke a stronger negative response (Porter and Mikellides 1976).

By working closely with the Units Works Department, and their ongoing redecoration programme, I was able, over the period of the residency, to offer an opinion on colour schemes for a large number of internal and exterior sites. The choice of colours available was increased from nine to one hundred and thirty. It became possible to use colour in a practical, as well as decorative, way. For example, the walls of the kitchens were painted to co-ordinate with the colour-coding system used for different food preparation areas. In the children's wards, where panels were being fixed above beds to secure lights and other fitments, it became possible to individualise each bed area. In the various lift lobby areas, confusion had resulted from visually identical areas on different areas on different floor levels. By painting these in individual colours, the problem was alleviated. Involvement in the hospital redecoration programme turned out also to be an effective way for me to discover the nature of many departments and wards, and to build contacts with staff and patients. I became interested in the potential functional uses of colour, as well as aesthetic considerations.

One area where such a multiple role for colour has been shown to be effective is in hospitals and hospital wards caring for elderly patients with some form of progressive, irreversible dementia. Such patients tend to wander into restricted areas, or hover around the exits, or rummage in other patients' lockers. By eliminating colours which attract attention to these areas it has been found that these, and other undesired activities, can be dramatically reduced. This use of colour to 'cue-out' areas seems to be more effective than attempts to provide some form of colour-coding, in order, for example, to help such patients to find a washroom or bedroom. However, patients are attracted by bright colours and are likely to stay longer in well-lit, brightly-decorated rooms (Cooper, Mohide

and Gilbert 1989). With a greater freedom of choice now given to staff in choosing colours, there is a great deal of value in increasing awareness of such functional aspects of colour. Artists on site can certainly contribute to this.

The role of colour in health care deserves more attention than it receives at the moment. There has been an explosion of colour in recent years in hospitals and health care centres. This expansion has not been confined to the use of colours in furnishings, signs and wallcolours. The use of colour for diagnostic purposes has also expanded rapidly. For example, the advances in endoscopy have resulted in colour imagery to provide information about the nature of lesions and identify sites for biopsy. Clearly it is important that those who calibrate the instruments and manipulate the colour controls should have a sound understanding of the basic visual principles of colour (Vakil, Knyrim and Everback 1991). At the moment, there appears to be virtually no colour training. The increased use of colour also raises questions about the consistency of colour terminology, not only within departments but across departments. Another consideration is colour blindness. Colour vision testing is almost unknown in the health service, even though around eight in every hundred men in Britain have some form of colour defect. Many individuals remain unaware that their vision is in any way impaired. Even in traditional areas where colour discrimination lies at the heart of the work, only recently has any attention been paid to this issue. In a study of thirty pathologists in one large English city, ten per cent had below-average colour perception. Of these, two have specific and major defects shown to affect their ability to interpret a wide range of stains (Rigby *et al.* 1991). These are obviously issues for each profession to consider, but an artist working in health care can contribute in a positive way to increasing colour awareness, and even suggesting the form some basic colour education can take.

Often a simple request 'to look over some colour schemes' can lead to a much more comprehensive introduction of the arts. An example is provided by my collaboration with the Community Mental Health Unit: the colour schemes had been drawn up for a new mental health building nearing completion. Initial discussions led to a much wider consideration of the possible role of the arts in the life of this new building. This ranged from simple measures, such as making provision for the display of artwork, to commissioning site-specific work and to creating some flexibility in the staffing of the new building in order to allow for arts projects to take place. A major sculpture commission, advertised nationally, resulted in an ambitious interactive courtyard sculpture by Kerry Morrison and attracted further significant funding for the hospital arts programme. Another important artwork, a textile piece for the main social area, was commissioned from Sue Houghton, who worked closely with the nearby sixth-form college. This has resulted in a valuable working link between the hospital and the college.

Painting and Drawing

The contact with the sixth form college, and with other schools, colleges and groups in the area, developed largely as a result of a life drawing group I set up in my studio within the hospital. Drawing and painting from a nude model was an unusual activity in Barrow-in-Furness (the suspicions of a night nurse resulted in a police raid on one occasion). But the rarity of the opportunity meant that serious artists were attracted to these weekly sessions from a wide geographical area. The goodwill of those whose support was essential in any long term arts activity within the hospital was gained. Direct informal links between the people within the hospital interested in the arts and those in the community were developed. Members of local arts societies were also regular attenders. The arts societies were already involved in the hospital through their popular exhibitions of members' work in the main hospital corridor. The potential benefits of having regular arts activities such as this within a hospital are great. People from inside and outside the hospital are brought together and resources shared. Such a group has the potential to become the nucleus of some form of hospital arts society. It could serve as a focus for the development of the arts in hospitals, and as an active link between the hospital and community. An annual hospital arts day could be established. This could even happen on a nationwide level. Another important role such a society could have would be to devise means by which arts activities within the hospital could be followed through in the community.

Largely because of the location of the studio, it was not possible to involve patients directly in these life drawing sessions. However, patients did become actively involved in creating artwork in other ways. The work I did with the elderly patients can serve as an example: on visits to these wards, I started by making some drawings. After a few visits I started some painting, including a portrait of one of the patients. This activity seemed to have a positive effect on the atmosphere of the wards but I wanted to develop some way for patients to become more directly involved themselves. There was a need for a medium which was easy to handle, clean, bright and fairly quick in producing results. By covering sheets of adhesive-backed paper with brightly-coloured vinyl tape (more usually seen as colour-coding for industrial pipes), it was soon possible to have large sheets of bright colour which could be cut easily into shapes, arranged and re-positioned at will. These large sheets of bright colour, spread on the floor and tables of the room, made quite an impact on the ward. Images drawn from memories, or from the ward itself, were made from them. I was later able to organise an exhibition of this work in the town's Art Centre. Later, these lively images (which included flowers, animals and the 'naughty milk-maid') were returned to decorate the hospital.

Working with Therapists

The work done by artists involving patients directly in artwork cannot be isolated from the work of health professionals such as Occupational Therapists and Art Therapists. Perhaps because of the need on the part of those introducing artists into hospitals to avoid areas of potential professional conflict, combined with an historical tendency on the part of these health professionals to stress the more easily-evaluated practical and diagnostic aspects of their work, it has been possible to keep the roles of artists and roles of health professionals separate. But the more successful the arts in health movement becomes, the more difficult it will be to avoid a clearer definition of this relationship. At present, one senses an almost apologetic note in statements about the therapeutic role of the artists – even from those most eager to promote the widest benefits of the arts in health care. 'Many people outside the health field are confused about the respective roles of the two professions. While there is often overlap in the work, therapists are essentially providing a diagnostic service as part of the clinical team. Artists' works may indeed be therapeutic in the general sense of the word, in that it is helping to heal; but that is only one aim of their work' (Senior and Croall 1993, p.7). At some stage, the exact role of professional artists working directly with patients – especially in areas such as mental health, where the potential for good is so great – will have to be more clearly defined. This may well be happening already with an increasing number of successful instances where artists are employed specifically to work together with a particular health professional. Perhaps a fuller discussion on the role of artists in this area will also enable the contribution of true pioneers of the arts in health movement fifty years ago to be acknowledged.

My involvement with the Occupational Therapy Department during the residency was wide-ranging. As well as working with patients attending the Day Hospital, using similar techniques to those developed on the wards for the elderly, I was able to use my experience with printing to help staff extend the use of the equipment in the department. Many Occupational Therapy Departments still have small hand-operated letterpress printing machines for the use of patients and some form of collaboration between a writer and graphic designer working with staff and patients could be very successful. Printing was also involved in a separate project. This was for a series of 'philosophy of care' notices to be positioned prominently outside wards and out-patients' departments. I felt it was important that these should themselves be statements of quality and a considerable amount of thought went into their design, decoration and presentation. Unfortunately, these proved to be ephemeral. Shortly after they had been positioned I received a call from the nurse manager who had initiated the project. 'We've been re-organised' she said 'can you come and change our philosophy please?'

Improving the Environment

The closure of Roose Hospital was one consequence of this re-organisation. As a result, it was necessary for a new day hospital building to be built as an extension to the Occupational Health Department on the main hospital site. The severity of financial constraints, and the speed with which the new building had to be designed and built, made it difficult for an arts input to be properly included. Even when the willingness is there, it is not always possible to plan in detail an integrated arts element into every new building project, despite the evident desirability of such an approach. What is always possible is to design a building which allows an arts element to develop from it. In this case, for example, I was able to work with the architect to create a number of large, well-lit recessed areas at nominal extra cost, which could be clearly seen as ideal sites for the installation of future artworks. These might well be textiles or paintings, perhaps involving the users of the new building. The courtyard area of the new building was to be used as an area for patients to try out wheelchairs, which again provided a good opportunity to create something visually pleasing as well as practically useful.

One of the courtyards at Furness General lies between the main corridor and the wheelchair store. This store has two walls, which were completely glazed. The result was that one of the main views within the hospital was of an unsightly crush of wheelchairs and cushions. By decorating these windows I was able to hide these wheelchairs from view and bring to life the whole area, including the courtyard space. Empty hospital courtyards are notorious as lost spaces. For the arts, they are often opportunities. These are recent examples where architects, aware of the problem, have decided to exercise their own broad creativity in these areas rather than allocating the resources to carefully thought-out individual projects. The results have often been unfortunate.

When the X-Ray Department staff decided to take over the neglected courtyards around their area, the results were a dramatic improvement. The sight of cared-for plants and flowers and seating delighted those who saw them on their way along the main corridor. In this case, the idea of courtyards being adopted was a great success. My main work with the X-Ray Department was the improvement of the entrance area to the department, which came off the main corridor. By working closely with staff, I was able to produce a number of X-ray images to be used on the glazed area of the entrance doors. These images were of a variety of objects. There were pieces made from fruit. Others used metal, some of which was cut to form letters. The results were clearly recognisable as X-rays and so served to highlight the nature of the area, but the imagery was positive. The project was also regarded as a valuable refresher-training element for the staff.

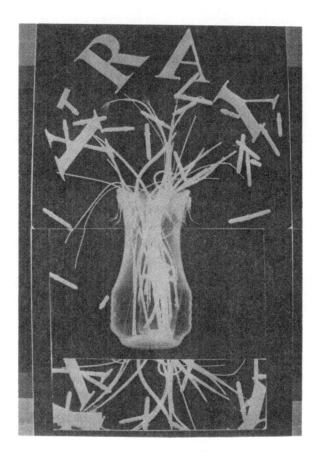

Figure 19.2. Furness General Hospital glass panel for X-ray Department Entrance
(illustration by Christopher Barrett)

The corridor and lift had been identified as priority areas in the original brief. Mention has already been made of the potential role of colour and this was carefully introduced. I also undertook a comprehensive clarification of the signposting. As part of this I drew up a possible colour-coding system, which, in the end, I felt was not necessary. All hospitals have recently paid considerable attention to waymarking and most have adopted some form of colour-coding. This has taken various forms. There are coloured lines snaking along the floor or around the walls, eye-catching coloured squares, circles, triangles, coloured images and coloured numbers. It is worth noting some of the reasons why a full-scale colour-coding system was not adopted in the major rationalisations of the 1960s, although it was certainly carefully considered. The aims at that time were to improve the clarity of waymarking, and to save money. The design team was led by the leading graphic designer of the time, Jock Kinneir. He

resisted pressure from management to introduce some form of colour-coding in all areas other than the red used for Accident and Emergency Departments. He argued that it was unnecessary and, in the longer term, likely to lead to greater confusion. Another consideration was nomenclature – what one person calls blue, for example, someone else will know as purple, or violet, or mauve – an important factor when directions are to be given verbally. The justified criticism of hospital waymarking, of its inadequacy and confusion, can be attributed to inconsistent application, thoughtless proliferation and poor positioning rather than to a lack of colour. There is still a possibility that inconsistent application, thoughtless proliferation and poor positioning will continue into the future, only now with the addition of a whole new world of colour and pattern. If hospitals make sure they can call on people who are visually aware, the risk could be reduced. As to cost, of all the design rationalisations of the 1960s only the standardisation of door designs saved the National Health Service more money than the monochrome waymarking system which was introduced (Kinneir 1992).

Perhaps the most experimental work I produced during the residency was a glass screen for the main lift lobby. This provided a visual focus for the end of the long main corridor, privacy for telephone users and character to that part of the hospital. The screen consisted of two glass layers with a gap of 18 inches between them. In this gap was placed silver solar glazing film, which has the unique optical property of being both reflective and transparent depending on the lighting. Both layers of glass are decorated. The resulting reflected images appear to float in space. The images of a large vase of flowers and a fountain (felt by one person to be too modern) complemented a linoleum floor design to suggest a garden with flowerbeds and paths. The potential of using linoleum in a simple decorative way, at minimal extra cost, has only begun to be explored in health care settings, despite the obvious decorative and practical advantages.

Murals

My main experience of working in hospitals has been with murals. At Furness General Hospital the most important of these was the panoramic mural I painted for the main corridor. The possible sites for a reasonably sized mural are often less than at first appears. There are often very few stretches of wall clear of doors, windows, notices, pipes, fire equipment and other obstacles. Unfortunately, mural painters are almost always called in to 'improve' an area, but no amount of mural painting can put right a fundamentally unsatisfactory space. The mural painter should be involved at the design stage, working with an architect. In this way a mural can help to define the architectural space and the architecture to frame the mural. But architects are rightly cautious of mural paintings. Michelangelo, with his profound understanding of the nature of murals, never tolerated any in buildings he had himself designed. This is

acknowledgement of the power of murals to alter the perceived space in a building. Unfortunately, in most hospital buildings this turns out to be a desirable aim. A number of my murals have been painted in claustrophobic spaces, where an apparent opening up of the area has had positive results. A mural painted for the John Radcliffe Hospital, Oxford, Maternity Department is one example. The site is a large windowless room, used for parentcraft and other classes. There were many instances of fainting in the oppressive enclosed space. I painted a large landscape mural which gave the illusion of light and space. Since the mural's completion there have been no reports of anyone fainting in the room.

The Oxford mural was based on a view from the hospital roof. The mural at Furness General Hospital was also a local landscape. I had resisted the request of one manager to 'turn the corridor into a ruin'. A local landscape is an effective way of bringing the locality into the hospital and encourages the perception that the building itself is part of the local environment. Approaches to subject matter for murals have developed over the years. In the past, a hospital mural might have consisted of Disney characters or jungle scenes. Whilst there are still a number of rather dull paintings on these themes, or dry illustrations of local history, today's hospital mural affords an opportunity for a much more imaginative approach.

The successful development of hospital murals depends on confidence, as it does for other aspects of the arts in health care. Artists need to feel confident that their work is worthwhile in this context, and that there is a base of support for it. Those commissioning work also need to feel confident of support, and that artists have a professional attitude. Confidence comes from familiarity and the many examples of successful arts projects in recent years has set the stage for a positive future. My time as hospital artist-in-residence certainly opened many eyes to the extent to which art could contribute to health care. As a mural painter, the belief that murals are highly appropriate in a health care environment was reinforced, as was the wish that they could be integrated into buildings at the planning stage.

References

Cooper, B., Mohide, A. and Gilbert, S. (1989) 'Testing the uses of colour in a longterm care setting.' *Dimensions* p.22–26.

Kinneir, J. (1992) Personal communication.

Lüscher, M. (1970) *The Lüscher Colour Test.* London: Jonathan Cape.

Porter, T. and Mikellides, B. (1976) *Colour for Architecture.* New York: Van Nostrand Reinhold.

Rigby, H.S., Warren, B.F., Diamond, J., Carter. C and Bradfield, J.W.B. (1991) 'Colour perception in pathologists, the Fransworth – Munsell 100 Hue Test.' *Journal of Clinical Pathology*, p.745–749.

Senior, P. and Croall, J. (1993) *Helping to Heal: The Arts in Health Care.* London: Calouste Gulbenkian Foundation.

Vakil, N., Knyrim, K. and Everback, E.C. (1991) 'The appreciation of colour in endoscopy.' *Baillieres Clinical Gastroenterology 5*, 1, pp.183–94.

Writing in Hospices

Lynne Alexander

> Ne'er pull your hat upon your brows;
> Give sorrow words: the grief that does not speak
> Whispers the o'er-fraught heart and bids it break.

<div align="right">

Shakespeare, *Macbeth* (VII, ii, 208)

</div>

My job as writer-in-residence at Sobell House was to encourage people to write: to give sorrow words but also ordinary pain and pleasure – anything from grief to giggles. To give words to being ill or being well or just being. I titled the book *Throwaway Lines*[1] not to devalue those words but to re-value them.

The book includes poems by 13 patients and two bereaved relatives. It also includes introductory sketches and some poems written by me.

Few of the people in this book would call themselves writers, fewer still poets. So how did the writing come about? What happened was this: in my role as writer-in-residence I engaged people in conversation, asked them about their thoughts and feelings – and they told me. They trusted me with their lives, their memories; we shared our stories.

Normally our words get lost: they fly off into space where they break up and disappear. But the things people at Sobell House were telling me – their so-called 'throwaway lines' – were all too beautiful and important for that. I decided to pluck them out of the air, as it were, and salvage them.

With permission, I took notes. From these I made – cobbled together, if you like – the poems in this book. I used those phrases which had moved me and which I thought would move others. I arranged them so they would sit comfortably on the page; rarely did I change any of the words. So they are,

1 *Throwaway Lines* is published by Sobell Publications, Sir Michael Sobell House, Churchill Hospital, Oxford OX3 7LJ at £2.50 (plus 70p postage and packing). The selection here is reproduced by kind permission of the publishers.

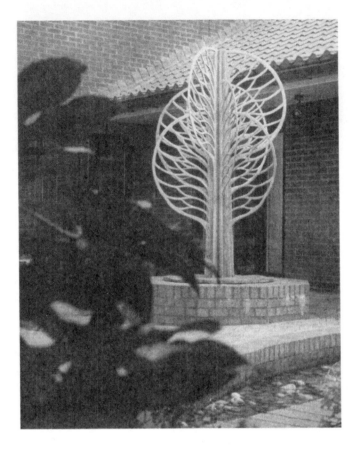

Figure 20.1. Tree of life 1992 (Bronze height 2.1 metres) at North London Hospice
 (sculpture by Charlotte Mayer)

with one or two exceptions, collaborations: the patients' words and my writing
or, as someone once put it, their libretto, my opera.

Many people avoid poetry because they think that it's too difficult and
clever. But it doesn't have to be, and these poems aren't. They are strong and
readable and very honest. Poetry is economical. Since you don't have to fiddle
about with grammar and sentence structure it gets into the bloodstream quicker
than prose. Like a drug to the veins, it has an immediate effect.

Writing is no solution to pain or illness. It cannot cure or heal physical
damage but it can help a person to feel whole again, a human being with a
story to tell. As a woman called Clara once said to me, 'I've lived to be eighty
and somebody thinks what I have to say is worth writing down. It's too funny
for words.'

'In the beginning was the Word', said St John. Words – with a small 'w' –
belong to us all and yet too often the people we term 'terminally ill' do not get

heard. Books and learned articles get written about them but their own words are ignored. It is time we paid attention.

Finally, this is my book too. In helping others to write I was also healing myself. Their words are my words. Read them, enjoy them, value them, and be moved by them as I am.

Imagination

I thought life would be condensed
into four walls
but it hasn't

Please come and talk to me,
tell me what you've done,
where you've been.

I can see flowers nodding over the wall –
Don't you think my lilies are fabulous? –
Yesterday I heard a little girl outside,
twittering away,
the neighbourhood dogs barking –
You can make up all sorts of things.
It's all going on out there.

You would curl up your toes and peg out
if you didn't have an imagination.

Greta Emery, 20 June 1991

A Load of Old Hypocrites

You're a load of old hypocrites
'Oh you look much better Cecil', they say.

It won't make me better, won't make me worse
They're cheering themselves up.

They give false impressions
'I'll give you a hot bath, you'll feel better' –

I felt fine when I came in.
By the time I left
I felt like I'd been punched about.

I've had a bloody bath.
an enema during break time.
I'm trying to thread a needle
somebody's looking, not helping.
Mind you, if he tried I'd tell him to piss off.

I don't like too much soft soap.

I'm here two days a week
'See you Monday Cecil'.
What about the other days?
I want somebody seven days a week!
I want to go and have a pee, a drink of water.

I want you to come and have a look,
When you come again and bring me so-and-so.

I think they need shaking up.

You're only trying to get medals.
Promotion
Thinking about pay day.

<div align="right">Cecil Knight, 28 February 1991</div>

For the Love of Wool (2)

All that wool
all that beautiful wool
better than any box of candy
a most superior thing
I loved it too much
it wasn't mine to love.

Sometimes we love
the things we can't have.
It left its scar.
From that day to this

I've not taken a pin.
You see that pin?
I must be careful
what I do with that pin.

<div align="right">'M', 29 July 1991</div>

I'll Knit and Knit and Knit

I have more wool than you'd ever believe:
eight huge boxes in the bedroom,
all sorts of wool; I have got:
Jaegar, Coates, Hayfield, Sheba;
some are thick, some are curly,
some plain, some thin and small – ply:
one is a spider web wool – one skein
knits a whole Christening robe.

And the colours: I've got all colours;
I even like fair isle.

I'd like to knit them myself
but my life is limited –
When I retired I thought
I'll knit and knit and knit,
and now I wind up with cancer of the spine.

It means my life will terminate.

Those words 'if only' –
they tell me I'm a good knitter –
but wasn't I lucky to buy all that wool?

'M', 8 August 1991

You Horrid Little Lump

You horrid little lump
You shouldn't be there
Who asked you in?
I wish you would go away
I wish you would go away
with your big nose and mouth
 bulging eyes
 leering look
 malformed tissue
 different colour
 blacky colour
 gritty, lumpy
 squadgy lump
Gets in the way
Shouldn't be there
Go away!
I would like to squeeze you
so hard and destroy you.
I would like to pinch
bits out of you until
you are all gone.
I want to hurt you
as you have hurt me.

Adele Strange, 3 May 1991

One day I noticed Jessie was wearing a black glove on her right hand and she
seemed to be staring at it as if it didn't belong to her. I asked her about that
hand and the things it used to do, and this is what she said:

My Hand

I can't use my right hand any more.
If I try to write it gets spidery.

It used to draw.
It used to paint
It used to make hats
It used to cook
It used to write
It used to play the piano
It couldn't do that now.

The mastectomy had an effect on my hand.

It sort of messed my life up.

 Jessie Wilkins, 12 March 1991

Part VII

The Quality of Care

Can I see another's woe
And not be in sorrow too?
Can I see another's grief,
And not seek for kind relief?

William Blake, *On Another's Sorrow*

Reminiscence Work with Older People in Health Care Settings

Bernie Arigho

Introduction

Reminiscence work is the generation of creative activities based on people's reminiscences. It is a fairly new field of work gradually increasing in professional recognition. Its objectives and guidelines for good practice are well-defined with large numbers of skilled and experienced practitioners working in the field. It is worth explaining why I use the term 'reminiscence work' to describe the work we do at the outset because the explanation will help to clarify some of the confusion surrounding this distinct approach to caring for and working with people.

To those who view reminiscing as merely the luxury of an idle moment, 'reminiscence work' may appear to be a contradiction in terms. It is true that reminiscence is a very natural mental activity often (but not always) associated with pleasant recollections. It is also true that most people will reminisce from time to time, either by themselves or in company they can trust, without any need for prompting by a reminiscence worker. However, it is my argument that commonly-held views of reminiscence do not fully appreciate its potential benefits and uses and that once the full potential is recognised, especially for older people with special needs living in residential care, the case for experienced and skilled reminiscence workers becomes clear. With sensitive prompting, imaginative ideas for creative work and individualised approaches, people can be enabled to extend themselves and succeed in a wide range of personal goals through their reminiscences. People engaged in serious reminiscence work have sometimes been unjustly accused of avoiding 'real work' and simply having a good time. Successful reminiscence work requires time, effort, skill and

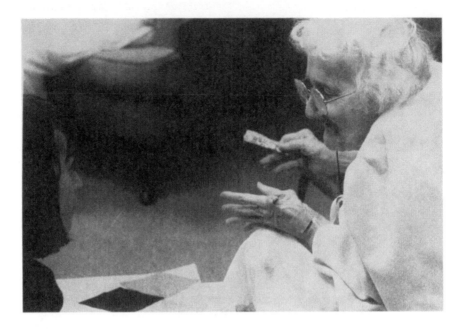

Figure 21.1. Conversation with a patient

expertise in order for it to meet its important aims and objectives and fully justifies being regarded as 'real work'.

'Reminiscence' is a word which is disliked by some because of its associations with the experience of being bored at some time by somebody's seemingly endless self-centred anecdotes. However, this is a false and unrealistic overall view of the way that people reminisce. It is like saying that you don't like music because you've heard a piece which grated on your nerves. The point is that though some people may be thought to be boring when reminiscing, there are many people who are absorbing, fascinating, challenging, entertaining, amusing, moving and educating when they share their reminiscences. The word 'reminiscence' has suffered from negative prejudice alongside many other words related to older people and ageing. By reclaiming the value of the word I am asserting the value of the process, and also the value of older people.

I use the term 'reminiscence work' as opposed to 'reminiscence therapy' because it is important to draw a distinction between the therapist's and the reminiscence worker's relationships with their clients. Counsellors and other psychotherapists may encourage their clients to reminisce in order to return to life experiences which may be partially repressed and deeply uncomfortable to their conscious minds. The client is willing to endure this pain with the support of the therapist because of a belief in the healing potential of the experience. Reminiscence workers, on the other hand, assist people to express creatively memories which they are willing and ready to share with a wider audience. It

is not a 'therapy', though, as with psychotherapy, its outcomes aim to be therapeutic in that they meet people's needs for fulfilment and enjoyment. Many of the communication skills employed by therapists are essential to good reminiscence work and there are a number of therapists who are skilled in both approaches. Many of Age Exchange's reminiscence workers and trainers are drawn from disciplines such as counselling, dramatherapy and clinical psychology. The link is formed by the common interest in working therapeutically with people and choosing the most effective method, having considered the needs and wishes of individual clients.

The Origins of Age Exchange Theatre Trust

Age Exchange Theatre Trust was founded in 1983 with the aim of improving the quality of life of older people by emphasising the value of their reminiscences to old and young through pioneering artistic, educational and therapeutic activities. It had only been in the previous 10 to 20 years that health and social care professionals had begun to recognise the importance to older people of expressing their memories. Until then reminiscence in older people had been largely viewed as something to be discouraged, as a symptom of decline. The new insights of such diverse groups as psychologists, sociologists, architects and oral historians demonstrated that older people needed the opportunity to talk about the past in order to meet important social and psychological needs. The growth of gerontology as a distinct academic discipline has drawn attention to the heterogeneity of the elderly population and so contributed to creating more positive and realistic attitudes to older people and ageing. Health care workers are now trained in biographical techniques which help them to deliver a service which is more personalised and meaningful to their clients.

It was in this more enlightened climate that Age Exchange entered the scene, recognising the potential of drama for both evoking and re-enacting remembered life experiences. Through its innovative programme of inter-generational theatre projects, Age Exchange was instrumental in developing the concept of the two-way mutually beneficial reminiscence exchange in which everyone involved (those giving and those receiving reminiscences) are benefiting in some way from the experience. Reminiscence workers, professional actors and older people were brought together to work on the older people's reminiscences for the creation of touring reminiscence theatre productions. The primary aim was the preservation of cultural history and the celebration of people's lives through theatre. Yet it became clear that the work was also valuable because of the increased self-confidence of the participants, the development of more positive attitudes to other age groups and the bringing together, in joint creative activities, of people from different backgrounds and with different skills. This was an early example of what has been described as 'the unrecognised bonanza' of reminiscence — that is, the potential of reminiscence work for achieving

unexpected and unplanned benefits of lasting value to people.[1] Books and exhibitions were also created to celebrate and give permanent form to the living memories which had inspired so much creativity and reflection. Age Exchange continues to produce at least four professional reminiscence shows per year highlighting specific themes to twentieth century history.

The Relationship Between Reminiscence and Creativity

The success of reminiscence work is measured in terms of the extent to which it enables people to participate in meaningful and enjoyable activities. The focus is on being active and creative in the here and now, though the inspiration is derived from the there and then. I have already touched on the reciprocal relationship between memories and drama. More generally, there is a mutuality between the mental process of remembering and the physical act of expressing memories creatively. Age Exchange reminiscence workers use a variety of creative activities in order to help people be creative and reminisce at the same time.

A simple drama activity involves asking someone if they would like to post themselves and other members of the group as if they were their family at a particular time in the past. The physical act of arranging people in the appropriate postures and attitudes towards each other stimulates further memories and so provides further detail with which to enrich the scene. The person reminiscing becomes the artistic director, responsible for ensuring truth to the essence of the reminiscence. People can be directed to take on the roles of individual members of the family, receiving information about what they would be doing, how they would be feeling towards each other, what they would be wearing and what they might be saying.

Another way of prompting creative activities on the theme of the family is to ask people to draw a rough plan of the rooms of their old home, noting what used to happen in each room and adding details such as ornaments, furniture and decor. The exercise may trigger memories of treasured items previously long forgotten or special occasions marking key moments in a lifetime. People may wish to focus their attention on particular objects of interest. What begins as a simple drawing exercise can develop into a highly detailed and informative piece of work and may lead on to other forms of artistic expression such as poetry or story-telling.

Some people find that writing down memories helps to concentrate attention, enhance expressiveness and unlock the past. A suitable subject for inspiration may be a day of celebration or a typical day at work. The act of picking up a pen and writing memories down on paper may prompt further

1 Taken from the title of an article by Robert Butler in The International Journal of Ageing and Human Development (12), 1980.

associated memories which, in turn, stimulate the creative writing process. People may wish to focus on quite extensive personal reflections of some aspect of their lives or may wish to contribute to a collective group reminiscence on a theme of interest to everyone, such as a day at the seaside or a night on the town.

Music is particularly evocative of memories and related feelings, whilst also being a powerful force for stimulating other creative activities such as singing and dancing. Different reminiscence themes have their own large repertories of musical accompaniment, such as songs specifically about such popular topics as travel, romance, work and play. Cherished songs and melodies may be realised, motivating communication and improved articulation, encouraging the group to sing together and evoking the memories which are so closely linked to the music. The joy of expressing important thoughts and feelings in words and music combines with the need to temporarily return to the past for comfort and inspiration.

Reminiscence Training

As more people have become aware of the benefits, so Age Exchange has responded to increasing demand for training and support for those who wish to apply reminiscence work to their work setting. It became clear that reminiscence work had a special part to play in the care of older people living in various kinds of residential care homes, and that there were specialist skills associated with achieving successful outcomes. Age Exchange began its programme of reminiscence in 1986, since when the range and numbers of courses has considerably expanded with the acquisition of new expertise and improved facilities.

Many older people in residential care have disabilities affecting their communication with other people. Sensitively and attentively engaging with their reminiscences may help to enrich their experience of the exchange. They are capable of communicating and being creative through their reminiscences, but they need skilled and committed support from the worker to overcome the obstacles to communication. There may also be other factors at work restricting people's activities, for example social deprivation, lack of stimulation in the living environment, lack of personal choice and lack of self-belief. Once people are encouraged to enjoy and participate in reminiscence activities which are appropriate to their interests and abilities, then a clearer picture of their true potential can be obtained. The stress is on finding and recognising what people *can* do. With imagination, positive thinking and realism the reminiscence worker can help people to find their creative outlet and be valued for themselves through their reminiscences. In return the worker is rewarded with the success of facilitating communication and creativity, and the privilege of sharing in some of the wealth of a unique lifetime's experience.

The one-day training course 'Introduction to Reminiscence' offers a general introduction to reminiscence work applicable to a variety of settings. It is open to everyone who would like to start doing some reminiscence work, giving students a grounding in the benefits of reminiscence and the basic principles underlying good practice and providing a range of learning opportunities to enable them to return to their workplace and undertake a piece of practical reminiscence work. A variety of different learning methods are used – including lectures, group discussion, reminiscence experiential exercises, role play and demonstrations of practical skills. A systematic approach to the work is emphasised, focusing on crucial stages of assessment, planning, implementation and evaluation. Students are directed towards being reflective about their work in terms of what they have learned, how their practice has developed, how they have changed personally and professionally and how their experience compares with other models of practice. Key texts are recommended to provide them with new practical ideas and to assist their reflective learning.

People benefit from reminiscence in their own individual ways and aims and objectives must be based on an individual assessment. However, there are a number of general benefits related to reminiscence work which demonstrate its importance and provide much of the motivation for people to become involved. It is vital that prospective reminiscence workers are clear in their own minds about why they are embarking on this special way of working. They must be able to articulate their reasons to their colleagues, and they must have the will to sustain their efforts. Faith Gibson (1994) offers ten good reasons why reminiscence should be encouraged. The list is not definitive, and workers must be constantly alert to the possibility of unplanned bonus rewards for participants:

1. People can be helped to come to terms with changes in their present circumstances if there is an appreciation of their past lifestyle, and if they can discover common ground with other people in their surroundings.

2. In a safe, supportive reminiscence group people can get to know and begin to trust other group members, gradually talking about more personal life experiences and opening up new rewarding relationships.

3. Care staff can become more aware of their clients' needs and less preoccupied with institutional demands and professional distance.

4. Reminiscences are an important source of oral history, helping to preserve and transmit cultural heritage.

5. When older people reminisce, it puts them in the position of the teacher, passing something important on to others around them.

6. Through showing an interest in the lives people have lived, they can be helped to have an increased sense of personal identity and self-worth.

7. Through affirming that people's lives have been significant, they can
 be assisted to reflect back on, and sum up, their lives in a more
 positive light.

8. Reminiscence helps us to appreciate people more as individuals who
 have been on a unique journey through life.

9. A knowledge of people's past capacities and activities helps us to
 make a more precise assessment of their present levels of functioning.

10. There is a great sense of enjoyment to be derived from sharing
 important memories with sympathetic, appreciative listeners.

Reminiscence training involves the teaching of essential principles related to
good practice. For example, it is essential to respect people's personal choice
concerning what they reminisce about and to what depth, and who they
reminisce with. Reminiscences which are not freely offered, and which take
people into areas of the past which they find uncomfortable or embarrassing,
will only lead to a breakdown of trust and communication. Reminiscence
workers must ensure that people are given choices about different reminiscence
themes and activities and that the reminiscence triggers which they use are
related to the individuals' preferred choices.

The Age Exchange Reminiscence Project

By 1986 it had become clear that there was a need for a special reminiscence-
based service which would meet important social and psychological needs for
older people living in residential care homes. The touring theatre productions
helped to stimulate memories and reinforce a sense of the value of the past, but
this was not leading to an active involvement in creative activities. Such people
needed a more interactive and personal approach in order to receive the support
and encouragement required for their participation in reminiscence activities.
The Age Exchange Reminiscence Project was launched with these two principal
aims:

* to help older people to enjoy their memories, express their
 reminiscences through creative activities and value their life experience

* to share reminiscence work skills with care staff so that creative
 reminiscence activities become established as a regular feature of life in
 the home.

The Age Exchange Project workers come from a broad range of backgrounds
with a common interest in working creatively with older people on the subject
of their life histories. They combine arts workshop skills with experience of
working in the health care services. This mixture of the arts and health care is
a special feature of reminiscence work, resulting in definitions of health which
more fully appreciate the aesthetic dimension. All project workers attend a

six-day training course which aims to prepare them to set up reminiscence groups in residential care settings. Course contents include: the benefits of doing reminiscence work, essential elements of good practice, special needs of people with dementia, the psychology of reminiscence, illustration of the use of different kinds of creative activities, resourcing reminiscing work facilitating group work and evaluating the quality of work done.

The Project offers an eight-session format commencing with a planning meeting to decide aims and objectives followed by six weekly sessions with an identified client group and concluding with a follow-up meeting with staff to support them in their continuing work. The group usually consists of six to ten people from the home and two or three members of staff. If there are special communication difficulties with some of the older people who have been invited, the numbers in the group are reduced to allow for individual support within the group. Together the group discuss and share their life experiences, participating in such varied activities as mime and improvisation, music making, games, recitations, writing and craft work. A wide range of resources are used to stimulate group discussion and activity including old objects, photographs, old musical recordings and other people's preserved reminiscences.

Examples of Recent Project Placements

The Hackney Hospital Project

The group of elderly residents, nursing staff and reminiscence workers came together in the art therapist's studio and decided that the topic for the project would be 'A Day at the Seaside'. Using objects and sounds which are reminiscent of seaside holidays (e.g. sea shells, a stick of rock, an ocean tape, a Brownie box camera), people were helped to share memories in pairs and in the larger group. Dressing up for photographs was fun and also helped to remember what it really felt like to be at the seaside (e.g. paddling, sunbathing, eating prawns or standing windswept at the end of the pier). Pretending to perform these typical seaside actions enabled people to express their memories and feelings through simple drama techniques. There was a marked increase in energy levels and contributions over the course of the five weeks. Shared memories in the group became more frequent. Some of the residents began to initiate group-singing of seaside songs.

The group decided that they would like to make a group collage representing all their individual memories of the seaside. First they made the waves, sand, beach and sky, working in pairs to draw and paint (on various textured materials such as sandpaper, crêpe, tissue, fabrics) the different sections, and then to cut them out and stick them onto the collage as background. Then they gradually added their personal reminiscences in the form of specific details, drawings, portrait and action photographs and a group poem about the sights, sounds, smells, tastes and textures of a day at the seaside:

Figure 21.2. Person cutting

> Merry-go rounds; funfair; music. Fishy kippers smell fatty.
> Seaweed; salty swishy waves.
> Eels, ships, people's voices.
> Vinegar; cars going up and down fast.
> Fine shovelling sand,
> And oily sweet doughnuts.

Staff felt that they now had a better understanding of their residents' potential for creativity and self-expression. The good news filtered through to other staff in the hospital. New reminiscence groups were formed with other residents and other nurses started to attend reminiscence training courses. The solid achievements of this project were the seaside collage, the singing, the shared memories, the humour, the drama, the friendship and the new understanding developed between residents and staff.

The St Mary's Hospital, Paddington, Project

The ward manager of the Care of the Elderly Unit contacted me and told me that she was keen to promote nursing care of elderly people as a specialist area of expertise. She saw the development of reminiscence work skills as an important part of this process. Being an acute care ward, the reminiscence group would be open to whichever patients were resident on the ward and willing

and able to take part. At the planning meeting nursing staff expressed the following aims for their patients:

- to provide a mental stimulus for them
- to help them with speech problems of a motivational nature
- to encourage sociability
- to relieve frustration and boredom
- to raise mood and improve self-esteem
- to reinforce their individuality on the ward.

The nurses also established aims for their own development:

- to introduce reminiscence work to the ward
- to train key staff to continue with the work after the project
- to improve standards of psychological care
- to improve staff morale
- to build up team spirit
- to raise the profile of the ward in the hospital
- to experience first-hand a reminiscence project from beginning to end, through all stages of assessment, planning, implementation and evaluation.

In the first sessions, the themes of leisure and entertainment emerged as most popular and the group came up with the idea of making a collage about going to the cinema in the 1930s. The project workers provided the materials needed for the work – paper, cloth, glue, scissors, photographs of favourite movie stars, reminiscence objects and suitable background music. The first stage of the work involved making the cinema curtains which would act as a backdrop for the collage. A member of staff paired up with a resident and one-to-one reminiscence exchanges about the cinema and other related memories began occurring very naturally. Conversation was a mixture of practical considerations regarding the collage and reminiscences of a more personal nature. Pairs worked together on the diamond-shaped templates for the cinema curtains – using a stencil, cutting out the shapes and then arranging them into a harlequin pattern. Everyone in the room was not only enjoying reminiscing, but was also involved in a reminiscence-based arts activity.

Photographs of the sessions demonstrated that there were high levels of enjoyment for all concerned, once the project had hit upon the right topic with the right activity. People were enjoying the simple human contact which the reminiscence session was enabling. Hospitals and residential homes can be depersonalising places sometimes, because of institutional demands. Anything which can reinforce individuality and build bridges between people must be welcomed. Reminiscence activities are particularly effective in doing this in

mutually enjoyable ways. Only if reminiscence work is genuinely enjoyed and appreciated by the carers and workers can it be empowering and rewarding for the person invited to participate. An occupational therapist commented that 'the behaviours exhibited by residents during the groups were in marked contrast to those exhibited on the ward. Their personalities were more apparent in the groups, and their individuality therefore enhanced'.

Conclusion

The experience of organising and supervising over 150 such reminiscence projects in the last eight years has given us more of an appreciation of the potential benefits of the work to our clients and greater expertise in the application of the relevant multi-disciplinary skills and knowledge (see Osborn 1993 for a host of practical ideas for creative reminiscence activities with older people). If reminiscence work is to continue to develop its practice and arrive at a stage where it can be considered a distinct professional discipline, the network of reminiscence workers must come together to critically evaluate their work and reach agreement as to codes of conduct and standards. Age Exchange has taken over publication of *Reminiscence Magazine* and is setting up the basis for an international network of people involved in different kinds of reminiscence work. The opening of the new European Reminiscence Training and Development Centre in the spring of 1995 will assist this process. Discussions are underway with Greenwich University about the accreditation of Age Exchange reminiscence training courses and formal assessment procedures for quality assurance. The future is full of possibilities for the continuing growth of reminiscence work – good news for those legions of older people and their carers who sometimes feel they have been forgotten.

References

Gibson, F. (1994) *Reminiscence and Recall: A Guide to Good Practice.* London: Age Concern.

Osborn, C. (1993) *The Reminiscence Handbook: Ideas for Creative Activities with Older People.* London: Age Exchange.

The Bolingbroke
Long-Term Care Project

Peter H Millard

Introduction

On its completion in 1987, the Bolingbroke Hospital Long Term Care Project
established new standards of accommodation for nine multiply-handicapped,
socially disadvantaged, older people. Their accommodation has public space
and private space and visitors can only enter the ward if they knock at the door.
The decorating and furnishing system is unique: reversible fabric covered panels
line the walls and these, plus the bedside lockers, chest of drawers and wardrobe,
hang from a specially designed picture rail. Because it is unique it is difficult
to emulate, but there is no reason why the basic principles of public and private
space, personalised accommodation, choice, dignity and a specially trained staff
should not be emulated in other countries.

All residents personalise their rooms with their own possessions; each has
their name picked out in vinyl letters on the door; each can choose whether
visitors enter their room. Adopting our fundamental principle of 'the best for
the worst' on a world-wide basis would transform the care of the aged sick, for
each country would struggle to create better, micro environments, for their long
stay patients.

Eight years after the Bolingbroke Project was completed the unit still
receives visitors from this country and abroad. They leave marvelling at the
standards that we provide and wondering how they could provide similar
standards for their long-stay, institutionalised, sick. I have been asked to write
this chapter so that others could understand why and how it was done. If,
through reading it, you gain the inspiration and courage to work to build a
better world, then my task will have been worthwhile.

Background to the Project

Though my medical school (University College Hospital) was the major provider of consultants in geriatric medicine in the sixties and seventies, I had no specific undergraduate training in geriatric medicine. One year after qualifying, my training enabled me to run – with the aid of books – an African hospital. However, when I returned into geriatric medicine as a senior house officer I did not know what to do. There were few books so I had to fall back on experiment and research. My senior registrar training taught me how to run rehabilitation services but there was no training in long-term care. I became a consultant in 1968, eight years after I qualified, and my interest in the environmental problems of the institutionalised elderly arose out of my responsibility for developing services. Thus personal medical responsibility coupled with research and experiment underpinned the development of the long-term care project.

When I was appointed the first consultant in geriatric medicine at St George's Hospital in 1968, my dowry was a waiting-list of 68 people. To serve them I was allocated 186 beds in five hospitals and four blocked beds at Tooting, the site of the new teaching hospital. The first priority was the development of rehabilitation: to that end, beds were lowered in height, cot-sides were removed, chairs of different heights were obtained and multidisciplinary, optimistic, therapeutic, rehabilitative, teamwork was introduced into three newly-upgraded wards in three different hospitals. These changes led to the provision, from 1972 onwards, of a no-waiting-list admission service, yet I still had one hundred, predominately bed-bound, patients who required long-stay care.

The Place of Art

The roots of the Bolingbroke project began as we worked to introduce patient activities into two isolated long-stay hospitals. Our early tentative endeavours involved the use of crayons and colouring pencils: it was not until a trained art teacher, Mrs Audrey Huntley, joined us that we made progress. Our mistake was our negative expectations of the potential for intellectual growth of older people. She altered that.

At Cheam Hospital, long since closed, we had a vacant room which the League of Friends upgraded to provide an art studio. Audrey only came twice a week. However, within a year she transformed our hospital. Prior to her arrival, visitors came reluctantly (if at all) to see the 'geriatrics'; after her arrival, they came to the art exhibitions to marvel at their work. As Rosenthal and Jakobson show in *Pygmalion in the Classroom*, if pupils are failing we should look at the teachers, not the taught.

Introducing professionally taught art to our long-stay hospital changed staff and patient attitudes. Attitudes reflect knowledge, and seeing is believing. Soon

after the art work began, Professor Michael Hall's film *Away from the Workhouse* was launched by Lipha Pharmaceuticals. Based in his long-stay hospital in Southampton, the film showed how the introduction of a patient committee had improved patient well-being. Impressed by the film, and confident in our own success, we took a coach load of staff and a patient to visit his hospital. Soon after, we established a patient committee ourselves.

Patient Power

To qualify for a long-stay hospital ward, our patients have to fail a multi-disciplinary rehabilitation programme. Without skilled tending by highly motivated, trained staff, long-stay patients get pressure sores, contracted limbs and demoralised spirit. William Asher described this well when he wrote:

> ...rest in bed is anatomically, physiologically and pathologically unsound. Look at a patient lying long in bed, what a pathetic picture he makes! The blood clotting in his veins, the lime draining from his bones, the scybala stacking up in his colon, the flesh rotting from his seat, the urine leaking from his distended bladder and the spirit evaporating from his soul! (1947, pp.967–968)

The move to rehabilitate the chronic sick started in the United Kingdom in the 1930s but the impetus for the development of my specialty was the 1947 government decision to transfer the chronic sick wards to the hospital service.

The aim was to attack the bed-bound state. At Cheam Hospital there were curtains between the beds, the brown walls had been painted in lighter colours, patients were out of bed (at least when the consultant came) and there were day rooms. But there were no personal belongings. Audrey Huntley's efforts gave us paintings to put onto the walls but I did not even think of bringing in personal belongings. I learnt the benefit of the personalisation solely after I went to Denmark.

Personal Belongings: A Positive Effect

The visit to Denmark in 1979, on a King's Fund sponsored visit, opened my eyes. The reason for our visit was to see the lack of rehabilitation. We came away marvelling at the quality of their long-stay nursing homes, the personalisation of every room, the dignity of the residents and the facilities for art. I was awe-struck: 'I felt like a burglar in their room.'

On my return, Chris Smith, a visiting psychologist, and I established a simple research project which confirmed (for me) that personal belongings have a positive effect. The study was of simple design. We split the students into two groups: one group saw a photograph of a patient surrounded with my family photographs, flowers and cards and the other group saw the same patient in bare surroundings. Our hypothesis was supported; 'the belongings changed the

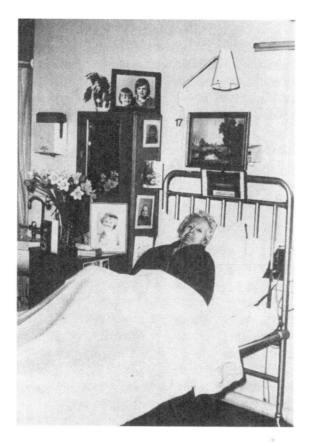

Figure 22.1. Personal belongings: a positive effect

perceptions of the observer'. Accordingly, I set out to personalise Cheam Hospital.

Social Asset-Stripping

Our long-stay patients had no belongings! The road to a long-stay ward is hard. At each stage on the journey possessions are lost. Thus long-stay patients have no belongings. Society, by the very nature of the wards it builds, and the education it gives, acts out a self-fulfilling prophecy. Asher (1947) stated forty years ago: 'I am sure that many hours of half-sleeping and dozing are less beneficial than a few hours of deep sleep, and I believe they encourage a certain confusion of mind'. Now we knew that the same was true of personal belonging, yet we could not change the ward because there were no belongings, and, 'how do you hang pictures on curtains?' It was not until I got to the Bolingbroke Hospital that the opportunity arose to put theory into practice.

Theory into Practice

In 1981, to improve the diagnostic and treatment facilities for the medical and rehabilitative management of 150 patients in the department of geriatric medicine at St Benedict's Hospital in South London, we encouraged the health authority to transfer their care to other hospitals. Fifty actively-treated patients went to St James's Hospital and 100 long-stay patients were transferred to the Bolingbroke Hospital where there was an old private patients' ward in a state of disrepair. There our project began. The aim was to develop a demonstration, showpiece, long-stay ward with single-room, personalised, carpeted accommodation. Something which, in a (Department of Health) National Health Service hospital, had never been done before.

Gathering the Experts

The success of the project depended on input from many people, each played their part. Some gave money, some gave advice, some did basic research, some gave encouragement, others (especially the patients) bent over backwards to assist us. Consider the scene: it's a wet and windy March day, we had ten long-stay patients cramped together in accommodation made for eight, with the wall of the ward knocked out and just polythene sheeting between them and the elements. They knew that one of their number would not reach the promised land, for only nine rooms were planned. However, because of their patient committee they knew exactly why the project was being done – though they, as we, had no idea of the beauty of the finished product.

Rosemary Horsfall was the key worker. An ex-nurse, she had many years of experience as a senior case worker for the Elderly Invalid's Fund (now Counsel and Care). In that post, she had visited the majority of residential and nursing homes in Southern England. She knew a better world was possible and our project gave her the chance to succeed. She applied for the post of research technician in my department, then threw herself whole-heartedly into achieving a dream.

Small Beginning

We started by involving one patient and her family with a single-room upgrade. We carpeted the floor, put in a picture rail, and, with the financial assistance of the League of Friends, wallpapered the room. Our first resident only lived three weeks. Mrs Parsons replaced her. That wheelchair-bound lady, with the help of her son, personalised the room, and it was she who gave willing permission for streams of visitors to see it. From that room we eventually raised £250,000 to complete the project.

A Chinese saying is 'a journey of a thousand miles starts with a single step'. Others say, more cynically, that 'one step is just one step', but for us the

important point was to have a vision of a better world and then to seek the expertise of others to help us complete it. Only if you know exactly what you want to do can you achieve it alone.

The Role of Others

Many people contributed their ideas. Our first tentative plans were drawn by Paul Smith, the dietitian's husband; Amanda Stokes-Roberts, our Occupational Therapist, inspired our work; Mrs Frances Williams, the hospital administrator, helped with her artistic talents; Jim Thompson and his team from the Hotel and Catering Department of the University of Surrey stepped in and designed the lay-out of the rooms; Brian Boothby and Alan Spindler from the London College of Furniture Designing for the Disabled Group designed the revolutionary furniture and decorative wall panels; Brian Hitchcox from the Department of Health Architects Department redesigned the lay-out. And finally, with the assistance of grant aid from the King's Fund, the Baring Foundation, the League of Friends, Ernest Dudley and others, we raised the money to put the dream into reality.

The Role of the Staff

Highly motivated, excellent nursing staff are central to the success of any project. The continued success of our project first depended on Sister Keane, then on Sister Seelochan. They, through their inspirational effort, motivated their staff to maintain the highest standards. They had to overcome many problems: coping with incontinence in carpeted rooms being one, dealing with visitors and educational groups from other hospitals being another. Their flexibility and willingness to adapt established new standards for care. Now we have to adopt the Bolingbroke standards of accommodation and staffing nationally to ensure that the tending of multi-handicapped, disabled people throughout our country reflect the standards that we have shown is possible. Achieving that requires universal education.

The Solution

Wait, I hear you asking 'What did they do? What was the solution? How can we repeat it if we don't know what it is?' OK, I'll tell you. Their imaginative, lateral solution was to hang demountable, reversible, fabric covered panels from a specially designed picture rail. They used Charles Den Roche's design for Simple Systems for demountable office and laboratory furniture and modified it for clinical care. By using fabric rather than paper, we could put up pictures, drive in nails and knock the walls without damaging the decorative standards. By using reversible, decorative, fabric covered, fire resistant panels we could re-decorate in 30 minutes, thus allowing each new resident to chose the wall

covering of their room. By making everything demountable we could, if necessary, without trouble, reconvert the rooms into active treatment units. Also, by swinging the furniture from the rail, we ensured that carpets could be easily cleaned and wheelchairs did not damage the walls.

How do you emulate it? I don't know. Unless an inspirational entrepreneur grasps the idea and makes it available for others, it is difficult to do. If one of you reading this would like to do it, or knows of anyone who would like to take it on, please let me know. Also, join me in the campaign for universal medical, nursing, therapy, care assistant and lay education in gerocomy, the science of tending old age.

Reference

Asher, R.A.J. (1947) 'The dangers of going to bed.' *British Medical Journal 2*, 967–968.

The Arts in a Secure Environment
Three Views from Ashworth Hospital

Introduction

Charles Kaye

Ashworth Hospital, Merseyside, is one of the three hospitals which provide for England and Wales a national service treating patients with severe psychiatric illness who are also adjudged to be dangerous to themselves or others and thus must be detained in secure conditions. Many of the patients have, by their behaviour, isolated themselves from their fellows and, effectively, their communities.

These requirements impose particular difficulties in terms of managing the environment and motivating the patients. Since the majority of the patients are chronically ill, they can stay in the hospital for a long period – the average length of stay is currently over six years. The security which, literally, surrounds the hospitals means that in a very real sense they are closed institutions with controlled and restricted access and exits. By the same token, particular care must be taken inside the hospital over materials and implements to which patients have access. The hospitals do have extensive recreational and workshop facilities available but the motivation and rehabilitation of the patients is only to be achieved with enthusiasm, skill and ingenuity.

The three following contributions describe some innovative approaches to the use of the arts in the context of patient care. They represent different views of the hospital's intensive and wide-reaching arts programme offering the insights and experiences of the hospital's Arts Co-ordinator, Ruth Preece, of the Assistant Education Curator at the Tate Gallery Liverpool, Adrian Plant, and of the artist, Brian Chapman. In addition – and very importantly – we hear something from the patients themselves.

The Arts and Self-Expression

Ruth Preece

The Beginning

Initiatives in art can both motivate and benefit those receiving treatment for mental illness and disorder. Patients can express themselves through involvement in arts-related activities such as dance, drama, painting and writing.

This chapter deals with in-patient care for those detained in the secure environment of a Special Hospital. Contributions are included from those directly involved in the development of expressive arts at Ashworth Hospital as well as patients' views. Patients are encouraged to express themselves in whatever acceptable form. At Ashworth Hospital an annual Arts, Crafts and Literature Exhibition has been held for over 17 years. This is an 'open' exhibition to allow patients, visitors and staff to contribute. The outside community is invited to assess the work from contacts made with schools, colleges and arts organisations. The external contacts have led to links being made with North-West Arts (Merseyside Arts), Tate Gallery Liverpool 'Outreach', Artreach Exhibitions and individual artists and artistes.

Workshops

From these links an idea was formed that a workshop could be held on a theme of free expression in many forms. The Tate Gallery 'Outreach' team projected this into a more ambitious undertaking of a series of workshops involving different artists. A planning team provided the structure and objectives were identified. These were:

1. To encourage a group of patients to pursue a modern arts project.

2. To create a relaxed and informal atmosphere for patients to pursue the activity.

3. To hold various exhibitions throughout the year, in a central area, to educate, stimulate and encourage interest through 'Merseyside Exhibitions'.

4. To arrange, with the patients library, displays of art literature for patient's use.

5. To facilitate freedom of self-expression.

6. To develop group work and patient involvement in forward planning and decision making with regard to their work.

7. To involve other disciplines in the ongoing projects and to assess the level of interest of group members attending.

The primary concern was that these workshops would be a voluntary activity for the patient group and not seen as part of any treatment-base for analysis. Staff would also be invited to participate. It was seen that the project was to have an educative and leisure function for patients, as well as being an aid to improving self-expression and personal development. To provide some guidance, the theme of 'The Self' and 'Self-Image' was adopted. This was felt to be particularly pertinent to a patient group whose self image is often extremely poor.

An introductory session was held for the project to be explained and interest assessed. This was followed by a series of practical workshops in aspects of modern art. These workshops were held on a Monday evening for nine months, culminating in a display of work to coincide with the annual exhibition. There were three blocks of six workshops. The different workshops have enabled participants to develop some familiarity with new art concepts and materials and then to have time to experiment themselves. Introductory workshops were held to allow for this process.

Ice-breaker exercises were held for all participants. This allowed for the group to gain confidence and the staff and external artists to assess the group's potential. These warm-up exercises also allow for some group identification to take place. Most complete these and it appears to ease some of the anxieties. These ice-breaker sessions can include relaxation games, name games and trust games. They involve participants gathering together before a workshop. A trust game, for example, would include individuals being blindfolded in turn, then guided around the room avoiding obstacles and gaining confidence in their partner to look after them.

The practical part of the workshops included: sculpture, painting, slide and photography, and, more recently, video, batik, physical theatre, drama, creative writing, textiles, multi-cultural activities, video documentary, dance and women's workshops.

In reality, the group can be handling tools and equipment that they would not normally have access to. This also encourages individual and group responsibilities.

Project Management

The external artists are from contacts made in the North-West. Each is invited to meet the planning team, discuss their work and develop ideas about self image and what they can do. Each workshop is designed to be different with sculpting in wood, painting photography slide images, video, card and paper and interpretation of dance movement. Other hospital disciplines are invited to participate and contribute. One series of workshops moved into the arts department and utilised the skills of the rehabilitation staff and hospital equipment.

Developing Skills and Confidence

It is noticeable that the commitment of the patients to the projects remains very high and this is reflected in the quality of the work, which includes tribal masks, surrealist figures and paintings, graphic designs and the photographic visualisation of poems. The workshops not only see patients developing a greater degree of responsibility for their own work but also for their relationship with each other. This manifests itself in the provision of snacks for the tea breaks, which have been made by the patients, either on the ward or in the cookery department, earlier in the day. Other patients take on the responsibility for the collection of tools and equipment at the close of the workshop.

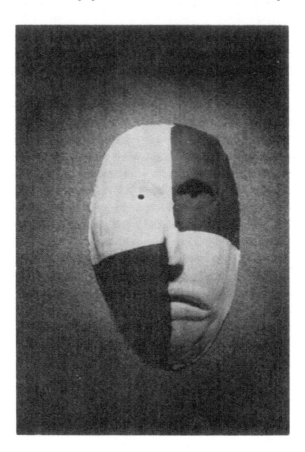

Figure 23.1. 'Mask' Ashworth Hospital

On occasions the project group is visited by individuals from outside the hospital, such as art students assigned to the Tate Gallery or the artists involved in our project. Such visitors are expected to take an active role in the workshops they attend and they invariably add impetus by bringing a fresh view to the

work being undertaken. From within the hospital both qualified and student nurses become involved with projects, often giving up their spare time to attend evening workshops.

Regular review meetings are held by the organiser to evaluate the work of the project. At one point it was felt that the focus of attention needed to be on group work. The programme was altered to facilitate this by inviting a muralist, David Jaques, to take a session. This involved the group members each creating a part of a mural and then having their work added to, or changed by, other members of the group. Though this was initially quite alarming for some, focusing upon the group rather than individual contributions to the project, the group worked together to create a mural using the original theme of the 'The Self'.

Group members, including patients, have been to visit the Tate Gallery in Liverpool to see modern art exhibitions. The visit can include a tour and discussion of the exhibition content together with some work in the class room to look at art as a means of interpreting aspects of the self. Attitudes and interest vary within the group according to the work they see but there is a general consensus that visits have a positive influence on the skills and ideas of the participants, as well as being an enjoyable experience.

The project, and involvement with the Tate Gallery, has stimulated interest from the press and one workshop, following a visit, was the occasion at which members of the local and national press were invited to the hospital to see and report upon the project.

Far from being inhibited by the presence of camera crews and reporters, the group seemed to be stimulated to greater creativity by the interest of 'outsiders'. The outcome of this visit was the results of the project and its value to the patients being recognised and publicised. Some concern was expressed by group members at the possible waning of interest following the Tate visit and subsequent press coverage. However, over the final six weeks of the first project most members remained motivated, in spite the fears of the organisers to the contrary. This last period culminated in the hospital annual Arts, Crafts and Literature Exhibition, when the group completed a large mural for the event. Additionally, individual pieces were exhibited and entered for the arts competition and three were adjudged worthy of special mention by the judges. One piece gained an award in the Koestler Exhibition in that year.

Evolution

As the nine-month project drew to a close it was proposed that a Hospital Arts Council should be formed, the broad aims of which would be the promotion of the arts in the hospital community. The patients, in particular, greeted this proposal with a sense of relief as they felt this would enable them to continue developing their abilities while remaining in contact with a variety of artists.

Given the limited resources for these projects, the provision of materials is a problem and the co-ordinating role extends to using local knowledge to make contact with firms prepared to make donations; their support and generosity guarantees the success of the projects.

From the evidence to date it is clear that the objectives formulated at the outset of the projects appear to have been met, with patients being involved in completing modern art workshops in a relatively informal atmosphere, using a variety of media, facilitated by a variety of artists. This is all the more impressive given the location of the workshops in the secure setting of a Special Hospital. There is also evidence of outcomes which were not predicted at the outset and which could broadly be described as facilitating personal growth and organisational development.

The projects generate a great deal of enthusiasm on the part of the patient members of the group as the workshops serve to decrease their inhibitions in using alternative media as a means of expression.

One outcome of Art in Health Care has been to raise for debate some of the moral issues relating to care provision for this patient group. The dilemma of the provision of resources which facilitate projects of this sort for people who have committed violent crimes rather than their victims is not one which necessarily has a resolution. However, the fact that the projects enable such issues to be raised and discussed can only be positive. The project organisers are not party to the dehumanisation of individuals by depriving them of the right to experience art and develop themselves from that experience, whatever their status or crime.

Comments from Patients
ASHWORTH ARTS COUNCIL 'VIDEO DOCUMENTARY' 1994 – PATIENTS' COMMENTS

'Since joining the workshops I feel I'm more self confident, and that my level of communication has gone up a tremendous amount. I've learnt a lot of new skills, like how to operate video equipment, how to draw better, poetry, story writing, all different kinds of things. I feel that patients who attend the workshops who don't normally get involved with things come out of their shells a bit, and talk to people more, and their level of motivation has gone up quite a lot as well.'

PATIENT FEEDBACK 1991 ANNUAL REPORT
BEFORE

'I was a bit sceptical. I didn't know whether I would go or not...'

'I thought it was going to be a Hospital drama, like Aladdin...'

'First of all I wondered if it was going to take off...'

'Apprehensive. Not too sure what it was about...'

DURING

'I enjoyed doing it.'

'The first couple of weeks I thought "what the hell's going on here?" But when I got into it I settled down.'

'Found it belittling in some parts, but overcame the feelings.'

AFTER

'You look for something to take it's place, it was that good.'

'I can't wait until the next one'.

'I am delighted by the way it went, and hope to have more'.

'It taught me to be more open with myself'.

This in turn leads to a greater degree of confidence and creativity amongst the patients. One of them epitomised this progress when he described his work as 'less infantile and more disciplined'.

The artists and staff members also benefit from the projects. For example, one of the artists felt that '...the workshops achieved a feeling of mutual understanding, respect and trust between staff and patients'. Another participant found her understanding of, and confidence in dealing with, patients was improved by becoming practically involved, rather than acting in a supervisory capacity. Another artist found she was initially apprehensive about working with men who had committed offences of violence, often against women. Nevertheless, she reported that '...overall it was a rewarding experience, even if I did feel vulnerable occasionally'.

Today

Ashworth Arts Council was formed in 1989 to develop and maintain links with external arts agencies. There are aims and objectives in place, with periodic reviews that give a direction for the Council members – who include patients, staff of various disciplines, artists and external agencies.

The range of media available has increased over the years to include video art and producing a video documentary, (drama which includes physical theatre and dance), women's projects, multi-cultural workshops and textiles with weaving and batik. A major collaboration with Yorkshire Sculpture Park has produced an exhibition in the grounds of Ashworth Hospital, with work by artists of international recognition. This exhibition, titled 'Facing the Wall', was to provide figurative work of contemporary style, which follows in the theme of Self and Self-Image benefits to this project being a feeling of patients having ownership of their external surroundings.

Tate Gallery Liverpool and Ashworth Hospital

Adrian Plant

Introduction

Tate Gallery Liverpool's partnership, in project work and in the development of Ashworth Arts Council, is one of a number of crucially important links for the hospital with 'the outside world'. Such partnerships can bring many benefits, including a sense that the hospital is 'opening up' and interested in cultivating a dialogue with a range of other professionals in the interests of staff and patient development. Outside partnerships also bring a potential threat providing, as they may, challenges to institutional norms, practices and constraints.

Partnership

From the beginning, the Tate's partnership was perceived as offering the opportunity for patients and staff to explore 'modern art'. The Gallery, eager to develop its regional outreach projects, was able to suggest ways in which artists and cultural theorists could be brought into the hospital. Project work was developed which could discuss the associations and preconceived ideas about modern art, many of which are deeply negative. This combined with introducing new approaches to practical art-making which stressed developing ideas and concepts rather than learning craft-based skills. The theoretical discussions, based on the group's response to slides of the Tate's Modern Collection and the occasional visit to the gallery, were intense and wide-ranging. The discussions were vital in challenging entrenched attitudes about art and artists and, in doing so, stimulating new ideas and possibilities.

Discussion introduced aspects of art history such as Fauvism or Cubism, as well as more general, philosophical questions such as 'Why do people make art?' and 'What qualities would you expect to find in a work of art?' Over time, discussions gradually built the group's confidence in using and developing a vocabulary with which to explore issues and engage with a wide range of artistic practice. There was an uncanny empathy with artists, especially those who were anti-establishment or anarchic, and an intuitive understanding of much avant-garde, 'difficult' modern art. I can remember long discussions about Joseph Beuys, his definition of art and his special relationship with Jimmy Boyle (then in prison at the Barlinnie Special Unit). Beuys claimed that criminal and artistic energy are connected facets of human creativity, both representing the urge to express oneself.

Prejudices and Concerns

It was perceived, amongst those working on the modern art project, that the majority view amongst hospital staff would dismiss Beuys (along with most modern art) as a con – the 'Emperor's New Clothes'. Indeed, incoming artists often felt that such negative views about modern art were compounded by a further general prejudice against all art, including drama, poetry and dance, whether modern or not. Art was considered either dangerously political, in a vaguely subversive way, or dismissed as outpourings of pretentious, pitiful individuals. Art was either seen as trivial and insignificant, or (on the contrary), described as dangerous and powerful in its ability to stir the emotions of vulnerable patients. In this climate artists were sometimes ridiculed and undermined in their attempts to work with patients.

Alongside prejudice there were also genuine concerns. There were fears that artists would unknowingly enter dangerous emotional territory and potentially interfere with the processes of patient therapy and analysis instigated by medical and clinical staff. There were fears that patients would plot to take advantage of the access afforded by the art workshops to certain restricted materials and tools. There were suspicions, from the patients, that the whole modern art project (with its theme of self-image) was an attempt to disguise 'psychoanalysis' and feed it to patients as 'art'.

Making Art

At the heart of the project's conceptual and organisational framework was the practical act of making art, on an individual and collective basis. Practical work concentrated on introducing making processes which at first de-mystified artists' methods. Working collectively, using processes which did not rely on mimetic drawing skills, using improvisation techniques to produce ideas and emphasising process rather than product are examples of how the practical work was (in athletic or dance terms) devised as a series of warm-up games and strengthening exercises. The weekly workshops developed their own rhythm, incorporating the different demands required to be both creative and reflective. At their best, the workshops achieved an integration where the act of making was a continuation of the talking and theorising.

Attitudes and Values

Arts projects, especially with outside partners, can represent a complex range of unique opportunities, but also potential threats. As I wrote in Ashworth Arts Council's first annual report: 'risks were taken, barriers broken down'. To develop and carry out such challenging work is not for the feint hearted, or those who would prefer a quiet life. Such projects demand a great deal of institutional understanding and support. Bringing about attitudinal change,

whether among staff or patients, can be a difficult and long-term process. With some people change is negligible.

It is attitudinal change that is vital if there are to be any real or lasting gains. Those who are most entrenched in a negative view of art and creativity (and patients access to such things) will only accept art if it is a 'safe' activity with which to sedate patients in a kind of soft, quasi-therapeutic way. An approach which explores modern art's desire to provoke, stimulate, challenge beliefs or express emotions is not always so safe and can appear a more dangerous activity.

For any meaningful legacy of this kind of approach to art, and the work of the Ashworth Arts Council, there needs to be continual and considered support. The innovative art projects co-ordinated by Ruth Preece within Ashworth Hospital have received the recognition of other hospitals and prisons through-out Great Britain, and deservedly so. It is, however, easier to applaud and appreciate from afar. The challenge to the Special Hospitals and the Prison Service is in recognising that the arts, concentrating as they do on communi-cation and the desire to be creative, have a great deal to offer both staff and inmates – if only they have the courage and vision to use them.

Hospital Arts and Ashworth Hospital

Brian Chapman

HOSPITAL ARTS is a Manchester-based arts organisation with 20 years experience of working in health care contexts in a wide range of situations, chiefly in the North-West and, from time to time, much further afield.

The First Project

In May 1992 we undertook a unique pilot project at Ashworth Hospital, Liverpool, for the Special Hospitals Service Authority. The aim was for artists to work with staff and patients on one ward in order to transform the communal areas. The means towards this end would be design and artwork. However, an equally important part of the achievement was to be the way in which the project was carried out, emphasising the patients' ownership of ideas, practical involvement of the ward community and nurturing a situation in which those involved were able to make decisions about their living – and working – environment.

One of the greatest challenges was to engender an atmosphere of mutual trust, respect and understanding; the situation we had entered into as artists was a new and unfamiliar one. Equally, staff and patients were being asked to participate in a learning process about us, and the reason we were there. We came to recognise that the situation required careful listening and positive

action, building upon the agreed aims and objectives with sensitivity to enable creative responses to a wide variety of issues which arose.

The project was completed successfully the following year and endorsed by patients, clinical and domestic staff and management. The artists had acted as catalysts and provided a focus for introducing positive change in a hitherto somewhat bleak, institutional environment. As well as the enjoyment in carrying out the work, as testified by many of the patients, new skills and interests were developed and self-esteem enhanced. Almost all of the patients were involved at some stage: a number from start to finish, others on an occasional basis when they felt well enough. Participation was encouraged and open to everyone, though nobody was pressurised. A relaxed atmosphere was promoted by playing taped music: this often led to light-hearted debate and numerous exchanges. Patients were involved in all aspects of the work: planning, preparing surfaces, designing and making artwork.

When the project was finished, each of the communal rooms had been given an individual identity with considerable attention to colour schemes, carpets, new furniture and soft furnishings and replica plants as well as artwork (see colour illustrations). Design solutions were found to 'wear and tear' problems (e.g. spillages). The artwork included a photographic display, three large paintings and two mural paintings, customised fixtures in addition to a one hundred-foot-long piece of artwork comprising a series of flowing wooden cut-outs made for the elevated ceiling space in the day area.

High-Dependency Ward

The second project, begun in 1993, was to work in a similar way on a high-dependency ward. This presented a greater challenge to the artists in terms of the patients' severe mental illness and behavioural difficulties. The ability and concentration-span of most of the patients was more limited than that experienced during the initial project.

A greater degree of consideration needed to be given to the possibility of either accidental or deliberate damage being sustained and arrangements regarding access and security needed to be tighter than before. Balanced against such difficulties, we had become familiar with hospital procedures and resources over the previous year – knowledge which we harnessed to our advantage.

We enlisted the co-operation of the Rehabilitation Therapy Service Department at an early stage and a number of its workshops contributed to the scheme. An additional benefit was that patients from other wards were able to engage in meaningful and creative activities for the benefit of fellow patients with more limited abilities. Over the course of the year the pottery workshop helped to make a ceramic mural and the joinery workshop made a welsh dresser – a fine replacement for the dining room's steel cupboard. We also involved the concrete workshop in rendering walls, thereby reducing the overpowering predomi-

nance of red brick, as well as helping to build solid marble surfaces in the rest room. The upholstery department made all the new armchairs.

Greater emphasis was placed on securing the involvement of ward staff by identifying and drawing upon their individual skills and interests. For example, we designed and built a large aquarium with the help of a keen aquarist and large colourful kites were made for the high ceiling space in the day area due to another staff member's interest in kite-making.

Creatively linking sections of the hospital in the way described provided new potential for environmental improvements across the site, in addition to enhancing patients' experience through widening available opportunities.

This project also proved to be a success. In the artists' terms it had altered our perspective regarding the potential for change involving the hospital community.

The Assembly Hall

In 1994, Hospital Arts began a commission to carry out an ambitious two-year project to transform the main social centre of the hospital, the Assembly Hall. At the outset we set up an ideas-generating and monitoring group with staff and patient representatives. Patient participation in the project is chiefly through the Rehabilitation Therapy Services' workshops. Detailed forward-planning has been essential since we are dealing with structural alterations. This also demands a high degree of staff commitment.

At the time of writing the project is in the fifth month of a two-year process. The final transformation ought to be achieved by means of a multi-layered process involving the whole hospital community.

The development of our work at Ashworth Hospital has represented an inspiring challenge, although in line with our broad philosophy. It has complemented the exciting arts programme run by Ruth Preece, Ashworth Hospital's Arts Co-ordinator. The work is bringing about a positive change in terms of culture, attitude and environment for the benefit of people separated from society due their illness (the patients) and for people managing care in demanding and difficult contexts (the staff).

Hospital Arts[1]

Hospital Arts is a multi-disciplinary professional arts organisation working in establishments devoted to giving care. Established in 1974, this organisation is involved with initiatives especially in the North-West of England and also further afield.

1 Hospital Arts is a registered charity no. 1049274. If you would like further information,
 please contact: Hospital Arts, St Mary's Hospital, Hathersage Road, Manchester M13 0JH.

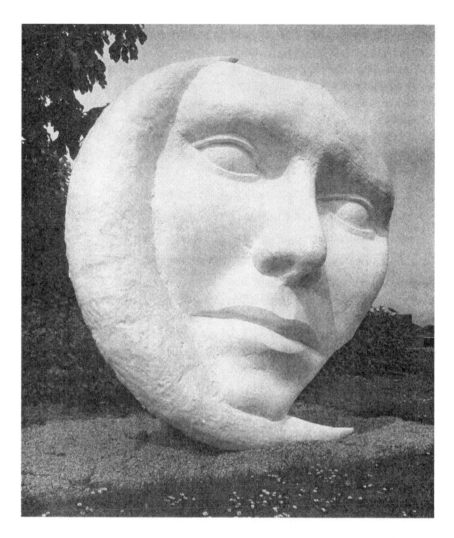

Figure 23.2. 'Eclipse' Ashworth Hospital by Hospital Arts with Patients and Staff
 (photograph by Helen Kitchen)

We work closely with the providers of, and those receiving, both primary and secondary health care services and address issues of environment, aesthetics, quality of life, communication, entertainment and social interaction.

Our work involves the development, co-ordination and the undertaking of a wide variety of arts-based projects, programmes of activity and events with a particular emphasis on involvement, skill-sharing and participation. We aim to produce the highest quality artwork demonstrating innovation and creative experimentation.

Hospital Arts considers that the arts – representing a diversity of creative, cultural, expressive and recreational activity – can play a fundamental role in enabling people to understand, respond to and influence the nature of their aesthetic, social and cultural environments.

The arts have healing potential in the widest sense and participation in artistic and creative endeavour can have a positive effect on the quality of experience – assisting wholeness of body, mind and spirit.

We firmly believe that the close collaboration between artists and users, health care professionals, managements and funding sources offers the opportunity for establishing and developing the unique and valuable role the arts can play:

- challenging the effects of institutional convention in health care settings
- stimulating pleasure and enjoyment amongst participants
- creating a new audience for the arts
- offering new challenges and opportunities for artists.

We also acknowledge that we have a wider responsibility to encourage the development of the very real potential for life-enhancement offered by the arts and associated activities in health care contexts and increasing emphasis is being placed on developing opportunities for working in conjunction with other arts organisations, arts practitioners and education establishments.

Our philosophy and artistic policy is currently expressed in terms of five areas of work:

- Environment work – to influence and improve the physical environment of health care buildings
- Secure Units and Special Hospitals – to improve the social and physical environment and quality of experience for patients, staff and visitors
- Work with elderly people – to improve the quality of experience for elderly people receiving long-term institutional or continuing care due to severe mental or physical frailty
- Curating space – to create opportunities for artists to show their work in hospitals and other health care contexts in order to introduce the public to a range of artistic endeavours and to create opportunities for artists to reach a wider audience
- Performance and aurally-based work – to provide opportunities for people receiving long-term or continuing care to enjoy recreational, interactive and/or participatory performance and cultural occasions.

Start
The Arts and Mental Health

Langley Brown

Introduction: What is Start?

START has been the inspiration for a growing number of schemes where people with mental health needs work in the community alongside artists and craftspeople on individual and group projects. It is an innovative and effective component of the Community Mental Health Service in the Central Manchester Health Care Trust's Directorate of Psychiatry (see Colgan *et al.* 1991). Additional support is provided by North West Arts Board and Salford City Council. Further income comes from commissions, sales and consultancy.

START's approach has been acclaimed by the Health Advisory Service (HAS Report 1991), the Arts Council of England (Earnscliffe 1993), the Department of the Environment, Arts for Health (Senior and Croall 1994),[1] and the European Institute for the Advancement of Social, Cultural and Development Issues.[2]

I have worked with mental health and arts and leisure service purchasers, providers, users and staff to set up similar schemes at Stockport, Oldham, Salford and Bury. Artists from these and other organisations are represented on the recently formed Forum for Artists working in Mental Health Care.

START is based at High Elms in Victoria Park, an attractive inner city enclave within five minutes walk of the hospital. It has a membership of more than fifty people with enduring mental health needs and provides a unique service which enables people to develop their skills and arts experience in a working studio

1 I acknowledge our indebtedness to ARTS for HEALTH whose Director, Peter Senior, helped to set up START and has given strong support and mentorship ever since.
2 START features in the 'Broader Horizons' video, 1994, made by the European Institute for the Advancement of Social, Cultural and Development Issues and the University of Luton as part of the European Union funded 'Social Inclusion' Project.

environment. The aims of the organisation are artistic rather than therapeutic and none of the staff has formal psychiatric qualifications.

STARŤ in Manchester comprises studios in photography (SNAPS), textiles, ceramics, stained glass, painting and mosaic. It has a full-time staff of five – some of whom are permanent, some on short-term contracts. In addition, there are a number of part-time and associate artists who run painting, stained glass, woodwork and mosaic studios. Some of the associates have been, or continue to be, clients of the mental health services.

START OUT is a component of START that undertakes environmental art commissions on which more experienced START members are employed. START OUT has completed many large-scale projects in schools, hospitals and other public sites.

Background: The Manchester Hospitals Arts Project

By the 1970s, many artists were making steps into the world of real people. Community Artists were out on the street. Peter Senior knocked on a hospital door and, without too much fuss, launched a revolution that would encourage Health (a major religion at the end of the millennium, as Professor Davies has suggested) to fill the vacuum left by Church in the patronage of the arts.

Peter Senior set up the arts team at St Mary's Hospital in Manchester. I joined that team in 1978, wondering what relevance my inward-looking paintings could possibly have for people cooped-up for repair, for babies, for pain and for death (as I then saw it) in this awful institution. I felt powerless in the face of fear, disfigurement and death until, after several weeks in which I nearly left the job, I got about on the wards, and ever since, I have been meeting such exhilarating displays of courage and good humour that I decided to lighten up and stay in the job a bit longer; there might be something in it after all!

We adapted our ideas to what we perceived as the needs of the novel situation we found ourselves working in; we were interactive! As a team we all gradually learnt to consult better with staff and patients and to involve people in the design and, increasingly, the making of the artworks for the hospitals. We enabled people to have a greater say in planning their work environment and opened the door to the arts for people of all ages. We made prestigious murals. We got media coverage. We went to conferences. We were anxious to please. We felt that it was important, at that time, not to be too challenging because we needed approval at all levels to ensure the future of the project.

A lot of the work we did was pretty kitsch. It was fun, though; it looked very nice. Just because people didn't know what they wanted didn't mean we weren't going to give it to them; but too often we underestimated people's wish for art to be stimulating, rather than purely decorative.

Head for the Hills!

Arts Team photographer Jack Sutton and I started a series of projects with people in the mental health services. I was organising exhibitions, projects and studio space for patients and ex-patients. Jack and a nursing assistant, Steve Lyons, had organised a photography club at the Day Hospital and a 'Camera and Canal' project and exhibition, which involved trips out and introduced a relaxed and social atmosphere that was to inform later projects and the ethos of START itself.

We then worked with patients and staff on a long-term project called 'Head for the Hills'. We wanted to combine the exploration of the countryside and related issues with the enjoyment of the arts and the making of a piece of work. This work would be a celebration of shared experience. All the patients involved had the shared experience of mental distress, that's why they were there; but the shared experience of getting into the Derbyshire Peak District on freezing February days was quite different: it was to become a paradigm for turning adversity into personal and communal growth. The lasting monument to this shared experience was a large mosaic mural in the entrance to the Psychiatric Department's new building.

'Head for the Hills' was about liberation. It made the connection between the struggle of workers in the 1930s to escape from the smog of Manchester and Sheffield to the 'lungs' of the Derbyshire Peak District and the struggle to liberate the spirit from the shackles of mental distress.

In 'Head for the Hills' we were actively involved in the real political issue of access to the wild countryside east of Manchester. We worked with key people in the Access Movement, and in particular Benny Rothman, the tireless campaigner who had been imprisoned for his part in the Kinder Scout Mass Trespass of 1932 – an event which was an important step towards the setting up of the Derbyshire Peak District as the first National Park in 1948.

Start Studios

Recognising the potential for lasting benefits that were possible with this arts-centred approach, START was launched in 1986 with a three-year grant from the Manchester Salford Inner Cities Partnership. Permanent funding was later taken over by the (then) Central Manchester Health Authority.

The name 'START' was originally an acronym for 'Sheltered Training in Art'. Soon after its inception we moved away from the old 'sheltered training' concept and cautiously launched ourselves onto the knife-edge between *integration* with a community mental health service and the *autonomy* of an 'outward' looking arts organisation.

Members come to START from the local mental health services. I prefer the term 'application' to 'referral' in that the former suggests an active choice. Even so, START is plugged into a centralised referral system which covers all the

district's mental health services. This ensures that people's wider needs are met without compromising the artistic function of START by the imposition of a 'therapy' role.

For many people, START becomes an important and often essential part of their lives. 'Without START I'd be back in hospital' is a typical comment backed up by clinical research (Colgan *et al.* 1991). *Art & Soul & the Cold Blue Walls* (1994), a book of creative writing and personal statements by users of mental health services involved in arts projects in Oldham, Manchester and Salford, makes movingly plain the value that people place on the creative release provided by the arts.

START aims for quality in all its endeavours but, in its arts practice especially, it aspires to the highest in process and product. People achieve such high standards that START has a reputation for the quality of its artwork alone and stands alongside other arts and environmental arts agencies. Many of START's projects have demonstrated this quality – for example the exuberant contribution to the 'Against the Grain' textile exhibition in Manchester, the making (with patients and in collaboration with Hospital Arts) of integrated artworks for the Edale Mental Illness Unit in Central Manchester Healthcare (NHS) Trust and the exhibition by START at the Centre for Developmental Arts in Glasgow as part of Glasgow's international Mayfest.

Linking 'health' and community by dynamic arts projects, combining continuity with the fresh ideas of changing artists and forging interactive long-term creative partnerships with staff and service users – in *collaboration* with people who experience disruption in their mental health – are the practical applications of a philosophy that is never fixed and always evolving. We should no longer be embarrassed to say that we begin with a faith in the dignity of humanity and a spiritual dimension that unconsciously binds us, as individuals, together in common experience and to common purpose.

We may have evolved by fits and starts. Playing the game has changed the rules and will, I hope, continue to do so. We have sought for unity in diversity, for collaboration, partnership and mutuality; without doubt we have progressed two steps forward and gone one back – but we have moved steadily forward. In a speech given in 1993 in Worcester, USA, about the Clubhouse employment programmes (which share much of the philosophy of START), Kenn Dudek suggested that the seeming randomness of organisations such as the Clubhouse (and START) conceals underlying structures and purpose that we may not see. He pointed out how this is supported by the modern scientific theories of *chaos, biodiversity* and *co-evolution.* We too might use theories to underpin the approach and illustrate the progress of START.

We're in the business of forging partnerships that enable the fullest participation of each, allowing both innocence and experience to lead in turn. Each gives 100 per cent. The artist doesn't have to hang back and conceal his or her knowledge and skill, nor does the person with a 'clinically' idiosyncratic view

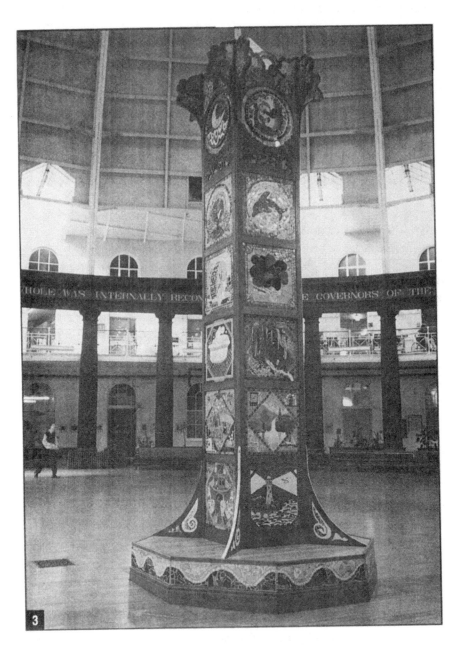

Figure 24.1. The Spa Column – Devonshire Royal Hospital, Buxton

of the world need to see his or her visions as pathologically second-best. We've entered the domain where obsession and passion are one and the same, where the terrifying store of human experience is converted into a springboard to growth.

The words that we use are powerful tools which reflect, influence and confirm our behaviour. It is important that we use them actively and not be ruled by them. People who attend START are known as *members* of an arts centre. They are not *clients* of START itself, although they may be clients or users of the mental health services. It is important to remind ourselves that, as artists, our *clients* will be those who experience, commission and purchase our work – the *arts* clientele to which we, as artists, are qualified to provide a service.

Whilst the passing on of skills in an atmosphere of mutual learning is the cornerstone of START's activities, not everyone wants to be considered as a 'student' – especially when he or she considers him or herself to be on an equal footing *as an artist* with the staff. If we are, as we should be, promoting an ethos of partnership, of hand-in-hand collaborative growth, then any term that reflects difference in status is rarely appreciated by the person who feels themself to be on the lower rung of a hierarchy: student/teacher, therapist/patient, professional/amateur – these terms more often reflect division rather than symbiosis and, in my view, should be used with extreme caution and awareness, if not sacrificed altogether on the altar of partnership. Of course I'm not suggesting this is easy – verbal vacuums, grey fogs, woolly heads and muddy zones are hard to deal with – but I firmly believe that it is by wading among these confusions that we prime the soil in which new ideas, approaches and forms grow.

Most of the activities of the Manchester START take place in a group setting where an awareness of the dynamics between the individual and the community is fostered. 'Sessions' have as their purpose artistic growth, leading to opportunities for change and development – towards projects, for instance, such as the START OUT commissions where more experienced members work with artists on environmental art works in the community and are employed for the duration of that particular project.

After START: What's Next?

When a member of START is ready, she or he may want to move on. But where to? The *sheltered* aspect is no longer as vital for many members now that they have acquired skills, confidence and a more independent artistic outlook. Younger people moving from mental health care into START should have the opportunity to follow an arts career but a survey of current arts opportunities to which members of START and the other projects in Greater Manchester might progress suggests that, apart from the Adult Education field, such

opportunities are few; it follows that they will have to be created as an emergent development of START and the other schemes.

We have seen how the skills gained by members of START have opened doors to encouraging employment opportunities on START OUT projects and commissions locally. At the same time, the clear health gains provided by START have led to a growing demand for advice on setting up similar schemes in other areas. This in turn requires the training of artists and administrators to develop such schemes, in fulfilment of the Health Advisory Service's recommendation that START and the Rovers demonstrate 'excellent good practice' which is 'applicable elsewhere' (HAS Report 1991). There is now an unmistakable need to disseminate the approach as widely as possible as an innovative and transforming complement to community mental health services.

In Greater Manchester there are a number of mental health arts organisations with which START works closely and in 1994 I set up a Forum to represent artists working in the field of mental health care. We share ideas and work towards a spirit of partnership to enable the 'arts in mental health movement' to grow in influence during a time of dangerous competition in health care and the arts.

The Forum of Artists working in Mental Health Care comprises:

- *Creative Arts Team* at Prestwich Hospital, run by Viv Hindle.

- *Hospital Arts*, represented by Brian Chapman and Helen Kitchen. Hospital Arts' reputation as leaders in the arts in health care includes many outstanding mental health projects including the long-term and revolutionary work at Ashworth Hospital on Merseyside.

- *MAPS (Mind Arts Project Stockport)*. Michael Anderson has recently been appointed co-ordinator with funding from the Opportunities for Volunteers Scheme, Stockport Borough Council and Stockport Health Commission.

- *Oldham* is represented by several artists and mental health workers including Mark Beddows, Eileen Wood and Mike Ash. The health services and the Borough Council are hoping to appoint a co-ordinator for the arts in mental health following a series of local initiatives and consultancy and project input from START.

- *Rovers* which, together with START, is part of Central Manchester's Community Mental Health Service. It is an activities-based, client-centered roving day-care service which employs an artist, Charlotte Brown, a wood worker and a gardener as well as two mental health workers.

- *The Insight Gallery* at High Elms, set up by Charlotte Brown in 1994 as a venue for exhibitions relevant to mental health issues.

- *St. Lukes Church Arts Project* in Longsight with Alison Kershaw as resident artist. Her church and art, mental and spiritual health, come together in a dynamic setting that is a model for community growth.
- *START in Bury*, with Brian Philips – which now meets two days a week.
- *START in Salford*, run by Bernadette Conlon, is jointly managed by START (Manchester). It was set up with initial funding from the Kings Fund 'Better Futures' Programme and is now funded by the Mental Health Services of Salford (NHS) Trust and Salford Social Services.
- *START Studios (Manchester)*
- *Stockport Arts and Health*, whose arts co-ordinator, Adrienne Brown, implements arts activities throughout the health services in the district – including mental health services.
- *The Craft Factory* in Prestwich, a part of Turning Point which works with people with addiction problems. Linda Boyles is the artist/manager.
- *Venture Arts* in Hulme, where John Adshead works with people referred by Social Services, several of whom have come into the community from Prestwich Hospital.
- *ZAP*, the arts project at the Zion Community Mental Health Resource Centre in Hulme.

We are also forming links further afield with:

- *The Trongate Studios* in Glasgow, run by sculptor Sean Taylor, which has evolved out of Projectability and the Centre for Developmental Arts mixed with the inspiration of START
- *The Sunderland Art Studio*, which evolved from the arts project at Cherry Knowle Hospital.

Links have also been made, at the instigation of the European Institute for the Advancement of Social, Cultural and Development Issues, with mental health services in Greece – where much needs to be done and where START is seen to be a good model for development.

The Forum will be involved in a collaborative venture between a number of agencies and users of mental health services to research and set up an independent (non-statutory) arts facility as a resource for all the arts and mental health projects in the region.

This centre will be the definitive bridge between mental distress and cultural well-being via the arts; it will be a force to impel and nurture future developments and will work with other arts and mental health agencies towards significant social and cultural change. Its primary aim will be to further the arts career of people with mental health needs. In particular it will be available to those wishing to move on from, or extend their experience beyond, those

arts/mental health schemes which, in five years time, will form a ring of localised centres around the Manchester conurbation. In addition, alongside its strong 'artist's studio' ethos, the new centre will train or re-train younger people, especially artists who may be long-term unemployed or mental health workers, in the setting up and management of arts and mental health programmes at home and abroad.

This new facility will be neither arts-elitist nor health-specific. It will be 'porous' to the local community and incorporate informal 'open' arts and performance studios and an exhibition space. It will have a strong fine arts and performance base and will actively support and promote issue-based work. It will be a potently creative force in the campaign against stigma and the promotion of mental health.

It will epitomise the philosophy of *social inclusion*, in accordance with the aims of the European Institute for the Advancement of Social, Cultural and Development Issues. The Institute, a key player in the proposals for the new centre, was born out of the experience of Nora Aperghi who, given the job of transforming the notorious mental hospital on the island of Leros by the Greek Government, realised that the fundamental problem was one of attitudes that were not specific to Leros but endemic in our cultural response to mental health issues. The Institute's 'Social Inclusion Project' is a trans-national programme to challenge and change these deeply ingrained attitudes.

The role of the new centre as a non-NHS interface between the arts and mental health will enable START and similar NHS-based schemes to clarify their roles as introductory training centres for people recovering from a mental illness, a resource for those members needing longer-term support and as touchstones in the evolution of wider networks.

Exchanges, residencies, workshops, courses and other activities could be arranged between START, other 'arts in mental health' agencies and the new Centre. This interaction will enhance opportunities and morale for artists, members and staff. A quota system of short-, medium- and long-term attendance at START would provide, for example, a more stimulating mix of abilities and duration of attendance. People could then move at will to the new Centre whilst retaining links as desired with START.

START Studios (Manchester) will then be in a position to avail itself of the wider opportunities under development whilst focusing on its rehabilitative role as an integral component of the Psychiatry Directorate. Here it has the particular ability to recruit, directly from within the care settings, a greater number of people with mental health needs who will most effectively benefit from the arts.

Conclusion

Anyone who has seen START in action has no doubt that it works. It is a signpost to the future, not only for people with mental health needs, but also for artists and craftspeople, for communities and for our culture as a whole; the ripples run deeper than the psychiatric department, wider than the art gallery. These ripples will in time, I hope, touch us all with a greater awareness of a society of unique individuals, with a greater appreciation of eccentricity and with a true identification with the central position that the creative arts must hold in any fulfilled society.

Peter Senior and Jonathan Croall, in the book *Helping to Heal*, recommend that all health authorities set up arts and mental health studios based on the START model. The Health Advisory Service too states that the approach is 'applicable elsewhere'. New schemes setting up should anticipate the long-term needs of members, artists and staff and ensure a healthy balance between continuity and flexibility. It is important for such schemes to be part of a strong network of agencies and individuals to provide scope for flexibility, development, collaboration and debate. The last word should be left with people who have experienced how other arts have transformed their lives. Marie Muncaster, a member of one of the Oldham projects, summed it all up better than I ever could when she wrote in *Art & Soul & the Cold Blue Walls*:

> For me the arts programme is invaluable. No amount of drugs could give me the kind of feelings I get when I'm doing something creative. After coming out of hospital and losing all my support I would have just gone back to the same circumstances, whereas the arts programme opened up a whole world of expression that I found was inside myself. It gave me back my confidence, which was absolutely zero. I met people who became my friends who didn't make me feel like a social outcast as we were all in the same boat, as it were. It has helped people to work in teams that could only work alone. The same way people who could only work in a team found they could do things by themselves.

> One of the best things it has done for me is helped me to find my sense of humour. It has given me tolerance and a purpose to my day.

> To be able to create and contribute means to gain back some self-respect; there are no drugs for that.

> There is something about art that can reach inside. Art can unlock so many thoughts and feelings.

And, finally, a member of START Studios in Manchester wrote:

> '...If there was no START I'd stop.' (p.7)

References

Brown, L., Thomas, S. *et al.* (1994) *Art & Soul & the Cold Blue Walls.* Oldham: Oldham Metropolitan Borough Council and START Studios.

Colgan, S., Bridges, K., Brown, L. and Faragher, B. (1991) 'A tentative start: evaluation of alternative forms of care for chronic users of psychiatric service.' *Psychiatric Bulletin 15,* 596–598.

Earnscliffe, J. (1993) *In through the Front Door – the Arts and Disabled People.* London: Arts Council of Great Britain.

Health Advisory Service Report (1991) 'Report on services for mentally ill people and elderly people in the central Manchester Health District.' NHS Health Advisory Department of the Health and Social Services Inspectorate. Ref. HAS/SS1(91)M1/E,53.

Senior, P. and Croall, J. (1993) *Helping to Heal: The Arts in Health Care.* London: Calouste Gulbenkian Foundation.

Culinary Arts in Health

John Rice

Foreword

'Ten days in hospital', they said, 'Then you'll be right as rain. The op's got an average 95 per cent success rate'.

First thought then – where's the 'Good Doctor' guide? Who's got the highest success rate? Who's got the top patient satisfaction ratings? Who's got the 'Surgeon of the Year' award?

Second thought – where's the 'Good Hospital Food' guide? Where's the highest spend per patient-day? Where are the best menus? The best cooking? Who's got a licence for God's sake? How do you tell a hospital's food success rate? And its failure rate? Salmonella ratings? Malnutrition? Packet soups? Instant whips?...

But why am I going to a government hospital? What hope for foodies in a no-star NHS temperance hospital? Why didn't I go private?...

It began well. I was offered a menu to fill in for lunch in two hours time.'Shouldn't this have been done three days ago?', I asked. 'We've meal-by-meal ordering', she said. Like a hotel inspector taking his first meal, I quietly scored the first of many on the ten-points-a-dish rating. You know the sort of thing: put a picture in your mind of what it should be, test it for appearance, taste, smell, texture and make your judgement. Everyday 'Salon Culinaire' stuff. How does it fare? How does the NHS fare gastronomically? Is there a place for the culinary arts in health? What are the culinary arts? Where are they? What do they entail? Can the NHS afford them? Where does one start?

Culinary Arts

Eating food keeps us alive. Culinary art – the skill and artistry in cooking and serving food – enriches life, whether entertaining at home, dining out at pubs and restaurants, taking a hotel break or eating in hospital.

Good food is a joy. It lifts the spirits. It tempts the appetite. It makes the occasion. It adds colour to life. The art of cooking is the freshest mouthwatering ingredients, good recipes, *Soigné* preparation, exact cooking, last-second timing and the simplest garnishes. For the professional, cooking – with its four dimensions of taste, smell, look and touch – bring out the spark and élan in people. It is a therapy. You make things at every meal to tempt and please. You watch eyes light up and smiles appear if your guests like your food (eyes drop and conversation dies if they don't). But the culinary arts don't end with cooking. They also include the service of food and the menu.

Good service reflects the importance of the guest in the eyes of the host. Welcome, courtesy, respect and warmth of hospitality are all shown in the service of food. The best service provides exactly the right sense of occasion, whether it is formal or relaxed. It suits the guests' individual needs and makes them comfortable and at ease, and presents meals at their most hot and appetising. It enhances meals with professionally-laid tableware and sparkling cutlery, shining glasses and napkins. It provides the extra touches that make meals memorable.

Good menus show an understanding of guests' needs. They also show if you care, your interest in food, your style, *élan* and flair. The best menus surprise and delight with tempting and imaginative choices and their mix of food colours, scents, flavours, textures and temperatures. They balance the simple and the sophisticated, the cold and the hot, the piquant and the subtle, the cheap and the expensive. Menus also set the chef's timetable by balancing dishes which can be prepared in advance with those which call for all the chef's concentration and last-minute attention to detail.

Place in Health

In hospitals the culinary arts are key to breaking the 'sickness barrier' – the great challenge of getting sickly patients with little or no appetite to eat the essential foods and nutrients they need for their treatments, recovery and health. The sickness barrier is there because patients are ill, and many enter hospital malnourished. They may have lost their appetites through illness, exhaustion, frailty, stress or medication. Yet it is essential that they are tempted to eat in order to obtain adequate nutrition.

Types of Need

On top of this key goal, the culinary arts give heart to a community and help to meet the differing basic, medical, and social needs of particular patient groups, and of hospital staff and visitors.

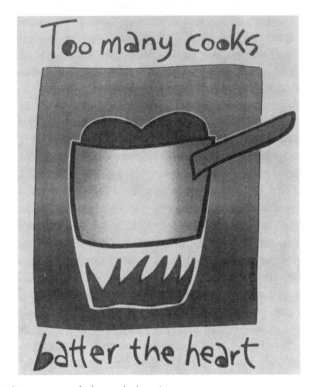

Figure 25.1. 'Too many cooks batter the heart'

Basic

The basic need is for tempting, wholesome, nutritious and freshly cooked meals retaining all possible nutrients. Even in the smallest hospitals and homes, without qualified chefs, the standard should be equal to the very best of home cooking with fresh ingredients, wholesome homemade soups, tender meats and nourishing sweets. In large hospitals, with qualified chefs, the cooking, menu and meal service should be of a high professional standard. Menus must list foods which patients and staff enjoy and which meet their differing tastes, appetites, eating abilities and ethnic requirements. Food service arrangements must provide special facilities to help patients with eating and feeding difficulties.

Social

The social need is for a catering service which helps to make a hospital stay less stressful, enables long-stay patients to lead fuller and more enjoyable lives and retain their individuality and dignity and provides a sense of community for patients and staff.

To make life less stressful means providing birthday cakes for children and long-stay patients, providing patient coffee shops and 'locals' in long-stay hospitals, serving special theme menus for Italian and French evenings, etc, and organising barbecues, picnics and cream teas.

To contribute to a fuller life means providing special self-help pantries for young, chronically sick patients – to help them entertain their visitors instead of always being the recipients of care – and running training courses for patients (e.g. with learning difficulties) in planning menus, cooking and cake making, laying tables, receiving guests and serving meals.

To retain individuality and dignity means serving 'takeaways' and pack lunches for patients wishing a break from communal eating, giving patients the opportunity to help in keeping herb gardens, etc, and to take part in everyday catering activities.

Medical

The medical need is for catering services which provide the nutrients needed to build up patients to withstand the effect of medical treatments, aid wound healing and combat infection following trauma and surgery and to supply therapeutic diets and meet the particular dietary needs of key patient groups (e.g. orthopaedic, maternity, children, elderly, mental illness, etc).

Rewards

When hospitals draw on the culinary arts to meet patient and staff requirements, the rewards are high. Good cooking means culinary reputations as well as medical and nursing ones. It means high patient and staff morale and good nutrition. Kitchens with culinary reputations don't need to advertise for chefs. Cooks are proud of their roles. The hospital restaurant is full. The work-force is well nourished. Morale is high. The hospital's reputation is assured because the public understand what good cooking means – for themselves and for their families.

Where are They Found?

IN PROFESSIONALISM

People go into catering because they enjoy it. They've got a flair for it. They want to learn more and be the best – the very best pastry cook, vegetable cook, sauce cook, whatever. They want to practice their art, be recognised as a professional and be paid for it. They don't want to be faced with packs of convenience foods which you just reheat or add water to (e.g. packet soups and sauces, gravy mixes, instant potatoes, powdered milk, frozen eggs, pre-cooked meats, etc.). Convenience foods are for working mums, weekend sailors, bedsit

students and pub landlords who can't cook! They break a chef's spirit and tarnish professional and hospital reputations.

AT COLLEGE

Culinary arts are found in the professionalism of the work-force. They are taught at college, honed in competitions and put to the test in kitchens and battles for ratings. Key to professional standing and pride, they are all built on a particular attitude and a range of catering skills.

The attitude is one of 'customer first' (diner, patient, visitor, guest). The whole service is planned to foresee and meet the needs of the customer. To smile. To want to please. To care.

The skills are the ability to receive guests, to cook, to serve and to manage. These arts are taught in catering colleges. They are recognised by national qualifications which are accepted across the whole of the Hotel and Catering industry – in hotels, hospitals, airlines, shipping, whatever. There is a set way of welcoming a guest, of preparing a menu, cooking asparagus or a cottage pie, serving a meal, pouring a glass of wine, making a cup of coffee and of clearing a table.

At college, prospective NHS chefs are taught the basics of good cooking, the *fonds de cuisine*, on which all recipes should be based. They are the ways to make natural stocks of chicken, meat, vegetable and fish. These stocks are the essence of all soups and sauces and all stewed, braised, casseroled and poached dishes. Chefs are taught to grill, bake and braise, make the lightest pastry and the smoothest sauces, understand the chemistry in cookery and know the many thousands of recipes listed in the chef's bible (the *Repertoire de la Cuisine*). They include over 300 ways of making soup, 150 ways of cooking sole, 160 lamb dishes, 100 different potatoes...

AT COMPETITIONS

Pure art and function are combined in culinary competitions. The famous *salon culinaire*. Row after row of white-clothed tables covered with edible exhibits which have been worked on late into the night and rushed in in car boots just in time for the judging. Presentation is all as restaurant competes against restaurant, hospital against hospital. On the top tables are the eye-catching ice carvings of swans, massive sculptures in butter or the Tower of London in chocolate. Next come the *trompe l'œil* centrepieces with huge platters of fighting crawfish, eye-to-eye, claw-to-claw. Leaping salmon in shiny aspic. Fighting cocks coated in *chaud froid*. Tables are grouped course-by-course, so you walk through main courses, vegetables and potatoes to sweets and petit four. Everyone waits for the judges to award prizes in each class. Chefs peer at each other's entries to see who has the edge. Professional pride is at stake.

IN HOSPITAL KITCHENS

Working in the professional kitchen is pure theatre. Two shows a day and fourteen a week, with hours passing as quickly as minutes as meal times get near and you rush to complete the orders. A great buzz. Not the wage-slave slog of Arnold Wesker's *The Kitchen*, but a team game of getting everything to come together at the right time as the adrenalin rises. Even the simplest dishes take your skills. A sea-fresh fillet of plaice grilled for minutes and topped with lemon and parsley just before serving. Thirty-second cheese omelettes shaken and stirred over the fiercest heat, as light as souffles. Home made pizzas pulled from the oven smelling of fresh baked dough, tomatoes and oregano. Bread and butter pudding baked in a *bain marie* to keep it as light as air. Cream potatoes whipped in peaks like Swedish ice cream. *Crème brûlées* flashed under the grill, just seconds before serving...

The cooking show is three to four hours at most. You start from scratch. Everything is staged. The language is theatrical. '*Mise en place*', '*mise en scène*'! Everything is geared to be ready in that brief window of time when food is at its peak, and after which it spoils and is left on the plate. The best chefs are obsessive about quality. They are perfectionists. They know the message of good catering – cook it fresh, keep it simple, keep it hot. They know that cooking is about ingredients, proven recipes, and, above all, spot-on timing. Top grade, fresh ingredients are chosen to keep flavours fresh and wholesome, to avoid 'off' taints from reheated and reconstituted meals which might put off uncertain appetites and to get the maximum yields needed to keep costs down.

TIMING

The difference between a good and bad kitchen is how busy they are at peak times. The best kitchens are 'flat out' at lunch from 12 noon onwards, continuously cooking and serving meals ward by ward. In bad kitchens everything is dead after 11.30am. Ward bulk trolleys are loaded with meals from 10am onwards and most food looks wet and steamy from hanging around an hour or more before it leaves the kitchen (this is because meals are cooked early to fit in with the NHS routine of chefs walking around the trolleys part-loading each menu item as it is cooked).

Professional cooking is an exercise in timing. Each menu item's cooking time is worked back from the time it is to be served to ensure top quality on the plate. Each ward's mealtime is staggered over an hour or more to allow continuous batch-cooking ward by ward. Foods are classified as 'off peaks', 'early starters' and 'late starters'. 'Off peaks' are cold foods, soups and sauces which don't spoil with keeping and can be prepared before the real cooking starts. 'Early starters' take the longest cooking time and are cooked first, in two or three twenty-minute batches. This means that casseroles, pies, joints, roast potatoes, etc, come out of the oven continuously over the hour of service. They are not all cooked at the same time and kept hot for over an hour. Most foods

are 'late starters' and can be prepared in minutes. 'Late starters' are cooked in batches continuously throughout the hour of service. They include fresh vegetables and potatoes, omelettes, fried fish, all grills, etc. They also include roast joints sliced carvery style straight onto the plate.

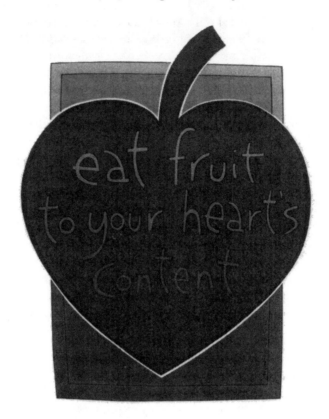

Figure 25.2. 'Eat fruit to your heart's content'

TASTING

Every food item is tasted for it's appearance, taste, smell and texture, as well as temperature, before it is issued to wards.

IN WARD SERVICES

In today's top hospital kitchens, as in today's top restaurants, cooking and service are synchronised. The patient's individual choice is prepared to order, plated by professionally trained staff under the eye of the chef and sent straight to the table or bedside. The days of clumsy fork-and-spoon 'bulk service' and 'silver service' are largely over. Ditched in order to avoid delays, sloppy service, forgetfulness, broken portions, lost diets, ward-circling delays and cold food. You no longer have to wait and watch your food getting cold as it circles the

ward for half an hour and then take pot-luck from what's left in the trolley. In today's hospitals the art of service is in putting your exact meal order before you on an attractive tray and in a hot and appetizing condition. Meals go to the diner under a covered dome or lid. Attractively garnished in half, full and large portion sizes, they are taken to the ward in a mobile oven and handed out as soon as they arrive. Great care is taken that steam can escape and foods retain their crispness. Vinaigrette is added to salads on request. Dessert forks are included in cutlery sets. Toast and warm rolls are served with breakfast. Napkins are provided. Trays are delivered within minutes of plating.

IN RESTAURANT SERVICES

In the hospital's restaurant and patient's dining rooms, food is sent in bulk from the kitchen. It is cooked continuously to order and replenished throughout the service time to avoid waste. Service staff are professionally trained in the presentation of meals and in the particular service skills needed in providing special functions. These service skills include the ability to lay a table: how to arrange cutlery and lay out glasses for different wines. The appropriate temperatures for different wines. How to serve foods from the left and liquids from the right. How to clear and crumb a table. How to shape napkins, polish glasses and produce table decorations.

Can the NHS Afford Them?

Culinary arts are used in cost-conscious hospitals to deliver quality at minimal cost by ensuring that the budget is focused on the value provided on the patient's plate. As in the £1 donated to charity, when the gift to an efficient organisation with low operating costs goes much further than that given to a top-heavy one, the budget for a quality-focused hospital is frequently less than the norm. This means that an efficient hospital is frequently able to deliver quality to patients at under £5 per patient per day on 1996 costs: spending £3–4 per patient per day on buying and cooking food and under £1 on serving it.

In high quality hospitals money is not wasted on buying low-value convenience foods (high package and process costs plus manufacturer's profit), discarded pre-cooked meals which have exceeded their sell-by date, low-cost processed foods with a high proportion of water and low yields, surplus ward meals, unsold restaurant meals, half-price restaurant meals, high (but hidden) bulk service costs and much more.

Summary

So what is the verdict on NHS catering? Is there a place for the culinary arts in government hospitals, or should they be left to the private sector?

Well, I cheated a bit. I did know that I was going to a hospital at the right end of the region's 'Good Eating' table. Its spend is around average for a tray-service hospital and it has been accredited for the quality of its catering. It has 24 menu choices at each meal plus a priced à la carte option at dinner. It has a herb garden and a kitchen team lining up for a star-rating in cooking.

I know too that it's not alone; that similar hospitals have 95 per cent of patients rating their cooking between good and excellent; that at least one had the highest quality rating and the lowest costs for a hospital of its type; that quality is being delivered to patients in many hospitals for under a fiver, daily.

Certainly hospitals in the NHS are performing well, but most are keeping very quiet about it, so that some of our best hospital chefs – unlike their star-rated restaurant counterparts – are still unrecognised for their efforts. Conversely, many hospitals are getting away with sub-standard catering and too often the public believe this to be typical of all hospitals.

To establish culinary arts in health the NHS needs to recognise the best performers as clearly as they are recognised in restaurant guides. This is the only way to get the standard required, to harness professional pride and to get hospitals to compete for the best food awards, the highest patient rating and the best nutrition. Caterers are competitive and culinary performance is a matter of professional pride. Without recognition it is tempting to take it easy, to settle for a quiet life and just to take the money – the story of lacklustre NHS kitchens.

The newly completed 1996 NHSE catering performance measures (how much? How professional? How rated by patients?) set the stage for national and local comparisons. The new NHSE Catering Good Practice Index, with its lists of professional culinary standards (for meal quality, nutrition, hygiene and cost controls), spells out what needs to be done to get high quality catering services. It also provides the basis for a star-rating system for culinary excellence similar to that in the hotel and restaurant sector (It is important that the increasingly popular benchmarking of hospital catering against locally agreed standards is not allowed to denigrate the industry's professional culinary standards and qualifications).

There is a place for culinary arts in the NHS but they have to be safe-guarded, promoted and rewarded if they are to survive in the face of the many soft options in the public sector, until such time as culinary outcomes are compared.

Poole Hospital NHS Trust

20 Basic Concepts in the Operation of the Catering Department

1. Menus are designed to utilise staff continuously throughout the day, as if on a production line.

2. Quickly assembled snacks and cold buffet are offered as alternatives to full meals to reduce workload.

3. Inexpensive snacks are offered to reduce food costs.

4. Multi-choice à la carte menus, listing the same 60 to 70 dishes daily, are used to simplify production and avoid waste.

5. Patient's meal orders are taken on the same day that they are to be served to ensure more accurate meal requirements and avoid over-production.

6. Kitchens are staffed around a single shift – 9am to 6pm – to avoid early cooking and ensure maximum productivity.

7. Chefs are only used for skilled preparation work and cooking. All other functions are delegated to supporting staff or specialist suppliers.

8. Kitchen support staff are interchangeable with tray service and restaurant staff for maximum flexibility.

9. Blast chillers and freezers are provided for off-peak preparation and selective chilling.

10. Cooking is focused on the professional standards, for example serving freshly cooked roast meats, stock-based sauces and using fresh vegetables and potatoes.

11. Ingredients, preparation and cooking methods ensure professionally acceptable results.

12. Ward mealtimes are staggered and food is cooked in batches, with each item's cooking time worked back from the time of consumption.

13. Meals are plated in the kitchen under the eyes of the Manager and chef, with each item plated at the last minute (e.g. omelettes plated straight from the pan and roasts sliced to order carvery style and plated).

14. All food is tasted before issued and any sub-standard items are replaced.

15. Batch cooking continues throughout the service period. Trolleys are taken to wards one at a time as soon as they are loaded and meals are served immediately on arrival.

16. Food temperatures are monitored throughout the cooking and serving processes.

17. The quality of each part of the catering service is assessed on patient and staff satisfaction ratings (i.e. meal times, menus, meal ordering system, cooking, temperature, beverages, service, nutrition and the service overall).

18. Patient and staff costs are separated to ensure value for money and to show the staff meal subsidy (cost per patient day).

19. Catering performance is co-ordinated across all disciplines with each department's responsibilities specified in the Trust's catering standards (catering, dietetic, housekeeping, nursing, supplies, works, etc).

20. The Trust's catering performance is measured and graded annually by an independent catering assessor to demonstrate compliance with local, regional and national catering standards and norms.

Part VIII

Evaluation
and Future Perspectives

I think it frets the saints in heaven to see
How many desolate creatures on the earth
Have learnt the simple dues of fellowship
And social comfort, in a hospital.

Elizabeth Barrett Browning, *Aurora Leigh*

Does Art Heal?
An Evaluative Approach to Art in the Health Service[1]

Malcolm Miles

Introduction

Healing was once considered an art. Modern medicine, which relies on diagnosis of symptoms and intervention through drugs or surgery, is related to the scientific thought of our industrial society. Older traditions, such as Chinese medicine, used a holistic approach and a more subtle intervention. We may save lives through science, but questions arise as to the quality of life and the extent to which mind influences matter. In the USA, a new subject is becoming established under the heading 'mind-body medicine'. Increasingly, two things are happening here within the National Health Service: more and more doctors, nurses, therapists and managers are broadening their concept of health care to include a concern for the patient as a person, not just an exhibitor of symptoms, and art and craft works are being commissioned to humanise new and refurbished health buildings. Programmes of performing art are also being organised in some cases, where a hospital is in a town with a strong arts tradition (such as Brighton) or in long-stay institutions where there is a need to involve residents in cultural activities.

A long tradition of art in hospitals has been cited by some observers. The patrons of hospitals, from the Renaissance onwards, commissioned altarpieces and statues but we should not assume this to demonstrate a relation between art and healing in a modern sense. Such patrons were members of a class for whom the patronage of art was a moral duty; the motivations of personal piety or family glory were sufficient ends. If art helped the sick, it was in preparing their spirits for death rather than in reducing recovery times from surgery.

1 This is part of a movement which affects the sciences generally (see Rubik 1992).

Besides, the hospital, as we know it, is a recent invention. Its forerunners included the medieval houses for lepers and Renaissance hostels for foundlings; from the seventeenth century there were insane asylums and, from the eighteenth, clinics for teaching medical knowledge. The District General Hospital is a twentieth-century development of the Victorian general infirmary. The infirmary was originally a new building type found in large cities, and its design reflected a wider institutional ethos. Still, some of these buildings, such as Gilbert Scott's General Infirmary at Leeds, had architectural grace. With the formation of the NHS, increased size, lack of vision, advanced technical requirements and cost constraints have made the hospital an architectural disaster area. In these factories for the processing of illness, and in some mental health units (which may still be housed in Victorian buildings), arts projects have developed which claim to influence the outcomes of care as part of a business case for their support. This is a new intention, driven by the need for financial accountability in the public sector. We might still think that, even in our mercenary society, the idea that 'works of imagination enrich life' could have some currency. But the moral case cannot be evaluated. We cannot measure the benefits of art for the soul, and it is difficult even to measure those for the body, but if the advocacy of hospital arts projects is to move from enthusiasm to a more rational basis, hence ensuring future budgets, then some kind of evaluation against a business case is necessary.

A New Climate

Hogarth painted two murals at St Bartholmew's Hospital, London – The Pool of Bethesda in 1735–6 and The Good Samaritan in 1737 – which remain in their original positions. Many hospitals retain tile pictures – often in childrens' areas and depicting nursery rhymes – commissioned from leading ceramic companies, such as Doultons, early this century (see Greene 1987). Whatever their impact on patients and staff, these works of art have appreciated greatly in monetary value. When the new wings of St Thomas' Hospital in London were built, the architect, Eugene Rosenberg, was able to use endowment funds to establish a collection of contemporary art for the building. The new Chelsea and Westminster Hospital also has a large collection, although it remains to be seen how well its value will stand the fluctuations of the art market. But investment is not the primary motive for locating art in a hospital. Today, many NHS buildings have arts projects. Design guidance on hospital building (see NHS Estates 1988 and 1993) includes the recommendation that art and craft works should be integral to new designs and this policy is one aspect of a new climate of concern that the design of health buildings should, in itself, be conducive to healing. Recent buildings, such as the West Dorset Hospital in Dorchester by Percy Thomas Partnership, or St Mary's, Isle of Wight by Ahrends Burton Koralek, or the Oncology Centre at Maidstone Hospital by

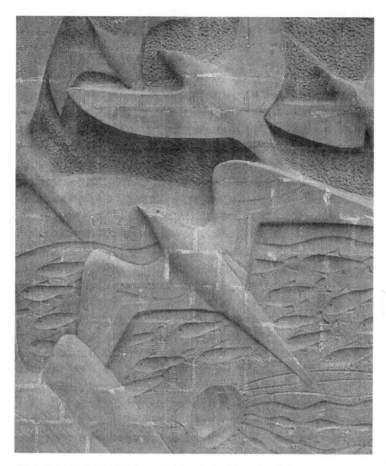

Figure 26.1. Brick Relief by Walter Mitchie – Bristol Eye Hospital

Powell Moya, are examples of a sympathetic approach through which good design is seen as part of good care. Colour is becoming more matched to the particular function of a space, in place of the once universally applied magnolia. A sense of human scale and attention to architectural detailing are returning after the barren years of the 1960s and 1970s. Several new hospital schemes have included sums for art within the capital budget: at Musgrove Park Hospital in Taunton, around £80,000 was set aside for art and craft works, £60,000 will be set aside in the redevelopment of the Royal Sussex County Hospital in Brighton and, at the General Infirmary in Leeds, following an exercise in Value Management, £1.5 million was saved (in a £49 million scheme) to be ploughed back into enhanced interior design and a major arts project. These are substantial sums and it is not surprising that the pressure for evaluation grows. Such evaluation needs to take into account at least two things: the extent to which

the arts assist in creating a positive ambience for staff and patients and the extent to which they contribute to achieving the aims of care for patients.

The Business Case

Organisations such as Healthcare Arts (in Dundee and Leeds) or Caring Arts (in Bradford) have focused on how commissioning artists and craftspeople helps a hospital do what it is there to do more effectively. This includes creating a humane and relaxing ambience and a good workplace for staff. Successful industries and high street retailers have invested heavily in staff facilities and see this as a direct contribution to the quality of their product or service. The potential benefits may include improved recruitment and staff retention and the way satisfied staff tend to increase customer satisfaction. The NHS is the largest employer in the UK; although it cannot be said to deal with customers, it can still learn from industry in how to raise staff morale and how to give patients a feeling that they are treated as individuals. A large hospital employs 3000 or more people and there are few areas where they have real choices. Selecting artists for commissions is one and the involvement of staff teams in art and design decisions leads to higher morale. There are many examples of staff teams making interesting, not just safe, choices and, whilst 'experts' can be very helpful, it is essential that the final decisions are made, and owned, by staff. As yet there are no detailed studies of the impact but one kind of anecdotal evidence is that staff who feel a pride in and ownership of their workplace ensure it is well maintained; this saves money in the long term.

The out-patients department at Queen Elizabeth Hospital, Gateshead was extended and re-designed in 1990 as a national demonstration project funded mainly by the Department of Health. After three years of heavy use, it was cited in a design guide in 1993 and found still to be in excellent repair. The design included several calculated risks: large areas of natural wood, carpet throughout the public areas and a lot of glass. There has been no damage and the plants are still alive. There is a complete absence of the scrappy, unofficial notices which festoon the walls of many hospitals – like litter somehow displaced from the floor to the wall. Staff morale at Gateshead was high and one manager commented: 'Anywhere bright and cheerful makes you feel that way yourself'. A nursing sister said: 'the extent of staff commitment is shown in that it still looks as good as new' (NHS Estates 1993, pp.20–21). The refurbishment included a stained and cast glass commission from local artists Cate Watkinson and Mike Davis and staff working the department, at various levels of seniority, were part of the team which made all design decisions. Staff selected the one abstract design from those short-listed because they thought people would go on looking at it longer, seeing things in it, like we see faces in clouds. The fact that the artists were local and the glass from a factory in nearby Sunderland contributed to the sense of ownership. The Gateshead project shows that staff

are valued by a well designed workplace and that selecting art can be a positive part of involvement in the design process. We need further studies to document findings from such projects in a more detailed and methodical way.

Now that most hospitals are locally managed as NHS Trusts, local identity is more important. It is undesirable to develop locally distinctive heart surgery or locally distinctive ways to set fractures; but art and craft commissions give a highly visible link to the catchment area when subjects are utilised by artists and to which patients and staff can relate. They provide a note of the familiar in buildings where many people are daunted by so much that is not familiar. The art project for the new wing at Musgrove Park, Taunton uses images derived from the local landscape in glass designs by Amber Hiscott and has a courtyard with willow planting designed by Serena de la Haye, a local artist, which reflects a traditional Somerset industry. Similarly, the new East Cleveland Community Hospital has a series of etched glass windows by local artist Chloe Buck depicting images from the catchment area. Staff were involved in design decisions and art choices. Staff Nurse Denise Hodgson said 'I have enjoyed being able to create a unique and relaxing atmosphere'. Divisional Manager Margaret Baily commented 'the incorporation of the arts will create an interesting as well as restful environment' (NHS Estates 1994, p.42). These remarks are typical of many NHS staff who see art and craft commissions as one aspect of creating the kind of environment in which they feel they can work at their best. The evidence is purely anecdotal but there is plenty. Again, we need studies to compile its documentation.

The third aspect of a business case for art in the NHS, which underpins much advocacy of art in health care, is more speculative. It is the idea that art has an impact on patient care. There is some evidence that building design can aid (or hinder) clinical care in some circumstances. The problem is: can we extend a case which might be demonstrated for building design to cover art and craft (or the performing arts) as well?

Art and Clinical Care

We need more research on the impact of art on acute care and the quality of continuing care for people with special needs. Most of the evidence available is anecdotal and concerned, in a general sense, with environments which enable patients to feel more comfortable. Studies conducted by environmental psychology students at Nottingham University (as yet unpublished) show variations in stress and alertness amongst patients in shabby and refurbished waiting rooms; pictures were amongst the elements patients noted, along with colour and light. There is also a growing area of art within primary health care and many new surgery buildings demonstrate that architects and clients can work together to produce good design (see NHS Estates 1994). Dr Malcolm Rigler, a West

Midlands GP, is working with artists to develop an evaluation project in that sector, with support from the Wellcome Foundation.

The hard evidence we have to date consists of a number of papers which show that the physical environment has a clinical impact. For example, Roger Ulrich (1984) used medical records from an L-shaped ward in a Pennsylvania hospital to demonstrate that a view of trees reduced the recovery time for patients who had undergone gall-bladder surgery. The average stay for the tree group was 7.96 days, compared with 8.7 days for patients whose only view was of a brick wall. Strong and medium doses of analgesic were also much reduced – strong doses during days two to five were 0.96 for the tree group and 2.48 for the wall group. This is a controlled study looking at one condition and one staff team. Another study, conducted by a consultant anaesthetist in the NHS, showed that patients suffered about twice as much from hallucinations and delusions as those in a similar unit with windows (Keep, James and Inman 1980). A third study gives similar findings for two matched intensive care units in the USA (Wilson 1972).

The environment influences healing. But it is a leap of faith from that to say art has the same impact. It may also be difficult to separate art from interior design and external views. In the USA there has been a tendency for interior designers to introduce landscape-based art, following Ulrich's paper. In windowless treatment rooms, where scanners and linear accelerators are used, large-format transparencies are used on lightboxes or ceilings. A forthcoming project at the General Infirmary in Leeds will evaluate patient responses to such a set of light-boxes, set within the ceiling grid in a treatment area. At the same time, we know art does not set broken bones and it will remain difficult to measure its impact in hospitals where the average length of in-patient stay is only a few days. Any impact measured may apply to both art and the broader ambience created by colour, lighting, flooring and so forth.

In the end, an evaluation of the business case for art will only go so far. We may still need to look at a moral case. Hospitals are amongst our most used, and largest, public buildings. They are monuments for the values held in our society. If they convey a bleak functionalism, like the concrete hulks of Northwick Park Hospital or the grey tower block of Hull Royal Infirmary, then that says something about us. It was partly for local distinctiveness that managers at Hull decided to invest in a major interior refurbishment, but also because they believed a visually interesting interior said something about the kind of healthy society in which they wished to live. The results, which are spectacular, cannot be measured scientifically but the Infirmary has been transformed (inside) from a symbol of dehumanising bureaucracy to one of articulate vitality. In the end, the business case for art in the acute hospital must be complemented by a moral case – that we value ourselves, and the sick amongst us, enough to create buildings which are themselves a sign of well being and include both the decorative and the functional. For a more direct

intervention in care, however, we need to look to the long-stay sector and mental health.

Art and Mental Health Care

In mental health hospitals, in which a core of highly dependent patients will remain, residents have individual care plans which are devised and monitored by staff. They include things such as self-esteem, making choices, communication and mobility. Sensory stimulation, and reminiscence, may be important. Art involves these and can be a direct contribution to care.

Arts programmes in long-stay institutions extend to the performing arts and include a high level of participation: the artist will use social skills to liberate the creativity of residents (and staff). Making a picture, a pot or a play involves making choices and these (visual, tactile or verbal) are part of that long process of regaining self-worth. The act of making art can be shared and gives a satisfaction in its completion, regardless of value judgements about good and bad art. Staff who monitor care plans are well placed to monitor the impact of art on their patients and at Strathmartine Hospital, Dundee, they provided evidence on the effects of an 18-month residency by a visual artist.

Strathmartine Hospital

A study was conducted by Healthcare Arts using one-to-one interviews (conducted by two interviewers using one checklist of questions) with 20 staff who had, in various ways, encountered the arts project. Part of the artist's brief was to work with the care team for residents with 'challenging behaviour' and part was to seed skills to staff, so that something remained after the end of the residency. The length of the residency – 18 months – reflected a need for a settling-in period at the outset. An exhibition of work by residents and the artist was held at the end, at the Seagate Gallery in Dundee. There was a general feeling of success, enough that the hospital set about organising a second residency, but the evaluation sought to explore more detailed responses.

One set of questions concerned the initial impact of the project. Only one in 20 gained information from the official note circulated and eight received no advance information by any route. Once the artist had made contact, ten formed a 'very positive' view and one a 'negative' view. One nurse said that 'anything new coming into the ward is a good thing', another that 'experiences with the outside world are beneficial'. About half the respondents saw no difficulty in the artist's being part of the daily routine. Some saw the artist as a useful link between nursing and therapy staff, able to work between two otherwise discrete groups.

Twelve staff were involved in a project for the locked ward. It produced an environment decorated with sculptures in wire and paper using both natural and artificial light. Colour was an important element, and the way light affects

colour. The texture of materials also encouraged sensory stimulation. Six other staff were involved in a project to make large metal flower sculptures for the greenhouse and garden area. Some staff were also involved with the artist in projects related to external locations, such as the shopping centre. Asked whether the residency, and these projects, had affected the delivery of care, eleven said a clear 'yes', and three a clear 'no'. The others felt it was difficult to give a clear answer. The creative abilities of residents were more recognised and the majority of staff on the challenging care ward felt that residents' quality of life had improved. Fifteen staff said the hospital environment had been significantly changed, using descriptions such as 'more pleasing, stimulating and calming'. As to the passing on of skills to staff, so that they could use simple and inexpensive art materials in projects of their own, thirteen said they had increased confidence to do so. The benefits to staff were wide in scope: 'I learned how to think through projects' being two comments; a third was 'I never realised before how art can have an effect on people with behavioural problems'. One member of the care team summed up her experience as: 'working with an artist has been beneficial to the clients. They have learned new skills and it is good for me to be involved with someone who is not driven by the NHS'. The implications of the study are that artists-in-residence need skills of communication as well as art and an ability to work with a team rather than in isolation of a studio. Although it was a carefully conducted study, many of the responses are necessarily subjective and it does not give hard data that people with mental health problems or behavioural difficulties will be 'cured' by art – but they are not 'cured' by medicine either. They live in institutions to receive care and 55 per cent of staff in this evaluation felt care was affected by the artist's residency, only 15 per cent saying it was not. Seventy-five per cent felt such projects should continue.

This study did not include interviews with residents, many of whom had communication difficulties. Evaluations in psychiatric wards, on the other hand, could include them. A report by the Kings Fund (1977) shows it can be done and that depression does not inhibit a person's ability to express a view on their surroundings. The report shows that 'In spite of all the efforts to organise industrial and occupational therapy and a variety of social activities, there were many hours when patients needed something to do' (p.23). The need for meaningful and creative activity remains after discharge. In Sunderland, patients repeatedly asked to return to the ward to work in the art room – leading to an innovative partnership between the health authority, local authority and the Artists Agency, to set up an art studio in a redundant industrial building. A second scheme also now operates in north Tyneside. The costs of providing the studio are modest – and the rate at which patients require re-admission has fallen considerably. The studios offer ex-patients with artistic ability an opportunity to work, to socialise and to play a role in running the studio – all important aspects of rehabilitation into the community.

Conclusions

The material currently available suggests that art is a significant contribution to the quality of care in hospitals. More studies are needed, particularly to compare matched groups of patients with and without an arts project or in wards before and after refurbishment. But perhaps as important is the increasing body of anecdotal evidence that the introduction of an arts project, if it is carefully planned and managed and fully 'owned' by staff, can be the beginning of a wider change of culture in an institution. The World Health Organisation sees cultural activities as necessary to what it calls 'healthy cities' and we can turn this argument to the institution of the hospital. The arts always ask questions, involve choices and open a vista of imagination, giving form to feelings. This counters the tendency of institutions to ossify, to become dehumanising spaces for control rather than care. The NHS is moving towards patient-centred care and a higher degree of local distinctiveness. The arts will play a significant role in this.

Note

This chapter has developed out of an article: 'Art in hospitals: does it work?', published in the *Journal of the Royal Society of Medicine 87*, March 1994, and a revision of that for the National Campaign for the Arts News (November 1994).

References

Greene, J. (1987) *Brightening the Long Days*. London: Tile Society.

Keep, P., James, J. and Inman, M. (1980) 'Windows in the intensive therapy unit.' *Anaesthesia 35*, 257–262.

King Edward's Hospital Fund for London (1977) *Psychiatric Hospitals Viewed by their Patients*. London.

NHS Estates (1988) *Health Building Note 1*. London: HMSO.

NHS Estates (1993) *Environments for Quality Care*. London: HMSO.

NHS Estates (1994) *Health Buildings in the Community*. London: HMSO.

Rubik, B. (1992) *The Interrelationship between Mind and Matter*. Philadelphia, PA: Temple University.

Ulrich, R.S. (1984) 'View through a window may influence recovery from surgery.' in *Science 224*, 420–321.

Wilson, L. (1972) 'Intensive care delirium.' *Arch Intern Med 130*, 225–6.

CHAPTER 27

Evaluating the Effectiveness of the Arts in Health Care

Robin Philipp

Introduction: (Where And How The Arts Can Help)

Health, it has been noted, 'represents a balanced relationship of the body and mind and complete adjustment to the external environment' (Howe 1973). Indeed, the World Health Organization (WHO) has defined 'health' as 'a state of complete physical, mental and social well-being and not merely the absence of disease or infirmity'. In contrast, 'disease' has been described as 'maladjust-ment or maladaptation in an environment, a reaction for the worse between man and hazards or adverse influences in his 'external' environment' (Howe 1973). The response of the individual to these external influences though is conditioned by the genetic make-up or 'internal' environment. Such environ-mental influences or hazards have been categorized as physical, biological, and human (Howe 1973). In addition to the widespread and long-standing study and control of the physical and biological determinants of health, the human factors are attracting renewed attention and, with the objectives of improved personal understanding and better empowering, individuals to have more control over internal and external environmental factors that can influence their health. It has been noted that, in particular, the younger generation are again 'putting more value on the emotional side of life than on purely scientific analysis' (Philipp 1995). To help achieve the integration of these elements for sustainable development, the World Health Organization (WHO) has called for greater intersectoral co-operation in national strategies for 'Health for All' (WHO 1986). Furthermore, the UK Government's strategy of 'Health for the Nation' (1992) and the World Health Organization's European Health for All programme (1985), as well as addressing physical health, both draw attention to the need for mental health promotion and ways of improving psychological (personal) well-being for individuals in our society.

In support of this broadened outlook for human development, it has been reasoned that using the arts in creative methods of health education helps to make health promotion palatable and that: 'health care professionals need to use lateral thinking to find different ways of presenting the concepts to their patients' as 'different people receive information in several different ways – visual, oral, aural, kinesthetic – it stands to reason that our efforts to present health information to them will be more effective if it appeals to their particular receptive sense' (Bower 1993). These innovative approaches are intended not only to help morale-building but to combine health education with a number of creative arts projects that encourage people to think about their own health as well as helping them to assimilate healthy messages (Bower 1993). Relevant activities include music, dance, drama, painting, murals, sculpture, textiles, writing and readings (Chaplin 1992; Senior and Croall 1993). Indeed, some of the arts projects and programmes in primary health care to date have shown how they can provide for basic human needs such as purpose, dignity, identity, humour, relaxation, creativity, harmony and meaning (Senior and Croall 1993). It has also been reported that artists working on specific projects have identified 'many possibilities for producing personal and aesthetically pleasing health information that is relatively cheap, effective and local' and that the effort: 'fuses value for money with values for living' (Jones 1992). Nevertheless, it has also been reported that 'very little has been done yet to document the achievements of using this creative approach in primary health care' and that although 'qualitative comments are very convincing…in terms of performance measures there is very little' (Bower 1993).

Aims and Objectives of Arts Interventions in Health Care

Clearly stated aims and objectives in health care projects and programmes are a first step in evaluation. They provide a basis to developing performance measures. For artists working in primary health care the aims can include:

- stimulating greater awareness and understanding of issues which affect health and well-being

- establishing the value of the creative arts and the role of artists, writers and musicians in the development of a participatory approach to expressing health and social care needs

- opening channels of communication between the communities and the people planning, providing and commissioning local services

- producing health information material that originates in response to local health concerns but is also suitable for national distribution (Philipp 1994).

A general lack of explicit aims and objectives for the arts in health care has meant that, until recently, two somewhat different viewpoints have existed

within the arts and health care professions. Thus, artists and arts administrators have commented that 'we know that the arts have an important role to play in health care and that what we are doing is useful and helps people'. Health service managers have noted that 'we know that the arts are being used in health care work but we do not know how the application of them in a primary care setting benefits patients, by how much, and if there are benefits whether or not they are cost effective' (Philipp 1994). Intersectoral collaboration is obviously needed to address the issues implicit in these viewpoints. Accordingly, as a first step in the management and towards the evaluation of any 'arts for health' project or programme, its purpose (the aims and objectives) should be stated and agreed by the artists, as its service providers. Clarification of the aims and objectives of a project or programme is needed before measures can be developed that will help to assess its benefit for public health. The process of evaluation, therefore, starts with addressing two questions that purchasers of health care will ask: 'what does this project or programme set out to do?' (the aims) and 'what does this project or programme hope to achieve?' (the objectives).

Towards Audit

Audit is part of good management. In May 1995, for example, it was reported that at least one health authority has already committed itself to developing a range of complementary therapies based in primary care and that this experimental approach needs to continue if commissioners are to think laterally about health care while struggling with all their other priorities. The immediate challenge, it was noted, is for such therapies to try to show that they work (Smith 1995). Increasingly, managers of health services are asking for evidence that health care initiatives will benefit health and that they will give the best possible health outcomes at the lowest possible costs required to achieve them, when measured against the costs of alternative interventions or treatments. Therefore, and so that managers can further consider the worth of arts projects and programmes in health care, the development and audit of suitable performance indicators is being sought. Measures are needed for the reliability and validity of 'inputs' such as manpower, equipment and finance, for the different 'processes' of arts delivery in health care, the 'outputs' in terms of changes in levels of physical and mental health and for the 'outcomes' that are often assessed as savings in direct and indirect health care costs.

In audit activities to assess the effectiveness of the arts in health care, two key areas for research can be identified:

- the impact of group activities that, in terms of its development, help to promote the health of the community

- measures of the nature and amount of therapeutic benefit for the individual in society and for the reduced burden of specific diseases as well as improvements in levels of well-being

Building a Practical Approach to Research and Development

As a basis to help formulate ideas for health services' research proposals, identify topics to be studied, decide on specific questions to be asked and to prepare research protocols for the evaluation of arts projects and programmes, a conceptual framework has been suggested (Philipp 1994). It has ten points. In sequence, they are:

(1) A community is more than a collection of individuals in that it has 'synergism' and not just 'summation'.

(2) Becoming actively involved in a community gives a sense of belonging and helps to increase personal well-being.

(3) 'Self-esteem' (a sense of personal value and worth) and 'well-being' (a feeling of contentment, happiness and health) are interdependent.

(4) Heightened self-esteem is likely to lead to a healthier lifestyle.

(5) Creative expression through group activities provides healthpromoting opportunities that help individuals to improve their well-being and self-esteem.

(6) Art therapy has evolved as one of the creative therapies used in psychotherapy ('the systematic use of a relationship between therapist and patient – as opposed to physical or social methods – to produce changes in cognition, feelings and behaviour') (Holmes 1994). There is evidence 'that the average patient having psychotherapy does better than 85 per cent of control subjects' (ibid.).

(7) Improved well-being and self-esteem lead to:

 (a) reduced dependence and prescriptions for psychotropic drugs (those that affect the mind),

 (b) less repeat attendances at Primary Health Care Centres and Hospital Accident and Emergency Departments,

 (c) healthier lifestyles (less smoking, use of alcohol and addictive drugs, improved diet and more physical exercise),

 (d) less delinquency,

 (e) less crime,

 (f) less sickness absence from school/work,

(g) more constructive leisure-time pursuits,

(h) greater attendance at adult extension further learning courses.

(8) The concept of 'arts for health' and the involvement of artists in health care is a multi-faceted approach that can be readily adapted to different health care settings. It can be viewed as a public health intervention 'package/s' targeted to mental health promotion and with the objective of helping to improve levels of well-being and self-esteem in the community.

(9) Counselling in primary care for mental health problems ranks seventh in a list of 27 research priorities identified by the National Health Service research and development programme as needing health technology assessment (Smith 1994).

(10) It has been argued that if something can be counted or measured, it gains a questionable scientific credibility often not afforded to the unmeasured or unmeasurable and that because of this, a finding or result is more likely to be accepted as a fact if it has been quantified than if it has not (Black 1994). Yet, it has also been noted that 'it has to be acknowledged that some situations are inevitably beyond the scope of quantitative methods but could be investigated more appropriately by qualitative ones' (ibid.). It therefore seems that an 'evaluation battery' of quantitative and qualitative research methods are needed to determine if the application of the arts in primary health care benefits patients (and if so, in what way and by how much), and if the perceived benefits from its delivery are cost-effective.

For one or more of the possible health benefits, point 7 (a-h) above, routinely available data could be used to make comparisons 'before' and 'after' an arts project or programme or to compare two or more different areas or services where a specific arts intervention has and has not been applied. These routinely available data might be obtained from the following local and national sources: General Practice, Family Health Services Authority, records of the Department of Health and the Prescription Pricing Authority (Harris 1994) or from the Home Office, Police, Social Services, District Councils, County Council Education Departments and local employers (Philipp 1994).

In support of encouraging individual researchers to consider both quantitative and qualitative research methods, it has been argued that wisdom is called for when questions arise that cannot be solved by technical considerations alone (Davies 1995). To help make the necessary choices, part of a Robert Frost poem can be quoted (ibid):

Two roads diverged in a wood, and I chose
the one less travelled by And that has made
all the difference.

Quantitative and Qualitative Research Methods

As one example of a quantitative study, a retrospectively-assembled cohort study could be undertaken to compare and contrast patterns of incidence, prevalence or participation rates from already existing routinely collected data for different geographical areas/General Practice (GP) catchment populations where 'Arts for Health' initiatives have been deployed (the public health 'intervention' areas) and 'control' areas where such initiatives have not been applied. The 'intervention' and 'control' areas being used for comparison would need to be similar in their population structures (i.e. of similar age, sex, ethnic and socio-economic compositions) as well as having similar staff compositions of their primary health care teams and comparable access to their primary health care facilities. Ideally too, and as a baseline to help ensure comparability of the geographical or GP catchment populations studied, retrospective data should be collected, collated and analysed from all areas *before* the arts for health initiatives were introduced as well as for comparisons *after* their introduction.

Other quantitative fieldwork such as a well-designed randomised controlled clinical trial using validated questionnaires to assess health status could also, and for example, examine the work of artists with psychotherapy treatments and determine any changes in community levels of self-esteem, attitudes, or lifestyle as a consequence of the arts intervention. A randomised controlled trial is an epidemiological experiment to study a preventive or therapeutic regimen. Subjects in a population (such as a population of patients with a specific disease or of people exposed to similar factors) are randomly allocated to groups, usually called treatment (or intervention) and control groups, and the results are assessed by comparing the outcome in the two or more groups (Beaglehole, Bonita and Kjellstrom 1993). The methodological issues in conducting such a trial have been addressed to help evaluate counselling in general practice and where, as with art therapists, counsellors come from different backgrounds, may have different qualifications and use a variety of therapies (King *et al.* 1994).

Unlike quantitative research methods, qualitative ones are not based on measures of quantity or frequency; their findings are described in words rather than numbers (Abramson 1990). Qualitative research methods are used to help understand the nature, strengths and interactions of variables. Like quantitative research, the approach can address causation and it involves observation and interpretation of events. Qualitative research can also assist quantitative work with information about the accuracy of quantitative data, identifying the appropriate variables to be measured, providing explanations for unexpected or unexplained findings and as a fertile source of hypotheses for quantitative

enquiry (Black 1994). A qualitative approach includes interviews, observation of activities and interpretation of written material and its focus may range from a single individual or small group, such as the interaction between a health professional and a patient, to the functioning of a large organisation (Black 1994). The interviews may be unstructured, with key informants, or in-depth, in which people describe their attitudes, perceptions, motivations, feelings and behaviour (Abramson 1990).

In support of qualitative research for evaluations of the arts in health care, it has been suggested that better and more social science research is needed to support health policy. For example, it was recently reported that Professor George Salmond, a former Director General of Health, New Zealand, had noted in 1994 that 'if progress is to be made in improving the nation's health, new concepts, knowledge and skills must be introduced. Analyses are needed which break away from the narrow confines of biomedicine and economic rationalism, and which encompass more socially and ecologically conscious constructs. The latter would empower people and involve communities in democratic approaches aimed at enhancing wellbeing and health status' (Mooney 1995). It has also been reported that 'genuine empowerment of patients as consumers of health care requires a cultural shift in the way in which services are traditionally delivered. It involves not only listening and talking to patients about the care which they receive, but also genuinely taking their views and opinions into account when designing services. It also means enabling them to make informed choices and becoming partners with health professionals in the care provided' (Donaldson and Donaldson 1993).

Examples of Published Research

There is little published research for evaluations of the arts in health care. Those that have been identified include:

- a qualitative study in two General Practices of the celebration of health through art (Rigler and Gardner 1994)

- quantitative studies of children's paintings to analyse their perceptions of the General Practitioner and factors which influence it (Philipp *et al.* 1984; Philipp *et al.* 1986; Philipp 1987)

- a qualitative study of benefits to health of reading or writing poetry (Philipp, Coppell and Freeman 1994; Philipp 1995; Philipp and Robertson 1996)

- critical comment in support of the writing of a fiction based on the writer's depth of professional and personal experience or on a body of research data (Bolton 1994; Rowland, Rowland and Winter 1990).

Preparing a Research Protocol

Regardless of whether quantitative or qualitative research methods are used, the likelihood of funding by arts and health care administrations for specific projects and programmes is increasingly likely to depend on well-formulated proposals that clarify the health care objectives of each project, identify a reliable and appropriate method(s) of measuring progress towards the objectives and consider ways that the required manpower support for the evaluations could be provided (Philipp 1994). Before embarking on a study, it is important to first undertake a comprehensive search of the published health promotion, medical, nursing, clinical psychology, occupational therapy, social sciences and speech therapy literature for the use and evaluation of the arts in health care. It will help to identify what projects have already been completed in the intended area of study, which ones could still be worthwhile to undertake, how different studies have been designed and how the appropriate research methods have been applied to different projects.

In a well-prepared research protocol, funding bodies should be able to find answers to the following questions:

- what are the aims and precise objectives of the study
- what questions are to be answered
- is the purpose to evaluate a new treatment, procedure or service or is it to obtain new facts about the causation or natural history of a disease or for the future planning and evaluation of a service
- what are the gaps in present knowledge
- how will the proposed study contribute to our knowledge and understanding of the problem
- what study design will be used in the project and is the proposal a pilot or main study
- how are the subjects of the study to be chosen and have the selection criteria, sampling methods and number of subjects needed to obtain a significant result been defined
- what data are to be collected and why
- what are the treatment schedules or other activities forming the 'intervention' in the study and how are the variables to be defined and measured
- how are the data to be collected and the measurements to be made
- have the methods been tested
- are they valid (that is, do they actually measure what they are intended to)
- are they reliable (that is, can they be repeated to yield the same results)

- are they sensitive (that is, can they identify all positive cases)
- are they specific (that is, can they identify only positive cases)
- will data be collected by observation, examination, interview or from record forms
- will special recording forms be needed
- who will collect the data
- what training will they need
- should an independent observer make the baseline or outcome measurements (or both)
- what checks and controls will be used to maintain accuracy and objectivity
- how will the data be processed and analysed
- what form of publication is likely to result
- what problems of ethics, etiquette, consent, collaboration and confidentiality does the project raise and have they been considered by an ethics committee of the health authority
- what arrangements are to be made for treating or referring patients for whom new needs come to light as a result of the project
- what is the expected timetable for the study, in what order will the different stages of the investigation be undertaken, by whom and how long will each stage take
- what will the project cost and does it include manpower, capital equipment, rents for accommodation, travelling and subsistence, stationery, printing, postage, telephone, FAX, photocopying, administration and overheads? (Warren 1978)

Conclusions

For many artists, the requirements of health service managers may seem excessive, the choice of research methods confusing and the list of points to be included in a well-prepared research protocol daunting. But the costs of health care in any general practice or hospital setting are considerable and evidence for the worth of arts interventions is largely lacking. Worthwhile studies to evaluate specific arts projects and programmes need a multidisciplinary research team of artists, arts administrators and health care professionals. Relevant health care professionals who can help include: Public Health Physicians, General Practitioners, Health Promotion Specialists, Clinical Psychologists, Occupational Therapists, Nurses, Medical Sociologists, Medical Statisticians and Health

Economists. The newcomer to research should, nevertheless, not be put off. It is worth emphasising that research is fun because it:

- widens the horizons of a subject
- stimulates identification and reading of relevant literature that encourages a discerning approach and better understanding of other people's work
- improves personal thinking and critical skills
- provides an opportunity for curiosity, individual creativity and innovation (Calnan 1976).

Furthermore, it has been pointed out that 'the discipline required (and acquired) to carry out research successfully is something well worth the effort; it is never lost. An opportunity to think and act as an individual, to raise a lone voice as opposed to that of a group, to fight conformity and walk the other way instead of following the crowd, to have a novel idea and show that it might be true all by yourself; all these provide self-satisfaction and intellectual fulfilment' (Calnan 1976). This chapter should, though, perhaps end with a cautionary note. The scientific approach cannot solve all the enigmas of life. As Sir James Jeans once wrote: 'science fishes in the sea of reality with a particular kind of net called the scientific method, and there may be much in the unfathomable sea which the meshes of science cannot catch' (Calnan 1976). As Socrates said, however: 'an unquestioned life is not worth living' (Taplin 1989).

References

Abramson, J.H. (1990) *Survey Methods in Community Medicine. Fourth Edition.* Edinburgh: Churchill Livingstone.

Beaglehole, R., Bonita, R. and Kjellstrom, T. (1993) *Basic Epidemiology.* Geneva: World Health Organization.

Black, N. (1994) 'Why we need qualitative research.' *Journal of Epidemiology and Public Health 48*, 425–426.

Bolton, G. (1994) 'Stories at work. fictional-critical writing as a means of professional development.' *British Educational Research Journal 20*, 1, 55–68.

Bower, H. (1993) 'Art attack!' *Practice Nurse*, 343–346.

Calnan, J. (1976) *One Way To Do Research: The A–Z For Those Who Must.* London: William Heinemann Medical Books Ltd.

Chaplin, J. (1992) 'Promoting health through the arts in a doctor's surgery.' *Community Health Action 26*, 4–5.

Davies, G.P. (1995) 'What does the community need from its public health workers?' *Australian Journal of Public Health 19*, 3, 225–226.

Donaldson, R.J. and Donaldson, L.J. (1993) *Essential Public Health Medicine.* Lancaster: Kluwer Academic Publishers.

Harris, C.M. (1994) 'Better feedback on prescribing for general practitioners.' *British Medical Journal 309*, 356.

HMSO (1992) *The Health of the Nation: A Strategy for Health in England, Cml 986.* London: HMSO.

Holmes, J. (1994) 'Psychotherapy – a luxury the NHS cannot afford?' *British Medical Journal 309*, 1070–1071.

Howe, M.G. (1973) 'The environment, its influences and hazards to health.' In G.M. Howe and J.A. Loraine *Environmental Medicine.* London: William Heinemann.

Jones, A. (1992) 'Celebratory Arts for Primary Health Care.' *Community Health Action 26*, 3.

King, M., Broster, G., Lloyd, M. and Horder, J. (1994) 'Controlled trials in the evaluation of counselling in general practice.' *British Journal of General Practice 44*, 229–232.

Mooney, G. (1995) 'Book Review: Social dimensions of health and disease. New Zealand perspectives.' *Australian Journal of Public Health 19*, 3, 318–319.

Philipp, E. (1995) 'The physician, the aged and society.' *The New Zealand Family Physician 22*, 1, 2–3.

Philipp, R. (1987) 'Through a child's eyes.' *Good Health 2*, 1, 32–33.

Philipp, R. (1994) *Towards an Evaluation of the Effectiveness of the Arts in Primary Health Care.* Environmental Epidemiology Report No. 183, Department of Epidemiology and Public Health Medicine, University of Bristol.

Philipp, R. (1995) 'Metred health care.' *Poetry Review 85*, 1, 58–59.

Philipp, R., Coppell, K. and Freeman, H. (1994) 'Poetry and the art of medicine.' *British Medical Journal 308*, 63.

Philipp, R., Philipp, E., Pendered, L., Barnard, C. and Hall, M. (1986) 'Can children's paintings of their family doctors be interpreted?' *The Journal of the Royal College of General Practitioners 36*, 325–327.

Philipp, R., Philipp, E., Polton, S. and Graham, A. (1984) 'Interpreting children's paintings of their doctors.' *The New Zealand Family Physician 11*, 23–24.

Philipp. R. and Robertson, I. (1996) 'Poetry helps healing.' *The Lancet 347*, 332–333.

Rigler, M. and Gardner, K. (1994) 'A celebration of health through art.' In *Community Participation in Primary Care, Occasional Paper 64.* London: The Royal College of General Practitioners.

Rowland, G., Rowland, S. and Winter, R. (1990) 'Writing fiction as inquiry into professional practice.' *Journal of Curriculum Studies 22*, 3, 291–293.

Senior, P. and Croall, J. (1993) *Helping to Heal: The Arts in Health Care.* London: Calouste Gulbenkian Foundation, with the support of the Wellcome Foundation Ltd.

Smith, I. (1995) 'Commissioning complementary medicine.' *British Medical Journal 310*, 1151–1152.

Smith, R. (1994) 'Towards a knowledge based health service.' *British Medical Journal 309*, 217–218.

Taplin, O. (1989) *Greek Fire.* London: Jonathan Cape.

Warren, M.D. (1978) 'Aide-memoire for preparing a protocol.' *British Medical Journal* 1, 1195–1196.

World Health Organization (1985) *Targets for Health for All.* Geneva: WHO Regional Office for Europe.

World Health Organization (1986) *Intersectoral Action for Health.* Geneva: WHO.

The Poole Approach to Planetree

Ruth Cusson

Poole Hospital NHS Trust is in the process of some massive redevelopment projects. With a bed complement of approximately 750 and providing a wide range of services, there are very few patient and staff areas not affected by this work in some way or another.

This huge investment provided us with a unique opportunity to re-think our basic philosophy of care and build on a quality of service that was already high.

In order to develop our new Poole philosophy, we undertook some research and the 'Planetree' organisation came to the fore. Following some further work, the broad philosophies which that organisation embodies seemed akin to the way Poole Hospital wished to go.

A broad consultation period, throughout the organisation, brought us to our own philosophy of care called the 'Poole Approach'. Much work and time has been spent ensuring that staff know and feel comfortable with its philosophy and values and our task now is to translate these ideals into practice.

Reducing the Threat

A key factor in this is the creation of a less threatening environment. This is an enormous challenge but the use of artwork is proving to have a major impact on both patients and staff.

In keeping with the Planetree philosophy and our 'Poole Approach', we are starting to address not only the physical needs of the our patients but also the emotional and aesthetic needs.

Poole Hospital is now incorporating the arts into the acute care setting, providing patients with entertainment, relaxation and diversion from their physical discomfort and emotional stress.

The Planetree philosophy of care and, subsequently, our own 'Poole Approach', led us quite comfortably to aim for our hospital environment to

become less clinical and, therefore, less threatening in appearance. In order to create a relaxing and more homely feel, every aspect of the environment was re-examined. As new furniture is required, a more domestic style is purchased but still to a high contract standard. Lighting is chosen that is of an acceptable level for the patients and staff but has the flexibility to be dimmed or increased through up-lighters or table lamps.

As we progress in this work, we are finding that the historic philosophy of hospital design tended to be one of 'just in case', for example:

- maximum light 'just in case' it is needed for a certain procedure
- maximum durability of furniture 'just in case' patients mark the furniture or attempt to maliciously damage it
- floor coverings that seem laid to last forever and 'just in case' anything is spilt.

It seems we are as bad with our walls. Not only do we have large, unsightly crash barriers but any area of empty wall that may be within easy sight of patients, visitors or even staff, is usually used to give a message. To make matters worse, the message more often than not takes the form of a chastisement or strong advice, for example:

- 'Don't smoke – smoking kills!'
- 'How high is your cholesterol? Are you eating the right diet?'
- 'This department is for emergencies only. Contact your GP first.'
- 'Have you still got our crutches? Please return them.'

Although the messages given are true and meant with the best intention, we tend to blind people with the written word – almost to absolve ourselves from using the spoken word.

These messages may be shared with patients, visitors and staff far more discreetly and effectively with a change of staff policy and attitude.

The Accident and Emergency Department

The first main area tackled was our Accident and Emergency Department. This has traditionally been an area where all sorts of messages were given to a captive, and usually reluctant, audience.

During a refurbishment scheme, the decision was taken to remove all notice boards and notices and use the wall space for artwork. The local art college was commissioned to produce paintings of the Poole area that were recognisable to local residents but which also produced a pleasing landscape for visitors unfamiliar with the area. This was part of other changes, such as lowering the reception desk and increasing the number of free-standing seating, as opposed to the traditional hard plastic bench seating. Although the overall effect of the department was tremendously improved, by far the most striking difference was

the artwork. The general view of the staff is that attenders to the department now are less stressed during their visit and consequently there have been fewer incidents of aggressive language or behaviour.

Paintings

The use of artwork throughout the hospital is flourishing. We have recently purchased nearly 200 pieces of art to go in a variety of highly visible areas. The general principle of selecting artwork is twofold:

(1) Getting the patient's perspective (literally as well as figuratively!).

(2) Captures familiar surroundings incorporating the local culture, for example landscape photographs or paintings of our local hills/harbours/water scenes, etc.

Using such familiar images helps to convey messages of comfort and relaxation.

In our new developments we are planning to provide wall-mounted picture frames that can accommodate a picture selected by the patient from an 'art-cart'. This will help personalise the room for the patient and can be changed easily and as often as wished.

The other main piece of artwork in the patient rooms is on a sliding frame that cover the medical gases. For the majority of time, the oxygen and suction facility is not required. Currently, these remain an obvious, clinical feature of any room, regardless of need. With a sliding frame, they will be hidden from view but easily accessible when required.

Ceilings

Using the principle of looking at the patient's perspective, we need to utilise ceiling space as this area is gazed at quite often by the patients.

We have addressed this issue at Poole Hospital by installing photographic transparencies illuminated by a light box. These are commonly seen in airports and other commercial buildings to good effect. To date, we have installed five light boxes in our theatre corridor ceiling and one in our x-ray department ceiling. We have also utilised our ceiling space in theatre with a large and colourful mural of a jungle. This is in our paediatric anaesthetic room and has proved to be a great success.

Lino

Another form of art that is planned, but perhaps less obvious, is the use of lino cut inlays. This is an integral part of the paediatric scheme and helps pa-tient/child orientation to the area as well as lifting the whole environment. To a lesser extent this has proved very effective with the Poole Hospital logo being lino cut into each lift lobby.

Music

In addition to the artwork being introduced throughout the hospital, music is also gaining in popularity. Many small music centres are being provided with a wide selection of tapes and CDs, as well as patients being invited to bring in their own choice. We also plan to have a piano in our main entrance with either volunteer pianists or visitors or staff being given the opportunity to play.

Negotiation and Training

This change in culture, philosophy and approach requires an enormous commitment from the hospital. The investment in staff training and awareness is key to the success of these changes. Poole has achieved a great deal so far in terms of staff involvement and reshaping the work we do, all in order to improve our delivery of patient care.

One major project that is currently under way is to reshape existing roles to improve patient care. This project arose from both opportunity and necessity. The opportunity surrounds major capital investment in the hospital, which was the catalyst for us to develop our own new philosophy of care. This is based upon an holistic approach to our patients, their family and carers. The necessity arose from national issues, such as changing childbirth, and local issues, such as staff discontent surrounding the clinical nurse grading and the need to expand the roles of support workers.

The process we have adopted for this project is, on the surface, straightforward but very complex to carry out. We must define job roles and competencies, which can only be achieved by developing our existing partnership with our staff.

For this and other developments and changes within Poole, key working groups have been established for any staff group affected. The members of these groups include managers, who are in a position to effect changes that are agreed through consultation. Open meetings are also used with staff, as well as linking into other established groups. The purpose is to ensure that there is a two-way exchange of information throughout so that there is a fairly high degree of ownership to any change.

Training is always an issue, especially with so many changes involving or affecting everybody within the organisation. Concerns over job boundaries and professional accountability rightly need highlighting and consideration. The training element associated with change requires a long-term strategy with a commitment from senior management to honour it. Initial awareness and training sessions are happening to ensure that the existing workforce are kept abreast of the current and planned changes to their hospital and the way this affects the hospital experience for all our customers and for staff themselves.

The Future

Poole Hospital has a strong commitment to make radical alterations to what is considered by many to be a standard NHS hospital design. The environment plays a key role in the overall hospital experience and the use of art must not be under-estimated.

With our staff on board with the new 'Poole Approach' philosophy and the hospital design supporting its values, we believe we have a winning formula that will take Poole Hospital into the 21st century and make us a yardstick for others to be measured by.

The Tree of Learning
A Culture for Patient Centred Care[1]

Malcolm Miles

Introduction

Hippocrates taught medicine under a plane tree. Healing, then, was more of an art than a science. Modern medicine and hospital design have become dehumanised, the patient has been disempowered and there is now a reaction towards a more holistic approach, a return to the tree of learning. The American community health organisation Planetree believes that patients want to learn more about their condition, in order to become active participants in their care. This vision of health care is very different from that experienced, or as yet expected, by most patients in the NHS. But things are changing.

A Hospital for the Twenty-First Century

We hear a lot of speculation about the hospital of the next century. Until recently, bigger was seen as better, despite the loss of orientation in buildings above a certain scale and the loss of accountability in large organisations. Now there is a return to human scale whereby even large hospitals can be composed of clusters of individualised elements in something like a 'village' structure. Local management increases accountability and has been established for virtually all hospitals. Patients have been alerted to their rights under the patients' charter and their expectations of a personal service are rising. The Tomlinson report on the provision of care in London has led to a rationalising of hospital sites and an increased investment in primary care throughout England. Primary care teams in GP surgeries, health centres and polyclinics are beginning to

1 This chapter is based on visits to the Mid-Columbia Medical Centre, The Dalles, Oregon, USA in 1991 and 1992 and is an expanded version of an article in Hospital Development, Nov 1992, 21–23.

undertake some of the functions previously available only in hospitals. Some out-patient work is already carried out by visiting consultants in GP surgeries. In future the hospital may be more like a trauma centre, with high-technology and highly specialist treatment. Minor injuries and much out-patient care will be available to patients nearer, even in, their homes. There will be a growth of community hospitals for low-technology services, such as maternity and elderly care. The Lambeth Community Care Centre in London already offers in-patient care provided by local GPs, together with community health day facilities. Mental health care may increasingly be provided at home, with the support of day facilities. There will be relatively few new general hospitals built in the twenty-first century, but a lot of refurbishment to house new kinds of service, such as day surgery. The hospital of the future may be smaller and more specialised, supporting a more developed network of local facilities. But what will be the culture of the NHS in the next century?

A Legacy of Control

In the middle ages, lepers were cared for by religious orders in Lazar houses – possibly the first kind of hospital, but one in which no bodily cures were practised and the intention was piety rather than the advancement of knowledge. From the Renaissance onwards, wealthy patrons endowed hostels for foundlings, such as the Foundling Hospital in London founded by Thomas Coram in 1739. These were less medical than social institutions. The insane too, and the vagrant, were gathered from the streets and put in hospitals following the establishment of royal edict of the first General Hospital in Paris in 1656 – a form of institution which spread rapidly throughout Europe. But these hospitals for the lost and sick in spirit were essentially places in which to contain the non-productive elements in society and those whose state of mind challenged the rational order. In Victorian times, the 'deserving poor' were gathered into workhouses – institutions in which it seemed as if poverty deserved punishment. Although the wide provision of medicine was a reform, in a moral climate of philanthropy and social improvement which led to the introduction of clean water supplies in cities, Victorian infirmaries (for the sick in body) were institutional spaces in which structures of authority were clearly articulated. These structures were echoed by the buildings themselves. The Nightingale ward with its high windows was a reform and relates to a belief that the circulation of air decreases infection; but it is difficult to resist an interpretation of its design as a form of control, like the panopticon design for prisons. The doctor, on entering the ward, is able to survey all the patients. They are the subjects of his gaze. It is in this context that scientific medicine was developed to its present level. The gaze still operates – the patterns on cubicle curtains are usually on the outside: the doctor, not the patient, has the sight of them.

The hospital was designed to support a structure of power in which doctors who were experts held dominion over patients, who were not. Most doctors were, and still are, men – as are most architects. Perhaps men have a tendency towards the abstract – doctors are heroes battling disease, whilst nurses, usually women, care for patients. The patient becomes a catalogue of symptoms, the treatment of the more unusual of which contributes to the advance of science. This nineteenth century attitude is waning, but is still present. One consultant at a large acute hospital wrote in 1994 that his patients did not want to be better informed about their conditions, leaving, as he put it, 'their brains and their dignity at the desk'. No design enhancement can overcome the impact on patients and families of that kind of culture.

Whilst modern medicine has treated patients as vehicles for clinical symptoms, hospital design and routine have dehumanised patients in other ways. Hospitals are daunting because they are too big and full of blind corners. There has been little design for personal space or privacy. Post-war buildings have been no more humane than their predecessors. The nucleus design, introduced for cost-effectiveness, has been replicated with numbing dullness.[2] The loss of individuality is the most damaging aspect. A recent paper states:

> When a person is admitted to a hospital, he or she must almost completely abandon those roles characteristic of non-hospital life and assume the status of someone who is 'sick' or 'injured'... These circumstances involve a loss of personal control, along with a concomitant ambiguity regarding the individual's personal responsibility for their progress through treatment. (Winkel and Holaham 1985, pp.11–33)

Access to information has been restricted. Medical training may be responsible for some of the difficulty. How can medical students retain their humanity when their first dissections are conducted in an ambience in which they cease to see the corpse as a person who has died? Of course, some protection is needed for people who tend the sick who may die but routines and uniforms may repress rather than address the uncertainties of mortality. Why should a carer not be upset when a patient dies? Why should a student not be upset at the first cut into a dead person?

All this, of course, is changing. Doctors are no longer in charge of hospitals, as management passes to professional managers. Maternity services are increasingly run by midwives. Nurses are assuming greater and more varied responsibilities in hospitals and as nurse-practitioners in primary care. Some doctors have seen the value of culture. In the USA, literature and humanities programmes have been set up in such respected centres as Johns Hopkins University,

2 St Mary's, Isle of Wight is the one exception, where the nucleus templates are arranged in a 'fan' rather than a row.

Baltimore and Duke University, Durham. A short course on literature and medicine was piloted for medical students in Glasgow, leading one participant to say 'medical students are even more narrow-minded than I thought' and another, 'reading is not a selfish pursuit' (Calman *et al.* 1988). In the UK and USA, senior doctors and managers have supported art projects which seek to humanise the environment, though in some cases as a cosmetic measure which does not challenge the underlying institutional culture. But there are changes taking place at a deeper level. Some doctors now see patients as active participants in care. Dr David McGavin, a GP in Maidstone, is a pioneer of a patient-centred approach: 'we all want to see the patient in terms of the whole person. Some of this we are being taught by patients, who are also experts on their health' (NHS Executive 1994, p.16). Dr Malcolm Rigler, a GP in the West Midlands, believes that creative experience is vital to a healthy practice. He has worked with local schools in art for health education projects and with a writer-in-residence in the waiting-room. He states: 'I'm just a doctor. Is all this showing off? No – the belief is that you cannot be healthy unless you are being creative. The art of medicine is to know when to use medical intervention, when to be comforting and when to be challenging' (NHS Executive 1994, p.34).

A New Ethos for Care?

Within the acute hospital, two new modes of organisation are being introduced – patient-focused care and patient-centred care. The terms are sometimes confused but patient-centred care includes patient-focused care and adds a humanising dimension. Patient-centred care seeks to overcome two centuries of authoritarianism to empower the patient. Both have implications for design and space utilisation.

Patient-focused care means bringing services such as X-ray to the patient, instead of taking the patient around the hospital. It is sometimes delivered in large 'bed floors' where more than one specialism is practised, by multi-skilled staff teams, each with responsibility for a group of patients. It is a reform, not a revolution.

Patient-centred care is the most radical of the new approaches currently under consideration. It was first developed by Planetree in California and is currently implemented in several hospitals in the USA, including the cardiac ward of Beth Israel, New York and throughout the Mid-Columbia Medical Centre, Oregon, and the Griffin Hospital, Connecticut. In the NHS, some trusts, notably Poole and South Tees, are working towards a version of patient-centred care to suit local circumstances, through new approaches to design and programmes for staff training.

Empowering the patient is at the heart of the Planetree philosophy. Part of this is medical: 'a premium on patient education in the belief that by providing information about diagnoses, medications and treatment, patients can become

more actively involved in their care' and part is cultural: 'Planetree also greatly improves the hospital's physical setting so that it becomes a more healing, nurturing environment. Activity rooms, solariums, family dining areas, more pleasant patient rooms, an atrium, entertainment…create an environment that is unique' (Plantree promotional literature). Part takes place in the hospital and part through health resource centres in the community. Anyone can have access to these, to read current information on a wide range of medical conditions and the alternatives for (and effects of) treatment. Information is available in formats from the most basic to the highly technical and volunteers assist users to find what they need. Whether the user is a patient, future patient or family member, it gives them the information they need to have a meaningful conversation with a professional.

Mid-Columbia Medical Centre

The design and organisation of a Planetree unit are closely linked. The Mid-Columbia Medical Centre, The Dalles, Oregon is a fully Planetree community hospital with acute care for a community of about 75,000 people in a mainly rural area. It has 49 beds, both CT and MRI scanners, maternity, intensive care and an accident unit. It employs about 350 people who work with 200 volunteers, many of them engaged in cultural activities. The building dates from 1958 with an addition in 1972; it was completely refurbished when the hospital adopted the Planetree philosophy in 1991.

Stepping over the threshold of the hospital, through the new glass atrium (turning the back of the hospital into a new front entrance), conveys a lot about Planetree. There is a grand piano in the atrium, played by volunteers at lunch times, and a small waterfall. The furniture is motel-style – big, soft arm chairs and coffee tables; there are large plants and a small sculpture. There is no clutter, nothing institutional. Along one side is the restaurant and patient lounges look over it from above. The circulation areas retain the style of the foyer, signs are few and carved in wood and the lift interiors have original art. What does the environment say? It does not look like a hospital. The first point about adopting a hotel style is to say that the visitor/patient stays in control of choices and requires a certain level of comfort. The second is that the absence of institutional litter – the old notices, the notes of authority which warn of the dangers of eating, smoking, drinking and sex, the abandoned equipment (because public spaces do not 'belong' to any department) – creates a sense of confidence. It looks like people know what they are doing because they take the trouble to exercise choices and maintain standards. For most people, the first impression is visual and this foyer gives positive signals.

There are more significant innovations in the bed floors. All patients here have single rooms in clusters round a nurse-base (although the concept could be applied to small bed-bays). Each bedroom has a comfortable chair, a shelf

and chest of drawers for personal items, pine headboard on the bed, a piece of original art by a local artist (often a local view) and attention to details such as curtains and bed covers, which give a sense that the room belongs to someone. People always knock before entering – privacy is one way we retain a sense of ourselves. A detail which is very much part of the Planetree ethic is the two-way cupboard between the room and the corridor; where possible, patients are self-medicating and their drugs are placed in the cupboard from outside, without a need to bring a drugs trolley into the room. Patients also have input to their notes. Their observations are taken seriously and might sometimes be clinically important. In the nursing-base for each cluster of rooms, empower-ment takes the form of designing-out barriers to communication. In place of a counter to separate nurses from patients, there are chairs around a domestic table. This signifies the equality of status between those who take part in discussions, both patients and staff.

For each dozen or so beds, there is a lounge, a patient library, a small kitchen and a family dining-room. The dietician bakes fresh bread and makes fresh coffee each morning; these are the odours estate agents tell us help persuade people to buy houses, and they are certainly more domestic than medical smells. Patients have the choice to eat in the restaurant, have food sent from there to their room or to use the kitchen themselves. Or, a friend or family member can cook a special meal for them. Food is an important part of life, a kind of culture, and an area in which we all make individual choices.

Planetree operates intensive staff training through a two-week programme in patient-centred care. This applies to anyone a patient or relative will meet, not only medical staff. Staff are valued, too, through good relaxation facilities, the availability of massages and child care. Both staff and patients can take part in the arts programme. Bill Noonan, the arts co-ordinator, says: 'Art is important because it helps meet the needs of the whole person, not just a person's body. We believe that by merging the resources of the mind and spirit, as well as the body, our patients may heal faster and more completely' (Miles 1991, pp. 21–23). The arts programme is multi-cultural too – some of the story tellers are native Americans. People who deal creatively with words can be helpful for patients for whom talking about life-threatening conditions, such as cancer, is difficult. Sometimes emotions can be released, or seem less threatening, if expressed through a story or poem or through music.

The contrast between Mid-Columbia Medical Centre and conventional hospital routine is summarised in one of their leaflets:

> Welcome to Anytown hospital. We'll have to take your clothes, but look at this stylish hospital gown you get. You say you feel a draught? Sorry, the temperature has been pre-set for the average patient. You must not be average. Maybe one of your family can tie your gown tighter. Then they'll have to leave – we have visiting hours. Here's lunch. Try it. You'll like it. Hope you don't mind that mural. Our former administrator was

a big Elvis fan. Gotta run. I'll wake you every couple of hours to make sure you're sleeping well.

Planetree has developed, and successfully applied, a philosophy of care which nourishes the whole person. Choices are not taken away as an arbitrary act of authority. Information is made accessible, not withheld. Cultural activities and complementary therapies are part of hospital life. Could this work in the NHS?

Design for Patient-Centred Care in the NHS

Two NHS trusts – Poole Hospital and South Tees Acute – have committed themselves to patient-centred care in large acute hospitals. Both have major site-redeveloped projects ahead which give them the opportunity to explore design for patient-centred care. A team of senior staff from Poole visited several Planetree sites in 1994; in the same year, South Tees organised a day conference on the topic. The Princess of Wales Community Hospital in Ely has begun to apply the principles in refurbished wards for elderly care. The Lambeth Community Care Centre is a model of patient-centred care for the primary sector; it is housed in a human-scale building, designed by Edward Cullinan Architects, set in a beautiful garden and patients are, whenever possible, self-medicating. A physiotherapist at Lambeth said: 'It's great – best job I've ever had. The building has a nice atmosphere, it's airy and bright. Everyone knows everyone. It's a friendly atmosphere. There's a team spirit, so you want the centre to work and everybody works that bit harder to see it does' (NHS Executive 1994, p.36). It can be done. Much will be written elsewhere about the organisational implications; the purpose here is to look next at some of the design factors.

At Princess of Wales, an old RAF hospital taken over by the NHS, each patient in the refurbished wards has a personal space; beds are arranged to have views onto the gardens and the configuration of furniture differs in each space. Many of the patients were transferred from 'the Tower', a workhouse hospital where people went to await death, and staff find that, with increased privacy, patients are more communicative. A staff nurse commented: 'There's less noise, less chance of a conversation being overheard... We have to do more walking and patients get more uninterrupted time. In this kind of care you have to spend time with a patient or you miss things which matter. If other patients are taking away attention it just doesn't work so well' (NHS Executive 1994, p.44).

For large acute hospitals, like Poole – a 1970s tower block – and South Cleveland – the site on which all South Tees acute care will be centralised – the question is how to map the human scale and sympathetic ethos onto a large and complex organisation. Staff training is important and both trusts are investing heavily in this, with facilitated workshops and seminars. Both have decided that the patient-centred philosophy must be adopted hospital-wide. South Tees is known for its pioneering work with quality circles through the

1980s and has a good basis of quality assurance from which to take the next step. In both cases, a degree of individuality will be created for clusters of specialisms within the hospital. This will be made visible through distinct entrances to departments, colour schemes and artwork. At South Cleveland, the existing buildings will be extended by a third and a new 'village green' atrium will be created as the social hub of the site. Both trusts are considering the extent of single-room provision, the need for small, flexible spaces for social and cultural activities and how design can ease communication between staff and patients. Many hospitals have already introduced low, open reception points to replace the security-conscious fixtures of the past; the introduction of domestic tables and chairs for nurse-points is the next step.

In projects like these, design, culture and care are integrated. It is a quite new development, compared with the cosmetic impact of many hospital art projects in the past two decades. Even in a new hospital such as the Chelsea and Westminster, art has not changed the culture. The building presents an industrial face to the street and huge cliffs of white walls inside. It has an extensive collection of contemporary art chosen by 'experts' whose art knowledge is used to replicate the power structure of medical knowledge. The art collection is housed in a building without intervening in its life. In a planetree hospital, the inclusion of art and craft works, usually by local artists, is simply one aspect of a design ethos which seeks to make everyone comfortable. The arts in a Planetree hospital are valuable because they are part of a wider culture of patient empowerment and care for the whole person.

The design of a reception-point or nurse-base might seem unglamorous. Yet it is exactly such details, when they are part of a pattern in which the patient's interests are put first and staff are valued at all levels of seniority, which are the visible signs of the 'hospital of the twenty-first century'.

The future for health care is patient-centred. The only questions are: how long it will take to achieve, how we adapt the existing model of Planetree to suit the NHS and how medical training can be changed to re-humanise doctors.

Perhaps there will be a role for the arts there too. The last word in this chapter goes to a professor of moral philosophy in Glasgow:

> We can sum up the contribution which literature can make to the education of the doctor. It can develop self-perception, but, more important, it can help to generate the particular sort of understanding which is sometimes called 'whole person' understanding. Whereas the medical and social sciences develop understanding of disease processes and typical behaviour, literature can remind us that what is scientifically typical occurs in unique forms in individual patients. (Downie 1991, pp.93–96).

References

Calman, K.C., Downie, R.S., Duthie. M. and Sweeney, B. (1988) 'Literature and medicine.' *Medical Education 22*, 265–269.

Downie, R.S. (1991) 'Literature and medicine.' *Journal of Medical Ethics 17*, 93–96.

Miles, M. (1991) 'The tree of learning.' *Hospital Development*, 21–23.

NHS Executive (1994) *Health Buildings in the Community*. London: HMSO.

Winkel, G. and Holahan, C. (1985) 'The environmental psychology of the hospital: Is the cure worse than the illness?' *Prevention in Human Services*, part 4, 11–33.

Selected Bibliography

The amount of literature on the Arts in Health Care is now considerable and there are many excellent bibliographies published elsewhere, e.g. in *Helping to Heal* (see below). We include a few details of books and articles here that we have found particularly relevant to the contributions and themes in this book.

General

Arts for Health (1994) *Catalyst for Care.* Exhibition Guide.

Arts for Health (1995) *Helping to Heal: A Brochure for the National Touring Exhibition about Arts for Health.*

Baron, J.H. (1995) 'The Fitzpatrick Lecture 1994.' *Journal of the Royal College of Physicians 29*, 2, March/April.

Baron, J.H. and Weaver, N. (1996) *Art in the Hammersmith Hospitals* London.

Breslow, D.M. (1993) 'Creative arts for hospitals: the UCLA experiment.' *Patient Education and Counselling 21*, 101–110.

Carnegie Council (1985) *Arts and Disabled People: The Attenborough Report.* London: Bedford Square Press.

Carnegie Council (1988) *After Attenborough: Arts and Disabled People.* London: Bedford Square Press.

Coles, P. (1983) *Art in the National Health Service.* London: DHSS.

Coles, P. (1985) *The Arts in a Health District.* London: DHSS.

Downie, R.S. (1994) *The Healing Arts.* Oxford: Oxford University Press.

Moss, L. (1988) *Arts and Health Care.* London: DHSS.

Nursing Times (1991) 'Arts in Action.' *Nursing Times,* April.

Royal Society of Medicine. 'Art in Hospitals: Past, Present and Future.' Programme for a symposium held on 1 March 1995 (includes comprehensive bibliography).

Santinelli, P. (1988) 'Aesthetics of recovery and enrichment.' *The Times Higher Educational Supplement,* 17th June.

Senior, P. and Croall, J. (1993) *Helping to Heal. The Arts in Health Care.* London: Calouste Gulbenkian Foundation.

The Mentally Ill

Cox, M. (1992) *Shakespeare Comes to Broadmoor: The Actors Are Come Hither.* London: Jessica Kingsley.

Goffman, E. (1968) *Asylums.* London: Pelican.

New Buildings

Hospital Development (1992) 'Building the best – Derbyshire Children's Hospital.' *Hospital Development*, March and April.

Moore, W. (1995) 'Creating caring environments.' (interviewing John Wells-Thorpe). *Health Director*, March.

Riboulet, P. (1994) *Naissance d'un hôpital.* Les Editions de l'Imprimeur.

Scher, P. (1992) 'Environmental design quality in health care.' *Arts for Health.*

Scher, P. (1994) 'Environmental Design Quality for Health Care. Wythenshawe Hospital Design Field Study.' *Arts for Health.* (summarised in *Hospital Development*, Sept. 1994)

Yarrow, S. (1992) 'Splitting the nucleus.' *Health Service Journal*, 8th October.

Old Buildings

Baron, J.H., Hadden, M. and Palley, M. (1993) *St Charles Hospital Works of Art,* second edition. St Charles Hospital.

Hospital Development (1992) 'Gilding the lily – St Thomas' Hospital.' *Hospital Development*, April.

Moore, W. (1991) 'In search of times past.' *Health Service Journal*, December.

Funding

Arts for Health. *An Introduction to Funding the Arts in Health Care.*

Baron, J.H. and Green, L. (1984) 'Art in the hospitals: funding works of art in new hospitals.' *British Medical Journal 289*, 1731–1737.

Reminiscence Therapy

Sim, R. (1991) 'Looking forward to looking back. Guidelines on reminiscence and the arts in the care of the elderly.' Sim, R. The Reminiscence Project, Hospital Arts, St Mary's Hospital, Manchester M13 OJH.

The Quality of Care

Calne, R. (1991) *The Gift of Life.* Hebden Bridge: Sheeran Lock Fine Art Consultants.

Keep, P., James, J. and Inman, M. (1980) 'Windows in the intensive therapy unit.' *Anaesthesia 35*, 257–262

Keep, P. (1977) 'Stimulus deprivation in windowless rooms.' *Anaesthesia 32*, 598–600

Liebmann, M. (ed) (1994) *Art Therapy with Offenders.* London: Jessica Kingsley.

Moss, L.M. (1986) 'The arts as healing agents in recovery from operation.' *Theoretical Surgery.*

Peaker, A. (1994) *The Arts and People in Institutions.* Oxford: Blackwell/NSEAD.

Artists in Residence

Alexander, L. (1991) *Throwaway Lines.* Oxford: Sobell Publications.

Miles, M. (ed) (1992) 'Artists in residence in hospitals.' *British Health Care Arts.*

Sampson, F. (1989) 'Writing in health care.' *Healing Arts,* Isle of Wight.

Evaluation

Miles, M. (1991) 'The tree of learning.' *Hospital Development,* November.

Miles, M. (1994) 'Art in hospitals: does it work? A survey of evaluation of arts projects in the NHS.' *Journal of the Royal Society of Medicine 87.*

Milne, D. (ed) (1987) *Evaluating Mental Health Practice.* London: Croom Helm.

Ulrich, R.S. (1984) 'View through a window may influence recovery from surgery.' *Science 224.*

List of Contributors

Lynne Alexander is the author of four internationally acclaimed novels: *Safe Houses, Resonating Bodies, Taking Heart* and *Adolf's Revenge*. Her fifth novel will be published in 1997 by Virago. She has been writer in residence at three hospices in the UK and has published two anthologies of poetry based on this work: *Now I Can Tell* and *Throwaway Lines*. She is a Regular Visiting Lecturer in Creative Writing at Sheffield Hallam University, and also teaches at Univesity College of St Martin's in Lancaster and The Brewery Arts Centre in Kendal.

Bernie Arigho took a BA in modern history and politics in 1978 and a Certificate in Education (History) in 1979. From 1979 to 1981 he worked as a residential social worker with young offenders and in 1986 became a registered general nurse, later specialising in psychiatry and the nursing of older people. He incorporated reminiscence activities into nursing care on a continuing care ward. He took his MSc in Gerontology at King's College, London in 1992 with a dissertation on reminiscence exchanges in nursing care. Since 1992 he has been Reminiscence Co-ordinator at Age Exchange where he is responsible for co-ordinating training programmes and outreach reminiscence work, developing new accredited training courses and conducting exhaustive studies of reminiscence projects.

Chris Barrett is a freelance artist who has worked for over ten years in health care environments. This has included large scale mural and design projects at the Royal Berkshire Hospital, Reading and at the John Radcliffe Hospital, Oxford. He was Artist in Residence at Furness General Hospital, Barrow for 16 months. He also has a studio based practice. Leading galleries of contemporary art in the UK, such as the Icon Gallery, Birmingham, and the Museum of Modern Art, Oxford, have shown his work, as have galleries in Paris, Florence and Warsaw. Recently he completed a number of murals for the out-patients department of the Royal Free Hospital, London, and is currently working on the United Leeds Teaching Hospitals NHS Trust Phase I Redevelopment.

Tony Blee was educated at University College School, Hampstead and Trinity College, Cambridge where he read Classics. He spent his National Service learning Russian. In 1962 he joined the King Edward's Fund National Administrative Training Scheme and took up his first post as Deputy Hospital Administrator at St George's Hospital, Hyde Park Corner, in 1964. He then held a number of posts in hospitals and authorities in and around London until

he moved to the Isle of Wight as District Administrator in 1982. He was the Island's General Manager from 1985 to 1992.

Jean Shinoda Bolen lives in Mill Valley, California. She is a psychiatrist and Jungian analyst with a private practice in San Francisco. She is also a clinical professor of psychiatry at the University of California Medical Center and faculty member of the San Francisco C.G. Jung Institute and founder and co-chair of Psychiatrists for ERA, the precursor to the Association for Women in Psychiatry. She is author of *The Tao of Psychology; Synchronicity and the Self; Goddesses in Everywoman: A New Psychology of Women* with a foreword by Gloria Steinem; *Gods in Everyman: A New Psychology of Men's Power: The Abandoned Child, the Authoritarian Father, and the Distemperold Feminine: a Jungian Understanding of Wagner's Ring Cycle; Crossing to Avalon: A Woman's Midlife Pilgrimage.*

Gail Bolland is the Northern Officer for Health Care Arts. She studied Fine Art at Middlesex Polytechnic and subsequently practised as a sculptor in London for several years. She won a number of Arts Council bursaries and has exhibited in London galleries, including the Riverside Studios, Hammersmith. She has been a visiting lecturer at various colleges of art and has worked as an artist in hospitals and she has developed and promoted the arts in the community at a local, national and international level. She is currently responsible for ULTH NHS Trust's Arts Programme, which includes commissioning and fundraising for projects for several hospitals and sites, co-ordination of interior design and corporate identity, and an exhibition programme supported by Yorkshire and Humberside Arts. As Northern Officer for Health Care Arts Gail acts as consultant for other NHS clients aiming to integrate the arts and improve the quality of design for people in the built environment. She has introduced a Special Study Module on the role of the arts in medicine for third year medical students at Leeds University.

Meryel Boyd has been joint manager of Independent Arts on the Isle of Wight for the last three years. She concentrates particularly on fund-raising and public relations. Previously, she has worked in advertising, taught swimming and has been a medical secretary. She holds a City and Guilds Certificate in horticulture.

Devra M. Breslow has spent over 30 years as a public health professional: journalist, historical researcher, hospice planner and medical school administrator. From 1982–89, she was founder-director of Art That Heals at UCLA, one of the pioneering hospital arts programmes in the United States. Since 1993, she has been a fine arts and social documentary photographer. One illustrated book in progress, *Women of my World*, traces the evolution of the author–artist during the period of empowered womanhood.

Langley Brown has been the Director of START studios in Manchester since its foundation in 1986. He was formerly a member of the Manchester Hospital Arts Project under its then Director, Peter Senior, who is now Director of Arts for Health. He is planning to leave START shortly to set up a freelance consultancy and project development service which, in collaboration with Arts for Health, will advise other health authorities in the setting up of arts and mental health schemes. He is an artist who works on collaborative pieces, murals and constructions in mosaic, paint, ceramic and wood.

Richard Burton has been a partner and director of the Architects, Ahrends, Burton and Koralek since 1961. Buildings for which he has been responsible include the British Embassy in Moscow, John Lewis at Kingston on Thames and, for the NHS, the 'Low Energy' Hospital at St Mary's, Newport, Isle of Wight.

Brian Chapman has been Artistic Co-ordinator with Hospital Arts since 1976. He is currently Chairperson of Ashworth Arts Council, Arts Consultant and Project Manager to Health Authorities throughout the U.K.

Ruth Cusson trained as a SRN in 1975 and then worked in Israel and in a private alcoholic unit in London. In 1981 she returned to the NHS and held posts at the Royal National Orthopaedic Hospital in Stanmore and at Dulwich Hospital. She then moved to Poole Hospital and became Service Manager of the Paediatric Unit in 1990 and later, following the development of the hospital to Trust status, Patient Care Development Manager.

Guy Eades has been Director of Healing Arts, Isle of Wight since 1986. Before that, having taken a first in Fine Art at the Goldsmith's College at the University of London, he was a freelance artist until 1977 when he became the manager of the Lady Lodge Arts Centre for the Peterborough Development Corporation. He obtained his MA in Arts Policy and Management at City University, London in 1987.

Raphael Eban has had a career in medicine since 1950. He was consultant radiologist at Ealing Hospital and Honorary Senior Lecturer at the Royal Postgraduate Medical School until 1986 when he became Unit General Manager at Ealing Hospital. Learning about paintings in hospitals, he borrowed 40 paintings for the new bare walls, approving payment of the rental from patients' amenity funds. On retirement in 1989 he joined the Committee of Paintings in Hospitals and was Honorary Director until 1994. He is a Fellow of the Royal College of Physicians and of the Royal College of Radiologists.

Sidney Homan is a Professor of English at the University of Florida. He co-ordinates the Shands Hospital, University of Florida Arts in Medicine's (AIM's) many educational activities and is designing a campus-wide educational

course for students on the arts and health. A unique aspect will be its use of cross-teaching by many UF colleges and departments, including medicine, nursing, psychology, fine arts, liberal arts and sciences, architecture, sociology, anthropology and education. He also co-ordinates all AIM's dramatic arts programmes, including workshops with patients, staff and students using theatre games to improve communication skills, and presenting plays to selected and public audiences with health-related themes, such as Pinter's *Come and Go*, Beckett's *Waiting for Godot*, and *Oh Doctor, Oh Nurse*.

Mary Hooper specialised in sculpture at North Staffordshire University between 1974 and 1997 where she obtained a BA in Fine Art. After what she calls 'time out for breeding' between 1979 and 1986 she worked at Hastings Museum and Art Gallery as Education Officer and created a series of displays for the local history museum. She began work on the Hospital Arts Project in 1989. She has carried out periods of teaching and many sculpture workshops for children. She is a practising sculptor and exhibits in local shows.

Charles Kaye OBE graduated from Manchester University in 1962 and joined the National Health Service as a trainee in administration with the King's Fund. He worked in a number of hospitals in London (including St. George's and the London Hospitals) before moving in the late 1970s to Hampshire. There he was a District Administrator, later General Manager, for the Basingstoke Health Authority where he employed one of the first Arts Co-ordinators in the Health Service in the early 1980s. From 1989 to 1996 he was a Chief Executive of the Special Hospitals Service Authority. Earlier this year he was awarded the OBE for services to health care.

Sylvia Lindsay MBE was Director of The Council for Music in Hospitals[1] for 20 years and is now President Emerita.

Mary Lockwood Lane, AIM's Nurse/Artist Coordinator, has served as a faculty member at the University of Florida's College of Nursing. She established and maintains the Artist-in-Residence program and is a practising professional in the visual arts. She is currently pursuing doctoral work emphasising the creative process and healing.

John Lynch is a practising architect who has been involved with Health Care Building for the Special Hospitals Service Authority. He has studied landscape architecture and has always held a particular interest in the relationship between buildings and their settings. He worked for a time, as a full-time watercolour artist concentrating, on townscape and landscape themes. He is currently working for the Home Office.

1 Council for Music in Hospitals, 74 Queens Road, Hersham, Surrey KT12 5LW.

Marilyn Maple has been the Co-ordinator for Educational Media at the University of Florida Health Science Center for almost 30 years. She holds degrees in Broadcast Journalism and Education. Her book *On the Wings of a Butterfly* is an important look at death and dying for children. Her most recent work includes *Actions Speak Louder: A Parent's Guide to the Non-verbal Communication of Children.*

Malcolm Miles was a Senior Lecturer in the history and theory of art at the University of Portsmouth, and Director of Health Care Arts between 1989 and 1993. He is now a Course Director at the School of Design at Chelsea College of Art and Design. He is author of *Art for Public Places* and *Environments for Quality Care – Health Buildings in the Community.*

Peter H Millard is the Eleanor Peel Professor of Geriatric Medicine at St George's Hospital Medical School, London. He was Senior Registrar to Professor Norman Exton-Smith in 1966 and was appointed Consultant at St George's Hospital in 1968. In 1976 he was appointed Director of the Geriatric Teaching and Research Unit and in 1979 he became Eleanor Peel Professor.

His research interests are related to the development of a better environment, the quality of long term care and the modelling of services. His MD thesis in 1989 introduced new methods of measurement and developed a theory for planning and his PhD thesis tested the theory in a regional study. His current research interests cover the development of audit tools and models of care.

He is the President of the British Geriatrics Society, a past President of the British Association for Service to the Elderly and a member of the British Society of Social Gerontology.

As Chairman of the Education Committee of the Royal Institute of Public Health and Hygiene, he co-ordinated the development of an examination for care assistants.

Graham Moore is a partner in the building practice of Moore Salmon Associates in Chichester, West Sussex. He is a Fellow member of the Royal Institution of Chartered Surveyors and his involvement in the field of health care commenced in 1974 when, upon leaving Guildford County Technical College with a Higher Diploma in Building Construction, he gained employment with Surrey Area Health Authority as a Works Assistant based at a large psychiatric hospital. Subsequent progression within the West Surrey and North East Hampshire Health District and latterly with the Lambeth Southwark and Lewisham Area Health Authority provided wide ranging experience in a variety of hospitals and other health buildings.

The practice currently undertakes much of its work within the public and private health care sectors and commissions range from evaluation studies and risk assessments through to the design, specification and control of a variety of projects.

Florence Nash is a research analyst and editorial co-ordinator for the Consortium to establish a Registry for Alzheimer's Disease, a multi-centre study administered from Duke University Medical Centre.

Stephen Nicoll is a freelance London-based artist/designer, working in the field of hospitals and health care. He is presently reviewing signage and 'wayfinding' systems for a number of Trusts, and was previously the interior design co-ordinator for the St Mary's Isle of Wight project.

He spent more than ten years working in architects' offices, before diverging in the 1980s with the intention of adding decoration and visual interest to furniture, interiors and graphics in previously neglected areas of the public sector.

Janice B. Palmer comes from an education and community arts background. Over the past fifteen years, she has developed a multi-faceted arts and humanities program to serve the patients, visitors, staff, and students of Duke University Medical Center. She co-authored *The Hospital Arts Handbook*, a guide for developing arts programme in health care settings, and she is one of the founders of the Society for the Arts in Health Care.

Robin Philipp was born and educated in New Zealand before coming to England for postgraduate training and to explore his family background. He is a Consultant Senior Lecturer in Public Health Medicine and Occupational Medicine and Director of the World Health Organization Collaborating Centre for Environmental Health Promotion and Ecology, in the Department of Social Medicine, University of Bristol. He represents the Regional Specialty Advisers on the Board of the Faculty of Occupational Medicine, Royal College of Physicians, London, is Liaison Person in the UK for the Australasian Faculty of Public Health Medicine, and is a member of Council and the Education Committee, the Royal Institute of Public Health and Hygiene, London. In the arts, he has twice been a finalist in the Hansells Contemporary Sculpture Competition, New Zealand, his sculpture has been exhibited in the New Zealand Academy of Fine Arts, and some of his poetry has been published in the UK.

Adrian Plant joined the Tate Gallery in Liverpool as Outreach Curator to run educational and audience development programmes linked to the Gallery's Collection displays and exhibitions. As Education Curator, Adrian is responsible for organising adult and community education programmes.

Adrian studied art and photography at Bournemouth and Poole College of Art 1978–81 and he is currently studying part-time for an MA in Contemporary Art at Liverpool University.

John Graham-Pole is a Professor of Paediatric and Affiliate Professor of Clinical and Health Psychology at the University of Florida. For over 20 years he has been an educator, researcher and clinician caring for young people with cancer and other life-threatening illnesses.

Ruth Preece is Arts Co-ordinator (Certificated) Ashworth Special Hospital and a founder member of Ashworth Arts Council. She is an organiser and practitioner in multimedia workshops and a visiting speaker in national/international arts and therapy conferences.

John Rice trained at Strathclyde's Scotting Hotel School and the King's Fund. He runs an independent catering consultancy service to the NHS and the private sector. He is author of *Better Food for Patients*, the *Total Quality Management (DIY) Catering Manual* and the NHS Executive's new catering good practice index, *Hospital Catering – Delivering a Quality Service*. John was formerly catering adviser to Wessex Regional Health Authority and held advisory posts at the King's Fund, Department of Health, Strathclyde University and in the private health sector. He specialises in benchmarking the quality and efficiency of catering services and in hospital grading.

Peter Salmon is a partner in the building practice of Moore Salmon Associates in Chichester, West Sussex.

He is a member of the Chartered Institute of Building. He is also a qualified teacher, a profession that he pursued until 1970. He then commenced his own building contracting business from which he moved to specialist contract management and latterly to building surveying with a large private practice. He became heavily involved in many schemes of hospital refurbishment and he has a particular interest in the environments for the care of the frail, elderly and mentally ill.

The practice currently undertakes much of its work within the public and private health care sectors and commissions range from evaluation studies and risk assessments through to the design, specification and control of a variety of projects.

Fiona Sampson's residencies for the Isle of Wight Health Authority and throughout the UK have attracted national and international press and professional attention and have pioneered the development of writing in health care. She is currently researching the theoretical foundations of this practice. Her awards for poetry include the Newdigate Prize, a Southern Arts Writer's Bursary and a residency at the Millay Colony, New York State. Her first collection, *Picasso's Men*, was published in 1993. Two commissions with the artist Meg Campbell – for the British Council and the Arts Council of England – have toured nationally. She is the first director of Aberystwyth International Poetry-fest.

Peter Senior is Director of Arts for Health, the national centre based at the Manchester Metropolitan University. As the founder and Director of Hospital Arts, Manchester, 22 years ago, he has unequalled experience of bringing the arts into health care. He has served as arts consultant to the Department of Health and was a member of both the Attenborough Committee of Enquiry into Arts and Disabled People and the Carnegie Council (established to promote and monitor developments following the Attenborough Report). In 1987 he received a National Art Collections Award for his 'outstanding contribution to the visual arts'. Formerly a member of the Executive Committee of North West Arts and Chairman of their Environmental Arts Panel, he is founder director of Partnership Arts Ltd, the environmental art company. He was an adviser to the Arts Council of Great Britain's Per Cent for Art Steering Group and is currently a member of the Minister for Health's Advisory Group for Architecture.

Nigel Weaver OBE entered the health service as a National Trainee (King's Fund College) in 1960–63 and after various posts in provincial and London hospitals, joined the staff of Charing Cross Hospital in 1968. He was District Administrator, South Hammersmith District (including Charing Cross Hospital) from 1974 to 1982. He moved to Barnet Health Authority as District Administrator 1982, as District General Manager 1985, and Chief Executive 1989–1992. He was a member of the Mental Health Act Commission 1993–1995, of the Advisory Committee of Paintings in Hospitals in 1994 and is Joint Chairman of The Hammersmith Hospitals Arts Committee. He has been founder Chairman of The Fry Public Art Gallery, Saffron Walden, Essex since 1984. He was awarded the OBE in 1992.

Index